The Art of Game Design

The Art of Game Design

A Book of Lenses

Jesse Schell

Carnegie Mellon University

AMSTERDAM • BOSTON • HEIDELBERG • LONDON
NEW YORK • OXFORD • PARIS • SAN DIEGO
SAN FRANCISCO • SINGAPORE • SYDNEY • TOKYO

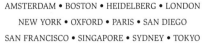 Morgan Kaufmann Publishers is an imprint of Elsevier

Morgan Kaufmann Publishers is an imprint of Elsevier.
30 Corporate Drive, Suite 400, Burlington, MA 01803, USA

This book is printed on acid-free paper.

First edition 2008
Reprinted 2009 (twice)
Reprinted 2010

© 2008 by Elsevier Inc. All rights reserved.

Library of Congress Cataloging-in-Publication Data
Application submitted

ISBN: 978-0-12-369496-6

For information on all Morgan Kaufmann publications,
visit our Web site at *www.mkp.com* or *www.elsevierdirect.com*

Printed in the United States of America

11 12 13 14 15 10 9 8 7 6

For Nyra
who always listens

TABLE OF CONTENTS

8 The Game is Made for a *Player*97

9 The Experience is in the *Player's Mind* ... 113

10 Some Elements are Game *Mechanics*... 129

TABLE OF LENSES

I will talk to you of art,
For there is nothing else to talk about,
For there is nothing else.

Life is an obscure hobo,
Bumming a ride on the omnibus of art.

—Maxwell H. Brock

ACKNOWLEDGMENTS

This has been a long project, and so many people have been kind enough to help make it come into being, I know I am going to miss some. A complete list can be found in the acknowledgments section of http://www.artofgamedesign.com, but I mention people here who really did more than their share.

Nyra and Emma, the loves of my life, who always encouraged me, and put up with years of me staring into space and jotting little notes when I should have been, say, mowing the lawn, doing the dishes, or putting out that fire in the backyard.

My mother, Susanne Fahringer, who, when I was twelve, understood somehow that Dungeons and Dragons was very, very important.

My brother, Ben, who taught me how to play Thunder, a card game he invented in a dream when he was four years old.

Jeff McGinley, for putting that whole ice cream cone in his mouth. And for putting up with me for three decades.

Reagan Heller, who worked with me for countless hours in countless restaurants, airplanes, and meeting rooms coming up with visualization ideas for the lens images on the card deck, designed the card layouts, and did graphic design for several aspects of the book.

Emma Backer, who performed all the Cinderella tasks — typesetting the cards, wrangling the card artists, cleaning up and organizing book images, tracking down copyright holders, and cleaning the ashes from the fireplace.

The team at Elsevier/Morgan Kaufmann, who kindly let a two-year project take five years: Tim Cox, Georgia Kennedy, Beth Millett, Paul Gottehrer, Chris Simpson, Laura Lewin, and Kathryn Spencer.

Everyone at the Disney VR Studio who put up with my rambling theoretical nonsense conversations for all those years, especially Mike Goslin, Joe Shochet, Mark Mine, David Rose, Bruce Woodside, Felipe Lara, Gary Daines, Mk Haley, Daniel Aasheim and Jan Wallace.

Katherine Isbister, who served as a mentor for me in several ways, partly by writing the first book in this series, *Better Game Characters by Design*, but also for giving me practical, technical, and moral support throughout the writing process.

The staff, faculty, and students of Carnegie Mellon's Entertainment Technology Center, who graciously let me teach Game Design and Building Virtual Worlds, which forced me to figure all this out. Most especially Don Marinelli, Randy Pausch,

Brenda Harger, Ralph Vituccio, Chris Klug, Charles Palmer, Ruth Comley, Josh Yelon, and Drew Davidson.

Randy Pausch deserves a double thank you, for his magical lens that let him see that I could do this when I didn't believe that I could. Thanks, Randy.

HELLO

Hello there! Come in, come in! What a nice surprise — I had no idea you would be visiting today. I'm sorry if it is a little messy in here, I've been writing. Please — make yourself comfortable. Good, good. Now let's see… where should we begin? Oh — I should introduce myself!

My name is Jesse Schell, and I have always loved designing games. Here's picture of me:

I was shorter then. Since that picture was taken, I've done a lot of different things. I've worked in circuses as a professional juggler. I've been a writer, comedian, and magician's apprentice. I've worked at IBM and Bell Communications Research as a software engineer. I've designed and developed interactive theme park rides and massively multiplayer games for the Walt Disney Company. I've started my own game studio, and become a professor at Carnegie Mellon University. But when people ask me what I do, I tell them that I am a game designer.

I mention all this only because at various times in this book, I will be drawing examples from these experiences, since every single one of them has taught me valuable lessons about the art of game design. That might sound surprising now, but hopefully, as you read this book, it will help you see the ways that game design meaningfully connects to the many experiences in your own life.

One thing I should clarify — while the goal of this book is primarily to teach you how to be a better videogame designer, many of the principles we explore will have little to do with videogames specifically — you will find they are more broadly applicable than that. The good news is that much of what you read here will work equally well no matter what kind of game you are designing — digital, analog, or otherwise.

What is Game Design?

As we begin, it is important for us to be absolutely clear about what is meant by "game design." After all, it is what the whole rest of the book is about, and some people seem a bit confused about it.

Game design is the act of deciding what a game should be.

That's it. On the surface, it sounds too simple.

"You mean you design a game by just making one decision?"

No. To decide what a game is, you must make hundreds, usually thousands of decisions.

"Don't I need special equipment to design a game?"

No. Since game design is simply decision making, you can actually design a game in your head. Usually, though, you will want to write down these decisions, because our memories are weak, and it is easy to miss something important if you don't write things down. Further, if you want other people to help you make decisions, or to help build the game, you need to communicate these decisions to them somehow, and writing them down is a good way to do that.

"What about programming? Don't game designers have to be computer programmers?"

No, they don't. First of all, many games can be played without the use of computers or technology; board games, card games, and athletic games, for example. Secondly, even for computer games or videogames, it is possible to make the decisions about what those games should be without knowing all the technical details of how those decisions are carried out. Of course, it can be a tremendous help if you do know these details, just as being a skilled writer or artist can help. This allows you to make better decisions more quickly, but it is not strictly necessary. It is like the relationship between architects and carpenters: an architect does not need to know everything the carpenter knows, but an architect must know everything the carpenter is capable of.

"So, you mean that the game designer just comes up with the story for the game?"

No. Story decisions are one aspect of a game design, but there are many, many others. Decisions about rules, look and feel, timing, pacing, risk-taking, rewards, punishments, and everything else the player experiences is the responsibility of the game designer.

"So the game designer makes decisions about what the game should be, writes them down, and moves on?"

Almost never. None of us has a perfect imagination, and the games we design in our heads and on paper almost never come out quite the way we expected. Many decisions are impossible to make until the designer has seen the game in action. For this reason, the designer is usually involved in the development of a game from the very beginning to the very end, making decisions about how the game should be all along the way.

It is important to make the distinction between "game developer" and "game designer." A game developer is anyone who has any involvement with the creation of the game at all. Engineers, animators, modelers, musicians, writers, producers and designers who work on games are all game developers. Game designers are just one species of game developer.

"So, the game designer is the only one allowed to make decisions about the game?"

Let's turn that around: Anyone who makes decisions about how the game should be is a game designer. Designer is a role, not a person. Almost every developer on a team makes some decisions about how the game will be, just through the act of creating content for the game. These decisions are game design decisions, and when you make them, you are a game designer. For this reason, no matter what your role on a game development team, an understanding of the principles of game design will make you better at what you do.

Waiting for Mendeleev

The voyage of discovery is not in seeking new landscapes but in having new eyes.

—Marcel Proust

The goal of this book is to make you the best game designer you can be.

Unfortunately, at present, there is no "unified theory of game design," no simple formula that shows us how to make good games. So what can we do?

We are in a position something like the ancient alchemists. In the time before Mendeleev discovered the periodic table, showing how all the fundamental elements were interrelated, alchemists relied on a patchwork quilt of rules of thumb about how different chemicals could combine. These were necessarily incomplete, sometimes incorrect, and often semi-mystical, but by using these rules, the alchemists were able to accomplish surprising things, and their pursuit of the truth eventually led to modern chemistry.

Game designers await their Mendeleev. At this point we have no periodic table. We have our own patchwork of principles and rules, which, less than perfect, allows us to get the job done. I have tried to gather together the best of these into

one place, so that you can study them, consider them, make use of them, and see how others have used them.

Good game design happens when you view your game from as many perspectives as possible. I refer to these perspectives as **lenses**, because each one is a way of viewing your design. The lenses are small sets of questions you should ask yourself about your design. They are not blueprints or recipes, but tools for examining your design. They will be introduced, one at a time, throughout the book. A deck of cards, with one card summarizing each lens, has been created to accompany this book, and is available at www.artofgamedesign.com, to make it easy to use the lenses while you are designing.

None of the lenses are perfect, and none are complete, but each is useful in one context or another, for each gives a unique perspective on your design. The idea is that even though we can't have one complete picture, by taking all of these small imperfect lenses and using them to view your problem from many different perspectives, you will be able to use your discretion to figure out the best design. I wish we had one all-seeing lens. We don't. So, instead of discarding the many imperfect ones we do have, it is wisest to collect and use as wide a variety of them as possible, for as we will see, game design is more art than science, more like cooking than chemistry, and we must admit the possibility that our Mendeleev will never come.

Focus on Fundamentals

Many people assume that to best study the principles of game design, one would naturally study the most modern, complex, high-tech games that are available. This approach is completely wrong. Videogames are just a natural growth of traditional games into a new medium. The rules that govern them are still the same. An architect must understand how to design a shed before he can design a skyscraper, and so, we will often be studying some of the very simplest games. Some of these will be videogames, but some will be far simpler: Dice games. Card games. Board games. Playground games. If we cannot understand the principles of these games, how can we have a hope of understanding more complex games? Some will argue that these games are old, and therefore not worth studying, but as Thoreau said, "We might as well omit to study Nature because she is old." A game is a game is a game. The principles that make the classic games fun are the same principles that make the most modern games fun. The classic games have the added advantage that they have withstood the tests of time. Their success is not due to the novelty of their technology, which is the case with many modern games. These classic games have deeper qualities that, as game designers, we must learn to understand.

As well as a focus on classic games, this book will strive to deliver the deepest and most fundamental principles of game design, as opposed to genre-specific principles ("Fifteen tips for a better story-based first-person shooter!"), because genres come and go, but the basic principles of game design are principles of human psychology that have been with us for ages, and will be with us for ages to come.

Well-versed in these fundamentals, you will be able to master any genre that appears, and even invent new genres of your own. As opposed to other books on game design, whose goal often seems to be to cover as much ground as possible, this book will not strive to cover ground, but to teach you to dig in the most fertile places.

And though this book will teach you principles you will be able to use to create traditional board and card games, it is very much slanted toward the videogame industry. Why? Because a game designer's job is to create new games. The explosion of computer technology over the last thirty years has allowed for innovation in the field of game design such as the world has never seen. There are more game designers alive today than have ever been alive in all of human history. Chances are, if you want to create games, you will be creating them somewhere on the cutting edge of this new technology, and this book is prepared to show you how to do just that, although the principles here will work just as well with more traditional game genres.

Talk to Strangers

Do not forget to entertain strangers, for by so doing some have unwittingly entertained angels.

—Hebrews 13:2

Game developers have a reputation for xenophobia, that is, fear of strangers. By this I mean not unfamiliar individuals, but rather unfamiliar techniques, practices, and principles. It almost seems like they believe that if it didn't originate in the game industry, it isn't worth considering. The truth is really that game developers are usually just too busy to look outside their immediate surroundings. Making good games is hard, so developers keep their heads down, stay focused, and get the job done. They usually don't have the time to seek out new techniques, figure out how to integrate them into their games, and take the risk that a new technique might fail. So, they play it safe, and stick with what they know, which unfortunately leads to a lot of the "cookie-cutter" game titles that you see on the market.

But to succeed, to create something great and innovative, you have to do something different. This is not a book about how to make cookie-cutter games. It is a book about how to create great new designs. If you were surprised by the focus this book places on non-computer games, you will be even more surprised to see how it uses principles, methods, and examples from things that aren't even games. Examples from music, architecture, film, science, painting, literature, and everything else under the sun will be pulled in. And why not? Why should we have to develop all our principles from scratch, when hard work has been going on in other fields, sometimes for hundreds or thousands of years? Design principles will come from everywhere because design is everywhere, and **design is the same everywhere**.

Not only will this book draw design inspiration from everywhere, it will persuade you to do the same. Everything you know and everything you have experienced is fair game at the game design table.

> *It does not make much difference what a person studies. All knowledge is related, and the man who studies anything, if he keeps at it, will become learned.*
>
> —Hypatia

The Map

Game design is not an easy subject to write about. Lenses and fundamentals are useful tools, but to truly understand game design is to understand an incredibly complex web of creativity, psychology, art, technology, and business. Everything in this web is connected to everything else. Changing one element affects all the others, and the understanding of one element influences the understanding of all of the others. Most experienced designers have built up this web in their minds, slowly, over many years, learning the elements and relationships by trial and error. And this is what makes game design so hard to write about. Books are necessarily linear. One idea must be presented at a time. For this reason, many game design books have an incomplete feeling to them — like a guided nighttime tour with a flashlight, the reader sees a lot of interesting things, but can't really comprehend how they all fit together.

Game design is an adventure, and adventure needs a map. For this book, I have created a map that shows the web of game design relationships. You can see the complete map near the end of the book, but to see the entire map at once is confusing and overwhelming. Picasso once said, "To create, one must first destroy." And so we will. We set everything aside, and begin our map as a blank slate. As we do this, I encourage you, too, to set aside your preconceptions about game design, so that you can approach this difficult but fascinating subject with an open mind.

Chapter one will begin by adding a single element, the designer. Successive chapters will add other elements, one at a time, gradually building up the complex system of relationships between designer, player, game, team, and client, so you can see how they fit together, and why they fit together the way they do. By the end of the book, you will have, both on paper and in your mind, a map of these relationships. Of course, the map on paper is not the important one — the important one is the one in your mind. And the map is not the territory. It will necessarily be imperfect. But hopefully, after this book helps to create a map of relationships in your mind, you will test your mental map against reality, altering it and augmenting it, as you find parts of it that can be improved. Every designer goes through the journey of building their own personal map of these relationships. If you are new to game

design, this book should be able to give you the beginnings of your map. If you are already a seasoned game designer, I hope that this book can give you some ideas about how to improve the map you have.

Learning to Think

Every truth has four corners: as a teacher I give you one corner, and it is for you to find the other three.

—Confucius

What is Confucius talking about? Shouldn't a good teacher show you all four corners, laying everything out plainly? No. To truly learn, remember, and understand, your mind must be in a state of questing, of seeking to find knowledge. If it is not in this state, a state of really wanting to deeply understand, the wisest principles will roll off you like water off a duck. There will be times in this book where things will not be laid out plainly — times where things are intentionally less clear so that when you do uncover the truth, it means something to you.

There is another reason for this sometimes cryptic approach. As discussed earlier, game design is not an exact science. It is full of mysteries and contradictions. Our set of lenses will be incomplete and imperfect. To become a great game designer, it is not enough to be familiar with the set of principles this book has to offer. You must be ready to think for yourself, to figure out why certain principles don't work in certain cases, and to invent new principles of your own. We await our Mendeleev. Perhaps it is you.

Why I Hate Books

I hate books, for they only teach people to talk about what they don't understand.

—Jean-Jacques Rousseau

It is very important to have a balanced approach to study and practice.

—The Dalai Lama

Please do not think that reading this book, or any book, will make you into a game designer, much less a great game designer. Game design is not a set of principles, it is an activity. You could no sooner become a singer, pilot, or basketball player by reading a book than you could become a game designer. There is only one path to becoming a game designer, and that is the path of designing

games — and more to the point, designing games that people really like. That means that simply jotting down your game idea isn't enough. You must build the game, play it yourself, and let others play it. When it doesn't satisfy (and it won't), you must change it. And change it. And change it again, dozens of times, until you have created a game that people actually enjoy playing. When you have been through this a few times, then you will start to understand what game design is. There's an saying among game designers: "Your first ten games will suck — so get them out of the way fast." The principles in this book will help to guide your designs, and give you useful perspectives on how to make better designs faster, but you can only become a good designer through practice. If you are not really interested in becoming a good game designer, put this book down now. It has nothing for you. But if you truly do want to be a game designer, then this book is not an end, but a beginning —the beginning of a continuous process of study, practice, assimilation, and synthesis that is going to last the rest of your life.

CHAPTER ONE

In the Beginning, There Is the Designer

FIGURE
1.1

Magic Words

Would-be designers often ask me, "How do you become a game designer?" And the answer is easy: "Design games. Start now! Don't wait! Don't even finish this conversation! Just start designing! Go! Now!"

And some of them do just that. But many have a crisis of confidence, and feel stuck in a catch-22: If only game designers can design games, and you can only become a game designer by designing games, how can anyone ever get started? If this is how you feel, the answer is easy. Just say these magic words:

I am a game designer.

I'm serious. Say them out loud, right now. Don't be shy — there's no one here but us.

Did you do it? If so, congratulations. You are now a game designer. You might feel, at this moment, that you aren't really a game designer yet, but that you're just pretending to be one. And that's fine, because as we'll explore later, people become what they pretend to be. Just go on pretending, doing the things you think a game designer would do, and before long, to your surprise, you will find you are one. If your confidence wavers, just repeat the magic words again: **I am a game designer**. Sometimes, I repeat them like this:

Who are you?
I am a game designer.
No, you're not.
I *am* a game designer.
What kind of a designer?
I am a *game* designer.
You mean you play games.
I am a game *designer*.

This game of confidence building may seem silly at first. But it is far from the silliest thing you will do as a designer. And it is terribly important that you get good at building your confidence, for doubts about your abilities will forever plague you. As a novice designer, you will think "I've never done this — I don't know what I'm doing." Once you have a little experience, you will think "My skills are so narrow — this new title is different. Maybe I just got lucky last time." And when you are a seasoned designer, you will think "The world is different now. Maybe I've lost my touch."

Blow away these useless thoughts. They can't help you. When a thing must be attempted, one must never think about possibility or impossibility. If you look at the great creative minds, all so different, you will find they have one thing in common: They lack a fear of ridicule. Some of the greatest innovations have come from people who only succeeded because they were too dumb to know that what they were doing was impossible. Game design is decision making, and decisions must be made with confidence.

Will you fail sometimes? Yes you will. You will fail again, and again, and again. You will fail many, many more times than you will succeed. But these failures are your only path to success. You will come to love your failures, because each failure brings you a step closer to a truly phenomenal game. There is a saying among jugglers: "If you aren't dropping, you aren't learning. And if you aren't learning, you aren't a juggler." The same is true for game design: If you aren't failing, you aren't trying hard enough, and you aren't really a game designer.

What Skills Does a Game Designer Need?

In short, all of them. Almost anything that you can be good at can become a useful skill for a game designer. Here are some of the big ones, listed alphabetically:

- **Animation** — Modern games are full of characters that need to seem alive. The very word "animation" means "to give life." Understanding the powers and limits

of character animation will let you open the door for clever game design ideas the world has yet to see.

- **Anthropology** — You will be studying your audience in their natural habitat, trying to figure out their heart's desire, so that your games might satisfy that desire.
- **Architecture** — You will be designing more than buildings — you'll be designing whole cities and worlds. Familiarity with the world of architecture, that is, understanding the relationship between people and spaces, will give you a tremendous leg up in creating game worlds.
- **Brainstorming** — You will need to create new ideas by the dozens, nay, by the hundreds.
- **Business** — The game industry is just that, an industry. Most games are made to make money. The better you understand the business end of things, the better chance you have of making the game of your dreams.
- **Cinematography** — Many games will have movies in them. Almost all modern videogames have a virtual camera. You need to understand the art of cinematography if you want to deliver an emotionally compelling experience.
- **Communication** — You will need to talk with people in every discipline listed here, and even more. You will need to resolve disputes, solve problems of miscommunication, and learn the truth about how your teammates, your client, and your audience really feel about your game.
- **Creative Writing** — You will be creating entire fictional worlds, populations to live in them, and deciding the events that will happen there.
- **Economics** — Many modern games feature complex economies of game resources. An understanding of the rules of economics can be surprisingly helpful.
- **Engineering** — Modern videogames involve some of the most complex engineering in the world today, with some titles counting their lines of code in the millions. New technical innovations make new kinds of gameplay possible. Innovative game designers must understand both the limits and the powers that each technology brings.
- **History** — Many games are placed in historical settings. Even ones placed in fantasy settings can draw incredible inspiration from history.
- **Management** — Any time a team works together toward a goal, there must be some management. Good designers can succeed even when management is bad, secretly "managing from below" to get the job done.
- **Mathematics** — Games are full of mathematics, probability, risk analyses, complex scoring systems, not to mention the mathematics that stands behind computer graphics and computer science in general. A skilled designer must not be afraid to delve into math from time to time.
- **Music** — Music is the language of the soul. If your games are going to truly touch people, to immerse, and embrace them, they cannot do it without music.

3

- **Psychology** — Your goal is to make a human being happy. You must understand the workings of the human mind or you are designing in the dark.
- **Public Speaking** — You will frequently need to present your ideas to a group. Sometimes you will speak to solicit their feedback, sometimes you will speak to persuade them of the genius of your new idea. Whatever the reason, you must be confident, clear, natural, and interesting, or people will be suspicious that you don't know what you are doing.
- **Sound Design** — Sound is what truly convinces the mind that it is in a place; in other words, "hearing is believing."
- **Technical Writing** — You need to create documents that clearly describe your complex designs without leaving any holes or gaps.
- **Visual Arts** — Your games will be full of graphic elements. You must be fluent in the language of graphic design and know how to use it to create the feeling you want your game to have.

And of course, there are many more. Daunting, isn't it? How could anyone possibly master all of these things? The truth is that no one can. But the more of these things you are comfortable working with, however imperfectly, the better off you will be. This is another reason that game designers must be confident and fearless. But there is one skill that is the key to all the others.

The Most Important Skill

Of all the skills mentioned in the previous section, one is far and away the most important, and it sounds so strange to most people that I didn't even list it. Many people guess "creativity," and I would argue that this is probably the second most important skill. Some guess "critical thinking" or "logic," since game design is about decision making. These are indeed important, but by no means the most important skills.

Some say "communication," which starts to get close. The word communication has unfortunately become corrupted over the centuries. It once referred to an exchange of ideas, but now has become a synonym for talking, as in "I have something to communicate to you." Talking is certainly an important skill, but good communication and good game design are rooted in something far more basic and far more important.

Listening.

The most important skill for a game designer is listening.

Game designers must listen to many things. These can be grouped into five major categories: Team, Audience, Game, Client, and Self. Most of this book will be about how to listen to these five things.

This may sound absurd to you. Is listening even a skill? We are not equipped with "earlids." How can we help but listen?

By listening, I don't mean merely hearing what is said. I mean a deeper listening, a thoughtful listening. For example, you are at work, and you see your friend Fred. "Hi, Fred, How are you?" you say. Fred frowns, looks down, shifts his weight uncomfortably, seems to be hunting for words, and then says quietly, without eye contact "Uh, fine, I guess." And then, he collects himself, takes a breath, and looks you in the eye as he determinedly, but not convincingly, says a little louder "I'm, uh, fine. How are you?"

So, how is Fred? His words say "He's fine." Great. Fred is fine. If you are just "surface listening," you might draw that conclusion. But if you listen more deeply, paying full attention to Fred's body language, subtle facial expression, tone of voice and gestures, you might hear a very different message: "Actually, I'm not fine. I have a serious problem that I think I might want to discuss with you. But I won't do that unless I get some kind of commitment from you that you really care about my problem, because it is kind of a personal issue. If you don't want to get involved with it, though, I won't bother you with it, and I'll just pretend that everything is okay."

All of that was right there, in Fred's "I'm fine." And if you were listening deeply to what he said, you heard it all; clear as a bell, plain as day, as if he'd said it out loud. This is the kind of listening that game designers must engage in, day in and day out, with every decision that they make.

When you listen thoughtfully you observe everything and constantly ask yourself questions. "Is that right?" "Why is it that way?" "Is this how she really feels?" "Now that I know that, what does it mean?"

Game designer Brian Moriarty once pointed out that there was a time when we didn't use the word "listen," instead we said "list!" And where did this come from? Well, what do we do when we listen? We tip our head to one side — our head literally lists, as a boat at sea. And when we tip to one side, we put ourselves off balance; we accept the possibility of upset. When we listen deeply we put ourselves in a position of risk. We accept that possibility that what we hear may upset us, may cause everything we know to be contradicted. It is the ultimate in open-mindedness. It is the only way to learn the truth. You must approach everything as a child does, assuming nothing, observing everything, listening as Herman Hesse describes in *Siddhartha*:

> *To listen with a silent heart, with a waiting, open soul. Without passion, without desire, without judgment, without rebuke.*

The Five Kinds of Listening

Because game design is such an interconnected web, we will be visiting and revisiting the five kinds of listening, and exploring their interconnections throughout this book.

You will need to listen to your **team** (Chapters 23 and 24), since you will be building your game and making crucial game design decisions together with them. Remember that big list of skills? Together, your team might have all of them. If you

can listen deeply to your team, and truly communicate with them, you will all function as one unit, as if you all shared the same skills.

You will need to listen to your **audience** (Chapters 8, 9, 21, 22, and 30) because these are the people who will be playing your game. Ultimately, if they aren't happy with your game, you have failed. And the only way to know what will make them happy is to listen to them deeply, getting to know them better than they know themselves.

You will need to listen to your **game** (most chapters in the book). What does this even mean? It means you will get to know your game inside and out. Like a mechanic who can tell what is wrong with a car by listening to the engine, you will get to know what is wrong with your game by listening to it run.

You will need to listen to your **client** (Chapters 27–29). The client is the one who is paying you to design the game, and if you don't give them what they want, they'll go to someone else who does. Only by listening to them, deeply, will you be able to tell what they really want, deep in their hearts.

And last, you will need to listen to your **self** (Chapters 1, 6, and 32). This sounds easy, but for many, it is the most difficult kind of listening. If you can master it, however, it will be one of your most powerful tools, and the secret behind your tremendous creativity.

The Secret of the Gifted

After all that fancy talk, your confidence might be fading already. You might be wondering whether game design is really for you. You might have noticed that skilled game designers seem to have a special gift for the work. It comes easily and naturally to them, and though you love games, you wonder if you are gifted enough to succeed as a designer. Well, here is a little secret about gifts. There are two kinds. First, there is the innate gift of a given skill. This is the minor gift. If you have this gift, a skill such as game design, mathematics, or playing the piano comes naturally to you. You can do it easily, almost without thinking. But you don't necessarily enjoy doing it. There are millions of people with minor gifts of all kinds, who, though skilled, never do anything great with their gifted skill, and this is because they lack the major gift.

The major gift is love of the work. This might seem backward. How can love of using a skill be more important than the skill itself? It is for this simple reason: If you have the major gift, the love of designing games, you will design games using whatever limited skills you have. And you will keep doing it. And your love for the work will shine through, infusing your work with an indescribable glow that only comes from the love of doing it. And through practice, your game design skills, like muscles, will grow and become more powerful, until eventually your skills will be as great, or greater than, those of someone who only has the minor gift. And people will say, "Wow. That one is a truly gifted game designer." They will think you have the minor gift, of course, but only you will know the secret source of your skill, which is the major gift: love of the work.

But maybe you aren't sure if you have the major gift. You aren't sure if you truly love game design. I have encountered many students who started designing games just to see what it was like, only to find that to their surprise, they truly love the work. I have also encountered those who were certain that they were destined to be game designers. Some of these even had the minor gift. But when they experienced what game design really was like, they realized it wasn't for them.

There is only one way to find out if you have the major gift. Start down the path, and see if it makes your heart sing.

So, recite your magic words, for down the path we go!

I **am a game designer**.

I *am* **a game designer**.

I am a *game* **designer**.

I am a game *designer*.

CHAPTER TWO

The Designer Creates an *Experience*

FIGURE
2.1

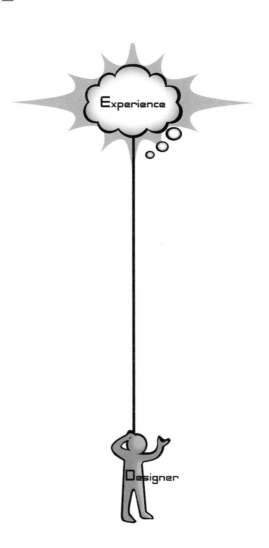

I already know the ending /
it's the part that makes your face implode /
I don't know what makes your face implode /
but that's the way the movie ends.

– They Might Be Giants, *Experimental Film*

Of the innumerable effects, or impressions, of which the heart, the intellect, or the
soul is susceptible, what one shall I, on the present occasion, select?

– Edgar Allen Poe, *The Philosophy of Composition*

In the last chapter we established that everything begins with the game designer, and that the game designer needs certain skills. Now it is time to begin talking about what a game designer uses those skills for. Put another way, we need to ask "What is the game designer's goal?" At first, the answer seems obvious: a game designer's goal is to design games.

But this is wrong.

Ultimately, a game designer does not care about games. Games are merely a means to an end. On their own, games are just artifacts — clumps of cardboard, or bags of bits. Games are worthless unless people play them. Why is this? What magic happens when games are played?

When people play games, they have an experience. It is this experience that the designer cares about. Without the experience, the game is worthless.

I will warn you right now, we are about to enter territory that is very difficult to talk about. Not because it is unfamiliar — in fact, quite the opposite. It is hard to talk about because it is *too* familiar. Everything we've ever seen (look at that sunset!), done (have you ever flown a plane?), thought (why is the sky blue?), or felt (this snow is so cold!) has been an experience. By definition, we can't experience anything that is *not* an experience. Experiences are so much a part of us, they are hard to think about (even thinking about experiences is an experience). But, as familiar as we are with experiences, they are very hard to describe. You can't see them, touch them, or hold them — you can't even really share them. No two people can have identical experiences of the same thing — each person's experience of something is completely unique.

And this is the paradox of experiences. On one level, they are shadowy and nebulous, and on another, they are all we know. But as tricky as experiences can be, *creating them is all a game designer really cares about*. We cannot shy away from them, retreating into the concreteness of our material game. We must use every means we can muster to comprehend, understand, and master the nature of human experience.

The Game Is Not the Experience

We must be absolutely clear on this point before we can proceed. The game is not the experience. The game enables the experience, but it *is not the experience*. This is a hard concept for some people to grasp. The ancient Zen question addresses this

directly: "If a tree falls in the forest, and no one is there to hear it, does it make a sound?" This has been repeated so often that it sounds hackneyed, but it is *exactly* what we are talking about. If our definition of "sound" is air molecules vibrating, then yes, the tree makes a sound. If our definition of sound is the *experience of hearing a sound*, then the answer is no, the tree makes no sound when no one is there. As designers, we don't really care about the tree and how it falls — we care only about the experience of hearing it. The tree is just a means to an end. And if no one is there to hear it, well, we don't care at all.

Game designers only care about what *seems* to exist. The player and the game are real. The experience is imaginary — but game designers are judged by the quality of this imaginary thing because it is the reason people play games.

If we could, through some high-tech magic, create experiences for people directly, with no underlying media — no game boards, no computers, no screens — we would do it. In a sense, this is the dream of "artificial reality" — to be able to create experiences that are in no way limited by the constraints of the medium that delivers the experiences. It is a beautiful dream, but only a dream. We cannot create experiences directly. Perhaps in the distant future, using technologies hard to imagine, such a thing could happen. Time will tell. For now, we live in the present, where all we can do is create artifacts (rule sets, game boards, computer programs) that are likely to create certain kinds of experiences when a player interacts with them.

And it is this that makes game design so very hard. Like building a ship in a bottle, we are far removed from what we are actually trying to create. We create an artifact that a player interacts with, and cross our fingers that the experience that takes place during that interaction is something they will enjoy. We never truly see the output of our work, since it is an experience had by someone else and, ultimately, unsharable.

This is why deep listening is so essential for game design.

Is This Unique to Games?

You might well ask what is so special about games, compared to other types of experiences, that requires us to get into all of this touchy-feely experience stuff. And really, on one level, there is nothing special about games in this regard. Designers of all types of entertainment — books, movies, plays, music, rides, everything — have to cope with the same issue: How can you create something that will generate a certain experience when a person interacts with it?

But the split between artifact and experience is much more obvious for game design than it is for other types of entertainment, for a not-so-obvious reason. Game designers have to cope with much more interaction than the designers of more linear experiences. The author of a book or screenplay is designing a linear experience. There is a fairly direct mapping between what they create and what the reader or viewer experiences. Game designers don't have it so easy. We give the player a great deal of control over the pacing and sequence of events in the experience.

We even throw in random events! This makes the distinction between artifact and experience much more obvious than it is for linear entertainment. At the same time, though, it makes it much harder to be certain just what experience is really going to arise in the mind of the player.

So, why do we do it? What is so special about game experiences that we would give up the luxuries of control that linear entertainers enjoy? Are we simply masochists? Do we just do it for the challenge? No. As with everything else game designers do, we do it for the experience it creates. There are certain feelings: feelings of choice, feelings of freedom, feelings of responsibility, feelings of accomplishment, feelings of friendship, and many others, which only game-based experiences seem to offer. This is why we go through all the trouble — to generate experiences that can be had no other way.

Three Practical Approaches to Chasing Rainbows

There ain't no rules around here! We're trying to accomplish something!

– Thomas Edison

So — we've established what we need to do — create games that will somehow generate wonderful, compelling, memorable experiences. To do this, we must embark on a daunting endeavor: to uncover both the mysteries of the human mind and the secrets of the human heart. No one field of study has managed to perfectly map this territory (Mendeleev, where are you?), but several different fields have managed to map out parts of it. Three, in particular, stand out: Psychology, Anthropology, and Design. Psychologists want to understand the mechanisms that make people tick, anthropologists want to understand people on a human level, and designers just want to make people happy. We will be using approaches borrowed from all three of these fields, so let's consider what each one has to offer us.

Psychology

Who better for us to learn the nature of human experience from than psychologists, the scientists who study the mechanisms that govern the human mind? And truly, they have made some discoveries about the mind that are incredibly useful, some of which will be covered in this book. In fact, you might expect that our quest for understanding how to create great human experiences might end right here; that the psychologists should have all the answers. Sadly, this is not the case. Because they are scientists, they are forced to work in the realm of what is real and provable. Early in the twentieth century, a schism in psychology developed. On one side of the battle were the behaviorists who focused only on measurable behavior, taking a "black box" approach to the study of the mind. Their primary tool was objective, controlled experimentation. On the other side were the phenomenologists who study what game designers care about

most — the nature of human experience and "the feeling of what happens." Their primary tool was introspection — the act of examining your experiences as they happen.

Unfortunately for us, the behaviorists won out, and for very good reasons. The behavioristic focus on objective, repeatable experiments makes for very good science. One behaviorist can do an experiment, publish a paper about it, and other behaviorists can repeat the experiment under the same conditions, almost certainly getting the same results. The phenomenological approach, on the other hand, is necessarily subjective. Experiences themselves cannot be directly measured — only described, and described imperfectly. When an experiment takes place in your mind, how can you possibly be sure the experimental conditions are controlled? As fascinating and useful as it might be to study our own internal thoughts and feelings, it makes for shaky science. As a result, for as much progress that has been made by modern psychology, it generally feels obligated to avoid the thing we care about the most — the nature of human experience.

Though psychology does not have all the answers we need, it does provide some very useful ones, as we'll see. More than that, it provides approaches we can use quite effectively. Not bound by the strict responsibilities of good science, game designers can make use of both behavioristic experiments and phenomenological introspection to learn what we need to know, since ultimately, as designers, we are not concerned with what *is definitely true* in the world of objective reality, but only with what *seems to be true* in the world of subjective experience.

But perhaps there is another scientific approach that lies somewhere between the two extremes of behaviorism and phenomenology?

Anthropology

Anthropology is the most humanistic of the sciences and the most scientific of the humanities.

– Alfred L. Kroeber

Anthropology is another major branch of study about human beings and what they think and do. It takes a much more holistic approach than psychology, looking at everything about people including their physical, mental, and cultural aspects. It is very concerned with studying the similarities and differences between the various peoples of the world, not just today, but throughout history.

Of particular interest to game designers is the approach of cultural anthropology, which is the study of living peoples' ways of life, mostly through fieldwork. Cultural anthropologists live with their subjects of study, and try to immerse themselves completely in the world of the people they are trying to learn about. They strive for objective observation of culture and practices, but at the same time they engage in introspection and take great pains to put themselves in the place of their subjects. This helps the anthropologist better imagine what it "feels like" to be their subjects.

13

We can learn a number of important things about human nature from the work of anthropologists — but much more important, by taking a cultural anthropologist's approach to our players, interviewing them, learning everything we can about them, and putting ourselves in their place, we can gain insights that would not have been possible from a more objective point of view.

Design

The third field that has made important study of human experience is, not surprisingly, the field of design. We will be able to learn useful things from almost every kind of designer: musicians, architects, authors, filmmakers, industrial designers, Web designers, choreographers, visual designers, and many more. The incredible variety of design "rules of thumb" that comes from these different disciplines do an excellent job of illustrating useful principles about human experience. But unfortunately, these principles can often be hard for us to use. Unlike scientists, designers seldom publish papers about their discoveries. The very best designers in various fields often know little about the workings of other fields of design. The musician may know a lot about rhythm, but probably has given little thought to how the principles of rhythm might apply to something non-musical, such as a novel or stage play, even though they may have meaningful practical application there, since they are ultimately rooted in the same place — the human mind. So, to use principles from other areas of design, we will need to cast a wide net. Anyone who creates something that people are meant to experience and enjoy has something to teach us, and so we will pull rules and examples from designers of every stripe, being as "xenophilic" as possible.

Ideally, we would find ways to connect all the varied principles of design to each other through the common ground of psychology and anthropology, since ultimately all design principles are rooted in these. In some small ways, we will do that in this book. Perhaps one day these three fields will find a way to unify all their principles. For now, we will need to be content with building a few bridges here and there — this is no small accomplishment, since these are three fields that seldom have much cross-pollination. Further, some of the bridges will prove to be surprisingly useful! The task before us, game design, is so difficult that we cannot afford to be snobbish about where we get our knowledge. None of these approaches can solve all our problems, so we will mix and match them, trying to use them appropriately, like we might use tools from a toolbox. We must be both open-minded and practical — good ideas can come from anywhere, but they are only good for us if they help us create better experiences.

Introspection: Powers, Perils, and Practice

We have discussed some of the places to find useful tools for mastering human experience. Let's now focus on one tool that has been used by all three disciplines: introspection. This is the seemingly simple act of examining your own thoughts and

feelings — that is, your own experiences. While it is true you can never truly know the experience of another, you certainly can know your own. In one sense, it is all you can know. By deeply listening to your own self, that is, observing, evaluating, and describing your own experiences, you can make rapid, decisive judgments about what is and is not working in your game, and why it is or is not working.

"But wait," you might say. "Is introspection really such a good idea? If it isn't good enough for the scientists, why is it good enough for us?" And this is a fair question. There are two main perils associated with using introspection:

Peril #1: Introspection Can Lead to False Conclusions About Reality

This is the scientists' main reason to reject introspection as a valid method of inquiry. Many pseudo-scientists over the years have come up with crackpot theories based mainly on introspection. This happens so often because what seems to be true in our personal experience is not necessarily really true. Socrates, for example, noted that when we learn something new, it often feels like we knew it all along, and that in learning it, it feels as if we were just reminded of something we already knew, but had forgotten. This is an interesting observation, and most people can remember a learning experience that felt this way. But Socrates then goes too far and forms an elaborate argument that since learning can feel like recollection, we must then be reincarnated souls who are just now remembering what we learned in past lives.

This is the problem with drawing conclusions about reality based on introspection — just because something feels true, it doesn't mean it is true. People very easily fall into the trap of building up structures of questionable logic to back up something that feels like it must be true. Scientists learn to be disciplined about avoiding this trap. Introspection certainly has its place in science — it allows one to examine a problem from points of view that mere logic won't allow. Good scientists use introspection all the time — but they don't draw scientific conclusions from it.

Fortunately for us, game design is not science! While "objective truth about reality" is interesting and sometimes useful to us, we primarily care about what "feels like it is true." Aristotle gives us another classical example that illustrates this perfectly. He wrote a number of works on a variety of topics, such as Logic, Physics, Natural History, and Philosophy. He is famous for the depth of his personal introspection, and when we examine his works, we find something interesting. His ideas about physics and natural history are largely discredited today. Why? Because he relied too much on what felt true, and not enough on controlled experiments. His introspection led him to all kinds of conclusions we now know to be false, such as:

- Heavier objects fall faster than light ones
- The seat of consciousness is in the heart
- Life arises by spontaneous generation

And many others. So why do we remember him as a genius, and not as a crackpot? Because his other works, about metaphysics, drama, ethics, and the mind, are still useful today. In these areas where what feels true matters more than what is objectively, provably true, most of his conclusions, reached through deep introspection, stand up to scrutiny thousands of years later.

The lesson here is simple: When dealing with the human heart and mind, and trying to understand experience and what things feel like, introspection is an incredibly powerful, and trustworthy tool. As game designers, we don't need to worry much about this first peril. We care more about how things feel and less about what is really true. Because of this, we can often confidently trust our feelings and instincts when making conclusions about the quality of an experience.

Peril #2: What Is True of My Experiences May Not be True for Others

This second danger of introspection is the one we must take seriously. With the first peril, we got a "Get Out of Jail Free Card" because we are designers, not scientists. But we can't get away from this one so easily. This peril is the peril of subjectivity, and a place where many designers fall into a trap: "I like playing this game, therefore it must be good." And sometimes, this is right. But other times, if the audience has tastes that differ from your own, it is very, very wrong. Some designers take extreme positions on this ranging from "I will only design for people like me, because it is the only way I can be sure my game is good" to "introspection and subjective opinions can't be trusted. Only playtesting can be trusted." Each of these is a "safe" position, but also has its limits and problems:

"I only design for people like me" has these problems:

- Game designers tend to have unusual tastes. There may not be enough people like you out there to make your game a worthwhile investment.

- You won't be designing or developing alone. If different team members have different ideas about what is best, they can be hard to resolve.

- There are many kinds of games and audiences that will be completely off-limits to you.

"Personal opinions can't be trusted" has these problems:

- You can't leave every decision to playtesting, especially early in the process, when there is no game yet to playtest. At this point someone has to exert a personal opinion about what is good and bad.

- Before a game is completely finished, playtesters may reject an unusual idea. They sometimes need to see it completed before they can really appreciate it. If you don't trust your own feelings about what is good and bad, you may, at the

advice of your playtesters, throw out an "ugly duckling" that could have grown up to be a beautiful swan.

- Playtesting can only happen occasionally. Important game design decisions must be made on a daily basis.

The way out of this peril, without resorting to such limiting extremes, is again, to listen. Introspection for game design is a process of not just listening to yourself, but also of listening to others. By observing your own experiences, and then observing others, and trying to put yourself in their place, you start to develop a picture of how your experiences differ from theirs. Once you have a clear picture of these differences, you can, like a cultural anthropologist, start to put yourself in the place of your audience and make predictions about what experiences they will and will not enjoy. It is a delicate art that must be practiced — and with practice your skill at it will improve.

Dissect Your Feelings

It is not such a simple thing to know your feelings. It is not enough for a designer to simply have a general sense about whether they like something or not. You must be able to clearly state what you like, what you don't like, and why. A friend of mine in college was notoriously bad at this. We would frequently drive each other crazy with conversations like:

Me: What did you eat at the cafeteria today?
Him: Pizza. It was bad.
Me: Bad? What was bad about it?
Him: It was just … bad.
Me: Do you mean it was too cold? Too hard? Too soggy? Too bitter? Too much sauce? Not enough sauce? Too cheesy? What was bad about it?
Him: I don't know — it was just bad!

He was simply unable to clearly dissect his experiences. In the case of the pizza, he knew he didn't like it, but was unable to (or didn't bother to) analyze the experience to the point where he could make useful suggestions about how the pizza might improve. This kind of experience dissection is a main goal of your introspection — it is something designers must do. When you play a game, you must be able to analyze how it made you feel, what it made you think of, and what it made you do. You must be able to state this analysis clearly. You must put words to it, for feelings are abstract, but words are concrete, and you will need this concreteness to describe to others the experiences you want your game to produce. You need to do this kind of analysis not only when designing and playing your own games, but also when playing games other people have created. In fact, you should be able to analyze any experience you might have. The more you analyze your own

experiences, the more clearly you will be able to think about the kinds of experiences your games should create.

Defeating Heisenberg

But there is still a greater challenge of introspection. How can we observe our own experiences without tainting them, since the act of observation itself is an experience? We face this problem quite often. Try to observe what your fingers are doing as you type at a computer keyboard and you will quickly find yourself typing slowly and making many errors, if you can still type at all. Try to observe yourself enjoying a movie or a game, and the enjoyment can quickly fade away. Some call this "paralysis by analysis," and others refer to it as the Heisenberg principle. This principle, in reference to the Heisenberg Uncertainty Principle from quantum mechanics, points out that the motion of a particle cannot be observed without disturbing the motion of that particle. Similarly, the nature of an experience cannot be observed without disturbing the nature of that experience. This makes introspection sound hopeless. While it is a challenging problem, there are ways around it that are quite effective, though some take practice. Most of us are not in the habit of openly discussing the nature of our thought processes, so some of the following is going to sound a little strange.

Analyze Memories

One good thing about experiences is that we remember them. Analyzing an experience while it is happening can be hard, because the part of your mind used to analyze is normally focused on the experience itself. Analyzing your memory of an experience is much easier. Memory is imperfect, but analyzing a memory is better than nothing. Of course, the more you remember, the better, so working either with memories of powerful experiences (these often make the best inspiration, anyway) or with fresh memories is best. If you have the mental discipline, it also can be very useful to engage in an experience (such as playing a game), with the intention of not analyzing it while you play, but with the intention of analyzing the memory of it immediately after. Just having this intention can help you remember more details of the experience without interfering with the experience itself. This does require you to remember that you are going to analyze it without letting that thought interfere with the experience. Tricky!

Two Passes

A method that builds on analyzing memories is to run through your experience twice. The first time, don't stop to analyze anything — just have the experience. Then, go back and do it again, this time, analyzing everything — maybe even pausing to take notes. You have the untainted experience fresh in your mind, and the

second run through lets you "relive it," but gives you a chance to stop and think, considering how it felt, and why.

Sneak Glances

Is it possible to observe your experience without spoiling it? It is, but it takes some practice. It sounds strange to say this, but if you "sneak quick glances" at your experience while it is happening, you can often observe it quite well without degrading or interrupting it significantly. It is kind of like trying to get a good look at a stranger in a public place. Take a few short glances at them, and they won't notice you are observing them. But look too long, and you will catch their attention, and they will notice you staring. Fortunately, you can learn a lot about an experience with a few short "mental glances." Again, this takes some mental discipline or you will get carried away with analysis. If you can make these mental glances habitual, just doing them all the time without thinking about it, they will interrupt things even less. Most people find what really interrupts their train of thought, or train of experience, is interior mental dialog. When you start asking and answering too many questions in your head, your experience is doomed. A "quick glance" is more like: "Exciting enough? Yes." Then, you immediately stop analyzing and get back to the experience, until the next glance.

Observe Silently

Ideally, though, you want to observe what is happening to you while it is happening, not just through a few quick glances, but through continuous observation. You want it to be as if you were sitting outside yourself, watching yourself, except that you see more than a normal observer. You can hear all of your thoughts and feel all of your feelings. When you enter this state, it is almost as if you have two minds: one moving, engaged in an experience, and one still, silently observing the other. This may sound completely bizarre, but it is quite possible and quite useful. It is a difficult state to achieve, but it can be reached. It seems to be something like the Zen practice of self-observation, and it is not unlike the meditation exercise of trying to observe your own breathing cycle. Normally we breathe without thinking, but at any moment, we may consciously take control of our breathing process — consequently interfering with it. With practice however, you can observe your natural, unconscious breathing without disturbing it. But this takes practice, just as observing your experiences takes practice. Observing your experiences can be practiced anywhere — while watching TV, while working, while playing, or while doing anything at all. You won't get it right at first, but if you keep experimenting and practicing, you will start to get the hang of it. It will take a great deal of practice. But if you truly want to listen to your *self*, and understand the nature of human experience, you will find the practice worthwhile.

Essential Experience

But how does all this talk about experience and observations really fit in with games? If I want to make a game about, say, a snowball fight, does analyzing my memories of a real snowball fight have any bearing on the snowball fight game I want to make? There is no way I can perfectly replicate the experience of a real snowball fight without real snow and real friends outside in the real world — so what is the point?

The point is that you don't need to perfectly replicate real experiences to make a good game. What you need to do is to capture the essence of those experiences for your game. What does "the essence of an experience" really mean? Every memorable experience has some key features that define it and make it special. When you go over your memory of a snowball fight experience, for example, you might think of a lot of things. Some you might even consider essential to that experience: "There was so much snow, school was canceled," "We played right in the street," "The snow was just right for packing," "It was so cold, but sunny — the sky was so blue," "There were kids everywhere," "We built this huge fort," "Fred threw a snowball really high — when I looked up at it, he chucked one right at my head!," "We couldn't stop laughing." There are also parts of that experience that you don't consider essential: "I was wearing corduroy pants," "I had some mints in my pocket," "A man walking his dog looked at us."

As a game designer trying to design an experience, your goal is to figure out the essential elements that really define the experience you want to create, and find ways to make them part of your game design. This way the players of your game get to experience those essential elements. Much of this book will be about the many ways you can craft a game to get across the experience you want players to have. The key idea here is that the essential experience can often be delivered in a form that is very different from a real experience. To follow up on the snowball fight example, what are some of the ways you could convey the experience "it was so cold" through a snowball fight game? If it is a videogame, you could certainly use artwork: the characters could breathe little puffs of condensation, and they could have a shivering animation. You could use sound effects — perhaps a whistling wind could convey coldness. Maybe there wasn't a cold wind on the day you are imagining, but the sound effect might capture the essence and deliver an experience that seems cold to the player. You could use the rules of the game, too, if cold was really important to you. Maybe players can make better snowballs without gloves, but when their hands get too cold, they have to put gloves on. Again, that might not have really happened, but that game rule helps deliver an experience of coldness that will be integral part of your game.

Some people find this approach strange — they say, "Just design a game, and see what experience comes out of it!" And I suppose it is true — if you don't know what you want, you might not care what you get. But if you do know what you want — if you have a vision of how you would like your game to feel to the players — you need to consider how you are going to deliver the essential experience. And this brings us to our first lens.

Lens #1: The Lens of Essential Experience

To use this lens, you stop thinking about your game and start thinking about the experience of the player. Ask yourself these questions:

- What experience do I want the player to have?
- What is essential to that experience?
- How can my game capture that essence?

If there is a big difference between the experience you want to create and the one you are actually creating, your game needs to change: You need to clearly state the essential experience you desire, and find as many ways as possible to instill this essence into your game.

The design of the very successful baseball game in *Wii Sports* is an excellent example of the Lens of Essential Experience in use. Originally, the designers had intended to make it as much like real baseball as possible with the added bonus that you could swing your controller like a bat. As they proceeded, though, they realized they wouldn't have time to simulate every aspect of baseball as well as they wanted. So, they made a big decision — since swinging the controller was the most unique part of this game, they would focus all their attention on getting that part of the baseball experience right — what they felt was the essential part. They decided that other details (nine innings, stealing bases, etc.) were not part of the essential experience they were trying to create.

It is true that many designers do not use the Lens of Essential Experience. They just kind of follow their gut instinct, and stumble across game structures that happen to enable experiences that people enjoy. The danger with this approach is that it relies on luck to a large extent. To be able to separate the experience from the game is very useful: If you have a clear picture in your mind of the experiences your players are having, and what parts of your game enable that experience, you will have a much clearer picture of how to make your game better, because you will know which elements of the game you can safely change, and which ones you cannot. The ultimate goal of the game designer is to deliver an experience. When you have a clear picture of your ideal experience, and its essential elements, your design has something to aspire to. Without that goal you are just wandering in the dark.

All That's Real Is What You Feel

All this talk of experience brings out an idea that is very strange indeed. The only reality that we can know is the reality of the experience. And we know that what we

experience is "not really reality." We filter reality through our senses, and through our minds, and the consciousness we actually experience is a kind of illusion — not really reality at all. But this illusion is all that can ever be real for us, because it *is* us. This is a headache for philosophers, but a wonderful thing for game designers, because it means that the designed experiences that are created through our games have a chance of feeling as real and as meaningful (and sometimes more so) than our everyday experiences.

We will explore that further in Chapter 9, but now it is time to look at the other side of the experience coin. We have studied the flame — it is time now to examine the log from which it rises.

CHAPTER THREE

The Experience Rises Out of a *Game*

FIGURE
3.1

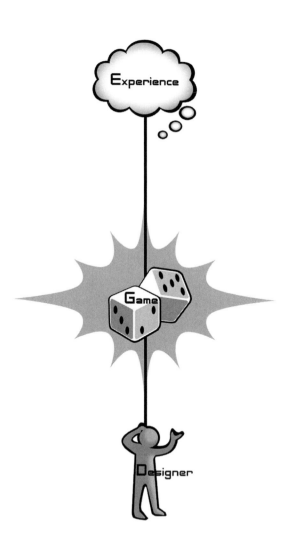

It is wonderful to talk about the design of experiences. Creating great experiences is indeed our goal. But we cannot touch experiences. We cannot manipulate them directly. What a game designer can control, can get his hands in, is the game. The game is your clay, and you will shape it and mold it to create all kinds of fabulous game experiences.

So, what kind of games are we talking about? In this book, we mean all kinds of games. Board games, card games, athletic games, playground games, party games, gambling games, puzzle games, arcade games, electronic games, computer games, videogames, and just about any other game that you might think of, for as we'll see, the same principles of design apply to all of them. It is a little surprising that with such variety between these kinds of games, we recognize them all as one kind, that is, as different as they are, we intuitively recognize them all as games.

What is it that these things have in common? Or, to put it another way, how do we define "game"?

A Rant About Definitions

Before we continue, I want to be clear about why we should seek such a definition. Is it so that we know what we mean when we say "game"? No. For the most part, we all know what we are talking about when we say game. It is true that the idea of what game (or any term) means will vary a bit from person to person, but mostly, we all know what a game is. Sometimes, in a discussion, a debate may arise about whether something is "truly a game," forcing the discussion participants to clarify their own personal definition of what a game is, and once that is settled, the discussion moves on. There is nothing wrong with people having their own personal opinions about the proper definition of game, and what is or is not really a game, just as they may have similar opinions about what really is or not "music," "art," or "a sport."

Some people, mostly academics, do not hold this view. They view the lack of standardized definitions in the world of game design as "a crisis" that is holding back the art form. Usually, the people most concerned about this are the farthest removed from the actual design and development of games. So, how do real-world designers and developers get by without a standardized vocabulary? Just like everyone else: when there is ambiguity, they simply explain what they mean. Does this sometimes slow down discussions and therefore the design process? Yes and no. Yes, it requires that at times, designers have to stop and explain what they mean, which can slow things down a little (and only a little). On the other hand, this pause for clarification often saves time in the long run, since after the pause, the designers are definitely each clear about what the other means.

Would it be best if there was some centralized dictionary of standard terms we could all refer to when discussing issues of game design? It would certainly be convenient, but it is far from necessary, and the fact that we don't have such a dictionary is far from a "barrier" or a "crisis." It is just a slight inconvenience,

because it means we sometimes have to stop and think about what we mean, and what we are trying to say. In fact, having to do this, in the long run, may make us better designers, not weaker ones, since we are forced to think just a little bit more. Further, such a dictionary would hardly be a gold standard for all time — as technologies change, they force us to reconsider some of our old definitions and terms, redefine some of them, and create new terms — so the process of definition and redefinition is likely to continue indefinitely, or at least as long as there are advances in technology that are relevant to games.

Others say that the "real problem" with a lack of game design vocabulary is not a problem of standardized definitions, but a lack of terms, at all, to discuss some of the complex ideas that arise as part of the game design process. Therefore, they argue, it is urgent that we try to put names on all these things. This is putting the cart before the horse, though, for the real problem we have is not a lack of words to describe elements of game design — the problem is a lack of clear thinking about what these ideas really are. As with many fields of design, game designers follow their gut instincts and feelings about what makes a good or a bad game, and sometimes have difficulty articulating what exactly it is about a certain design that is good or bad — they just know it when they see it, so they are able to design great things. And you can certainly get by this way. What is important is to state clearly what you mean when you say a design is good or bad, and how, specifically, it can improve. It is not a matter of knowing the vocabulary of game design — it is a matter of knowing the ideas of game design — what we call them matters little. Standardized terms for these things will evolve over time — this is not a process that can be rushed. The terms designers find useful will survive, the ones they don't will fall by the wayside.

That said, clear statements about important game design ideas, and terms to refer to them, are introduced all the time, and several are introduced in this book. These are not meant to be canonical definitions, but rather a clear expression of ideas that I hope you can use. If you have better ideas, or better terms, please use them instead — if your ideas and terms are indeed clear and strong, they will catch on and help other people more clearly think and express what they mean.

Some of the ideas we will have to deal with are necessarily murky. Terms like "experience," "play," and "game" are defined differently by different people, and considering that the ideas these terms represent do not have clear definitions even after the thousands of years we've been thinking and talking about them, it is unlikely they will be rigidly defined any time soon.

Does this mean we should shy away from trying to define them? By no means. Defining things forces you to think about them clearly, concisely, and analytically. Having a list of terms and their definitions would teach you little. Embarking on the journey of trying to define these terms will teach you a great deal and strengthen your ability to think about design, even though the definitions you end up with may prove imperfect. For this reason you may find this chapter offers you more questions than it does answers. But that's okay: the goal of this book is to make you a better designer, and a good designer must think.

So, What Is a Game?

Now that we have discussed why we should define these things, let's give it a try, beginning with some things we can say for sure about games. Here's a start:

A game is something you play.

I don't think anyone will disagree with that. But it doesn't tell us very much. For example, is a game different than a toy? Yes. Games are more complex than toys, and involve a different kind of play. We even use different language:

A toy is something you play *with*.

Okay, interesting. Since toys are simpler than games, maybe we should try defining them first. Let's see if we can do better with our definition of toy. You can play with friends, and they aren't toys. Toys are objects.

A toy is an object you play with.

Well, that's something. But I might play with a roll of tape while I talk on the phone. Does that make it a toy? Technically, yes, but probably not a very good one. In fact, anything you play with could be classified as a toy. Perhaps it is a good idea for us to start considering what makes for a good toy. "Fun" is one word that comes to mind in conjunction with good toys. In fact, you might say:

A good toy is an object that is fun to play with.

Not bad. But what do we mean when we say "fun?" Do we simply mean pleasure, or enjoyment? Pleasure is part of fun, but is fun simply pleasure? There are lots of experiences that are pleasurable; for example, eating a sandwich, or lying in the sun, but it would seem strange to call those experiences "fun." No, things that are fun have a special sparkle, a special excitement to them. Generally, fun things involve *surprises*. So, a definition for fun might be:

Fun is pleasure with surprises.

Can that be right? Can it be that simple? It is strange how you can use a word your whole life, and know for certain what it means, but not be able to express it clearly when asked. A good way to test definitions is to come up with counterexamples. Can you think of things that are fun, but not pleasurable, or fun, but don't involve some feeling of surprise? Conversely, can you think of things that are pleasurable and have surprises but aren't fun? Surprise and fun are such important parts of every game design that they become our next two lenses.

Lens #2: The Lens of Surprise

Surprise is so basic that we can easily forget about it. Use this lens to remind yourself to fill your game with interesting surprises. Ask yourself these questions:

- What will surprise players when they play my game?
- Does the story in my game have surprises? Do the game rules? Does the artwork? The technology?

- Do your rules give players ways to surprise each other?
- Do your rules give players ways to surprise themselves?

Surprise is a crucial part of all entertainment — it is at the root of humor, strategy, and problem solving. Our brains are hardwired to enjoy surprises. In an experiment where participants received sprays of sugar water or plain water into their mouths, the participants who received random sprays considered the experience much more pleasurable than participants who received the sprays according to a fixed pattern, even though the same amount of sugar was delivered. In other experiments, brain scans revealed that even during unpleasant surprises, the pleasure centers of the brain are triggered.

Lens #3: The Lens of Fun

Fun is desirable in nearly every game, although sometimes fun defies analysis. To maximize your game's fun, ask yourself these questions:

- What parts of my game are fun? Why?
- What parts need to be more fun?

So, back to toys. We say that a toy is an object you play with, and a good toy is an object that is fun to play with. But what do we mean by play? This is a tricky one. We all know what play is when we see it, but it is hard to express. Many people have tried for a solid definition of what play means, and most of them seem to have failed in one way or another. Let's consider a few.

Play is the aimless expenditure of exuberant energy.

– Friedrich Schiller

This is an expression of the outdated "surplus energy" theory of play, that the purpose of play is to expend extra energy. Throughout the history of psychology, there has been a tendency to oversimplify complex behaviors, and this is an early example of that. It also uses the word "aimless," as if play did not have goals, which it most certainly does. Surely we can do better than this.

Play refers to those activities which are accompanied by a state of comparative pleasure, exhilaration, power, and the feeling of self-initiative.

– J. Barnard Gilmore

That certainly covers some of the territory. Those are certainly things that are often associated with play. But it doesn't seem complete, somehow. Other things are also associated with play, like imagination, competition, and problem-solving. At the same time, this definition is too broad. For example, an executive might work hard to land a contract, and in doing so experience "comparative pleasure, exhilaration, power, and the feeling of self-initiative," but it would seem strange to call that an act of play. Let's try something else.

Play is free movement within a more rigid structure.

– Katie Salen and Eric Zimmerman

This unusual definition, from the book *Rules of Play*, is an attempt to create a definition of play so open that it can include things like "the play of the light along the wall" and "the play of a car's steering wheel." And while it is hard to find something we would call play that is not covered by this definition, one can easily come up with examples of what seem to be non-play activities that do fit. For example, if a child is forced to scrub the kitchen floor, the child is enjoying (enjoying may be the wrong word) free movement (can slide the brush around freely) within a more rigid structure (the floor), but it would sound strange to classify this activity as play. Nonetheless, thinking about your game from the point of view of this definition can be interesting. Perhaps a different definition can better capture the spirit of play.

Play is whatever is done spontaneously and for its own sake.

– George Santayana

This one is interesting. First let us consider spontaneity. Play is quite often spontaneous. When we talk about someone being "playful" that is part of what we mean. But is all play spontaneous? No. Someone might plan a softball game months in advance, for example, but when the game finally happens, it is still "play." So, spontaneity is sometimes part of play, but not always. Some consider spontaneity so important to the definition of play that any attempt to dampen it renders an activity not play. Bernard Mergen states his view: "Games, competitive games, which have a winner or a loser, are not, in my definition, play." This viewpoint is so extreme as to seem ridiculous — by this logic, games (as we typically think of them) are not something you can play. This extreme aside, spontaneity does seem to be an important part of play.

But how about the second part of Santayana's definition: "done for its own sake"? By this he seems to mean "we play because we like to." As trivial as it sounds, this is an important characteristic of play. If we don't like to do it, it probably isn't play. That is, an activity itself cannot be classified as a "work activity" or "play activity." Instead, what matters is one's attitude about the activity. As Mary Poppins tells us in the Sherman brothers' wonderful song, Spoonful of Sugar:

In ev'ry job that must be done
There is an element of fun.

You find the fun and snap!
The job's a game.

But how do we find the fun? Consider the story that psychologist Mihaly Csikszentmihalyi (pronounced "Chick sent me high") relates about how factory worker Rico Medellin turns his job into a game:

The task he has to perform on each unit that passes in front of his station should take forty-three seconds to perform — the same exact operation almost six hundred times in a working day. Most people would grow tired of such work very soon. But Rico has been at this job for over five years, and he still enjoys it. The reason is that he approaches his task in the same way an Olympic athlete approaches his event: How can I beat my record?

This shift in attitude turned Rico's job from work into play. How has it affected his job performance? "After five years, his best average for a day has been twenty-eight seconds per unit." And he still loves doing it: "'It's better than anything else,' Rico says. 'It's a whole lot better than watching TV.'"

What is going on here? How does simple goal setting suddenly redefine an activity we would normally classify as work into an activity that is clearly a kind of play? The answer seems to be a change in the reason he is doing the activity. He is no longer doing it for someone else, he is now doing it for his own personal reasons. Santayana actually elaborates on his definition, stating that upon further examination:

Work and play ... become equivalent to servitude and freedom.

When we work, we do it because we are obligated to. We work for food because we are slaves to our bellies. We work to pay the rent because we are slaves to our safety and comfort. Some of this servitude is willing servitude, such as willingness to earn money to care for our families, but it is servitude nonetheless. We are doing it because we have to, not because "we feel like it." The more obligated you are to do something, the more it feels like work. The less obligated you are to do something, the more it feels like play. Stated differently, "It is an invariable principle of all play ... that whoever plays, plays freely. Whoever *must* play cannot *play*."

Building off of this, I'd like to share my own definition of play, which, though imperfect like these others, has its own interesting perspective. I often find when trying to define things about human activity, it can be useful to pay less attention to the activity itself, and more attention to the thoughts and feelings that motivate the activity. I can't help but notice that most play activities seem to be attempts to answer questions like:

- "What happens when I turn this knob?"
- "Can we beat this team?"
- "What can I make with this clay?"
- "How many times can I jump this rope?"
- "What happens when I finish this level?"

When you seek to answer questions freely, of your own volition, and not because you are obligated to, we say you are curious. But curiosity doesn't immediately imply you are going to play. No, play involves something else — play involves willful action, usually a willful action of touching or changing something — manipulating something, you might say. So, one possible definition would be:

Play is manipulation that indulges curiosity.

When Rico tries to beat his assembly line goal, he is trying to answer the question: "Can I beat my record?" Suddenly, the reason for his activity is not to earn money to pay the rent, but instead to indulge his curiosity about a personal question.

This definition calls some things play that we might not ordinarily think of as play, such as an artist experimenting on canvas. On the other hand, he might say he is "playing with color." A chemist who tries an experiment to test a pet theory — is she playing? She might say she is "playing with an idea." This definition has flaws (can you find them?), but I do find it a useful perspective, and personally, it is my favorite definition of play. It also brings us to Lens #4.

Lens #4: The Lens of Curiosity

To use this lens, think about the player's true motivations — not just the goals your game has set forth, but the reason the player wants to achieve those goals. Ask yourself these questions:

- What questions does my game put into the player's mind?
- What am I doing to make them care about these questions?
- What can I do to make them invent even more questions?

For example, a maze-finding videogame might have a time-limit goal such that at each level, players are trying to answer the question: "Can I find my way through this maze in 30 seconds?" A way to make them care more would be to play interesting animations when they solve each maze, so players might also ask the question: "I wonder what the next animation will be?"

No, Seriously, What Is a Game?

We've come up with some definitions for toys, and fun and even made a good solid run at play. Let's try again to answer our original question: How should we define "game"?

Earlier we stated that "a game is something you play," which seems to be true, but isn't narrow enough. As with play, many people have tried to define "game." Let's look at a few of these.

> *Games are an exercise of voluntary control systems, in which there is a contest between powers, confined by rules in order to produce a disequilibrial outcome.*

> – Elliot Avedon and Brian Sutton-Smith

Wow. Very scientific! Let's pick it apart.

First, "an exercise of voluntary control systems": That is, like play, games are entered willfully.

Second, "a contest of powers": That does seem to be part of most games. Two or more things striving for dominance. Some single-player games don't always feel this way (would you really call Tetris a contest of powers?), but this phrase gets across two things: games have goals, and games have conflict.

Third, "confined by rules": A very important point! Games have rules. Toys do not have rules. Rules are definitely one of the defining aspects of games.

Fourth, "a disequilibrial outcome": disequilibrial is an interesting word. It does not simply mean "unequal," it instead implies that at one time there was equilibrium, but that it was then lost. In other words, things started out even, but then somebody won. This is certainly true of most games — if you play, you either win or lose.

So this definition points out some key qualities important to games.

Q1. Games are entered willfully.

Q2. Games have goals.

Q3. Games have conflict.

Q4. Games have rules.

Q5. Games can be won and lost.

Let's consider another definition — this time, from not from academia, but from the world of design:

> *[A game is] an interactive structure of endogenous meaning that requires players to struggle toward a goal.*

> – Greg Costikyan

Some of this is pretty clear, but what in the world is "endogenous"? We'll get to that shortly. Let's take this one apart, like the last one.

First, "an interactive structure": Costikyan wants to make it very clear that the player is active, and not passive, and that the player and game interact with one

another. This is definitely true of games — they have a structure (defined by the rules) with which you can interact, and which can interact with you.

Second, "Struggle toward a goal": Again, we see the idea of a goal, and struggle implies some kind of conflict. But it implies more — it implies challenge. Partly, Costikyan seems to be trying not just to define what makes a game, but what makes a good game. Bad games have little challenge, or too much challenge. Good games have just the right amount.

Third, "endogenous meaning": Endogenous is an excellent term that Costikyan brought from the world of biology to game design, and it means "caused by factors inside the organism or system," or "internally generated." So what is "endogenous meaning"? Costikyan is making the very important point that things that have value inside the game have value *only* inside the game. Monopoly money only has meaning in the context of the game of Monopoly. It is the game itself that gave it that meaning. When we play the game, the money is very important to us. Outside the game it is completely unimportant. This idea and term are very useful to us, because they are often an excellent measure of how compelling a game really is. The game of roulette does not have to be played with real money — it can be played with tokens or play money. But the game, on its own, generates little endogenous value. People will only play it when real money is at stake, because it just isn't that compelling a game. The more compelling a game is, the greater the "endogenous value" that is created within the game. Some massively multiplayer role playing games have proved so compelling to people that imaginary game items are actually bought and sold for real money outside the game. Endogenous value is such a useful perspective that it becomes Lens #5.

Lens #5: The Lens of Endogenous Value

To use this lens, think about your players' feelings about items, objects, and scoring in your game. Ask yourself these questions:

- What is valuable to the players in my game?
- How can I make it more valuable to them?
- What is the relationship between value in the game and the player's motivations?

Remember, the value of the items and score in the game is a direct reflection of how much players care about succeeding in your game. By thinking about what the players really care about and why, you can often get insights about how your game can improve.

An example of the Lens of Endogenous Value: The game Bubsy for the SNES and Sega Genesis is a fairly standard platform game. You play a cat who tries to navigate to the end of levels, defeating enemies and avoiding obstacles, and collecting yarn balls for extra points. However, the points serve no purpose other than to measure how many things you have collected. No other in-game reward is given for earning points. Most players gather yarn balls at first, with the expectation that they are valuable, but after playing a short while, they completely ignore them, focusing only on defeating enemies, avoiding obstacles, and getting to the end of the level. Why? Because the player's motivation (see Lens #4: The Lens of Curiosity) is merely to complete the levels. A higher score doesn't help that, and thus the yarn balls have no endogenous value. Theoretically, a player who defeated all the levels might have a new motivation: defeat them again, but this time getting the highest score possible. In practice, the game itself was so difficult that the number of players who actually completed the game must have been small indeed.

Sonic the Hedgehog 2, for the Sega Genesis, was a similar platform game, but did not suffer from this problem. In Sonic 2, you collect rings instead of yarn balls, and the number of rings collected is very important to players — the rings have a lot of endogenous value. Why? Because carrying rings helps protect you from enemies, and every time you collect one hundred rings, you receive an extra life, which increases the chances you will be able to complete all the levels. In the end, Sonic 2 was a much more compelling game than Bubsy, and one of the reasons was this mechanism, which clearly shows its importance through endogenous value.

Costikyan's definition gives us three new qualities that we can add to our list:

Q6. Games are interactive.

Q7. Games have challenge.

Q8. Games can create their own internal value.

Let's consider one more definition of game:

A game is a closed, formal system, that engages players in structured conflict, and resolves in an unequal outcome.

– Tracy Fullerton, Chris Swain, and Steven Hoffman

Most of this has been covered by the previous definitions, but there are two parts of this one I want to pick out:

First, "engages players": It is a good point that players find games to be engaging, that is, they make players feel "mentally immersed." Technically, we might argue this is a quality of good games, though not all games, but it is an important point.

Second, "a closed, formal system": This implies a lot of things. "System" means games are made of interrelated elements that work together. "Formal" is just a way of saying that the system is clearly defined, that is, it has rules. "Closed" is the interesting part here. It means that there are boundaries to the system. This

hasn't been mentioned explicitly yet in the other definitions, although the idea of endogenous value does imply it. Much has been made of this boundary at the edge of the game. Johan Huizinga called it "the magic circle," and it does indeed have a kind of magical feeling to it. When we are mentally "in the game" we have very different thoughts, feelings, and values than when we are "out of the game." How can games, which are nothing more than sets of rules, have this magical effect on us? To understand, we have to look to the human mind.

Let's review the list of game qualities we have picked out of these various definitions:

Q1. Games are entered willfully.

Q2. Games have goals.

Q3. Games have conflict.

Q4. Games have rules.

Q5. Games can be won and lost.

Q6. Games are interactive.

Q7. Games have challenge.

Q8. Games can create their own internal value.

Q9. Games engage players.

Q10. Games are closed, formal systems.

That's a lot, isn't it? Alan Kay, the computer researcher, once advised me: "If you've written a software subroutine that takes more than ten arguments, look again. You probably missed a few." This was his way of saying that if you need a long list to convey what you mean, you should find a better way to regroup your ideas. And indeed, this list of ten things does not seem complete. It is likely that we have missed a few.

It does seem odd that something as simple, compelling, and innate to us as the playing of games would require such an unwieldy definition. But maybe we're approaching this the wrong way. Instead of approaching the gameplay experience from the outside in; that is, focusing on how games relate to people, as we have been doing, perhaps we should look from the other direction: How do people relate to games?

What is it that people like so much about games? People give many answers to this question that are true for some but not all games: "I like playing with my friends," "I like the physical activity," "I like feeling immersed in another world," and many more. But there is one answer that people often give when they talk about playing games, which seems to apply to all games: "I like solving problems."

That's kind of weird, isn't it? Normally, we think of problems as something negative. But we really do get pleasure from solving them. And, as humans, we are really good at solving problems. Our big complex brains can solve problems better

than any of the other animals, and this is our primary advantage as a species. So, it should not seem strange that it is something we enjoy. The enjoyment of problem solving seems to be an evolved survival mechanism. People who enjoy solving problems are going to solve more problems, and probably get better at solving problems, and be more likely to survive.

But is it really true that most games involve problem solving? One is hard pressed to come up with a game that does not. Any game with a goal effectively has presented you with a problem to solve. Examples might be:

- Find a way to get more points than the other team.
- Find a way to get to the finish line before the other players.
- Find a way to complete this level.
- Find a way to destroy the other player before he destroys you.

Gambling games, at first, seem like a possible exception. Is someone playing craps really trying to solve a problem? Yes. The problem is how to take the right calculated risks and make as much money as possible. Another tricky example is a game where the outcome is completely random, such as the children's card game of War. In War, the two players each have a stack of playing cards. In unison, they each flip over the top card from their stack to see who has the higher card. The player with the higher card wins the round keeping both cards. In the case of a tie, more cards are flipped, and the winner gets a larger take. Play continues until one player has all the cards.

How could a game like that possibly involve any problem solving? The outcome is predetermined — the players make no choices, they just gradually reveal who the winner will be. Nonetheless, children play this game just as happily as any other, and draw no special distinction about this game differing somehow from other games. This baffled me for some time, so I took the cultural anthropologist point of view. I played the game with some children and tried hard to remember what it felt like to be a child playing War. And the answer quickly became obvious. For children, it is a problem-solving game. The problem they are trying to solve is "Can I control fate, and win this game?" and they try all kinds of ways to do it. They hope, they plead to the fates, they flip over the cards in all kinds of crazy ways — all superstitious behaviors, experimented with in an attempt to win the game. Ultimately, they learn the lesson of War: You cannot control fate. They realize the problem is unsolvable, and at that point, it is no longer a game, just an activity, and they soon move on to games with new problems to solve.

Another possible objection one might raise is that not every activity associated with gameplaying is a problem-solving activity. Often, the things people enjoy most about games, such as social interaction or physical exercise, have nothing to do with problem solving. But while these other activities might improve a game, they are not essential to the game. When problem solving is removed from a game, it ceases to be a game and becomes just an activity.

So, if all games involve some kind of problem solving, and problem solving is one of the things that defines us as a species, perhaps we should look more closely at the mental mechanisms we use for problem solving to see if they have anything to do with the properties of games.

Problem Solving 101

Let's consider what we do when we solve a problem and how it might relate to our numbered list of game qualities.

One of the first things we do is to state the problem we are trying to solve, that is, define a clear goal (Q2). Next, we frame the problem. We determine its boundaries and the nature of the problem space. We also determine what methods we are allowed to use to solve the problem; that is, we determine the rules of the problem (Q4). How we do this is kind of hard to describe. It is not a completely verbal process. It is almost as if our minds are equipped to set up an internal, minimized, simplified version of reality that only includes the necessary interrelationships needed to solve the problem. This is like a cleaner, smaller version of the real-world situation, which we can more easily consider and manipulate, or interact with (Q6). In a sense, we are establishing a closed, formal system (Q10) with a goal. We then work to reach that goal, which is usually challenging (Q7), because it involves some kind of conflict (Q3). If we care about the problem, we quickly become engaged (Q9) in solving it. When we are occupied in doing so, we kind of forget about the real world, since we are focused on our internal problem space. Since this problem space is not the real world, and just a simplified version of it, and solving the problem is important to us, elements in the problem space quickly gain an internal importance, if they get us closer to our goal of solving the problem, and this importance does not need to be relevant outside the context of the problem (Q8). Eventually, we defeat the problem, or are defeated by it, thus winning or losing (Q5).

Now we see the magic circle for what it really is: our internal problem solving system. This does not make it any less magical. Somehow, our minds have the ability to create miniature realities based on the real world. These micro-realities have so effectively distilled the essential elements of reality for a particular problem that manipulations of this internal world, and conclusions drawn from it, are valid and meaningful in the real world. We have little idea of how this really works — but it does work very, very well.

Could our definition of game possibly be this simple:

A game is a problem-solving activity.

That can't be right. It might be a true statement, but it is too broad. There are lots of problem-solving activities that are not play. Many of them feel more like work. Many of them ("How can we reduce the production costs of these widgets by 8%?") literally are work. But we've already determined that the difference between a play activity and a work activity has nothing to do with the activity itself, but

one's motivation for doing the activity. Astute readers will notice that only nine of our ten qualities were covered in our problem-solving analysis. A key quality: "Games are entered willfully" (Q1) was omitted. No, games cannot simply be problem-solving activities. One who plays them must also have that special, hard-to-define attitude that we consider essential to the nature of play. So, a definition that nicely covers all ten qualities might be:

A game is a problem-solving activity, approached with a playful attitude.

This is a simple, elegant definition, which has the advantage of no fancy jargon. Whether you accept this definition or not, viewing your game as a problem to be solved is a useful perspective, and that perspective is Lens #6.

Lens #6: The Lens of Problem Solving

To use this lens, think about the problems your players must solve to succeed at your game, for every game has problems to solve. Ask yourself these questions:

- What problems does my game ask the player to solve?
- Are there hidden problems to solve that arise as part of gameplay?
- How can my game generate new problems so that players keep coming back?

The Fruits of Our Labors

So, we have embarked on a long journey of defining our terms. Let's review what we came up with:

- Fun is pleasure with surprises.
- Play is manipulation that satisfies curiosity.
- A toy is an object you play with.
- A good toy is an object that is fun to play with.
- A game is a problem-solving activity, approached with a playful attitude.

So, are these the keys to the secrets of the universe? No. They only have value if they give you some insight into how to make better games. If they do, great! If not, then we had best move on, and find something that will. You might not even agree with these definitions — if that's the case, then good for you! It means you

are thinking. So, keep thinking! See if you can come up with better examples than what I have here. The whole point of defining these terms is gain new insights — it is the insights that are the fruits of our labors, not the definitions. Perhaps your new definitions will lead to new and better insights that can help us all. One thing I feel certain of:

> *The whole truth regarding play cannot be known until the whole truth regarding life itself is known.*

> – Lehman and Witty

So let's not dawdle here. We've spent enough time thinking about what a game is. Now let's go see what a game is made of.

CHAPTER FOUR

The Game Consists of *Elements*

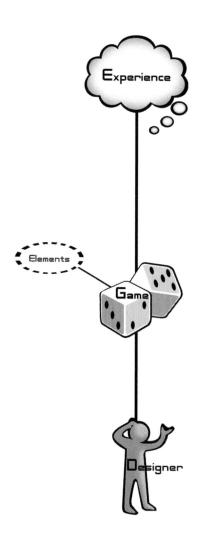

FIGURE
4.1

What Are Little Games Made Of?

FIGURE
4.2

When my daughter was three years old, she became quite curious one day about what different things were made of. She ran around the room, excitedly pointing to things, trying to stump me with her questions:

"Daddy, what is the table made of?"

"Wood."

"Daddy, what is the spoon made of?"

"Metal."

"Daddy, what is this toy made of?"

"Plastic."

As she looked around for a new object, I turned it around on her, with a question of my own.

"What are *you* made of?"

She paused to consider. She looked down at her hands, turning them over, and studying them. And then, brightly, she announced:

"I'm made of *skin!*"

And for a three-year-old, this is a perfectly reasonable conclusion. As we get older, of course, we learn more about what people are really made of — the complex relations between bones, muscles, organs, and the rest. Even as adults, though, our understanding of human anatomy is incomplete (can you point to your spleen,

for instance? Or describe what it does, or how?), and this is acceptable for most of us, because we generally know enough to get by.

But we expect more from a doctor. A doctor needs to know, really know, how everything works inside us, how it all interrelates, and when something goes wrong, how to figure out the source of the problem, and how to fix it.

If you have just been a game player up until now, you probably haven't thought too much about what a game is made of. Thinking about a videogame, for example, you might, like most people, have a vague idea that a game is this kind of story world, with some rules, and a computer program lurking around somewhere in there that somehow makes it all go. And that's enough for most people to know in order to get by.

But guess what? You're a doctor now. You need to know, intimately, what your patients (games) are really made of, how their pieces all fit together, and what makes them tick. When things go wrong, you'll need to spot the true cause, and come up with the best solution, or your game will surely die. And if that doesn't sound hard enough, you'll be asked to do things that most doctors are never asked: to create new kinds of organisms (radically new games) no one has ever seen before, and bring them to life.

Much of this book is devoted to developing this essential understanding. Our study of anatomy begins with an understanding of the four basic elements that comprise every game.

The Four Basic Elements

There are many ways to break down and classify the many elements that form a game. I have found that the categories shown in Figure 4.3, which I call the *elemental tetrad*, are very useful. Let's look briefly at each of the four, and how they relate to the others:

1. **Mechanics**: These are the procedures and rules of your game. Mechanics describe the goal of your game, how players can and cannot try to achieve it, and what happens when they try. If you compare games to more linear entertainment experiences (books, movies, etc.), you will note that while linear experiences involve technology, story, and aesthetics, they do not involve mechanics, for it is mechanics that make a game a game. When you choose a set of mechanics as crucial to your gameplay, you will need to choose technology that can support them, aesthetics that emphasize them clearly to players, and a story that allows your (sometimes strange) game mechanics to make sense to the players. Mechanics will be given detailed attention in Chapters 10–12.

2. **Story**: This is the sequence of events that unfolds in your game. It may be linear and pre-scripted, or it may be branching and emergent. When you have a story you want to tell through your game, you have to choose mechanics that will

FIGURE
4.3

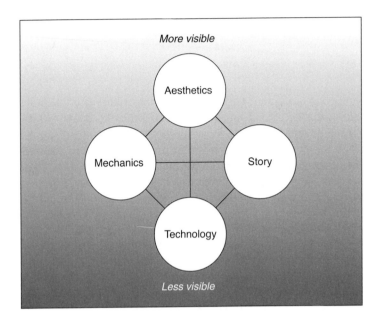

both strengthen that story and let that story emerge. Like any storyteller, you will want to choose aesthetics that help reinforce the ideas of your story, and technology that is best suited to the particular story that will come out of your game. Story, and its special relationship with game mechanics, will be studied in Chapters 15 and 16.

3. **Aesthetics**: This is how your game looks, sounds, smells, tastes, and feels. Aesthetics are an incredibly important aspect of game design since they have the most direct relationship to a player's experience. When you have a certain look, or tone, that you want players to experience and become immersed in, you will need to choose a technology that will not only allow the aesthetics to come through, but amplify and reinforce them. You will want to choose mechanics that make players feel like they are in the world that the aesthetics have defined, and you will want a story with a set of events that let your aesthetics emerge at the right pace and have the most impact. The skill of choosing aesthetics that reinforce the other elements of the game to create a truly memorable experience will be examined in Chapter 20.

4. **Technology**: We are not exclusively referring to "high technology" here, but to any materials and interactions that make your game possible such as paper and pencil, plastic chits, or high-powered lasers. The technology you choose for your game enables it to do certain things and prohibits it from doing other things. The technology is essentially the medium in which the aesthetics take place, in

which the mechanics will occur, and through which the story will be told. We will talk in detail about how to choose the right technology for your game in Chapter 26.

It is important to understand that *none of the elements is more important than the others*. The tetrad is arranged here in a diamond shape not to show any relative importance, but only to help illustrate the "visibility gradient"; that is, the fact that technological elements tend to be the least visible to the players, aesthetics are the most visible, and mechanics and story are somewhere in the middle. It can be arranged in other ways. For example, to highlight the fact that technology and mechanics are "left brain" elements, whereas story and aesthetics are "right brain" elements, you might arrange the tetrad in a square. To emphasize the strong connectedness of the elements to one another, they could be arranged as a tetrahedral pyramid — it really doesn't matter.

The important thing to understand about the four elements is that they are all essential. No matter what game you design, you will make important decisions about all four elements. None is more important than the others, and each one powerfully influences each of the others. I have found that it is hard to get people to believe in the equality of the four elements. Game designers tend to believe that mechanics are primary; artists tend to believe the same about aesthetics; engineers, technology; and writers, story. I suppose it is human nature to believe your piece is the most important. But, believe me, as a game designer, *they are all your piece.* Each has an equally powerful effect on the player's experience of your game, and thus, each deserves equal attention. This point of view is crucial when using Lens #7.

Lens #7: The Lens of the Elemental Tetrad

To use this lens, take stock of what your game is truly made of. Consider each element separately, and then all of them together as a whole.

Ask yourself these questions:

- Is my game design using elements of all four types?
- Could my design be improved by enhancing elements in one or more of the categories?
- Are the four elements in harmony, reinforcing each other, and working together toward a common theme?

Consider the design of the game Space Invaders (Taito, 1978) by Toshihiro Nishikado. If (somehow) you aren't familiar with the game, do a quick Web search so that you understand the basics. We will consider the design from the points of view of the four basic elements.

Technology: All new games need to be innovative in some way. The technology behind Space Invaders was custom designed for the game. It was the first video-game that allowed a player to fight an advancing army, and this was only possible due to the custom motherboard that was created for it. An entirely new set of game-play mechanics was made possible with this technology. It was created solely for that purpose.

Mechanics: The gameplay mechanic of Space Invaders was new, which is always exciting. But more than that, it was interesting and well-balanced. Not only does a player shoot at advancing aliens that shoot back at him, the player can hide behind shields that the aliens can destroy (or that the player can choose to destroy himself). Further, there is the possibility to earn bonus points by shooting a mysterious flying saucer. There is no need for a time limit, because the game can end two ways: the player's ships can be destroyed by alien bombs, or the advancing aliens will eventually reach the player's home planet. Aliens closest to the player are easier to shoot and worth fewer points. Aliens farther away are worth more points. One more interesting game mechanic: the more of the 48 aliens you destroy, the faster the invading army gets. This builds excitement and makes for the emergence of some interesting stories. Basically, the game mechanics behind Space Invaders are very solid and well-balanced and were very innovative at the time.

Story: This game didn't need to have a story. It could have been an abstract game where a triangle shoots at blocks. But having a story makes it far more exciting and easier to understand. The original story for Space Invaders, though, was not a story of alien invaders at all. It was originally a game where you fired at an army of advancing human soldiers. It is said that Taito decided this sent a bad message, so the story was changed. The new story, a story about advancing aliens, works much better for several reasons:

- Several war-themed games had already been released (Sea Wolf, 1976, for example). A game where you could be in a space battle was actually novel at the time.

- Some people are squeamish about war games where you shoot people (Death Race, 1976, had made violence in videogames a sensitive issue).

- The "high tech" computer graphics lent themselves well to a game with a futuristic theme.

Marching soldiers are necessarily walking on the ground, which means the game would have had a "top down" view. Space Invaders gives the sense that the aliens are gradually lowering toward the surface of your planet, and you are shooting up at them. Somehow, hovering, flying aliens are believable, and make for a more dramatic story — "if they touch down, we're doomed!" A change in story allowed for a change in camera perspective with a dramatic impact on aesthetics.

Aesthetics: Some may sneer at the visuals, which now seem so primitive, but the designer did a lot with a little. The aliens are not all identical. There are three different designs, each worth a different amount of points. They each perform a

simple two-frame "marching" animation that is very effective. The display was not capable of color — but a simple technology change took care of that! Since the player was confined to the bottom of the screen, the aliens to the middle, and the saucer to the top, colored strips of translucent plastic were glued to the screen so that your ship and shields were green, the aliens were white, and the saucer was red. This simple change in the technology of the game worked only because of the nature of the game mechanics, and greatly improved the aesthetics of the game. Audio is another important component of aesthetics. The marching invaders made a sort of heartbeat noise, and as they sped up, the heartbeat sped up, which had a very visceral effect on the player. There were other sound effects that helped tell the story, too. The most memorable was a punishing, buzzing crunch noise when your ship was hit with an alien missile. But not all aesthetics are in the game! The cabinet for Space Invaders had a design that was attractive and eye-catching that helped tell the story of the evil alien invaders.

Part of the key to the success of Space Invaders was that each of the four basic elements were all working hard toward the same goal — to let the player experience the fantasy of battling an alien army. Each of the elements made compromises for the other, and clearly deficits in one element often inspired the designer to make changes in another. These are the sort of clever insights you are likely to have when you view your design through the Lens of the Elemental Tetrad.

Skin and Skeleton

We will be discussing the four basic elements in more detail throughout this book as well as many other aspects of game anatomy. It is a wonderful thing to learn enough so that you can see past the skin of a game (the player's experience) into the skeleton (the elements that make up the game). But you must beware of a terrible trap that many designers fall into. Some designers, thinking constantly about the detailed internal workings of games, forget about the player experience. It is not enough to merely understand the various game elements and how they interrelate with one another — you must always consider how they relate to the experience. This is one of the great challenges of game design: to simultaneously feel the experience of your game while understanding which elements and elemental interactions are causing that experience, and why. You must see skin and skeleton at once. If you focus only on skin, you can think about how an experience feels, but not understand why it feels that way or how to improve it. If you focus only on skeleton, you can make a game structure that is beautiful in theory, but potentially horrible in practice. If you can manage to focus on both at once, you can see how it all works while feeling the power of your game's experience at the same time.

In Chapter 2, we discussed the importance and the challenge of observing and analyzing your own experiences. As challenging as that is, it is not enough. You must also be able to think about the elements in your game that make the experience possible. This takes practice, just as the observation techniques of Chapter 2

take practice. Essentially, the skill you need to develop is the ability to observe your own experience *while* thinking about the underlying causes of that experience.

This important skill is called *holographic design*, and it is detailed in Lens #8.

Lens #8: The Lens of Holographic Design

To use this lens, you must see everything in your game at once: the four elements and the player experience, as well as how they interrelate. It is acceptable to shift your focus from skin to skeleton and back again, but it is far better to view your game and experience holographically.

Ask yourself these questions:

- What elements of the game make the experience enjoyable?
- What elements of the game detract from the experience?
- How can I change game elements to improve the experience?

In future chapters, we will say much more about the elements that make up a game. Now let's turn our attention to the reason these elements need to work together.

CHAPTER FIVE

The Elements Support a *Theme*

FIGURE
5.1

To write a mighty book, you must choose a mighty theme.

– Herman Melville

Mere Games

Great themes and deep meanings are often associated with literature or with great works of art. Is it pretentious for a "mere game" to aspire to the same levels of greatness?

As game designers, we must confront the painful truth that many people view games, in all their forms, as meaningless diversions. Usually, when I press people who hold this view, I can get them to admit some game that is very important to them. Sometimes it is a sport, either one they have played, or one they watch religiously. Sometimes it is a card or board game that formed the cornerstone of their relationship with someone important to them. Sometimes it is a videogame with a storyline and characters that they identify with. When I point out the hypocrisy of games as meaningless, but a game as meaningful, they explain, "Well, it really wasn't the game I cared about — it was the experience that went with the game." But as we've discussed, experiences aren't just associated with games at random, they are what emerge when players interact with a game. The parts of the experience that are important to people, such as the drama of a sporting event, the camaraderie between bridge players, or the rivalry of chess enthusiasts, all are determined by the design of the game.

Some people make the argument that games, especially videogames, cannot be deep and meaningful because they are simply too primitive in nature. The same argument was made about film at the beginning of the twentieth century when it was silent, and black and white. As technology increased, this argument faded away. And the same is happening for games. In the 1970s, videogames were so simplified as to be almost completely abstract. Today, they can include text, pictures, video, sound, music, and more. As technology advances, more and more aspects of human life and expression will be integrated into games. There is nothing that cannot be part of a game. You can put a painting, a radio broadcast, or a movie into a game, but you cannot put a game into these other things. All these other types of media, and all media that is to come, are subsets of games. At their technological limit, games will subsume all other media.

Really, the problem is that games have only recently emerged as anything like a serious medium of expression. It will take time for the world to grow used to this idea. But we have no reason to wait. We can create games with powerful themes right now. But why? Why do this? Out of a selfish need for artistic expression? No. Because we are designers. Artistic expression is not our goal. Our goal is to create powerful experiences. It is possible to create games that do not have themes or that have very weak themes. However, if our games have unifying, resonant themes, the experiences we create will be much, much stronger.

Unifying Themes

The primary benefit of basing your design around a single theme is that all of the elements of your game will reinforce one another, since they will all be working toward a common goal. Sometimes it is best to let a theme emerge as you are creating the game. The sooner you have settled on a theme, the easier things will be for you, because you will have an easy method of deciding if something belongs in your game or not: If it reinforces the theme, it stays, but if it doesn't, it goes.

There are two simple steps to using a theme to strengthen the power of your game's experience.

Step 1: Figure out what your theme is.

Step 2: Use every means possible to reinforce that theme.

Sounds easy, but what is a theme? The theme is what your game is about. It is the idea that ties your entire game together — the idea that all the elements must support. If you don't know what your theme is, it is very likely that your game is not engaging people as much as it could. Most game themes are *experience-based*; that is, the goal of the design is to deliver an essential experience to the player.

Designer Rich Gold describes an elementary example of theming in his book *The Plenitude*. As a child, he had a book about elephants. The idea of the book was simple: to deliver an experience to children that let them understand what elephants were. In a sense, you could say the theme was "What are elephants?" So, step one is done. This brings us to step two: use every means possible to reinforce that theme. The authors did the obvious — the book contained text about elephants and pictures of elephants. But they took it a step further, and cut the entire book, cover and pages, into the *shape of an elephant*, as well. At every turn, you need to look for opportunities to reinforce your theme in clever and unexpected ways.

Let me give a more detailed example based on a virtual reality game I worked on for Disney called *Pirates of the Caribbean: Battle for the Buccaneer Gold*. Our team (the Disney VR Studio) was given the assignment of creating an interactive adaptation of the popular Pirates of the Caribbean theme park ride, which can be seen in various incarnations at all the Disney parks. We knew we were going to put it in a Computer Augmented Virtual Environment (CAVE), which is basically a small room with 3D projections on the walls at DisneyQuest (Disney's virtual reality center at Disneyworld), and the experience had to be about five minutes long, but no storyline or specific game goals had been set.

We already had the beginnings of a theme: this attraction was going to be about pirates, which narrowed things down, but we were hoping to be more specific. What point of view did we want to take about pirates? There are several we could have taken:

- A historical documentary about pirates
- A battle between competing pirate ships

- A search for hidden pirate treasure

- Pirates are villains, and must be destroyed

Several others came to mind as well. You can see that even with something as narrow as "pirates," we still didn't really have a theme, because there are many possible experiences around the idea of pirates that we could create. We started doing research, looking for game ideas, aesthetic ideas, and hopefully a clear, unifying theme.

We read a lot about the history of pirates, and we looked at pirate-themed video-games other people had made. We talked to people who had been involved in the creation of the original Pirates of the Caribbean ride. We got lots of good details, but were not getting much closer to a theme. One day, we all piled into a car and headed down to Disneyland to study the ride up close. We rode the ride dozens of times before park hours frantically scribbling notes and snapping pictures. There is a huge amount of detail in the ride — it is incredibly compelling. We could see that details were going to be very important. But what about the story? Weirdly, the Pirates of the Caribbean ride doesn't tell a coherent story. It just features several immersive tableaus of pirates doing pirate things. In a sense, this is a real strength: the story is left to the rider's imagination.

So, we learned some good things from riding, but we still didn't have a theme. We interviewed park employees, and when the park opened, we chatted with guests about their feelings about the ride. We got lots of great details about how the ride looks, how it makes people feel, and what their favorite parts were, but none of it really clued us into a solid point of view for our theme.

On the way home in the car, as we talked over the thousands of details we had observed, we fretted a little that we still didn't have a clear path forward. As we sat and thought, it was almost impossible not to hum the catchy theme song from the ride, having heard it so many times... "Yo ho, yo ho, a pirate's life for me." And suddenly it became clear! The Pirates of the Caribbean ride is not about *pirates*, it is about *being* a pirate! The whole goal of the ride is to fulfill the fantasy of what it is like to throw aside the rules of society and just start being a pirate! It might sound obvious in retrospect, but this shift in our thinking crystallized everything. This was not a historical re-creation, and it was not about destroying pirates. It was about fulfilling the pirate fantasy that everyone has bubbling just below the surface, and what better way to create this feeling of being a pirate than through an immersive, interactive experience? We now had our experience-based theme: *The fantasy of being a pirate.*

And so step one was completed. We knew our theme. Now for step two: use every means possible to reinforce that theme. And we really did work hard to use everything we could to do just that. Some examples include:

- **CAVE shape**: In the past, we had used square and hexagonal CAVES. We created a new, four-screen CAVE shape that was better suited to a pirate ship simulation.

- **Stereoptics**: Not every CAVE experience uses stereoptics, but we chose to do so, because the sense of depth they give. Letting your eyes focus on infinity really helped make it feel like you were out at sea.

- **Modified 3D Glasses**: Many off-the-shelf 3D glasses for theaters have blinders on the side to reduce distractions when watching a movie. We knew that a person's sense of motion is strongly influenced by their peripheral vision, so these blinders were a problem — they were detracting from our theme, since players weren't getting enough of a sense of sailing at sea. We made arrangements with the manufacturer to have the blinders cut off.

- **Motion Platform**: We wanted to give the feeling of a rocking, swaying boat. A motion platform seemed like a good idea, but what kind? Eventually, we custom built a platform using pneumatics, because it felt the most like a ship at sea.

- **Interface**: Part of the pirate fantasy is steering a ship, and part of it is firing cannons. We could have used joysticks, or other off-the-shelf hardware, but that wouldn't be very good theming. Instead, the ship is steered with a ship's wheel, and we had real metal cannons that players would use to aim and fire.

- **Visuals**: We had to make things look beautiful. The ride features a kind of "hyper-real" look, which fits perfectly with our theme. We used high-end graphics hardware and rich textures and models to achieve a similar look.

- **Music**: Through some pains, we got permission to use the music from the ride. It captures the theme so well, and connects the game to the ride, in a powerful nostalgic way.

- **Audio**: Our sound designers created a custom ten-speaker sound system that could play sounds from all directions, making you feel like you were out at sea. Some of the speakers were designed only to play cannon blasts, and were placed at precisely the right distance from the boat so that the waveform would hit you in the stomach, so you would not just hear, but *feel* the cannons firing.

- **A Feeling of Freedom**: Piracy is all about freedom. Our gameplay mechanics were designed to let players sail wherever they chose, but at the same time ensure the players have an exciting time. Details of how this was accomplished will be discussed in detail in Chapter 16.

- **Dead Men Tell No Tales**: How to handle death in the game was a real question. Some advocated that this was a videogame, and we should handle it like videogames traditionally do: if you die, there is some penalty, and then you come back to life, to play again. This didn't fit in well with our theme of living the pirate fantasy — in the fantasy, you don't die, or if you do, it is in an incredibly dramatic way, and you do not return. Further, we were trying very hard to maintain a dramatic interest curve (explained in Chapter 14) for our five-minute

experience, since drama is part of the pirate fantasy. If the players could suddenly die in the middle of the game, it would spoil that. Our solution was to make players invulnerable throughout the majority of the game, but if they took too many hits over the course of the experience, their ship would sink dramatically at the end of the final battle. This broke with videogame tradition, but theme is more important than tradition.

- **Treasure**: Collecting vast hordes of treasure is an essential part of the pirate fantasy. Unfortunately, piles of gold are actually pretty hard to render convincingly in a videogame. We came up with a special technique that made flat, hand-painted treasures seem to be solid, dimensional objects that sat prominently on the ship's deck.

- **Lighting**: We needed to light the room the players stood in. How could we theme that? We used special filters on the light that made it look like it was light reflected off of water.

- **A Place for my Stuff**: People who step up to the controls need a place to put their bags, purses, etc. We could have just made a shelf. Instead, we created bags out of fishing nets that really look like they belong on a boat.

- **Air Conditioning**: The people in charge of facilities in the building where the game was going to go asked if we cared where the air conditioning vents in the room were placed. Our first thought was "who cares?" But then we thought, "How can we use this to reinforce our theme?" The vents were placed at the front of the ship, blowing back, so players feel a breeze as they sail their ship.

- **The Eyes of Bluebeard**: One thing we never figured out how to theme was the 3D glasses. We experimented with making them look like pirate hats, and bandanas, but it didn't really work. One witty gentleman suggested that players should be forced to wear eye patches, so the 3D effect was unnecessary. In the end, we gave up, and let that detail go unthemed. To our surprise, when the game had been installed at Disneyworld, and we went to try it out, the cast member who was about to lead us on board proclaimed "Before ye board, ye must wear the *Eyes of Bluebeard*." This was surprising, because it was not in the "official script" given to cast members. The ride attendants succeeded where we had failed. It was a simple and effective way to theme a detail that escaped us, and a powerful illustration that when you have a strong unifying theme, it makes it easier for everyone on the team to make useful contributions.

This is not a complete list. Everything we did and every decision we made was focused on whether it would reinforce the theme and deliver the essential experience we wanted to get across. You might argue that without a big budget, you can't afford to do fancy theming. But many theming details are really quite inexpensive. They can be a line of text, or a color choice, or a sound effect. And theming is fun — once you get in the habit of trying to make as many things as possible fit your theme, it's hard to stop. But why would you stop? And this gives us Lens #9.

Lens #9: The Lens of Unification

To use this lens, consider the reason behind it all. Ask yourself these questions:

- What is my theme?
- Am I using every means possible to reinforce that theme?

The Lens of Unification works very well with the Lens of the Elemental Tetrad. Use the tetrad to separate out the elements of your game, so you can more easily study them from the perspective of a unified theme.

Resonance

A unifying theme is good — it focuses your design toward a single goal. But some themes are better than others. The best themes are ones that resonate with players — themes that touch players deeply. The "fantasy of being a pirate" theme is powerful because it is a fantasy that everyone — kids, adults, men, and women — has had at one time or another. In a sense, it resonates with our desire to be free — free from our obligations, free from our worries and cares, free to do what we want, when we want to.

When you manage to tap into one of these resonant themes, you have something deep and powerful that has a true ability to move people and to give them an experience that is both transcendent and transforming. Earlier we discussed that some themes are experience-based, that is, they are all about delivering a certain essential experience. When this experience is one that resonates with the fantasies and desires of your players, it will be an experience that quickly becomes important to them. But there is another kind of theme that can be just as resonant as an experience-based theme; sometimes more so. This is the *truth-based* theme.

Consider the movie *Titanic*. This film deeply moved audiences the world over. Why? Sure, it was well-executed, and it had great special effects and a sweet (though sometimes schmaltzy) love story, but lots of movies have those things. What was special here was a deep and resonant theme reinforced by every element of the film. So, what was the theme? At first, you might say that the theme was the Titanic itself and its tragic accident. And that is an important component of the movie. In fact, you could argue that it is *a* theme of the movie, but it is not the *main* theme. The main theme is not experience-based. Instead, it is a simple statement, which I would phrase as something like "Love is more important than life, and stronger than death." This is a powerful statement. But it is a statement that many of us believe

deeply in our heart of hearts. It is certainly not a scientific truth, but for many, it is a deeply held, though rarely expressed, personal truth.

Many Hollywood insiders did not believe this movie could possibly be successful: audiences would know the ending. But where better to tell a story that fits this powerful theme than in a place where we know almost everyone is going to die? The expensive special effects were not gratuitous — to fully grasp the import of this theme, we must feel like it is all real, like we are right there, like we are dying ourselves.

Truth-based themes can sometimes be hard to spot. Part of the power of these deep truths is that they are hidden. Often, a designer might not even consciously know they have chosen a particular theme or be able to express it verbally — they just have a certain feeling about how the experience should be. But it is worth the trouble to explore your feelings about these things to the point that you can express your theme concretely. It will make it much easier for you to decide what should and shouldn't go into your game, and make it easier for you to explain the rationale of these decisions to others on your team.

Another example of a truth-based theme is the *Hercules* story. The VR Studio team was asked to create a game based upon Disney's version of the ancient Hercules myth. When a story stays alive, told and retold, for thousands of years like this story has, it is a pretty good clue that there is a truth-based theme hiding inside it. Sure, Hercules was a strong man, but that doesn't seem quite important enough that it would so deeply resonate with people. We looked at the various versions of the story. Interestingly, there was not one canonical telling, even in ancient times. Sometimes Hercules had ten labors, sometimes twelve, and sometimes twenty. But there were certain aspects of the story that were always the same. In every story, Hercules is a man so virtuous that he defeats death. And this is a truth so deep that it is at the heart of many religions: If you are virtuous enough, you can defeat death. The Disney animators embodied this theme in Hercules' conflict with Hades, Lord of the Underworld. We continued this theme in our game, by having it take place mostly in the Underworld, until the end, when you triumphantly break through to the world of the living for a final aerial battle against Hades. There were sub-themes too, such as a theme about the importance of teamwork, but ultimately, we placed these sub-themes in the service of the main theme.

Sometimes you figure out your theme a piece at a time. Another Disney story: when we started work on the Toontown Online project (Disney's first massively multiplayer game), we were again unsure of our theme. We had done our homework on Toontown, studying both the *Who Framed Roger Rabbit?* movie and the Toontown section of Disneyland. Curiously, Toontown was not well-defined in either place. We could see Toontown was powerful, though. The reason it was so ill-defined was that everyone seemed to already have a sense of what it was — as if they had known all along that there was a special place where cartoon characters lived when they weren't on the screen. This (slightly creepy) fact gave us a sense we were tapping into something fundamental and hidden. We started

making lists of things we thought Toontown should be about. Three big ones stood out:

1. Having fun with your friends

2. Escaping from reality

3. Simplicity and transcendence

The first one lent itself really well to online networked play, and we liked that. The second one made a lot of sense — cartoons are a good form of escapism. The third one (which we'll be exploring in more detail in Chapter 17) is basically the idea that things are simpler in Toontown than they are in the real world, but you are also more powerful in Toontown than you are in the real world.

All of this helped clarify what we wanted to see in the game, but none of it really established a clear theme. These felt more like sub-themes. At some point, we realized that these three things together strongly characterize something: *play*. Play is about having fun with your friends and escaping from reality, and a play world is simpler than the real world, but you have much more power. But we didn't feel like play was a powerful theme on its own. We needed something with more bite, with more conflict. This led us to play's natural opponent: work. And then it was clear — "work vs. play" would be a very strong theme. Stated in more detail, "Work wants to destroy play, but play must survive, because play is more important," was the truth-based theme we arrived at. Replace "work" and "play" with "slavery" and "freedom" as we did in Chapter 3, and the power of this theme becomes clear. It really felt right. We wanted to create a game that kids and parents could play together, with a theme they could both relate to — how better to do that than by playfully exploring one of the primary conflicts in their lives? And so we did. The story of Toontown Online became a story of robot executives (the Cogs) trying to turn colorful Toontown into a dingy office park. The Toons team up to fight off the Cogs with gags and practical jokes, and the Cogs fight back with office supplies. This story was strange enough that it raised some eyebrows inside the company, but we were confident it would work because it was an expression of a theme that we knew would resonate with our audience.

Resonant themes elevate your work from craft to art. An artist is someone who takes you where you could never go alone, and theme is the vehicle for getting there. Not every theme needs to be a resonant theme, of course. But when you find a deep resonant theme, it makes sense to use it for all it is worth. Some will be experience-based, others will be truth-based. You can never tell which themes are resonant just through logic — you have to feel the resonance, deep inside yourself. It is an important form of self-listening, and is also Lens #10.

Lens #10: The Lens of Resonance

To use the Lens of Resonance, you must look for hidden power.
 Ask yourself these questions:

- What is it about my game that feels powerful and special?
- When I describe my game to people, what ideas get them really excited?
- If I had no constraints of any kind, what would this game be like?
- I have certain instincts about how this game should be. What is driving those instincts?

The Lens of Resonance is a quiet, delicate instrument. It is a tool for listening to yourself and listening to others. We bury important things deep inside ourselves, and when something causes them to resonate, it shakes us to our very core. The fact that these things are hidden gives them power, but also makes them hard for us to find.

Back to Reality

You may think that all this talk of resonant themes is too lofty for game design. And for some games, maybe it is. Does *Super Monkey Ball* have a deep resonant theme? Maybe not, but it certainly does have a unifying theme which helped to drive the design. Resonant themes can add great power to your work, but even if your game doesn't seem to have one, it will still be strengthened by a unifying theme to focus the experience.

Some designers reject the notion of theme, because they say "the players will never notice." And it is certainly true that the players cannot always state clearly the theme of a work that truly moves them — and that is because theme often operates at a subconscious level. Players know they like a game, but they can't quite say why. Often, the reason is that all of the elements are reinforcing a theme that is interesting or important to them. Theme is not about some puzzle-based symbolism where the designer intends a secret message. Theme is about focusing your work toward something that holds meaning for your players.

Different designers use theme in different ways as part of their design process. Now it is time for us to explore the many other aspects of the overall process of game design.

The Game Begins with an *Idea*

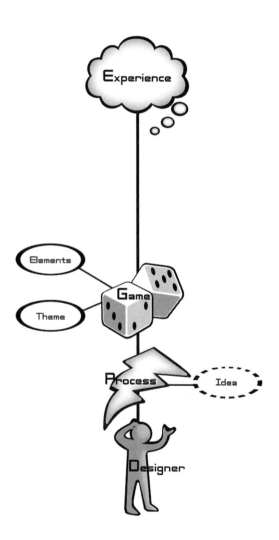

FIGURE
6.1

Hopefully, this book will inspire you to try designing some games of your own. When you do that (maybe you have already), you might be thinking that you aren't going about it the right way, not using the methods that "real" game designers use. I'm guessing the method you used to design your games was something like

1. Think of an idea.
2. Try it out.
3. Keep changing it and testing it until it seems good enough.

Which sounds kind of amateurish. Well, guess what? That is exactly what real game designers do. And this chapter would end here, except for the fact that some ways to do these things are better than others. You already know *what* to do. In this chapter and the next, we are going to discuss *how* to do it as well as possible.

Inspiration

As I mentioned earlier, I worked for several years as a professional juggler. When I was about fourteen years old, and my repertoire of tricks was limited to two, I attended my first juggling festival. If you haven't attended one, they are remarkable to see — they mainly consist of jugglers of all levels of skill and ability standing around in a large gymnasium, talking about, experimenting with, and sharing new techniques. It is a place where you can attempt the impossible and drop without shame. But attending alone, my first time, it didn't feel that way. I was incredibly nervous — after all, I wasn't a "real" juggler. I mostly walked around, eyes wide, hands in my pockets, terrified that someone would point and shout "Hey! What's HE doing here?" But of course, that didn't happen. Everyone at the festival had learned just like I had — they had taught themselves. Once I grew comfortable, I took out my beanbags and did a little practicing of my own. I watched other people do tricks, and I tried imitating them — sometimes I could do it. But as I looked around for more examples of techniques to try, there was one juggler who stood out from the rest. He was an old man in a powder blue jumpsuit, and his tricks were not like the others at all. He used patterns and rhythms that were unique, and his tricks, though not astonishing in their difficulty, were simply beautiful to watch. I had to watch a long time before I realized that some of the tricks that seemed so special and unique when he did them were things *I could already do* — but when he did them they had such a different style, a different feeling, that they seemed like something completely new. I watched him for about twenty minutes, and suddenly he looked at me, and said "Well?"

"Well, what?" I said, kind of embarrassed.

"Aren't you going to try to copy me?"

"I — I don't think I would know how," I stammered out.

He laughed. "Yeah, they never can. Know why my tricks look so different?"

"Uh, practice?" I managed.

"No — everybody practices. Look around! They're all practicing. No, my tricks look different because of where I get them. These guys, they get their tricks from each other. Which is fine — you can learn a lot that way. But it will never make you stand out."

I thought about it. "So where do you get them?" I asked. "Books?"

"Ha! Books. That's a good one. No, not books. You wanna know the secret?"

"Sure."

"The secret is: don't look to other jugglers for inspiration — *look everywhere else.*" He proceeded to do a beautiful looping pattern, where his arms kind of spiraled, and he turned occasional pirouettes. "I learned that one watching a ballet in New York. And this one…" he did a move that involved the balls popping up and down as his hands fluttered delicately back in forth. "I learned that from a flock of geese I saw take off from a lake up in Maine. And this," he did a weird mechanical looking movement where the balls almost appeared to move at right angles. "I learned that from a paper punch machine on Long Island." He laughed a little, and stopped juggling for a minute. "People try to copy these moves, but they can't. They always try… yeah, look at that fella, over there!" He pointed to a juggler with a long ponytail across the gym who was doing the "ballet" move. But it just looked dumb. Something was missing, but I couldn't say what.

"See, these guys can copy my moves, but they can't copy my inspiration." He juggled a pattern that made me think of a spiraling double helix. Just then, the PA announced a beginner's workshop — I thanked him, and ran off. I didn't see him again, but I never forgot him. I wish I knew his name, because his advice changed my approach to creativity forever.

Lens #11: The Lens of Infinite Inspiration

When you know how to listen, everybody is the guru.

– Ram Dass

To you use this lens, stop looking at your game, and stop looking at games like it. Instead, *look everywhere else.*

Ask yourself these questions:

- What is an experience I have had in my life that I would want to share with others?
- In what small way can I capture the essence of that experience and put it into my game?

Using this lens requires an open mind and a big imagination. You need to search you feelings and observe everything around you. You must be willing to try the impossible — for surely it is impossible for a roll of the dice to capture the excitement of a swordfight, or for a videogame to make a player feel afraid of the dark — isn't it? Use this lens to find the non-game experiences that will inspire your game. Your choices in the different quadrants of the tetrad (technology, mechanics, story, and aesthetics) can each be united by a single inspiration, or each can build on different inspirations, blending them together to create something entirely new. When you have concrete visions based on real life that guide your decision making, your experience will acquire an undeniable power, strength, and uniqueness.

This lens works hand in hand with Lens #1: Essential Experience. Use the Lens of Infinite Inspiration to seek and find beautiful experiences, and the Lens of Essential Experience to bring them into your game.

Inspiration is one of the secrets behind the strongest games. But how can you turn inspiration into a great game design?

The first step is admitting you have a problem.

State the Problem

The purpose of design is to solve problems, and game design is no exception. Before you start coming up with ideas, you need to be certain of why you are doing it, and a problem statement is a way to state that clearly. Good problem statements tell both your goal and your constraints. For example, your initial problem statement might be:

"How can I make a Web-based game that teenagers will really like?"

This makes clear both your goal (something teenagers will really like) and your constraints (it must be a Web-based game). One advantage of stating things so clearly is that it can make you realize that you might be mistakenly over-constraining the real problem. Maybe you've been thinking "Web-based game," but really, there is no reason that what you create has to be a game at all — maybe some kind of Web-based toy or activity would be okay as long as teenagers really like it. So, you might restate your problem in broader terms:

"How can I make a Web-based experience that teenagers really like?"

It is crucial that you get the problem statement right — if you make it too broad, you might come up with designs that don't meet your true goal, and if you make it too narrow (because you were focusing on solutions instead of the problem) you

might cut yourself off from some clever solutions because you assumed that a certain kind of solution was the only valid one for your problem. People who come up with clever solutions are almost always the same people who take the time to figure out the real problem.

Three advantages of clearly stating your problem:

1. **Broader creative space**. Most people jump to solutions too fast and start their creative process there. If you start your process at the problem instead of at a proposed solution, you will be able to explore a broader creative space and find solutions that are hiding where no one else is looking.

2. **Clear measurement**. You have a clear measurement of the quality of proposed ideas: How well do they solve the problem?

3. **Better communication**. When you are designing with a team, communication is much easier if the problem has been clearly stated. Very often, collaborators will be trying to solve quite different problems and not realize it if the problem has not been clearly stated.

Sometimes, you will have already explored several ideas before you realize what the problem "really" is. That's fine! Just make sure you go back and restate the problem clearly, once you see what it is.

A completed game design will cover all four elements of the elemental tetrad: technology, mechanics, story, and aesthetics. Often, your problem statement will constrain you to some established decisions about one (or more) of the four elements, and you will have to build from there. As you try to state your problem, it can be useful to examine it from the point of view of the tetrad to check where you have design freedom, and where you don't. Take a look at these four problem statements: Which ones have already made decisions in what parts of the tetrad?

1. How can I make a board game that uses the properties of magnets in an interesting way?

2. How can I make a videogame that tells the story of Hansel and Gretel?

3. How can I make a game that feels like a surrealist painting?

4. How can I improve on Tetris?

What if, by some miracle, you have no constraints? What if somehow you have the liberty to make a game about anything, anything at all, using any medium you like? If that is the case (and it seems highly unlikely!) you need to decide some constraints. Pick a story you might like to pursue or a game mechanic you would like to explore. The moment you pick something, you will have a problem statement. Viewing your game as the solution to a problem is a useful perspective and Lens #12.

Lens #12: The Lens of the Problem Statement

To use this lens, think of your game as the solution to a problem.

Ask yourself these questions:

- What problem, or problems, am I really trying to solve?
- Have I been making assumptions about this game that really have nothing to do with its true purpose?
- Is a game really the best solution? Why?
- How will I be able to tell if the problem is solved?

Defining the constraints and goals for your game as a problem statement can help move you to a clear game design much more quickly.

How to Sleep

We have stated our problem and are ready to brainstorm! At least we will be, once we have properly prepared. Sleep is crucial to the process of idea generation — a good designer uses the tremendous power of sleep to its maximum advantage. No one explains this better, I think, than surrealist painter Salvador Dali. The following (Dali's Secret #3) is an excerpt from his book *Fifty Secrets of Magic Craftsmanship*.

In order to make use of the slumber with a key you must seat yourself in a bony armchair, preferably of Spanish style, with your head tilted back and resting on the stretched leather back. Your two hands must hang beyond the arms of the chair, to which your own must be soldered in a supineness of complete relaxation...

In this posture, you must hold a heavy key which you will keep suspended, delicately pressed between the extremities of the thumb and forefinger of your left hand. Under the key you will previously have placed a plate upside down on the floor. Having made these preparations, you will have merely to let yourself be progressively invaded by a sense of serene afternoon sleep, like the spiritual drop of anisette of your soul rising in the cube of sugar of your body. The moment the key drops from your fingers, you may be sure that the noise of its fall on the upside-down plate will awaken you, and you may be equally sure that this fugitive moment during which you cannot be assured of having really slept is totally sufficient, inasmuch as not a second more is needed for your whole physical and psychic being to be revivified by just the necessary amount of repose.

Your Silent Partner

Is Dali crazy? The benefits of a good night's sleep are easy to believe — but what possible benefit could there be in a nap that lasts only a fraction of a second? The answer becomes clear only when you consider where your ideas come from. Most of our good, clever, creative ideas are not arrived at through a process of logical, reasoned argument. No, the really good ideas just seem to pop up out of nowhere; that is, they come from somewhere below the surface of our consciousness — a place we call the subconscious. The subconscious mind is not well understood, but it is a source of tremendous, and possibly all, creative power.

Proof of this power is evident when we consider our dreams. Your subconscious has been creating these fascinating little comedies and dramas, each one different, three shows nightly, since *before you were born*. Far from a sequence of random images, most people frequently have dreams that are quite meaningful. There are many known instances of important problems solved in dreams. One of the most famous is the story of the chemist Friedrich Von Kekule who had long been puzzling over the structure of benzene (C_6H_6). No matter how he tried to make the chains of atoms fit together, it didn't work. Nothing about them made sense, and some scientists were wondering if this pointed to a fundamental misunderstanding about the nature of molecular bonding. And then, his dream:

Again the atoms danced before my eyes. My mind's eye, sharpened by many previous experiences, distinguished larger structures of diverse forms, long series, closely joined together; all in motion, turning and twisting like serpents. But see what was that? One serpent had seized its own tail and this image whirled defiantly before my eyes. As by a lightning flash, I awoke.

And upon awakening, he knew that benzene's structure was a ring shape. Now, would you say the Kekule himself thought of the solution? From his description, he merely watched the solution play out in front of him and recognized it when he saw it. It was as if the author of the dreams had solved the problem and was merely presenting it to Kekule. But who is the author of these dreams?

On one level, the subconscious mind is part of us, but on another, it seems to be quite separate. Some people become quite uncomfortable at the idea of regarding one's subconscious mind as another person. It is an idea that sounds, well, kind of crazy. But creativity is crazy, so that shouldn't stop us — in fact, it should encourage us. So, why not treat it like a separate entity? No one has to know — it can be your little secret. Bizarre as it sounds, treating your subconscious like another person can be quite useful, because as humans, we like to anthropomorphize things, because it gives us a well-understood model for thinking about and interacting with them. You won't be alone in this practice — creative minds have been doing it for thousands of years. Stephen King describes his silent partner in his book *On Writing*:

There is a muse (traditionally, the muses were women, but mine's a guy; I'm afraid we'll just have to live with that), but he's not going to come fluttering

down into your writing room and scatter creative fairy-dust all over your type-writer or computer station. He lives in the ground. He's a basement guy. You have to descend to his level, and once you get down there you have to furnish an apartment for him to live in. You have to do all the grunt labor, in other words, while the muse sits and smokes cigars and admires his bowling trophies and pretends to ignore you. Do you think this is fair? I think it's fair. He may not be much to look at, that muse-guy, and he may not be much of a conver-sationalist (what I get out of mine is mostly surly grunts, unless he's on duty), but he's got the inspiration. It's right that you should do all the work and burn all the midnight oil, because the guy with the cigar and the little wings has got a bag of magic. There's stuff in there that can change your life.

Believe me, I know.

So, if we pretend our creative subconscious is another person, what is that person like? You might already have a mental picture of yours. Here are some common characteristics of the creative subconscious that most people seem to share:

- **Can't talk**, or at least chooses not to. Not in words, anyway. Tends to communicate through imagery and emotions.

- **Impulsive**. Tends not to plan ahead, tends to live in the moment.

- **Emotional**. Gets swept up in whatever you are feeling — happy, angry, excited, afraid — the subconscious seems to feel things more deeply and more powerfully than the conscious mind.

- **Playful**. It has a constant curiosity, and loves wordplay and pranks.

- **Irrational**. Not bound by logic and rationality, the subconscious comes up with ideas that often make no sense. Need to go to the moon? Perhaps a long ladder will work. Sometimes these ideas are a useless distraction, but sometimes they are the clever perspective you have sought all along — whoever heard of a ring molecule, for example?

I sometimes wonder if the long-term appeal of the character of Harpo Marx, from the Marx Brothers films has to do with the fact that he matches the profile of the creative subconscious almost perfectly — perhaps this is his resonant theme. Harpo doesn't speak (or doesn't care to), is impulsive (eats whatever he sees, chases girls, gets into fights), is very emotional (always laughing, crying, or having fits of anger), is always playful, and is certainly irrational. However, his crazy solutions to problems often save the day, and in quiet moments, he plays music of angelic beauty — not for the praise of others, but simply for the joy of doing it. I like to think of Harpo as the patron saint of the creative subconscious (see Figure 6.2).

Sometimes, though, working with the creative subconscious can make you feel like you have a deranged four-year-old living inside your head. Without the rational mind to plan things out, take precautions, and set things straight, this guy would never survive on his own. For this reason, many people get in the habit of ignoring

FIGURE
6.2

Salvador Dali paints a portrait of Harpo Marx on a dinner plate.

what the subconscious mind suggests. If you are doing your taxes, that is probably a good idea. But if you are brainstorming about games, your silent partner is more powerful than you are. Keep in mind that he has been creating entertaining virtual worlds for you each night, since before you were born, and he is more in touch with the essence of experience than you can ever hope to be. Here are some tips for getting the most out of this unusual creative partnership.

Subconscious Tip #1: Pay Attention

As usual, the key is listening, this time to your *self* (sort of). The subconscious is no different than anyone else: If you get in the habit of ignoring it, it is going to stop making suggestions. If you get in the habit of listening to it, seriously considering its ideas, and thanking it when you get a good one, it will start to offer more and better suggestions. So, how do you listen to something that can't talk? What you must do is pay closer attention to your thoughts, your feelings, your emotions, and your dreams, for those are the ways the subconscious communicates. This sounds really strange, but it really does work — the more you pay attention to what the subconscious has to say, the more work it will do for you.

For example, say you are brainstorming ideas for a surfing game. You are thinking about which beaches it should be set at and what kind of camera systems are going to be best for a surfing game. Suddenly, you have this inkling of an idea: "What if the surfboards were bananas?" which is crazy, of course — and where do you think it came from? Now, you could say to yourself, "That's stupid — let's constrain this to reality, please." Or, you could take a few moments, and seriously consider the idea: "Okay, so what if the surfboards *were* bananas?" And then another thought comes: "With monkeys surfing on them." And suddenly, this doesn't seem so dumb — maybe

this banana surfing monkey game could be something different, something new, something that might gain you a wider audience than the more realistic game you had originally planned. And even if you ultimately reject the idea, your subconscious might feel a little more respected and take part more seriously in the brainstorming process because of the time you spent considering suggestions — and what did it cost you? Only a few seconds of quiet reflection.

Subconscious Tip #2: Record Your Ideas

Certainly you will record your ideas during a brainstorming session, but why not record them all the time? The human memory is terrible. By recording all of your ideas, two things happen. First, you'll have a record of many ideas that you would likely have forgotten otherwise, and second, you'll free up your mind to think of other things. When you think of an important idea, and you don't write it down, it kind of bangs around up there, taking up space and mental energy, because your mind recognizes it as important and doesn't want to forget the important idea. Something magic happens when you record it — it is like your mind doesn't feel the need to think about the idea as much. I find it makes my mind feel clean and open, as opposed to cluttered and cramped. It leaves the freedom to think seriously about the design of the day, without tripping over the clutter of important unrecorded ideas. It sounds weird, but that is how it feels. An inexpensive voice recorder can be an invaluable tool for a game designer. Whenever an interesting idea comes to you just speak it into the recorder and deal with it later. You have to have the discipline to periodically transcribe those recordings, but really, that is a small price to pay for a huge idea collection and a clean mental workspace.

Subconscious Tip #3: Manage Its Appetites (Judiciously)

Let's be honest here — the subconscious mind has appetites, some of which are primal. These appetites seem to be part of its job — just as it is the rational mind's job to determine which appetites can be safely fed, and how to go about doing that. If the subconscious mind feels one of these appetites too strongly, it will obsess about it. When it is obsessing, it can't do good creative work. If you are trying to come up with new ideas for a real-time strategy game, and all you can think about is candy bars or how your girlfriend left you, or how much you hate your roommate, you aren't going to be able to get much good work done, because these intrusive thoughts will distract you, and the source of these intrusive thoughts, your subconscious mind, isn't getting any work done either, and he's the one who has to do the heavy lifting. Maslow's hierarchy, which we'll discuss in Chapter 9, is a pretty good guide here — if you don't have food, safety, and healthy personal relationships, it will be hard to do self-actualizing creative work. So, make it a priority to

for where things are positioned around us is very good. By posting your ideas in the room all around you, you can more easily remember where they are. This is crucial, since you will be trying to find connections between dozens of different ideas, and you need any help you can get — particularly if you will be brainstorming over several sessions. It is quite remarkable. If you put a bunch of ideas up on the walls, and you go away for a few weeks, you will forget most of it. But walk back into that room where the ideas are posted, and it feels like you never left.

Brainstorm Tip #11: Write Everything

The best way to have a good ideas is to have a lot of ideas.

– Linus Pauling

You've got your fancy pens, your fancy paper, your fancy coffee, some toys, some modeling clay, everything you think you might need to be creative. Now you are waiting for that brilliant idea to come. Mistake! Don't wait — just start writing down everything you can think of that is remotely connected to your problem. Write down every stupid idea that comes into your head. And a lot of them will be stupid. But you have to get the stupid ones out of the way before the good ones start showing up. And sometimes a stupid idea becomes the inspiration for a genius idea, so write it all down. Don't censor yourself. You have to give up your fear of being wrong and your fear of looking silly. This is hard for most of us to do, but it comes with practice. And if you are brainstorming with other people, certainly don't censor them — their stupid ideas are just as good as your stupid ideas!

Brainstorm Tip #12: Number Your Lists

Much of your brainstorming will consist of lists. When you make lists, number them! This does two things: First, it makes the lists easier to discuss ("I like ideas 3 through 7, but 8 is my favorite!"), secondly, and this is *extremely weird*, when a list of things is numbered, the numbers somehow give a certain dignity to the things in the list. Consider these two lists:

- chicken broth
- umbrellas
- wind
- spatulas

1. chicken broth
2. umbrellas
3. wind
4. spatulas

Don't the items in the numbered list seem more important, somehow? If one of them suddenly disappeared, you would be much more likely to notice. This dignity will make you (and others) more likely to take the ideas on the list seriously.

Brainstorm Tip #13: Mix and Match Categories

It's great when game ideas, Athena-like, spring forth from your head, fully formed. But it doesn't happen that way every time. A great technique for helping ideas come together is to brainstorm in categories. The elemental tetrad comes in handy here. For example, you might have decided you want to make a game for teenage girls. You might make separate lists, which you can start to mix and match. Something like

Technology Ideas

1. Cell phone platform
2. Handheld game
3. PC
4. Integrated with instant messaging
5. Game console

Mechanics Ideas

1. Sims-like game
2. Interactive fiction game
3. The winner makes the most friends
4. Try to spread rumors about the other players
5. Try to help as many people as possible
6. Tetris-like game

Story Ideas

1. High school drama
2. College-themed
3. You play cupid
4. You're a TV star
5. Hospital theme

6. Music theme
 a. You're a rock star
 b. You're a dancer

Aesthetic Ideas

1. Cel shaded
2. Anime style
3. All characters are animals
4. R&B music defines the game
5. Edgy rock/punk music defines the feel

Once you have lists like these (though you should have dozens more entries on each list!) you are free to start mixing and matching ideas — maybe a cell-phone-based Tetris-like game, which has a hospital theme, where all the characters are animals.... Or how about a Sims-like console game based on high school with an anime style? By having all these lists of partial ideas that can easily be mixed and matched, fully formed game ideas that you might never have thought of start springing up all over the place, each taking on a life of their own. Don't be afraid to make up other categories, either, as you need them!

Brainstorm Tip #14: Talk To Yourself

There is tremendous social stigma against talking to yourself. But when brainstorming alone, some people find it really helpful — there is something about saying things out loud that makes them more real than just thinking them in your head. Find a place where you can freely talk to yourself without getting funny looks. Another trick, if you are brainstorming in a public place: hold a cell phone next to your head while you talk to yourself — it's silly, but it works.

Brainstorm Tip #15: Find a Partner

When you brainstorm with other people, it is a very different experience than brainstorming alone. Finding the right brainstorming partner can make a world of difference — sometimes the two of you can get to great solutions many times faster than either of you could alone, as you bounce ideas back and forth and complete one another's sentences. Just having someone to talk out loud to, even if they say nothing, can sometimes move the process along faster. Do keep in mind that adding more and more people doesn't necessarily help, though. Usually, small groups of no more than

four are best. Groups work best when brainstorming a narrow problem, not a broad, open-ended one. Also, certain people make bad brainstorming partners — these are usually people who try to poke holes in every idea, or people who have very narrow tastes. These people are best avoided, and you'll be more productive without them. Team brainstorming can have tremendous benefits and tremendous perils, which we will discuss in greater detail in Chapter 23.

Look At All These Ideas! Now What?

Our goal with this chapter was to "Think of an idea." After a little brainstorming, you probably have a hundred! And this is how it should be. A game designer must be able to come up with dozens of ideas on any topic. As you practice, you will be able to come up with more and better ideas in less time. But this is just the beginning of your design process. The next step is to narrow down this broad list of ideas, and start doing something useful with them.

make it fail another one. In a sense, the design process mainly consists of stating your problem, getting an initial idea, and finding a way to get it past all eight filters.

The eight filters are

Filter #1: Artistic Impulse: This is the most personal of the filters. You, as the designer, basically ask yourself whether the game "feels right" to you, and if it does, it passes the test. If it doesn't, something needs to change. Your gut feelings are important. They won't always be right, but the other filters will balance that out.
Key Question: *"Does this game feel right?"*

Filter #2: Demographics: Your game is likely to have an intended audience. This might be an age bracket, or a gender, or some other distinct audience (e.g., "golf enthusiasts"). You have to consider whether your design is right for the demographic you are targeting. Demographics will be discussed in more detail in Chapter 8.
Key Question: *"Will the intended audience like this game enough?"*

Filter #3: Experience Design: To apply this filter, take into account everything you know about creating a good experience, including aesthetics, interest curves, resonant theme, game balancing, and many more. Many of the lenses in this book are about experience design — to pass this filter, your game must stand up to the scrutiny of many lenses.
Key Question: *"Is this a well-designed game?"*

Filter #4: Innovation: If you are designing a new game, by definition there needs to be something new about it, something players haven't seen before. Whether your game is novel enough is a subjective question, but a very important one.
Key Question: *"Is this game novel enough?"*

Filter #5: Business and Marketing: The games business is a business, and designers who want their games to sell must consider the realities of this and integrate them into their game's design. This involves many questions. Are the theme and story going to be appealing to consumers? Is the game so easily explainable that one can understand what it is about just by looking at the box? What are the expectations consumers are going to have about this game based on the genre? How do the features of this game compare to other similar games in the marketplace? Will the cost of producing this game be so high as to make it unprofitable? Will retailers be willing to sell this game? The answers to these and many other questions are going to have an impact on your design. Ironically, the innovative idea that drove the initial design may prove to be completely untenable when viewed through this filter. This will be discussed in detail in Chapter 29.
Key Question: *"Will this game sell?"*

Filter #6: Engineering: Until you have built it, a game idea is just an idea, and ideas are not necessarily bound by the constraints of what is possible or practical. To pass this filter, you have to answer the question "How are we going to build this?" The answer may be that the limits of technology do not permit the idea as originally envisioned to be constructed. Novice designers often grow frustrated with the limits that engineering imposes on their designs. However, the engineering filter can just as often grow a game in new

directions, because in the process of applying this filter, you may realize that engineering makes possible features for your game that did not initially occur to you. The ideas that appear during the application of this filter can be particularly valuable, since you can be certain that they are practical. More issues of engineering and technology will be discussed in Chapter 26.

Key Question*: "Is it technically possible to build this game?"*

Filter #7: Social/Community: Sometimes, it is not enough for a game to be fun. Some of the design goals may require a strong social component, or the formation of a thriving community around your game. The design of your game will have a strong impact on these things. This will be discussed in detail in Chapters 21 and 22.

Key Question*: "Does this game meet our social and community goals?"*

Filter #8: Playtesting: Once the game has been developed to the point that it is playable, you must apply the playtesting filter, which is arguably the most important of all the filters. It is one thing to imagine what playing a game will be like, and quite another to actually play it, and yet another to see it played by your target audience. You will want to get your game to a playable stage as soon as possible, because when you actually see your game in action, important changes that must be made will become obvious. In addition to modifying the game itself, the application of this filter often changes and tunes the other filters as you start to learn more about your game mechanics and the psychology of your intended audience. Playtesting will be discussed in detail in Chapter 25.

Key Question*: "Do the playtesters enjoy the game enough?"*

Sometimes, in the course of design, you may find a need to change one of the filters — perhaps originally you targeted one demographic (say, males ages 18–35), but while designing, you stumbled into something that better fits another demographic (say, females over 50). Changing the filters is fine, when your design constraints will allow it. The important thing is that somehow, by changing the filters or by changing your design, you find a way to get through all eight.

You will be using these filters continuously throughout the rest of the design and development process of your game. When picking an initial idea, it makes sense to evaluate which of your ideas is going to have the best shot of being molded and shaped to the point it can survive this gauntlet. The perspective of the eight filters is a very useful way to evaluate your game, so let's make it Lens #13.

Lens #13: The Lens of the Eight Filters

To use this lens, you must consider the many constraints your design must satisfy. You can only call your design finished when it can pass through all eight filters without requiring a change.

Ask yourself the eight key questions:

- Does this game feel right?
- Will the intended audience like this game enough?
- Is this a well-designed game?
- Is this game novel enough?
- Will this game sell?
- Is it technically possible to build this game?
- Does this game meet our social and community goals?
- Do the playtesters enjoy this game enough?

In some situations, there may be still more filters; for example, an educational game will also have to answer questions like "Does this game teach what it is supposed to?" If your design requires more filters, don't neglect them.

The Rule of the Loop

It is somewhat daunting to consider that all of Chapter 6 and the first part of this one have merely been an elaboration of "1. Think of an idea." On the other hand, ideas are at the root of design, and their production is so mysterious as to be almost magical, so perhaps it shouldn't surprise us that there is so much to say about this single step.

At this point in the process, you have thought of many ideas, and chosen one, and now it is time to move on to the next step: "2. Try it out." And many designers and developers do just that — leap in and try out their game. And if your game is simple — such as a card game, board game, or very simple computer game — and you have plenty of time to test it and change it, over and over, until it is great, you probably should do just that.

But what if you can't just build a working prototype of your game in an hour or two? What if your game vision requires months of artwork and programming before you will even be able to try it out? If this is the case (as it is for many modern videogame designs), you need to proceed cautiously at this point. The process of game design and development is necessarily iterative, or looping. It is impossible to accurately plan how many loops it is really going to take before your game passes all eight filters and is "good enough." This is what makes game development so incredibly risky — you are gambling that you will be able to get your game to pass all eight filters on a fixed budget, when you really don't know if it will.

The naïve strategy, that many still use today, is to start slapping the game together and hope for the best. Sometimes this works. But when it doesn't, you are in a horrible mess. You either have to ship a game that you know isn't good enough, or suffer the expense of continuing development until it is. And often, this extra time and expense is enough to make the project completely unprofitable.

In truth, this is a problem for all software projects. Software projects are so complex that it is very difficult to predict how long they will take to build, and how long it will take to find and fix all of the bugs that will surely appear during development. On top of all that, games have the added burden of needing to be fun — game developers have a couple of extra filters that non-game software developers don't need to worry about.

The real problem here is the Rule of the Loop.

The Rule of the Loop: The more times you test and improve your design, the better your game will be.

The Rule of the Loop is not a lens, because it is not a perspective — it is an absolute truth. There are no exceptions to the Rule of the Loop. You will try, at times in your career, to rationalize it away, to convince yourself that "this time, the design is so good, we don't have to test and improve," or "we really have no choice — we'll have to hope for the best," and you will suffer for it each time. The horrible thing about computer games is that the amount of time and money it takes to test and adjust the system is so much greater than for traditional games. It means computer game developers have no choice but to loop fewer times, which is a terribly risky thing to do.

If you are indeed embarking on the design of a game that is likely to involve long "test and improve" loops, you need to answer these two questions:

- Loop Question 1: How can I make every loop count?
- Loop Question 2: How can I loop as fast as possible?

The software engineering people have thought about this problem a lot over the last forty years, and they have come up with some useful techniques.

A Short History of Software Engineering

Danger — Waterfall — Keep Back

In the 1960s, when software development was still relatively new, there was very little in the way of formal process. Programmers just made their best guesses about how long things would take, and they would start coding. Often the guesses

were wrong, and many software projects went disastrously over budget. In the 1970s, in an attempt to bring some order to this unpredictable process, many developers (usually at the behest of non-technical management) tried to adopt the "waterfall model" of software development, which was an orderly seven-step process for software development. It was generally presented looking something like this:

FIGURE
7.2

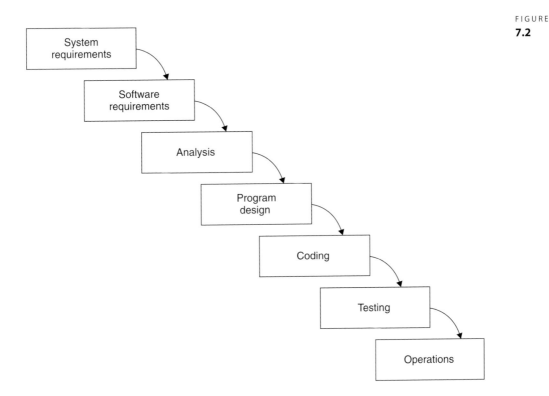

And it certainly looks appealing! Seven orderly steps, and when each is complete, nothing remains but to move on to the next one — the very name "waterfall" implies that no iteration is needed, since waterfalls generally do not flow uphill.

The waterfall model had one good quality: it encouraged developers to spend more time in planning and design before just jumping into the code. Except for that, it is complete nonsense, because it violates the Rule of the Loop. Managers found it incredibly appealing, but programmers knew it to be absurd — software is simply too complex for such a linear process to ever work. Even Winston Royce, who wrote

the paper which was the foundation for all of this, disagreed with the waterfall model as it is commonly understood. Interestingly, his original paper emphasizes the importance of iteration and the ability to go back to previous steps as needed. He never even used the word "waterfall"! But what was taught at universities and corporations everywhere was this linear approach. The whole thing seems to have been wishful thinking, mostly promulgated by people who did not actually have to build real systems themselves.

Barry Boehm Loves You

Then, in 1986, Barry Boehm (pronounced "beam") presented a different model, which was based more closely on how real software development actually happens. It is usually presented as a somewhat intimidating diagram, where development starts in the middle, and spirals out clockwise, passing through four quadrants again and again (Figure 7.3).

His model has a lot of complex detail, but we don't need to go into all of that. There are basically three great ideas wrapped up in here: risk assessment, prototypes, and looping. In brief, the spiral model suggests that you:

1. Come up with a basic design.
2. Figure out the greatest risks in your design.
3. Build prototypes that mitigate those risks.
4. Test the prototypes.
5. Come up with a more detailed design based on what you have learned.
6. Return to step 2.

And basically, you repeat this loop until the system is done. This beats the waterfall model hands down, because it is all about the Rule of the Loop. Also, it answers the questions we stated earlier:

- **Loop Question 1**: How can I make every loop count?
 Spiral Model Answer: Assess your risks and mitigate them.
- **Loop Question 2**: How can I loop as fast as possible?
 Spiral Model Answer: Build many rough prototypes.

There have been many descendants of the spiral model, which you may want to investigate. Although these have their differences, they all feature risk assessment and prototyping at their core.

FIGURE
7.3

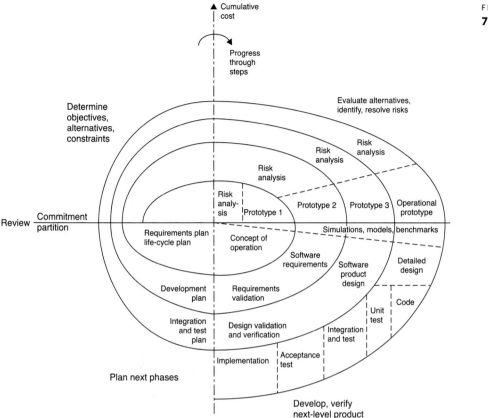

The spiral model of software development

Risk Assessment and Prototyping

Example: Prisoners of Bubbleville

Let's say you and your team have decided you want to make a videogame all about parachuting into a city. You have a brief design description that you based on the elemental tetrad:

Prisoners of Bubbleville — Design Brief

Story: You are "Smiley," a parachuting cat. The good people of Bubbleville are trapped in their houses by an evil wizard. You must find a way to defeat the wizard, by repeatedly parachuting into the city and sliding down chimneys to visit the citizens and get clues about how to stop the wizard.

Mechanics: As you parachute toward the city, you are trying to grab magic bubbles that rise up from the city and use their energy to shoot rays at evil vultures that

try to pop the bubbles and rip your parachute. Simultaneously, you must navigate down to one of several target buildings in the city.

Aesthetics: A cartoony look and feel.

Technology: Multiple platform 3D console game using a third-party engine.

One approach you could take would be to just start building the game. Start writing code, designing detailed levels, animating the characters, while you wait for it all to come together, to see what it will really be like. But this could be incredibly dangerous. Assuming this is an eighteen-month project, it might take as long as six months before you even have anything you can playtest. What if you learned, at that point, that your game idea wasn't fun? Or your game engine wasn't up to the job? You would be in real trouble. You would be one-third of the way through the project and would only have completed a single loop!

Instead, the right thing is to sit down with your team, and do a risk analysis. This means making a list of all the things that might jeopardize the project. A sample list for this game might be:

Prisoners of Bubbleville — Risk List

Risk #1: The bubble collecting/vulture shooting mechanic might not be as fun as we think.

Risk #2: The game engine might not be able to handle drawing an entire city and all those bubbles and vultures at once.

Risk #3: Our current thinking is that we need thirty different houses to make a full game — creating all the different interiors and animated characters might take more time than we have.

Risk #4: We aren't sure people will like our characters and story.

Risk #5: There is a chance the publisher might insist we theme this game to a new summer movie about stunt parachuting.

In reality, you will probably have many more risks, but for the sake of our example, we'll just consider these. So, what do you do about these risks? You could just cross your fingers and hope these things don't happen, or you could do the smart thing: risk mitigation. The idea is to reduce or eliminate the risks as soon as possible, often by building small prototypes. Let's look at how each of these risks could be mitigated:

Prisoners of Bubbleville — Risk Mitigation

Risk #1: The bubble collecting/vulture shooting mechanic might not be as fun as we think.

Game mechanics can often be abstracted and played in a simpler form. Have a programmer make a very abstract version of this gameplay mechanic, perhaps in 2D, with simple geometric shapes instead of animated characters. You can probably have a working game in a week or two, and start answering questions about whether it is fun right away. If it isn't, you can make quick modifications to the simple prototype, until it is fun, and then begin work on the elaborate 3D version. You'll be doing more loops sooner, wisely taking advantage of the Rule of the Loop. You might object to this approach, thinking that throwing out the 2D prototyping code, which the players will never see, is wasteful. In the long run, though, you will

have saved time, because you will be coding the right game sooner, and not endlessly coding and recoding the wrong game.

Risk #2: The game engine might not be able to handle drawing an entire city and all those bubbles and vultures at once.

If you wait for all the final artwork to answer this question, you could put yourself in a horrible situation: If the game engine can't handle it, you now have to ask the artists to redo their work so it is less strain on the game engine, or ask the programmers to spend extra time trying to find tricks to render everything more efficiently (or most likely, both of these things). To mitigate the risk, build a quick prototype, right away, that does nothing but show the approximate number of equivalent items on screen, to see if the engine can handle it. This prototype has no gameplay; it is purely to test technical limits. If it can handle it, great! If it can't, you can figure out a solution now, before any art has been generated. Again, this prototype will be a throwaway.

Risk #3: Our current thinking is that we need thirty different houses to make a full game — creating all the different interiors and animated characters might take more time than we have.

If you get halfway into development before you realize that you don't have the resources to build all the artwork, you are doomed. Have an artist create one house and one animated character immediately to see how long it takes, and if it takes longer than you can afford, change your design immediately — maybe you could have fewer houses, or maybe you could reuse some the interiors and characters.

Risk #4: We aren't sure people will like our characters and story.

If you really are concerned about this, you cannot wait until the characters and story are in the game to find out. What kind of prototype do we build here? An art prototype — it might not even be on a computer — just a bulletin board. Have your artists draw some concept art, or produce test renders of your characters and settings. Create some storyboards that show how the story progresses. Once you have these, start showing them to people (hopefully people in your target demographic) and gauge their reactions. Figure out what they like, don't like, and why. Maybe they like the look of the main character, but hate his attitude. Maybe the villain is exciting, but the story is boring. You can figure most of this out completely independent of the game. Each time you do this, and make a change, you've completed another loop and gotten one step closer to making a good game.

Risk #5: There is a chance we might have to theme this game to a new summer movie about stunt parachuting.

This risk might sound absurd, but this kind of thing happens all the time. When it happens in the middle of a project, it can be horrible. And you can't ignore this kind of thing — you must seriously consider every risk that might threaten your project. Will a prototype help in this case? Probably not. To mitigate this risk, you can lean on management to get a decision as fast as possible, or you could decide to make a game that could more easily be re-themed to the movie. You might even come up with a plan for making two different games — the key idea is that you consider the risk immediately and take action now to make sure it doesn't endanger your game.

Risk assessment and mitigation is such a useful perspective to take, it becomes Lens #14.

Lens #14: The Lens of Risk Mitigation

To use this lens, stop thinking positively, and start seriously considering the things that could go horribly wrong with your game.
 Ask yourself these questions:

- What could keep this game from being great?
- How can we stop that from happening?

 Risk management is hard. It means you have to face up to the problems you would most like to avoid, and solve them immediately. But if you discipline yourself to do it, you'll loop more times, and more usefully, and get a better game as a result. It is tempting to ignore potential problems and just work on the parts of your game you feel most confident about. You must resist this temptation and focus on the parts of your game that are in danger.

Eight Tips for Productive Prototyping

It is widely understood that rapid prototyping is crucial for quality game development. Here are some tips that will help you build the best, most useful prototypes for your game.

Prototyping Tip #1: Answer a Question

Every prototype should be designed to answer a question and sometimes more than one. You should be able to state the questions clearly. If you can't, your prototype is in real danger of becoming a time-wasting boondoggle, instead of the time-saving experiment it is supposed to be. Some sample questions a prototype might answer:

- How many animated characters can our technology support in a scene?
- Is our core gameplay fun? Does it stay fun for a long time?
- Do our characters and settings fit together well aesthetically?
- How large does a level of this game need to be?

Resist the temptation to overbuild your prototype, and focus only on making it answer the key question.

Prototyping Tip #2: Forget Quality

Game developers of every stripe have one thing in common: they are proud of their craft. Naturally, then, many find the idea of doing a "quick and dirty" prototype completely abhorrent. Artists will spend too much time on early concept sketches — programmers will spend too much time on good software engineering for a piece of throwaway code. When working on a prototype all that matters is whether it answers the question. The faster it can do that, the better — even if it just barely works and looks rough around the edges. In fact, polishing your prototype may even make things worse. Playtesters (and colleagues) are more likely to point out problems with something that looks rough than with something that looks polished. Since your goal is to find problems immediately so you can solve them early, a polished prototype can actually defeat your purpose by hiding real problems, thus lulling you into a false sense of security.

There is no getting around the Rule of the Loop. The faster you build the prototype that answers your question, the better, despite how ugly it may look.

Prototyping Tip #3: Don't Get Attached

In *The Mythical Man Month*, Fred Brooks made the famous statement "Plan to throw one away — you will anyway." By this he means that whether you like it or not, the first version of your system is not going to be a finished product, but really a prototype that you will need to discard before you build the system the "right" way. But in truth, you may throw away many prototypes. Less experienced developers often have a hard time doing this — it makes them feel like they have failed. You need to enter the prototyping work with the mindset that it is all temporary — all that matters is answering the question. Look at each prototype as a learning opportunity — as practice for when you build the "real" system. Of course, you won't throw out everything — you'll keep little pieces here and there that really work and you'll combine them to make something greater. This can be painful. As designer Nicole Epps once put it, "You must learn how to cut up your babies."

Prototyping Tip #4: Prioritize Your Prototypes

When you make your list of risks, you might realize that you need several prototypes to mitigate all the risks that you face. The right thing to do is to prioritize them, so that you face the biggest risks first. You should also consider dependence — if the results of one prototype have the potential to make the other prototypes meaningless, the "upstream" prototype is definitely your highest priority.

Prototyping Tip #5: Parallelize Prototypes Productively

One great way to get more loops in is to do more than one at a time. While the system engineers work on prototypes to answer technology questions, the artists can work on art prototypes, and the game scripters can work on gameplay prototypes. Having lots of small, independent prototypes can help you answer more questions faster.

Prototyping Tip #6: It Doesn't Have to be Digital

Your goal is to loop as usefully and as frequently as possible. So, if you can manage it, why not just get the software out of the way? If you are clever, you can prototype your fancy videogame idea as a simple board game, or what we sometimes call a **paper prototype**. Why do this? Because you can make board games *fast,* and often capture the same gameplay. This lets you spot problems sooner — much of the process of prototyping is about looking for problems, and figuring out how to fix them, so paper prototyping can be a real time saver. If your game is turn-based to start with, this becomes easy. The turn-based combat system for Toontown Online was prototyped through a simple board game, which let us carefully balance the many types of attacks and combos. We would keep track of hit points on paper or on a whiteboard, and play again and again, adding and subtracting rules until the game seemed balanced enough to try coding up.

Even real-time games can be played as paper prototypes. Sometimes they can be converted to a turn-based mode that still manages to capture the gameplay. Other times, you can just play them in real-time, or nearly. The best way to do it is to have other people help you. We'll consider two examples.

Tetris: A Paper Prototype

Let's say you wanted to make a paper prototype of *Tetris*. You could cut out little cardboard pieces, and put them in a pile. Get someone else to draw them at random, and start sliding them down the "board" (a sketch you've drawn on a piece of paper), while you grab them, and try to rotate them into place. To complete a line, you have to just use your imagination, or pause the game while you cut the pieces with an X-acto knife. This would not be the perfect Tetris experience, but it might be close enough for you to start to see if you had the right kinds of shapes, and also enough to give you some sense of how fast the pieces should drop. And you could get the whole thing going in about 15 minutes.

Doom: A Paper Prototype

Would it be possible to make a paper prototype of a first person shooter? Sure! You need different people to play the different AI characters as well as different players. Draw out the map on a big piece of graph paper, and get little game pieces to represent the different players and monsters. You need one person to control each

of the players and one for each of the monsters. You could then either make some turn-based rules about how to move and shoot, or get yourself a metronome! It is easy to find free metronome software online. Configure your metronome to tick once every five seconds, and make a rule that you can move one square of graph paper with every tick. When there is a line of sight, you can take a shot at another player or monster, but only one shot per tick. This will give the feeling of playing the whole thing in slow motion, but that can be a good thing, because it gives you time to think about what is working and not working while you are playing the game. You can get a great sense of how big your map should be, the shapes of hallways and rooms that make for an interesting game, the properties your weapons should have, and many other things — and you can do it all lightning fast!

Prototyping Tip #7: Pick a "Fast Loop" Game Engine

The traditional method of software development is kind of like baking bread:

1. Write code
2. Compile and link
3. Run your game
4. Navigate through your game to the part you want to test
5. Test it out
6. Go back to step 1

If you don't like the bread (your test results), there is no choice but to start the whole process over again. It takes way too long, especially for a large game. By choosing an engine with the right kind of scripting system, you can make changes to your code while the game is running. This makes things more like working with clay — you can change them continuously:

1. Run your game
2. Navigate through your game to the part you want to test
3. Test it out
4. Write code
5. Go back to step 3

By recoding your system while it is running, you can get in more loops per day, and the quality of your game goes up commensurately. I have used Scheme, Smalltalk, and Python for this in the past (I'm a big fan of Panda3D: www.panda3d.com), but any late-binding language will do the job. If you are afraid that these kinds of languages run too slowly, remember that it is okay to write your games with more

than one kind of code: write the low-level stuff that doesn't need to change much in something fast but static (Assembly, C++, etc.), and write the high-level stuff in something slower but dynamic. This may take some technical work to pull off, but it is worth it because it lets you take advantage of the Rule of the Loop.

Prototyping Tip #8: Build the Toy First

Back in Chapter 3, we distinguished between toys and games. Toys are fun to play with for their own sake. In contrast, games have goals and are a much richer experience based around problem solving. We should never forget, though, that many games are built on top of toys. A ball is a toy, but baseball is a game. A little avatar that runs and jumps is a toy, but Donkey Kong is a game. You should make sure that your toy is fun to play with before you design a game around it. You might find that once you actually build your toy, you are surprised by what makes it fun, and whole new ideas for games might become apparent to you.

Game designer David Jones says that when designing the game *Lemmings*, his team followed exactly this method. They thought it would be fun to make a little world with lots of little creatures walking around doing different things. They weren't sure what the game would be, but the world sounded fun, so they built it. Once they could actually play with the "toy," they started talking seriously about what kinds of games could be built around it. Jones tells a similar story about the development of *Grand Theft Auto*: "Grand Theft Auto was not designed as Grand Theft Auto. It was designed as a medium. It was designed to be a living, breathing city that was fun to play." Once the "medium" was developed, and the team could see that it was a fun toy, they had to decide what game to build with it. They realized the city was like a maze, so they borrowed maze game mechanics from something they knew was good. Jones explains: "GTA came from Pac-Man. The dots are the little people. There's me in my little, yellow car. And the ghosts are policemen."

By building the toy first, and then coming up with the game, you can radically increase the quality of your game, because it will be fun on two levels. Further, if the gameplay you create is based on the parts of the toy that are the most fun, the two levels will be supporting each other in the strongest way possible. Game designers often forget to consider the toy perspective. To help us remember, we'll make it Lens #15.

Lens #15: The Lens of the Toy

To use this lens, stop thinking about whether your game is fun to play, and start thinking about whether it is fun to play *with*.

Ask yourself these questions:

- If my game had no goal, would it be fun at all? If not, how can I change that?
- When people see my game, do they want to start interacting with it, even before they know what to do? If not, how can I change that?

There are two ways to use the Lens of the Toy. One way is to use it on an existing game, to figure out how to add more toy-like qualities to it — that is, how to make it more approachable, and more fun to manipulate. But the second way, the braver way, is to use it to invent and create new toys before you even have any idea what games will be played with them. This is risky if you are on a schedule — but if you are not, it can be a great "divining rod" to help you find wonderful games you might not have discovered otherwise.

Closing the Loop

Once you have built your prototypes, all that remains is to test them, and then based on what you have learned, start the whole process over again. Recall the informal process we discussed earlier:

The Informal Loop:

1. Think of an idea.
2. Try it out.
3. Keep changing it and testing it until it seems good enough.

Which we have now made a bit more formal:

The Formal Loop:

1. State the problem.
2. Brainstorm some possible solutions.
3. Choose a solution.
4. List the risks of using that solution.
5. Build prototypes to mitigate the risks.
6. Test the prototypes. If they are good enough, stop.
7. State the new problems you are trying to solve, and go to step 2.

With each round of prototyping, you will find yourself stating the problems in more detail. To give an example, let's say you are given the task of creating a racing

game — but there has to be something new and interesting about it. Here is a summary of how a few loops of that process might play out.

Loop 1: "New Racing Game"

- Problem Statement: Come up with a new kind of racing game
- Solution: Underwater submarine races (with torpedoes!)
- Risks:
 - Not sure what underwater racetracks should look like
 - This might not feel innovative enough
 - Technology might not be able to handle all the water effects
- Prototypes:
 - Artists working on concept sketches of underwater racetracks
 - Designers prototyping (using paper prototypes and by hacking an existing racecar game) novel new effects (subs that can also rise out of water and fly, tracking missiles, depth charges, racing through a minefield)
 - Programmers testing out simple water effects
- Results:
 - Underwater racetracks look okay if there is a "glowing path" in the water. Underwater tunnels will be cool! So will flying submarines following tracks that go in and out of the water!
 - Early prototypes seem fun, provided the submarines are very fast and maneuverable. It will be necessary to make them be "racing subs." The mix of flying and swimming feels very novel. Subs should go faster when flying, so we will need to find a way to limit the amount of time they can spend in the air. The little playtesting we have done makes it clear this game must support networked multiplay.
 - Some water effects are easier than others. Splashes look good, so do underwater bubbles. Making the whole screen waver takes too much CPU, and is kind of distracting anyway.

Loop 2: "Racing Subs" Game

- New Problem Statement: Design a "racing sub" game, where subs can fly.
- Detailed problem statements:
 - Not sure what "racing subs" look like. We need to define the look of both subs and racetracks.

- ○ Need to find a way to balance the game, so that subs spend the right amount of time in and out of the water.
- ○ Need to figure how to support networked multiplay.
- • Risks:
 - ○ If the racing subs look "too cartoony" they might turn off older players. If they look too realistic, they might just seem silly with this kind of gameplay.
 - ○ Until we know how much time we are spending in and out of the water, it is impossible to design levels, or to do the artwork for the landscapes.
 - ○ The team has never done networked multiplay for a racing game. We aren't completely sure we can do it.
- • Prototypes:
 - ○ Artists will sketch different kinds of subs, in a number of different styles: cartoony, realistic, hyper-realistic, subs that are living creatures. The team will vote on them, and we will also informally survey members of our target audience.
 - ○ Programmers and designers will work together on a very crude prototype that lets them experiment with how much time should be spent in and out of the water, and different mechanics for managing that.
 - ○ Programmers will build a rough framework for networked multiplay that should handle all the kinds of messages this kind of game will need.
- • Results:
 - ○ Everyone loves the "dino-sub" designs. There is strong agreement between team members and potential audience members that "swimming dinosaurs" are the right look and feel for this game.
 - ○ After several experiments, it becomes clear that for most levels, 60% of time should be spent underwater, 20% in the air, and 20% near the surface, where players who grab the right powerups can fly above the water for a speed advantage.
 - ○ The early networked experiments show that mostly the racing is not a problem for multiplay, but if we can avoid using rapid-fire machine guns, multiplay will be a lot easier.

Loop 3: "Flying Dinos" Game

- • Problem Statement: Design a "flying dinos" game where dinosaurs race in and above the water.
- • Detailed Problem Statements:
 - ○ We need to figure out if we can schedule all the animation time needed for the dinosaurs.

○ We need to develop the "right" number of levels for this game.

○ We need to figure out all the powerups that will go into this game.

○ We need to determine all the weapons that this game should support (and avoid rapid-fire machine guns because of networking constraints).

Notice how the problem statements gradually evolved and got more specific with each loop. Also notice how ugly problems bubbled to the surface quickly: What if the team hadn't tried out all the different character designs so early? What if three levels of the game had already been designed and modeled before anyone noticed the problem of keeping players in the air for the right amount of time? What if the machine gun system had already been coded up, and the whole gameplay mechanic centered around it, before anyone realized it would break the networking code? These problems got addressed quickly because of so many early loops. It looks like just two complete loops, and the beginning of a third one, but because of the wise use of parallelism, there were really six design loops.

Also notice how the whole team was involved in important design decisions. There is no way that a lone designer could have done this — much of the design was informed by the technology and the aesthetics.

How Much is Enough?

You might wonder how many loops are needed before the game is done. This is a very hard question to answer, and it is what makes game development so difficult to schedule. The Rule of the Loop implies that one more loop will always make your game a little better. So, as the saying goes, the work is never finished — only abandoned. The important thing is to make sure you get enough loops in to produce a game you are proud of before you've used up the entire development budget.

So, when you stand there at the beginning of the first loop, is it possible to make an accurate estimate of when you will have a finished, high-quality game? No. It is simply not possible. Experienced designers, after a time, get better at guessing, but the large number of game titles that ship later than originally promised, or with lower quality than originally promised, is testament to the fact that there is just no way to know. Why is this? Because at the beginning of the first loop, you don't yet know what you are going to build! With each loop, though, you get a more solid idea of what the game will really be, and this allows for more accurate estimates.

Game designer Mark Cerny has described a system for game design and development that he calls "The Method." Not surprisingly, this features a system of iteration and risk mitigation. But The Method makes an interesting distinction between what Cerny calls "pre-production" and "production" (terms borrowed from Hollywood). He argues that you are in pre-production until you have finished two publishable levels of your game, complete with all necessary features. In other words, until you have two completely finished levels, you are still figuring out the fundamental

design of your game. Once you reach this magic point, you are now in production. This means that you know enough about what your game really is that you can safely schedule the rest of development. Cerny states that usually this point is generally reached when 30% of the necessary budget has been spent. So, if it costs you $1 million to get to this point, it will probably cost you another $2.3 million to actually complete the game. This is a great rule of thumb, and realistically, this might be the most accurate way to really plan the release date for a game. The problem with it is that you won't really know what the game will cost or when it will be complete until you have already spent 30% of what it will take to get there. In truth, this problem is unavoidable — The Method just guides you toward reaching a point of predictability as soon as is realistically possible.

The principles of iteration described here might sound special to game design, but they are not. Gradual, evolutionary development is the key to any kind of design.

Now that we have discussed how games should be made, let's consider who we are making them for.

CHAPTER EIGHT

The Game is Made
for a *Player*

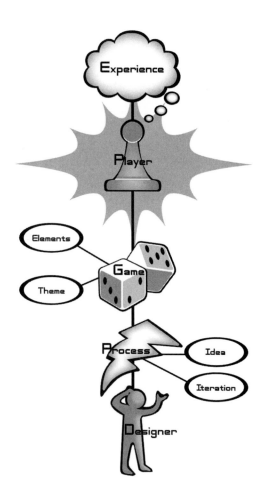

FIGURE
8.1

Einstein's Violin

At one point in his career, Albert Einstein was asked by a small local organization to be the guest of honor at a luncheon and to give a lecture about his research. He agreed to do so. The luncheon was quite pleasant, and when the time came, the host anxiously announced that Albert Einstein, the famous scientist, was here to talk about his theories of special and general relativity. Einstein took the stage, and looking out a largely non-academic audience consisting of mostly old ladies, he explained to them that he certainly could talk about his work, but it was a bit dull, and he was thinking perhaps instead the audience would prefer to hear him play the violin. The host and audience both agreed that it sounded like a fine idea. Einstein proceeded to play several pieces he knew well, creating a delightful experience the entire audience was able to enjoy, and surely one they remembered for the rest of their lives.

FIGURE
8.2

Einstein was able to create such a memorable experience because he *knew his audience.* As much as he loved thinking and talking about physics, he knew that it wasn't something that his audience would be really interested in. Sure, they asked him to talk about physics, because they thought it would be the best way to get what they really wanted — an intimate encounter with the famous Albert Einstein.

To create a great experience, you must do the same as Einstein. You must know what your audience will and will not like, and you must know it even better than they do. You would think that finding out what people want would be easy, but it isn't, because in many cases, they don't really know. They might think they know, but often there is a big difference between what they think they want, and what it is they will actually enjoy.

As with everything else in game design, the key here is a kind of listening. You must learn to listen to your players, thoroughly and deeply. You must become intimate with their thoughts, their emotions, their fears, and their desires. Some of these will be so secret that your players themselves are not even consciously aware of them — and as we discussed in Chapter 5, it is often these that are the most important.

Project Yourself

So, how can you do this kind of deep listening? One of the best ways is to use your power of empathy (discussed further in Chapter 9) to put yourself into their place. In 1954, when Disneyland Park was being constructed, Walt Disney would frequently walk around the park inspecting the progress. Often, he would be seen to walk for a distance, stop, and suddenly crouch to the ground, peering at something in the distance. Then he would get up, walk a few steps, and crouch again. After seeing him do this repeatedly, some of his designers asked what he was doing — was something wrong with his back? His explanation was simple: how else could he know what Disneyland would look like to children?

In retrospect, this seems obvious — things look different at different eye heights, and the perspective of children at Disneyland is just as important, if not more, than the perspective of adults. And physical perspective is not enough — you must adopt their mental perspective as well, actively projecting yourself into the mind of your player. You must actively try to become them, trying to see what they see, hear what they hear, and think what they think. It is very easy to get stuck in the high and mighty mind of the designer and forget to project yourself into the mind of the player — it is something that requires constant attention and vigilance, but you can do it if you try.

If you are creating a game for a target audience that you used to be part of (a woman creating a game for teen girls, for example), you have an advantage — you can get in touch with your memories about how you thought, what you liked, and how things felt when you were that age. People are surprisingly good at forgetting what things were really like when they were younger. As a designer, you can't afford to forget. Work hard to bring back your old memories, and make them vivid and strong again. Keep these old memories well oiled — they are some of your most valuable tools.

But what if you are making something for an audience that you have never been a part of, and perhaps never will be (a young man creating a game for middle-aged women, for example)? Then you must use a different tactic — you must think hard about people you have known who are in the target demographic, and imagine what it is like to be them. Like a cultural anthropologist, you should spend time with your target audience, talking with them, observing them, imagining what it is like to be them. Everyone has some innate power to do this — but if you practice it, you will improve. If you can mentally become any type of player, you can greatly expand the audience for your games, because your designs will be able to include people that other designers have ignored.

Demographics

We know that all individuals are each unique, but when creating something meant to be enjoyed by vast numbers of people, we have to consider ways that groups of

people are the same. We call these groups *demographics*, or sometimes *market segments*. There is no "official" means of establishing these groups — different professions have different reasons for grouping them differently. For game designers, the two most significant demographic variables are age and gender. We all play differently as we get older, and males and females play differently than one another at all ages. What follows is an analysis of some of the typical age demographics that a game designer has to consider.

FIGURE
8.3

- **0–3: Infant/Toddler.** Children in this age bracket are very interested in toys, but the complexity and problem solving involved in games is generally too much for them.
- **4–6: Preschooler.** This is the age where children generally show their first interest in games. The games are very simple, and played with parents more often than with one another, because the parents know how to bend the rules to keep the games enjoyable and interesting.

observed that healing other players was very appealing to girls and women we discussed the game with, and it was important to us that this game work equally well for males and females, so we made a bold decision. In most role-playing games, players mostly heal themselves, but have the option of healing others. In Toontown, *you cannot heal yourself* — only others. This increases the value of a player with healing skill and encourages nurturing play. A player who wants to can make healing their primary activity in Toontown.

4. **Dialog and Verbal Puzzles**. It is often said that what females lack in spatial skills they make up for in increased verbal skills. Women purchase many more books than men do, and the audience for crossword puzzles is mostly female. Very few modern videogames do much very interesting or meaningful with dialog or verbal puzzles at this point in time, and this may be an untapped opportunity.

5. **Learning by Example.** Just as males tend to eschew instructions, favoring a trial-and-error approach, females tend to prefer learning by example. They have a strong appreciation for clear tutorials that lead you carefully, step-by-step, so that when it is time to attempt a task, the player knows what she is supposed to do.

There are many other differences, of course. For example, males tend to be very focused on one task at a time, whereas females can more easily work on many parallel tasks, and not forget about any of them. Games that make use of this multitasking skill (the Sims, for example) can sometimes have a stronger female appeal. You must look closely at your game to determine its strengths and weaknesses on a gender basis. Sometimes this leads to fascinating discoveries. The designers of Hasbro's *Pox*, a wireless electronic handheld game, knew that their game was going to be an inherently social experience, and so they reasoned that it should have features that girls would like as well as boys. As they observed children playing in playgrounds, however, they noticed something very interesting: girls almost never play games spontaneously in large groups. There is no female equivalent of a pickup game of touch football. On the surface, this is strange — girls tend to be more social, so you might expect that games involving large gatherings would appeal to them more. The problem seems to lie in conflict resolution. When a group of boys play a game, and there is a dispute, play stops, there is a (sometimes heated) discussion, and the dispute is resolved. At times, this involves one boy going home in tears, but despite that, play continues. When a group of girls play a game, and there is a dispute, it is a different story. Most of the girls will take sides on the dispute, and it generally cannot be resolved right away. Play stops, and often cannot continue. Girls will play team sports when they are formally organized, but two informal competing teams puts too much stress on their personal relationships to be worth the trouble. The Hasbro designers realized that though their game concept was social, it was also inherently competitive, and ultimately they decided to design it for boys only.

The introduction of digital technology has done a great deal to make clear gender differences in gameplay. In the past, most games were very social, played in the real

world, with real people. The introduction of affordable computers gave us a type of game that:

- Had all social aspects removed
- Had most verbal and emotional aspects removed
- Was largely divorced from the real world
- Was generally hard to learn
- And offered the possibility for unlimited virtual destruction

It is hardly surprising that early computer and videogames were primarily popular with a male audience. As digital technology has evolved to the point that videogames can now support emotional character portrayals, richer stories, and the opportunity to play against real people while talking to them, the female audience for videogames has been commensurately growing. It will be interesting to see which upcoming technological and design advances attract even more female gamers.

Whether you consider age, gender, or other factors, the important thing is that you put yourself in the perspective of the player, so you can carefully consider what will make the game the most fun for them. This important perspective is Lens #16.

Lens #16: The Lens of the Player

To use this lens, stop thinking about your game, and start thinking about your player.

Ask yourself these questions about the people who will play your game:

- In general, what do they like?
- What don't they like? Why?
- What do they expect to see in a game?
- If I were in their place, what would I want to see in a game?
- What would they like or dislike about my game in particular?

A good game designer should always be thinking of the player, and should be an advocate for the player. Skilled designers hold The Lens of the Player and the Lens of Holographic Design in the same hand, thinking about the player, the experience of the game, and the mechanics of the game all at the same time. Thinking about the player is useful, but even more useful is watching them play your game. The more you observe them playing, the more easily you'll be able to predict what they are going to enjoy.

When developing *Pirates of the Caribbean: Battle for the Buccaneer Gold* for DisneyQuest, we had to consider a wide range of demographics. Many arcades and interactive location-based entertainment centers have a somewhat narrow demographic: teenage boys. DisneyQuest's goal was to support the same demographic as the Disney theme parks: pretty much everybody, particularly families. Further, DisneyQuest's goal is to get the whole family playing games together. With such a broad range of skill levels and interests within any given family, this was quite a challenge. But by carefully considering the interests of each potential player, we found a way to make it work. Roughly, we broke it down this way:

Boys: We had little worry that boys would enjoy playing this game. It is an exciting "adventure and battle fantasy" where players can pilot a pirate ship, and man powerful cannons. Early tests showed that boys enjoyed it a great deal, and tended to play offensively — trying to seek out and destroy every pirate ship they could find. They engaged in some communication, but always stayed very focused on the task of destroying the enemy as skillfully as possible.

Girls: We were not so confident that girls would like this game, since they don't usually have the same zeal for "blowing up bad guys." To our surprise, girls seemed to like the game a great deal, but they played it in a different way. Girls generally tended to play more defensively — they were more concerned about protecting their ship from invaders than chasing down other ships. When we became aware of this, we made sure to create a balance of invading ships and enemies that could be chased to support offensive as well as defensive play. The girls seemed very excited about the treasures you could gather, so we made sure to pile them up conspicuously on the deck and make them visually interesting. Further, we designed the final battle so that flying skeletons would charge the ship and snatch the treasures off of the deck. This made the skeleton shooting task much more important and rewarding to the girls. The girls also seemed to enjoy the social aspects of the game more than the boys did — they would constantly shout warnings and suggestions to each other, occasionally having face-to-face "huddles" where they would divide up responsibilities.

Men: We sometimes joked that men were just "tall boys with credit cards." They seemed to like the game in the same ways the boys did, although they tended to play the game in a slightly more reserved way — often carefully puzzling out the optimal way to play the game.

Women: We had very little confidence that women, mothers in particular, would find much to enjoy with this game. Mothers tend to have a different theme park experience than the rest of the family, because their main concern is not how much fun they personally have, but how much fun the rest of the family has. In early tests of Pirates, we noticed that women, and mothers in particular, tended to gravitate toward the back of the ship, while the rest of the family moved toward the front. This usually meant that the family members manned the cannons, and that mom steered the ship, since the ship's wheel was in the back. At first, this seemed a recipe for disaster — mom doesn't have much videogame experience, and a poorly steered ship has the potential to ruin the experience for everyone.

But this isn't what happened at all. Since mom wants to see everyone have a good time, she suddenly has a vested interest in steering the ship as well as possible. Being at the helm, which has the best view, she has a chance to keep an eye on everyone, to steer the ship to interesting places, and to slow things down if her family is overwhelmed. Further, she is in a good position to manage her crew, warning them of oncoming dangers, and giving orders ("Dylan! Give your sister a turn on that side!") designed to make sure everyone has fun. This was a great way to make mom really care about how the game turned out.

Accepting the fact that women would be steering the ship more often than boys, girls, or men meant that we had to be sure that steering the ship was easy for someone who was not a frequent videogame player, but this was a small price to pay to include a key part of our audience. Frequently, we would hear kids comment when coming off the ride: "Wow, Mom, you were really good at that!"

By paying close attention to the desires and behaviors of our various target demographics, we were able to balance the game to suit all of them. In the beginning, we just had ideas about where there might be problems making the game appeal to all four of these groups — it was only through attentive prototyping and playtesting that we started to realize the possible solutions to these problems. We watched closely to see how each demographic group tried to play our game, and then we changed it to support each group's style of play.

Psychographics

Of course, age and gender aren't the only ways to group potential players. There are many other factors you can use. Demographics generally refer to external factors (age, gender, income, ethnicity, etc.), and those can sometimes be a useful way to group your audience. But really, when we group people by these external factors, we are trying to get at something internal: what each group finds pleasurable. A more direct approach is to focus less on how players appear on the outside and more on how they think on the inside. This is called *psychographics*.

Some psychographic breakdowns have to do with "lifestyle" choices, such as "dog lover," "baseball fan," or "hardcore FPS player." These are easy to understand, since they are tied to concrete activities. If you are creating a game about dogs, baseball, or shooting people in tunnels, you will naturally want to pay close attention to the preferences of each of these lifestyle groups.

But other kinds of psychographics aren't so tied to concrete activities. They have more to do with what a person enjoys the most — the kind of pleasures they look for when participating in a game activity, or really, any activity. This is important, for ultimately, the motivation for every human action can be traced back to some kind of pleasure seeking. It is a tricky business, though, for there are many kinds of pleasures in the world, and no one seeks only one kind. But it is certainly true that people have their pleasure preferences. Game designer Marc LeBlanc has proposed a list of eight pleasures that he considers the primary "game pleasures."

LeBlanc's Taxonomy of Game Pleasures

1. **Sensation**. Pleasures of sensation involve using your senses. Seeing something beautiful, hearing music, touching silk, and smelling or tasting delicious food are all pleasures of sensation. It is primarily the aesthetics of your game that will deliver these pleasures. Greg Costikyan tells a story about sensation:

 As an example of the difference that mere sensation can make, consider the board game Axis & Allies. I first bought it when it was published by Nova Games, an obscure publisher of hobby games. It had an extremely garish board, and ugly cardboard counters to represent the military units. I played it once, thought it was pretty dumb, and put it away. Some years later, it was bought and republished by Milton Bradley, with an elegant new board, and with hundreds of plastic pieces in the shapes of aircraft, ships, tanks, and infantrymen — I've played it many times since. It's the sheer tactile joy of pushing around little military figures on the board that makes the game fun to play.

 Sensory pleasure is often the pleasure of the toy (see Lens #15). This pleasure cannot make a bad game into a good one, but it can often make a good game into a better one.

2. **Fantasy**. This is the pleasure of the imaginary world, and the pleasure of imagining yourself as something that you are not. We will discuss this pleasure further in Chapters 17 and 18.

3. **Narrative**. By the pleasure of narrative, LeBlanc does not necessarily mean the telling of a prescribed, linear story. He means instead a dramatic unfolding of a sequence of events, however it happens. We'll be talking more about this in Chapters 14 and 15.

4. **Challenge**. In some sense, challenge can be considered one of the core pleasures of gameplay, since every game, at its heart, has a problem to be solved. For some players, this pleasure is enough — but others need more.

5. **Fellowship**. Here, LeBlanc is referring to everything enjoyable about friendship, cooperation, and community. Without a doubt, for some players, this is the main attraction of playing games. We will discuss this further in Chapters 21 and 22.

6. **Discovery**. The pleasure of discovery is a broad one: any time you seek and find something new, that is a discovery. Sometimes this is the exploration of your game world, and sometimes it is the discovery of a secret feature or clever strategy. Without a doubt, discovering new things is a key game pleasure.

7. **Expression**. This is the pleasure of expressing yourself and the pleasure of creating things. In the past, this is a pleasure that was generally neglected in game design. Today, games allow players to design their own characters, and build and share their own levels. Often, the "expression" that takes place in a game does

little to achieve the goals of the game. Designing new outfits for your character doesn't help you advance in most games — but for some players, it may be the very reason they play.

8. **Submission**. This is the pleasure of entering the magic circle — of leaving the real world behind, and entering into a new, more enjoyable, set of rules and meaning. In a sense, all games involve the pleasure of submission, but some game worlds are simply more pleasing and interesting to enter than others. In some games, you are forced to suspend your disbelief — in others, the game itself seems to suspend your disbelief effortlessly, and your mind easily enters and stays in the game world. It is these games that make submission truly a pleasure.

It is useful to examine these different pleasures, because different individuals place different values on each one. Game designer Richard Bartle, who has spent many years designing MUDs and other online games, observes that players fall into four main groups in terms of their game pleasure preferences. Bartle's four types are easy to remember, because they have the suits of playing cards as a convenient mnemonic. It is left as an exercise to the reader to understand why each card suit was chosen to represent each category.

Bartle's Taxonomy of Player Types

1. ♦ **Achievers** want to achieve the goals of the game. Their primary pleasure is Challenge.

2. ♠ **Explorers** want to get to know the breadth of the game. Their primary pleasure is Discovery.

3. ♥ **Socializers** are interested in relationships with other people. They primarily seek the pleasures of Fellowship.

4. ♣ **Killers** are interested in competing with and defeating others. This category does not map well to LeBlanc's taxonomy. For the most part, it seems killers enjoy a mix of the pleasures of competition and destruction. Interestingly, Bartle characterizes them as primarily interested in "imposing themselves on others," and includes in this category people who are primarily interested in helping others.

Bartle also proposes a fascinating graph (Figure 8.4) that shows how the four types neatly cover a sort of space: that is, Achievers are interested in acting on the world, Explorers are interested in interacting with the world, Socializers are interested in interacting with players, and Killers are interested in acting on players.

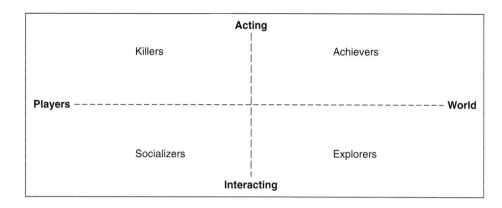

FIGURE
8.4

We must use caution when trying to make such simple taxonomies to describe something as complex as human desire. Under close scrutiny, both LeBlanc's and Bartle's taxonomies (and other similar lists) have gaps, and when misused can gloss over subtle pleasures that might easily be missed, such as "destruction" and "nurturing," which we encountered in our discussion of gender. Below is a list of a few more pleasures to be considered.

- **Anticipation**. When you know a pleasure is coming, just waiting for it is a kind of pleasure.

- **Delight in Another's Misfortune**. Typically, we feel this when some unjust person suddenly gets their comeuppance. It is an important aspect of competitive games. The Germans call it *schadenfreude* (pronounced shoddenfroyd).

- **Gift Giving**. There is a unique pleasure when you make someone else happy through the surprise of a gift. We wrap our presents to heighten and intensify this surprise. The pleasure is not just that the person is happy, but that *you* made them happy.

- **Humor**. Two unconnected things are suddenly united by a paradigm shift. It is hard to describe, but we all know it when it happens. Weirdly, it causes us to make a barking noise.

- **Possibility**. This is the pleasure of having many choices and knowing you could pick any one of them. This is often experienced when shopping or at a buffet table.

- **Pride in an Accomplishment**. This is a pleasure all its own that can persist long after the accomplishment was made. The Yiddish word *naches* (pronounced "nock-hess") is about this kind of pleased satisfaction, usually referring to pride in children or grandchildren.

- **Purification.** It feels good to make something clean. Many games take advantage of the pleasure of purification — any game where you have to "eat all the dots," "destroy all the bad guys," or otherwise "clear the level" is taking advantage of this pleasure.

- **Surprise.** As Lens #2: Surprise shows us, the brain likes surprises.

- **Thrill**. There is a saying among roller coaster designers that "fear minus death equals fun." Thrill is that kind of fun — you experience terror, but feel secure in your safety.

- **Triumph over Adversity**. This is that pleasure that you have accomplished something that you knew was a long shot. Typically this pleasure is accompanied by shouts of personal triumph. The Italians have a word for this pleasure: *fiero* (prounounced fee-air-o).

- **Wonder**. An overwhelming feeling of awe and amazement.

And there are many, many more. I list these pleasures that fall outside of easy classification to illustrate the richness of the pleasure space. Lists of pleasures can serve as convenient rules of thumb, but don't forget to keep an open mind for ones that might not be on your list. The crucial perspective of pleasure gives us Lens #17.

Lens #17: The Lens of Pleasure

To use this lens, think about the kinds of pleasure your game does and does not provide.

Ask yourself these questions:

- What pleasures does your game give to players? Can these be improved?
- What pleasures are missing from your experience? Why? Can they be added?

Ultimately, the job of a game is to give pleasure. By going through lists of known pleasures, and considering how well your game delivers each one, you may be inspired to make changes to your game that will increase your players' enjoyment. Always be on the lookout, though, for unique, unclassified pleasures not found in most games — for one of these might be what gives your game the unique quality it needs.

Knowing your players intimately, more intimately than they know themselves, is the key to giving them a game they will enjoy. In Chapter 9, we will get to know them even better.

The Experience is in the *Player's Mind*

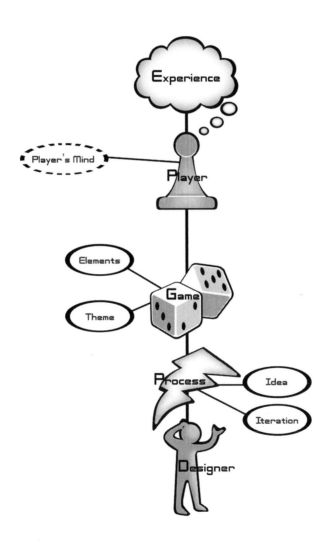

FIGURE
9.1

We have already discussed that ultimately, experiences are what a game designer creates. These experiences can only happen in one place — the human brain. Entertaining the human brain is hard because it is so complex — it is the most complex object in the known universe.

Even worse, most of its workings are hidden from us.

Until you got to this sentence, were you at all conscious of the position of your body, the rate of your breathing, or how your eyes were moving across the page? Do you even know how your eyes move across the page? Do they move smoothly and linearly, or do they take little hops? How could you have read books for so many years without being sure of the answer to that question? When you speak, do you really know what you are going to say before you say it? Incredibly, when you drive a car, somehow you observe the curvature of the roadway and translate that into a rotational angle by which you move the steering wheel. Who does that calculation? Can you even remember paying attention to the curvature of the roadway? And how does it happen that just because this sentence contains the words "imagine eating a hamburger with pickles" that your mouth is watering right now?

Consider this pattern:

FIGURE
9.2

Somehow, you know what comes next. How did you reach that conclusion? Was it through a process of deductive logic, or did you just "see" the answer? If you just saw it, what did you see? And who drew the picture that you saw?

Here's one more. Try this experiment: Find a friend, and ask them to do these three things:

1. Say the word "boast" five times. "Boast, boast, boast, boast, boast."

2. Spell the word "boast" out loud. "B-O-A-S-T."

3. Answer this question: "What do you put in a toaster?"

Your friend will likely give the answer "toast." Generally, toast is what you take out of a toaster, not what you put in. If you omit the first two steps, most people will give a more correct answer, like "bread." Priming the brain's networks with "boast" is enough make the word "toast" seem like a better candidate than the correct answer, "bread." We normally think of answering a question like "What do you put in a toaster?" as a very conscious event, but the truth is that the subconscious exerts terrific control over almost everything we say and do. Mostly it does that wisely and well, and we feel like "we" are doing it — but from time to time it makes a laughable mistake, and reveals how much control it truly has.

The majority of what is going on in our brains is hidden from the conscious mind. Psychologists are gradually making progress toward understanding these subconscious processes, but generally, we are in the dark as to how they really work. The workings of our mind are mostly outside our understanding, and mostly outside our control. But the mind is the place that game experiences happen, so we must do what we can to get a working knowledge of what seems to be going on in there. In Chapter 6 we talked about using the power of the creative subconscious to be a better designer. Now we must consider the interaction of the conscious and subconscious in the mind of the player. Everything that is known about the human mind would fill many encyclopedias — we will contain our examination of the mind to some of the key factors that relate to game design.

There are four principal mental abilities that make gameplay possible. These are modeling, focus, imagination, and empathy. We will consider each in turn, and then examine the secret priorities of every player's subconscious mind.

Modeling

Reality is amazingly complex. The only way our minds are able to get by at all is by simplifying reality so that we can make some sense of it. Correspondingly, our minds do not deal with reality itself, but instead with models of reality. Mostly we do not notice this — the modeling takes place below our awareness. Consciousness is an illusion that our internal experiences are reality, when in truth they are imperfect simulations of something we may never truly understand. The illusion is a very good one, but at times we run into places where our internal simulations fail. Some of these are visual, like this picture:

FIGURE
9.3

In reality, those dots are not changing color as our eyes move around, but our brain sure does make it look like they are.

Some examples don't become clear until you think about them a little bit, such as the visible light spectrum. From a physics point of view, visible light, infrared, ultraviolet, and microwaves are all the same kind of electromagnetic radiation, just at different wavelengths. Our eyes can only see a tiny fraction of this smooth spectrum, and we call this fraction visible light. It would be very useful if we could

see other kinds of light. Seeing infrared light, for example, would let us easily spot predators in the dark, since all living things emit infrared light. Unfortunately, the insides of our eyeballs emit infrared as well, so if we could see it, we would be quickly blinded by our own glow. As a result, a huge amount of useful data, that is, everything outside the visible light range of the electromagnetic spectrum, is not part of our perceived reality.

Even the visible light we can see is strangely filtered by our eyes and brains. Because of the construction of our eye, this spread of visible light wavelengths looks like it falls into distinct groupings, which we call colors. When we look at a rainbow that comes out of a prism, we can draw lines to separate one color from another. In truth, though, this is just an artifact of the mechanics of the retina. In reality, there is no sharp separation of colors, just a smooth gradient of wavelengths, even though our eyes tell us that blue and light blue are much more similar than say, light blue and green. We evolved this eye structure because breaking up the wavelengths into groups like this is a useful way to better understand the world. "Colors" are only an illusion, not part of reality at all, but a very useful model of reality.

Reality is full of aspects that aren't at all part of our day-to-day modeling. For example, our bodies, our homes, and our food are teeming with microscopic bacteria and mites. Many are single celled, but others, such as the *Demodex follicularum*, that lives in our eyelashes, pores, and hair follicles, are almost large enough (up to 0.4 mm) to be seen with the naked eye. These tiny creatures are everywhere around us, but are generally not part of our mental models at all, because mostly, we don't need to know about them.

FIGURE
9.4

One good way to get a grasp on some of our mental models is to look for things that feel natural to us until we think about them. Consider this picture of Charlie Brown. At first glance, nothing seems too unusual about him — he's just a boy. But upon reflection, he looks nothing like a real person. His head is nearly as big as his body! His fingers are little bumps! Most distressing of all, he is made of lines. Look around you — nothing is made of lines — everything is made of lumps. His unreality doesn't become apparent until we stop and consciously think about it, and this is a clue to how the brain models things.

Charlie Brown seems like a person even though he doesn't look like anyone we know because he matches some of our internal models. We accept his giant head because our minds store much more information about heads and faces than the rest of the body, since so much information about a person's feelings come from their face. If instead, he had a small head, and giant feet, he would immediately look ridiculous, because he wouldn't match our internal models at all.

And what about his lines? It is a challenging problem for the brain to look at a scene and pick out which objects are separate from each other. When it does, below our conscious level, our internal visual processing system draws lines around each separate object. Our conscious mind never sees these lines, but it does get a feeling about which things in a scene are separate objects. When we are presented with a picture already drawn with lines, it has been "pre-digested" in a sense, matching our internal modeling mechanisms perfectly, and saving them a lot of work. This is part of why people find cartoons and comics so soothing to look at — our brain needs to do less work to understand them.

Stage magicians amaze us by taking advantage of our mental models and then breaking them. In our mind, our models *are* reality, so we feel like we are seeing someone do the impossible. The audible gasp that comes from an audience at the culmination of a magic trick is the sound of their mental models being torn asunder. It is only through our faith that "it must be a trick" that we are able to reason that magicians don't have supernatural powers.

Our brains do a tremendous amount of work to boil down the complexity of reality into simpler mental models that can be easily stored, considered, and manipulated. And this is not just the case for visual objects. It is also the case for human relationships, risk and reward evaluation, and decision making. Our minds look at a complex situation and try to boil it down to a simple set of rules and relationships that we can manipulate internally.

As game designers, we care a lot about these mental models because games, with their simple rules, are like Charlie Brown — they are pre-digested models that we can easily absorb and manipulate. This is why they are relaxing to play — they are less work for our brain than the real world, because so much of the complexity has been stripped away. Abstract strategy games, like tic-tac-toe and backgammon, are almost completely bare models. Other games, like computer-based RPGs, take a simple model and coat it with some sugary aesthetics, so that the very act of working to digest the model is pleasurable. This is so different from the real world, where you have to work so hard to figure out what the rules of the game even are, and then work even harder to achieve them, never sure if you are doing the right thing. And this is why games can sometimes be great practice for the real world — it is why they still teach chess at West Point — games give us practice digesting and experimenting with simpler models, so we can work our way up to ones as complex as the real world, and be competent at dealing with them when we are ready.

The important thing to understand is that everything we experience and think about is a model — not reality. Reality is beyond our understanding and comprehension. All we can understand is our little model of reality. Sometimes this model

breaks, and we have to fix it. The reality we experience is just an illusion, but this illusion is the only reality we will ever know. As a designer, if you can understand and control how that illusion is formed in your player's mind, you will create experiences that feel as real, or more real, than reality itself.

Focus

One crucial technique our brains use to make sense of the world is the ability to focus its attention selectively, ignoring some things, and devoting more mental power to others. The brain's ability to do this can be startling. One example is the "cocktail party effect," which is our remarkable ability to pay attention to a single conversation when a roomful of people are all talking at once. Even though the sound waves from many conversations are hitting our ears simultaneously, we somehow have the ability to "tune in" one, and "tune out" the others. To study this, psychologists have performed what are sometimes called "dichotic ear studies." In these experiments, subjects wear headphones that deliver different audio experiences to each ear. For example, a voice in a subject's left ear might be reading Shakespeare, and the voice in a subject's right ear might be reading a stream of numbers. Provided the voices are not too similar, subjects who are asked to focus on one of the voices, and repeat back what they are hearing as they hear it, are generally able to do so. Afterwards, when asked questions about what the other voice was saying, subjects generally have no idea. Their brains focused only on selected information and tuned out the rest.

What we focus on at any given moment is determined through a blend of our unconscious desires and our conscious will. When we create games, our goal is to create an experience interesting enough that it holds the player's focus as long and as intensely as possible. When something captures our complete attention and imagination for a long period, we enter an interesting mental state. The rest of the world seems to fall away, and we have no intrusive thoughts. All we are thinking about is what we are doing, and we completely lose track of time. This state of sustained focus, pleasure, and enjoyment is referred to as "flow," and has been the subject of extensive study by psychologist Mihaly Csikszentmihalyi and many others. Flow is sometimes defined as "a feeling of complete and energized focus in an activity, with a high level of enjoyment and fulfillment." It pays for game designers to make a careful study of flow, because this is exactly the feeling we want the players of our games to enjoy. Some of the key components necessary to create an activity that puts a player into a flow state are

- **Clear goals**. When our goals are clear, we are able to more easily stay focused on our task. When goals are unclear, we are not "into" our task, for we aren't at all certain whether our current actions are useful.
- **No distractions**. Distractions steal focus from our task. No focus, no flow.

- **Direct feedback**. If every time we take an action, we have to wait before we know what effect the action caused, we will quickly become distracted and lose focus on our task. When feedback is immediate, we can easily stay focused.

- **Continuously challenging**. Human beings love a challenge. But it must be a challenge we think we can achieve. If we start to think we can't achieve it, we feel frustrated, and our minds start seeking an activity more likely to be rewarding. On the other hand, if the challenge is too easy, we feel bored, and again, our minds start seeking more rewarding activities.

Flow activities must manage to stay in the narrow margin of challenge that lies between boredom and frustration, for both of these unpleasant extremes cause our mind to change its focus to a new activity. Csikszentmihalyi calls this margin the "flow channel." He gives an example of the flow channel, using, not surprisingly, a game.

> Let us assume that the figure below represents a specific activity — for example, the game of tennis. The two theoretically most important dimensions of the experience, challenges and skills, are represented on the two axes of the diagram. The letter A represents Alex, a boy who is learning to play tennis. The diagram shows Alex at four different points in time. When he first starts playing (A_1), Alex has practically no skills, and the only challenge he faces is hitting the ball over the net. This is not a very difficult feat, but Alex is likely to enjoy it because the difficulty is just right for his rudimentary skills. So at this point he will probably be in flow. But he cannot stay there long. After a while, if he keeps practicing, his skills are bound to improve, and then he will grow bored just batting the ball over the net (A_2). Or it might happen that he meets a more practiced opponent, in which case he will realize that there are much harder challenges for him than just lobbing the ball — at that point, he will feel some anxiety (A_3) concerning his poor performance.

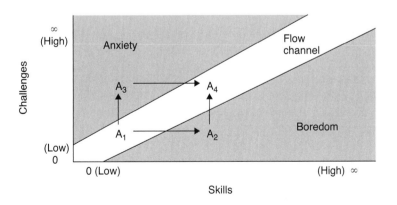

FIGURE
9.5

119

Neither boredom nor anxiety are positive experiences, so Alex will be motivated to return to the flow state. How is he to do it? Glancing again at the diagram, we see that if he is bored (A_2) and wishes to be in flow again, Alex has essentially only one choice: to increase the challenges he is facing. (He also has a second choice, which is to give up tennis altogether — in which case A would simply disappear from the diagram.) By setting himself a new and more difficult goal that matches his skills — for instance, to beat an opponent just a little more advanced that he is — Alex would be back in flow (A_4).

If Alex is anxious (A_3), the way back to flow requires that he increase his skills. Theoretically he could also reduce the challenges he is facing, and thus return to the flow where he started (in A_1), but in practice it is difficult to ignore challenges once one is aware that they exist.

The diagram shows that both A_1 and A_4 represent situations in which Alex is in flow. Although both are equally enjoyable, the two states are quite different in that A_4 is a more complex experience than A_1. It is more complex because it involves greater challenges, and demands greater skill from the player.

But A_4, although complex and enjoyable, does not represent a stable situation either. As Alex keeps playing, either he will become bored by the stale opportunities he finds at that level, or he will become anxious and frustrated by his relatively low ability. So the motivation to enjoy himself again will push him to get back into the flow channel, but now at a level of complexity even higher than A_4.

It is this dynamic feature that explains why flow activities lead to growth and discovery. Once cannot enjoy doing the same thing at the same level for long. We grow either bored or frustrated; and then the desire to enjoy ourselves again pushes us to stretch our skills, or to discover new opportunities for using them.

You can see how keeping someone in the flow channel is a delicate balance, for a player's skill level seldom stays in one place. As their skill increases, you must present them with commensurate challenges. For traditional games, this challenge primarily comes from seeking out more challenging opponents. In videogames, there is often a sequence of levels that gradually get more challenging. This pattern of levels of increasing difficulty is nicely self-balancing — players with a lot of skill can usually move through the lower levels quickly, until they come to the levels that challenge them. This connection between skill and the speed of finishing a level helps keep skilled players from getting bored. However, it is the rare player who is persistent enough to win the game, mastering all levels. Most players eventually reach a level where they spend so much time in the frustration zone that they give up on the game. There is much debate about whether that is a bad thing (many players are frustrated) or a good thing (since only skilled, persistent players can reach the end, the accomplishment is special).

Many designers are quick to point out that while staying in the flow channel is important, some ways of moving up the channel are better than others. Moving straight up the channel, like this…

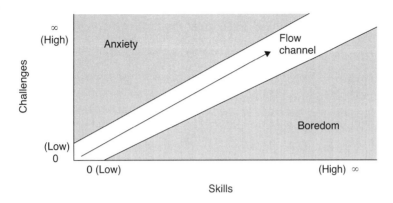

FIGURE
9.6

…is definitely better than the game ending in anxiety or boredom. But consider the play experience that follows a track more like this:

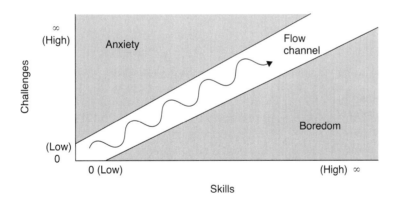

FIGURE
9.7

This will probably feel much more interesting to a player. It is a repeating cycle of increasing challenge, followed by a reward, often of more power, which gives an easier period of less challenge. Soon enough, the challenge ramps up again. For example, a videogame might feature a gun that lets me destroy enemies if I shoot them three times. As I proceed through the game, the enemies grow more numerous, increasing the challenge. If I rise to the challenge, though, and defeat enough enemies, I might be rewarded with a gun that lets me destroy the enemies with only two shots. Suddenly the game is easier, which is very rewarding. This easy period

121

doesn't last though, because soon new enemies that take three and even four shots to destroy, even with my new gun, will start to appear, taking the challenge to new heights.

This cycle of "tense and release, tense and release" comes up again and again in design. It seems to be inherent to human enjoyment. Too much tension, and we wear out. Too much relaxation, and we grow bored. When we fluctuate between the two, we enjoy both excitement and relaxation, and this oscillation also provides both the pleasure of variety, and the pleasure of anticipation.

You can see how useful the idea of flow and the flow channel can be for discussing and analyzing a gameplay experience — so useful that it is Lens #18.

Lens #18: The Lens of Flow

To use this lens, consider what is holding your player's focus.
Ask yourself these questions:

- Does my game have clear goals? If not, how can I fix that?

- Are the goals of the player the same goals I intended?

- Are there parts of the game that distract players to the point they forget their goal? If so, can these distractions be reduced, or tied into the game goals?

- Does my game provide a steady stream of not-too-easy, not-too-hard challenges, taking into account the fact that the player's skills may be gradually improving?

- Are the player's skills improving at the rate I had hoped? If not, how can I change that?

Flow is a very hard thing to test for. You won't see it in ten minutes of gameplay. You must observe players for longer periods. Even trickier, a game that keeps someone in flow the first few times they play it may later become boring or frustrating.

When observing a player, flow can be easy to miss — you must learn to recognize it. It is not always accompanied by external expressions of emotion — it often involves quiet withdrawal. Players in flow playing solo games will often be quiet, possibly muttering to themselves. They are so focused that they are sometimes slow to respond or irritated if you ask them questions. Players in flow during multiplayer games will sometimes communicate with one another enthusiastically, constantly focused on the game. Once you notice a player going into flow during your game, you need to watch them closely — they won't stay there forever. You must watch for that crucial moment — the event that moves them out of the flow channel, so

you can figure how to make sure that event doesn't happen in your next prototype of the game.

One final note: don't forget to turn the Lens of Flow on yourself! You will surely find that times of flow are when you get the most done as a designer — make sure to organize your design time so you can get to that special state of mind as frequently as possible.

Empathy

As human beings, we have an amazing ability to project ourselves into the place of others. When we do this, we think the other person's thoughts and feel their feelings, to the best of our ability. It is one of the hallmarks of our ability to understand one another that we can do this, and it is an integral part of gameplay.

There is an interesting theater exercise where a group of actors is divided into two groups. In the first group, each actor chooses an emotion (happiness, sadness, anger, etc.), and then they all mill about the stage, each trying to project their chosen emotion through attitude, walk, and facial expression. The second group does not choose an emotion. They just walk about at random among the first group, trying to establish eye contact with others. The first time they try this, the actors in the second group discover themselves doing something shocking — whenever they make eye contact with someone projecting an emotion, they take on the emotion themselves, and make the corresponding facial expression, without consciously willing to do so.

This is how strong our power of empathy can be. Without even trying, we become other people. When we see someone who is happy, we can feel their joy as if it is our own. When we see someone who is sad, we can feel their pain. Entertainers use our power of empathy to make us feel we are part of the storyworld they are creating. Amazingly, our empathy can be cast from one person to another in the blink of an eye. We can even empathize with animals.

Have you noticed that dogs have much richer facial expression than other animals? They express emotion with their eyes and eyebrows much like we do (Figure 9.8). Wolves (dog ancestors) don't have nearly the range of facial expression of domesticated dogs. Dogs appear to have evolved this ability as a survival skill. Dogs that could make the right faces could capture our empathy, and we, suddenly feeling their feelings, became more likely to take care of them.

Of course, the brain does all this using mental models — in truth, we are empathizing not with real people or animals, but with our mental models of them — which means we are easily tricked. We can feel emotion when there is none. A photo, a drawing, or a videogame character can just as easily capture our empathy. Cinematographers understand this, and they fling our empathy all over the place, from one character to another, thus manipulating our feelings and emotions. Next time you watch television, pay attention, moment to moment, about where your empathy is going, and why it is going there.

FIGURE
9.8

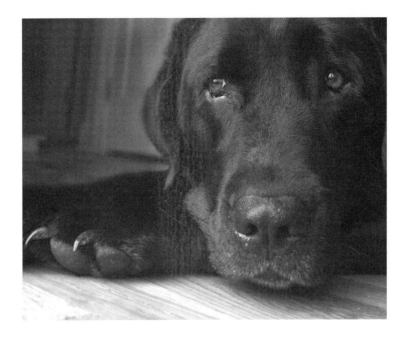

As game designers, we will make use of empathy in the same ways that novelists, graphic artists, and filmmakers do, but we also have our own set of new empathic interactions. Games are about problem solving, and empathic projection is a useful method of problem solving. If I can imagine myself in the place of another, I can make better decisions about what that person can do to solve a particular problem. Also, in games, you don't just project your feelings into a character, you project your entire decision-making capacity into that character, and can become them in a way that isn't possible in non-interactive media. We will discuss the implications of this in detail in Chapter 18.

Imagination

Imagination puts the player into the game by putting the game into the player (Figure 9.9).

You might think, when I talk about the power of the player's imagination, that I might mean their creative imagination, and the power to make up dreamlike fantasy worlds — but I am talking about something much more mundane. The imagination I'm talking about is the miraculous power that everyone takes for granted — the everyday imagination that every person uses for communication and problem solving. For example, if I tell you a short story: "The mailman stole my car yesterday," I have actually told you very little, but already you have a picture of what happened.

FIGURE
9.9

Weirdly, your picture is full of details that I didn't include in my story. Take a look at the mental image that formed, and answer these questions:

- What did the mailman look like?
- What kind of neighborhood was my car in when he stole it?
- What color was the car?
- What time of day did he steal it?
- How did he steal it?
- Why did he steal it?

Now, I didn't tell you any of those things, but your amazing imagination just made up a bunch of these details so that you could more easily think about what I was telling you. Now, if I suddenly give you more information, like, "It wasn't a real car, but an expensive model toy car," you quickly reformulate your imaginary image to fit what you have heard, and your answers to the above questions might change correspondingly. This ability to automatically fill in gaps is very relevant for game design, for it means that our games don't need to give every detail, and players will be able to fill in the rest. The art comes in knowing what you should show the player, and what you should leave to their imagination.

This power, when you think about it, is quite incredible. The fact that our brains only deal in simplified models of reality means that we can manipulate these models effortlessly, sometimes into situations that wouldn't be possible in reality. I can see an armchair and imagine what it would look like if it were a different color, a different size, if it was made of oatmeal, or if it was walking around. We do a lot of problem solving this way. If I ask you to find a way to change a light bulb without a stepladder, you immediately start imagining possible solutions.

Imagination has two crucial functions: the first is communication (often for storytelling), and the second is problem solving. Since games prominently feature both of these, game designers must understand how to engage the player's imagination as a storytelling partner, as well as having a sense of the problems it will and will not be able to solve.

Motivation

We have now examined four of the key mental abilities that make gameplaying possible: modeling, focus, empathy, and imagination. Let's now consider why the brain is motivated to use any of these at all.

In 1943, psychologist Abraham Maslow wrote a paper titled "A Theory of Human Motivation," which proposed a hierarchy of human needs. This is often presented as a pyramid:

FIGURE
9.10

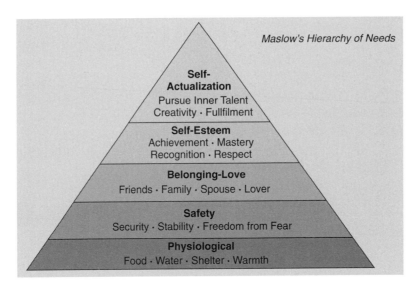

The idea here is that people are not motivated to pursue the higher level needs on this list until the lower needs are satisfied. For example, if someone is starving to death, this is a priority over a feeling of safety. If someone doesn't feel safe, they aren't going to seriously pursue human relationships. If someone doesn't feel love and social belonging, they aren't going to pursue things that will boost their self-esteem. And if they don't have good self-esteem, they will not be able to pursue their talents (remember the major gift?) to do what they were "born to do."

If you think hard, you can come up with some possible exceptions to this model, but overall, it works well enough to be a very useful tool for discussing player's

motivations in games. It is interesting to think about different game activities, and where they fall on this hierarchy. Many game activities are about achievement and mastery, which places them at level four, self-esteem. But some are lower. Looking at the hierarchy, the reasons for the appeal and staying power of multiplayer games suddenly becomes clear — they fulfill more basic needs than single player gameplay, so it shouldn't be surprising that many players will feel more motivated to do them.

Can you think of gameplay activities that go even farther down on the hierarchy, to the second or first levels? How about activities on the fifth level?

Any game that connects you with other people, lets you feel a sense of accomplishment, and lets you build and create things that let you express yourself fulfills needs on the third, fourth, and fifth levels. Viewed from this perspective, the popularity and staying power of games with both online communities and content creation tools makes a lot of sense. It is also interesting to consider how the different levels can feed into one another.

This needs-based perspective on game design is Lens #19.

Lens #19: The Lens of Needs

To use this lens, stop thinking about your game, and start thinking about what basic human needs it fulfills.

Ask yourself these questions:

- On which levels of Maslow's hierarchy is my game operating?
- How can I make my game fulfill more basic needs than it already is?
- On the levels my game is currently operating, how can it fulfill those needs even better?

It sounds strange to talk about a game fulfilling basic human needs, but everything that people do is an attempt to fulfill these needs in some way. And keep in mind, some games fulfill needs better than others — your game can't just promise the need, it must deliver fulfillment of the need. If a player imagines that playing your game is going to make them feel better about themselves, or get to know their friends better, and your game doesn't deliver on these needs, your player will move on to a game that does.

Judgment

The fourth level of Maslow's hierarchy, self-esteem, is the one most intimately connected to games. But why? One deep need common to everyone is the need to be

judged. This might sound wrong — don't people hate being judged? They don't — they only hate being judged unfairly. We have a deep inner need to know how we stack up. And when we aren't happy with how we are judged, we work hard until we are judged favorably. The fact that games are excellent systems for objective judgment is one of their most appealing qualities.

Lens #20: The Lens of Judgment

To decide if your game is a good judge of the players, ask yourself these questions:

- What does your game judge about the players?
- How does it communicate this judgment?
- Do players feel the judgment is fair?
- Do they care about the judgment?
- Does the judgment make them want to improve?

The human mind is truly the most fascinating, amazing, complex thing that we know. We may never unravel all of its mysteries. The more we know about it, the better a chance we'll have of creating a great experience in it, for it is the site where all our game experiences take place. And never forget! You are equipped with one yourself. You can use your own powers of modeling, focus, empathy, and imagination to get to know how these powers are being used in the mind of your player. In this way, self-listening can be the key to listening to your audience.

Some Elements are Game *Mechanics*

FIGURE
10.1

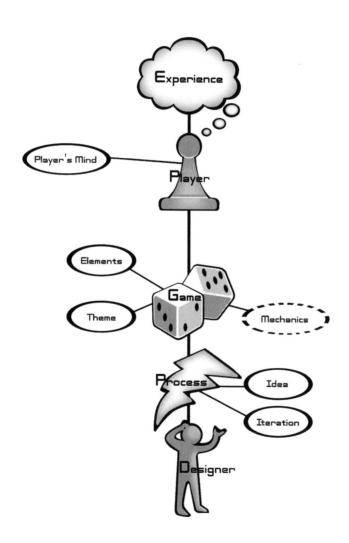

We have talked a lot about designers, players, and the experience of game playing. It is time to talk nuts and bolts about what games are really made of. Game designers must learn to use their X-ray vision to be able to see past the skin of a game and quickly discern the skeleton, which is defined by the game mechanics.

But what are these mysterious mechanics?

Game mechanics are the core of what a game truly is. They are the interactions and relationships that remain when all of the aesthetics, technology, and story are stripped away.

As with many things in game design, we do not have a universally agreed upon taxonomy of game mechanics. One reason for this is that the mechanics of gameplay, even for simple games, tend to be quite complex, and very difficult to disentangle. Attempts at simplifying these complex mechanics to the point of perfect mathematical understanding result in systems of description that are obviously incomplete. Economic "game theory," is an example of this. You would think with a name like "game theory," it would be of great use to game designers, but in truth, it can only handle such simple systems that it is seldom useful for designing real games.

But there is another reason that taxonomies of game mechanics are incomplete. On one level, game mechanics are very objective, clearly stated sets of rules. On another level, though, they involve something more mysterious. Earlier, we discussed how the mind breaks down all games into mental models that it can easily manipulate. Part of game mechanics necessarily involves describing the structure of these mental models. Since these exist largely in the darkness of the subconscious mind, it is hard for us come up with a well-defined analytical taxonomy of how they work.

But that doesn't mean we shouldn't try. Some authors have approached this problem from a very academic perspective, more concerned with an analysis that is philosophically watertight than with one that might be useful to designers. We can't afford this kind of pedantry. Knowledge for the sake of knowledge is a fine thing, but our interest is in knowledge for the sake of great games, even if it means a taxonomy that has some gray areas. With that said, I present the taxonomy that I use to classify game mechanics. These mechanics fall largely into six main categories, and each one can provide useful insights on your game design.

Mechanic 1: Space

Every game takes place in some kind of **space**. This space is the "magic circle" of gameplay. It defines the various places that can exist in a game, and how those places are related to one another. As a game mechanic, space is a mathematical construct. We need to strip away all visuals, all aesthetics, and simply look at the abstract construction of a game's space.

There are no hard and fast rules for describing these abstract, stripped-down game spaces. Generally, though, game spaces:

1. Are either discrete or continuous
2. Have some number of dimensions
3. Have bounded areas which may or may not be connected

The game of tic-tac-toe, for example, features a board that is discrete, and two-dimensional. What do we mean by "discrete"? Well, even though we commonly draw a tic-tac-toe board like this:

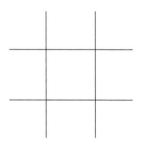

FIGURE
10.2

It is not really a continuous space, because we only care about boundaries, not the space within each cell. Whether you put your X...

FIGURE
10.3

FIGURE
10.4

FIGURE
10.5

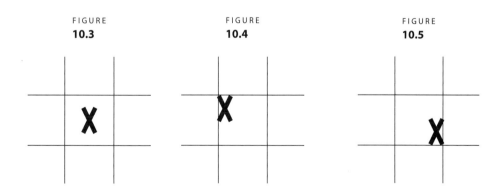

It doesn't really matter — all those are equivalent in terms of the game. But if you put your X here:

FIGURE

10.6

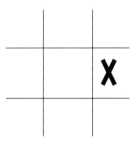

That is another matter entirely. So, even though the players can make their marks in an infinite number of places in a continuous two-dimensional space, there are really only nine discrete places that have any actual meaning in the game. In a sense, we really have nine zero-dimensional cells, connected to each other in a two-dimensional grid, like this:

FIGURE

10.7

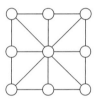

Each circle represents a zero-dimensional place, and each line shows which places are connected to each other. In tic-tac-toe, there is no movement from place to place, but adjacency is very important. Without adjacency, it would just be nine disconnected points. With the adjacency, it becomes a discrete two-dimensional space, with clear boundaries — the space is three cells wide and three cells high. The space for a chessboard is similar, except that it is an 8 × 8 space.

A game with fancy aesthetics can fool you into thinking that its functional space is more complex than it really is. Consider a Monopoly board.

At first glance, you might say it is a discrete two-dimensional space, like a chessboard, with most of the middle cells missing. But it can be more simply represented as one-dimensional space — a single line of forty discrete points, which connects to itself in a loop. Sure, on the game board, the corner spaces look special because they are bigger, but functionally that doesn't matter, since each game square is a zero-dimensional space. Multiple game pieces can be in a single game square, but their relative positions within that square are meaningless.

But not all game spaces are discrete. A pool table is an example of a continuous two-dimensional space. It has a fixed length and width, and the balls can freely move about on the table, ricocheting off of the walls, or falling into the holes, which are in fixed positions. Everyone would agree that the space is continuous, but is it two-dimensional? Since clever players can sometimes cause the balls to leave the table and hop over each other, you could certainly argue that this is really a three-dimensional game space, and for some purposes, it is useful to think of it that way. There are no hard and fast rules for these abstract functional spaces. When designing a new game, there are times it will be useful for you to think of your space as two-dimensional, and times when thinking of it as three-dimensional is more useful. The same goes for continuous vs. discrete. The purpose of stripping down a game into a functional space is so that you can more easily think about it, without the distractions of aesthetics or the real world. If you are thinking about modifying the game of soccer to a playingfield with new boundaries, you will probably think about it in terms of a two-dimensional continuous space.

FIGURE
10.8

Old New!

But if you are thinking about modifying the height of the goal, or changing the rules about how high the players can kick the ball, or adding hills and valleys to the field, it is useful to think of it as a continuous three-dimensional space instead.

FIGURE
10.9

There might even be times you think about a soccer field as a discrete space — breaking it up into, say, nine major areas of play, with two extra areas on the left

133

and right representing the goals. This mode of thinking might prove useful if you are analyzing the different kinds of play that take place in different parts of the field, for example. The important thing is that you come up with abstract models of your game space that help you better understand the interrelationships of your game.

Nested Spaces

FIGURE
10.10

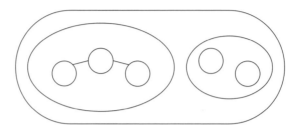

Many game spaces are more complex than the examples we have looked at here. Often they feature "spaces within spaces." Computer-based fantasy role-playing games are a good example of this. Most of them feature an "outdoor space" that is continuous and two-dimensional. A player traveling this space sometimes encounters little icons representing towns, or caves, or castles. Players can enter these as completely separate spaces, not really connected in any way to the "outdoor space" but through the gateway icon. This is not geographically realistic, of course — but it matches our mental models of how we think about spaces — when we are indoors we think about the space inside the building we are in, with little thought to how it exactly relates to the space outside. For this reason, these "spaces within spaces" are often a great way to create a simple representation of a complex world.

Zero Dimensions

Does every game take place in a space? Consider a game like "Twenty Questions," where one player thinks of an object, and the other player asks "yes or no" questions trying to guess what it is. There is no game board and nothing moves — the game is just two people talking. You might argue that this game has no space. On the other hand, you might find it useful to think of the game happening in a space that looks like Figure 10.11.

The mind of the answerer contains the secret object. The mind of the questioner is where all the weighing of the previous answers is going on, and the conversation space between them is how they exchange information. Every game has some kind

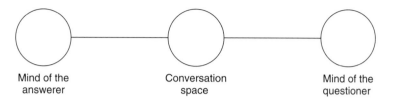

FIGURE
10.11

of information or "state" (as we'll see later in Mechanic 2), and this has to exist somewhere. So, even if a game takes place in a single point of zero dimensions, it can be useful to think of it as a space. You may find that figuring out an abstract model for a game whose space seems to be trivial may lead you to insights about it that surprise you.

Being able to think about the space of your game in functional abstract terms is an essential perspective for a designer, and it is Lens #21.

Lens #21: The Lens of Functional Space

To use this lens, think about the space in which your game really takes place when all surface elements are stripped away.

Ask yourself these questions:

- Is the space of this game discrete or continuous?

- How many dimensions does it have?

- What are the boundaries of the space?

- Are there sub-spaces? How are they connected?

- Is there more than one useful way to abstractly model the space of this game?

When thinking about game spaces, it is easy to be swayed by aesthetics. There are many ways to represent your game space, and they are all good, as long as they work for you. When you can think of your space in these pure abstract terms, it helps you let go of assumptions about the real world, and it lets you focus on the kinds of gameplay interactions you would like to see. Of course, once you have manipulated the abstract space so that you are happy with its layout, you will want to apply aesthetics to it. The Lens of Functional Space works quite well with Lens #8: The Lens of Holographic Design. If you can simultaneously see your abstract functional space and the aesthetic space the player will experience, as well as how they interrelate, you can make confident decisions about the shape of your game's world.

135

Mechanic 2: Objects, Attributes, and States

A space without anything in it is, well, just a space. Your game space will surely have **objects** in it. Characters, props, tokens, scoreboards, anything that can be seen or manipulated in your game falls into this category. Objects are the "nouns" of game mechanics. Technically, there are times you might consider the space itself an object, but usually the space of your game is different enough from other objects that it stands apart. Objects generally have one or more **attributes**, one of which is often the current position in the game space.

Attributes are categories of information about an object. For example, in a racing game, a car might have maximum speed and current speed as attributes. Each attribute has a current **state**. The state of the "maximum speed" attribute might be 150 mph, while the state of the "current speed" attribute might be 75 mph if that is how fast the car is going. Maximum speed is not a state that will change much, unless perhaps you upgrade the engine in your car. Current speed, on the other hand, changes constantly as you play.

If objects are the nouns of game mechanics, attributes and their states are the adjectives.

Attributes can be static (such as the color of a checker), never changing throughout the game, or dynamic (the checker has a "movement mode" attribute with three possible states: "normal," "king," and "captured"). Primarily, we are interested in dynamic attributes.

Two more examples:

1. In chess, the king has a "movement mode" attribute with three important states ("free to move," "in check," and "checkmated.")

2. In Monopoly, each property on the board can be considered an object with a dynamic "number of houses" attribute with six states (0, 1, 2, 3, 4, hotel), and a "mortgaged" attribute with two states (yes, no).

Is it important to communicate every state change to the player? Not necessarily. Some state changes are better hidden. But for others, it is crucial to be sure they are communicated to the player. A good rule of thumb is that if two objects behave the same way, they should look the same. If they behave differently, they should look different.

Videogame objects, especially ones that simulate intelligent characters, have so many attributes and states that it is easy for a designer to get confused. It is often useful to construct a state diagram for each attribute to make sure you understand which states are connected to which, and what triggers state changes. In terms of game programming, implementing the state of an attribute as a "state machine" can be a very useful way to keep all this complexity tidy and easy to debug. Figure 10.12 is a sample state diagram for the "movement" attribute of the ghosts in *Pac Man*.

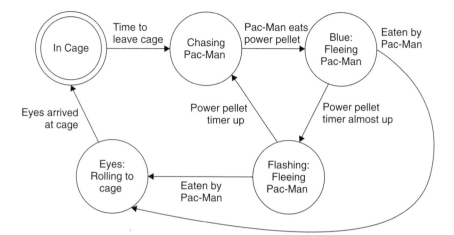

FIGURE
10.12

The circle that reads "In Cage" is the initial state for the ghosts (double circle is often used to indicate the start state). Each of the arrows indicates a possible state transition, with an event that triggers that transition. Diagrams like this are very useful when trying to design complex behaviors in a game. They force you to really think through everything that can happen to an object, and what makes it happen. By implementing these state transitions in computer code, you automatically forbid illegal transitions (such as "In Cage" → "Blue"), which helps cut down on puzzling bugs. These diagrams can get quite complicated and are sometimes nested. For example, it is quite likely that the real Pac-Man algorithm actually has several sub-states in "Chasing Pac Man," such as "Scanning for Pac Man," "On Pac Man's Tail," "Moving through a Tunnel," etc.

Deciding which objects have what attributes and what states is up to you. There are often multiple ways to represent the same thing. In a game of poker, for example, you could define a player's hand as an area of the gamespace that has five card objects in it, or you could decide you don't want to think of cards as objects, and just call the player's hand an object that has five different card attributes. As with everything in game design, the "right" way to think about something is whichever way is most useful at the moment.

Secrets

A very important decision about game attributes and their states is who is aware of which ones. In many board games, all information is public; that is, everyone knows it. In a game of chess, both players can see every piece on the board, and every piece that has been captured — there are no secrets, except what the other

player is thinking. In card games, hidden or private state is a big part of the game. You know what cards you hold, but which ones your opponents hold is a mystery for you to puzzle out. The game of poker, for example, is largely about trying to guess what cards your opponents have while attempting to conceal information about what cards you might have. Games become dramatically different when you change what information is public or private. In standard "draw poker," all states are private — players can only guess your hand based on how much you bet. In "stud poker," some of your cards are private and some are public. This gives opponents much more information about each other's situations, and the game feels very different. Board games such as Battleship and Stratego are all about guessing the states of your opponent's private attributes.

In videogames, we face something new: a state that only the game itself knows about. This raises a question about whether virtual opponents, from a game mechanics standpoint, should be thought of as players, or just part of the game. This is well illustrated by a story: In 1980, my grandfather bought an Intellivision game console, which came with a "Las Vegas Poker and Blackjack" game cartridge. He had great fun with it, but my grandmother refused to play. "It cheats," she insisted. I told her that was silly — it was just a computer — how could it cheat? She explained her reasoning: "It knows what all my cards are, and all the cards in the deck! How can it *not* cheat?" And I had to admit that my explanation that the computer "doesn't look at those" when it is making decisions about playing the game sounded kind of weak. But it brings out the point that there were really three entities in that game who knew the states of different attributes: my grandfather, who was aware of the state of his hand; the virtual opponent algorithm, that was "aware" of the state of its hand; and lastly, the main algorithm for the game, which was aware of both players' hands, every card in the deck, and everything else about the game.

So, it seems that from a public/private attribute point of view, it makes sense to consider virtual opponents as individual entities on par with players. The game itself, though, is yet another entity, with a special status, since it isn't really playing the game, although it may be making decisions that enable the game to happen. Celia Pearce points out another kind of information, which is private from all of the entities we have mentioned so far: randomly generated information, such as a die roll. Depending on your views about predestination, you might argue that this information doesn't even exist until it is generated and revealed, so that referring to it as private is a little silly. But it does fit well into a Venn diagram I call the "hierarchy of knowers," which helps to visualize the relationship between the public and private states:

Each circle in Figure 10.13 represents a "knower." The "knowers" are God, the Game, and Players 1, 2, and 3. Each point represents some information in the game — the state of an attribute.

- **A** is information that is completely public, such as the position playing piece on a game board, or a face-up card. All the players are aware of it.

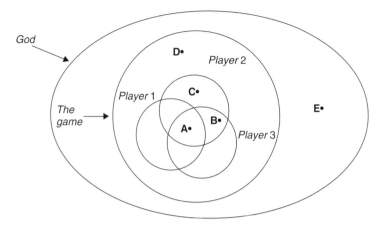

FIGURE
10.13

- **B** is the state that is shared between players 2 and 3, but kept secret from player 1. Perhaps 2 and 3 each had the opportunity to look at a face-down card, but player 1 didn't. Or maybe players 2 and 3 are virtual opponents of player 1, and their algorithm has them sharing information so they can team up against player 1.

- **C** is information private to a single player, in this case, player 2. It could be cards he was dealt, for example.

- **D** is information that the game knows about, but not the players themselves. There are some mechanical board games where this kind of state exists in the physical structure of the board game, but is unknown to the players. *Stay Alive* was a classic example, with plastic sliders that when moved, revealed holes in the board. *Touché* is another interesting example, where magnets of unknown polarity are placed under each square of the board. The states are "known" by the game, but not by the players. Another example is tabletop role-playing games, which feature a "dungeon master," or "game master," who is not one of the players, and who privately knows a great deal of the game state, since he is the operational mechanism of the game, so to speak. Most computer games have a great deal of internal state that is not known to the players.

- **E** is randomly generated information, known only by the Fates, God, etc.

Games that force the players to be aware of too many states (too many game pieces, too many statistics about each character) to play can confuse and overwhelm. In Chapter 11 we'll discuss techniques for optimizing the amount of state the players have to deal with.

Thinking of your game strictly as a set of objects and attributes with changing states can give a very useful perspective, and it serves as Lens #22.

Lens #22: The Lens of Dynamic State

To use this lens, think about what information changes during your game, and who is aware of it. Ask yourself these questions:

- What are the objects in my game?
- What are the attributes of the objects?
- What are the possible states for each attribute? What triggers the state changes for each attribute?
- What state is known by the game only?
- What state is known by all players?
- What state is known by some, or only one player?
- Would changing who knows what state improve my game in some way?

Game playing is decision making. Decisions are made based on information. Deciding the different attributes, their states, and who knows about them is core to the mechanics of your game. Small changes to who knows what information can radically change a game, sometimes for the better, sometimes for the worse. Who knows about what attributes can even change over the course of a game — a great way to create drama in your game is to make an important piece of private information suddenly become public.

Mechanic 3: Actions

The next important game mechanic is the **action**. Actions are the "verbs" of game mechanics. There are two perspectives on actions, or put another way, two ways to answer the question "What can the players do?"

The first kind of actions are the **operative actions**. These are simply the base actions a player can take. For example, in checkers a player can perform only three basic operations:

1. Move a checker forward
2. Jump an opponent's checker
3. Move a checker backwards (kings only)

The second kind of actions are **resultant actions**. These are actions that are only meaningful in the larger picture of the game — they have to do with how the player is using operative actions to achieve a goal. The list of resultant actions is

generally longer than the list of operative actions. Consider the possible resultant actions in checkers:

- Protect a checker from being captured by moving another checker behind it
- Force an opponent into making an unwanted jump
- Sacrifice a checker to trick his opponent
- Build a "bridge" to protect his back row
- Move a checker into the "king row" to make it a king
- ...and many others

The resultant actions often involve subtle interactions within the game, and are often very strategic moves. These actions are mostly not part of the rules, per se, but rather actions and strategies that emerge naturally as the game is played. Most game designers agree that interesting emergent actions are the hallmark of a good game. Consequently, the ratio of meaningful resultant actions to operative actions is a good measure of how much emergent behavior your game features. It is an elegant game indeed that allows a player a small number of operative actions, but a large number of resultant actions. It should be noted that this is a somewhat subjective measure, since the number of "meaningful" resultant actions is a matter of opinion.

Trying to create "emergent gameplay," that is, interesting resultant actions, has been likened to tending a garden, since what emerges has a life of its own, but at the same time, it is fragile and easily destroyed. When you notice some interesting resultant actions showing up in your game, you must be able to recognize them, and then do what you can to nurture them and give them a chance to flourish. But what makes these things spring up in the first place? It is not just luck — there are things you can do to increase the chances of interesting resultant actions appearing. Here are five tips for preparing the soil of your game and planting seeds of emergence.

1. **Add more verbs**. That is, add more operative actions. The resultant actions appear when operative actions interact with each other, with objects, and with the game space. When you add more operative actions, there are more opportunities for interaction, and thus emergence. A game where you can run, jump, shoot, buy, sell, drive, and build is going to have a lot more potential for emergence than a game where you can just run and jump. Be careful, though — adding too many operative actions, especially ones that don't interact with each other well, can lead to a game that is bloated, confusing, and inelegant. Keep in mind that the ratio of resultant actions to operative actions is more important than the sheer number of operative actions. It is usually better to add one good operative action than a slew of mediocre ones.

2. **Verbs that can act on many objects**. This is possibly the single most power-ful thing you can do to make an elegant, interesting game. If you give a player a gun that can only shoot bad guys, you have a very simple game. But if that same gun can also be used to shoot a lock off a door, break a window, hunt for food, pop a car tire, or write messages on the wall, you now start to enter a world of many possibilities. You still only have one operative action: "shoot," but by increasing the number of things you can usefully shoot at, the number of meaningful resultant actions increases as well.

3. **Goals that can be achieved more than one way**. It's great to let players do all kinds of different things in your game, giving them lots of verbs, and verbs with lots of objects. But if the goals can only be achieved one way, players have no reason to look for unusual interactions and interesting strategies. To follow up with the "shoot" example, if you let players shoot all kinds of things, but the goal of your game is just "shoot the boss monster," the players will only do that. On the other hand, if you can shoot the monster, or shoot out a support chain so a chandelier could crash down on him, or maybe even not shoot him at all, but stop him through some non-violent means, you will have rich, dynamic game-play, where lots of things are possible. The challenge with this approach is that the game becomes hard to balance, for if one of the options is always signifi-cantly easier than the others (a dominant strategy), players will always pursue that option. We will discuss that further in Chapter 11.

4. **Many subjects.** If checkers involved just one red checker and one black one, but had the same rules, the game would not be interesting at all. It is because the players have many different pieces they can move, pieces which can interact with one another, coordinating and sacrificing, that the game becomes interest-ing. This method obviously doesn't work for all games, but it can work in some surprising places. The number of resultant actions seems to have roughly a mag-nitude of subjects times verbs times objects, so adding more subjects is very likely to increase the number of resultant actions.

5. **Side effects that change constraints**. If, every time you take an action, it has side effects that change the constraints on you or your opponent, very interesting gameplay is likely to result. Let us again look to checkers. Every time you move a piece, you not only change the squares that you threaten with capture, but you simultaneously change which squares your opponent (and you) can move into. In a sense, every move changes the very nature of the game space, whether or not you intended it to. Think how different checkers would be if multiple pieces could peacefully cohabitate on a single square. By forcing multiple aspects of the game to change with every operative action, you are very likely to cause interesting resultant actions to suddenly appear.

Lens #23: The Lens of Emergence

To make sure your game has interesting qualities of emergence, ask yourself these questions:

- How many verbs do my players have?
- How many objects can each verb act on?
- How many ways can players achieve their goals?
- How many subjects do the players control?
- How do side effects change constraints?

When comparing games with books and films, one of the most striking differences is the number of verbs. Games usually limit players to a very narrow range of potential actions, while in stories the number of possible actions that characters can engage in seems nearly limitless. This is a natural side effect of the fact that in games, the actions and all their effects must be simulated on the fly, while in stories it is all worked out ahead of time. In Chapter 16 we will discuss how this "action gap" can be bridged in the mind of the player, so that you can give the feeling of limitless possibilities while keeping the number of operational actions at a manageable limit.

The reason so many games seem similar to one another is because they use the same set of actions. Look at the games that are considered "derivative," and you will see that they have the same set of actions as older games. Look at games that people call "innovative," and you will find that they give the players new kinds of actions, either operational or resultant. When *Donkey Kong* first appeared, it seemed very different because it was about running and jumping, which was new at the time. *Harvest Moon* was a game about farming. *Katamari Damacy* was about rolling a sticky ball. The actions a player can take are so crucial to defining a game's mechanics that changing a single action can give you a completely different game.

Some designers dream of games where any verb the player can think of is a possible action, and this is a beautiful dream. Some massively multiplayer games are starting to move in that direction, offering a wide range of verbs for combat, crafting, and social interaction. In a way, this is a return to the past — in the 1970s and 1980s, text adventures were very popular typically featuring dozens or hundreds of possible verbs. Only with the rise of more visual games did the number of verbs suddenly decrease, because it was not feasible to support all those actions in a visual-based game. The demise (or hibernation?) of the text adventure genre is usually attributed to the public's hunger for fancy visuals — but perhaps, from an action perspective, there is another explanation. Modern 3D videogames give you a very limited range of operative actions. The player generally knows every action

they can possibly attempt. In text adventures, the complete set of operative actions was unclear, and discovering them was part of the game. Very often, the solution to a tricky puzzle was thinking to type an unusual verb, like "spin the fish" or "tickle the monkey." While this was all very creative, it was also often frustrating — for every one of the hundreds of verbs a game supported, there were thousands it did not. As a result, players did not really have the "complete freedom" that text adventure interfaces pretended to give them. It is possible that this frustration, more than anything else, caused text adventures to fall from favor.

Your choice of actions significantly defines your game structure, so let's make that Lens #24.

Lens #24: The Lens of Action

To use this lens, think about what your players can do and what they can't, and why.

Ask yourself these questions:

- What are the operative actions in my game?
- What are the resultant actions?
- What resultant actions would I like to see? How can I change my game in order to make those possible?
- Am I happy with the ratio of resultant to operative actions?
- What actions do players wish they could do in my game that they cannot? Can I somehow enable these, either as operative or resultant actions?

A game without actions is like a sentence without verbs — nothing happens. Deciding the actions in your game will be the most fundamental decision you can make as a game designer. Tiny changes to these actions will have tremendous ripple effects with the possibility of either creating marvelous emergent gameplay or making a game that is predictable and tedious. Choose your actions carefully, and learn to listen to your game and your players to learn what is made possible by your choices.

Mechanic 4: Rules

The **rules** are really the most fundamental mechanic. They define the space, the objects, the actions, the consequences of the actions, the constraints on the actions, and the goals. In other words, they make possible all the mechanics we have seen so far and add the crucial thing that makes a game a game — goals.

Parlett's Rule Analysis

David Parlett, game historian, did a very good job of analyzing the different kinds of rules that are involved with gameplay, as shown in this diagram.

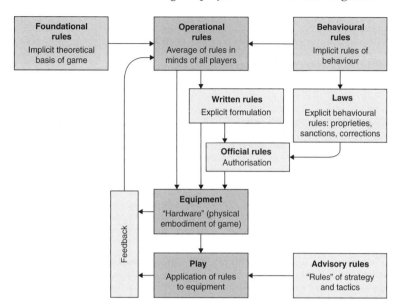

FIGURE
10.14

This shows the relationships between all the kinds of rules we are likely to encounter, so let's consider each.

1. **Operational Rules**: These are the easiest to understand. These are basically, "What the players do to play the game." When players understand the operational rules, they can play a game.

2. **Foundational Rules**: The foundational rules are the underlying formal structure of the game. The operational rules might say "The player should roll a six-sided die, and collect that many power chips." The foundational rules would be more abstract: "The player's power value is increased by a random number from 1 to 6." Foundational rules are a mathematical representation of game state and how and when it changes. Boards, dice, chips, health meters, etc., are all just operational ways of keeping track of the foundational game state. As Parlett's diagram shows, foundational rules inform operational rules. There is not yet any standard notation for representing these rules, and there is some question about whether a complete notation is even possible. In real life, game designers learn to see the foundational rules on an as-needed basis, but seldom do they have any need to formally document the entire set of foundational rules in a completely abstract way.

3. **Behavioral Rules**: These are rules that are implicit to gameplay, which most people naturally understand as part of "good sportsmanship." For example,

145

during a game of chess, one should not tickle the other player while they are trying to think, or take five hours to make a move. These are seldom stated explicitly — mostly, everyone knows them. The fact that they exist underlines the point that a game is a kind of social contract between players. These, too, inform the operational rules. Steven Sniderman has written an excellent essay about behavioral rules called "Unwritten Rules."

4. **Written Rules**: These are the "rules that come with the game," the document that players have to read to gain an understanding of the operational rules. Of course, in reality, only a small number of people read this document — most people learn a game by having someone else explain how to play. Why? It is very hard to encode the non-linear intricacies of how to play a game into a document, and similarly hard to decode such a document. Modern videogames have gradually been doing away with written rules in favor of having the game itself teach players how to play through interactive tutorials. This hands-on approach is far more effective, though it can be challenging and time-consuming to design and implement as it involves many iterations that cannot be completed until the game is in its final state. Every game designer must have a ready answer to the question: "How will players learn to play my game?" Because if someone can't figure out your game, they will not play it.

5. **Laws**: These only form when games are played in serious, competitive settings, where the stakes are high enough that a need is felt to explicitly record the rules of good sportsmanship, or where there is need to clarify or modify the official written rules. These are often called "tournament rules," since during a serious tournament is when there is the most need for this kind of official clarification. Consider these tournament rules for playing *Tekken 5* (a fighting game) at the *2005 Penny Arcade Expo*:

- Single Elimination
- You may bring your own controller
- Standard VS Mode
- 100% Health
- Random stage select
- 60 second timer
- Best 3 of 5 rounds
- Best 2 of 3 games
- Mokujin is banned

Most of these are just clarifying exactly which game settings will be used in the tournament. "You may bring your own controller" is a formalized decision about what is "fair play." The most interesting rule here is "Mokujin is banned." Mokujin is one of the characters you can choose to play in *Tekken 5*. The general feeling

among players is that Mokujin's "stun" move is so powerful that any player who chooses to play Mokujin is likely to win the game, making a tournament pointless. So this "law" is an attempt to improve the game, ensuring the tournament is balanced, fair, and fun.

6. **Official Rules**: These are created when a game is played seriously enough that a group of players feels a need to merge the written rules with the laws. Over time, these official rules later become the written rules. In chess, when a player makes a move that puts the opponent's king in danger of checkmate, that player is obligated to warn the opponent by saying "check." At one time, this was a "law," not a written rule, but now it is part of the "official rules."

7. **Advisory Rules**: Often called "rules of strategy," these are just tips to help you play better, and not really "rules" at all from a game mechanics standpoint.

8. **House Rules**: These rules are not explicitly described by Parlett, but he does point out that as players play a game, they may find they want to tune the operational rules to make the game more fun. This is the "feedback" on his diagram, since house rules are usually created by players in response to a deficiency perceived after a few rounds of play.

Modes

Many games have very different rules during different parts of play. The rules often change completely from mode to mode, almost like completely separate games. One memorable instance was the racing game *Pitstop*. Most of the time it was a typical racing game, but with a twist — if you didn't pull over to change your tires periodically, they would burst. When you did pull over, the game changed completely — now you were not racing your car, but rather racing to change your tires, with a completely different game interface. When your game changes modes in a dramatic way like this, it is very important that you let your players know which mode you are in. Too many modes and the players can get confused. Very often, there is one main mode, with several sub-modes, which is a good hierarchical way to organize the different modes. Game designer Sid Meier proposes an excellent rule of thumb: players should never spend so much time in a sub-game that they forget what they were doing in the main game.

The Enforcer

One of the most significant differences between videogames and more traditional games is how the rules are enforced. In traditional games, rules are primarily enforced by the players themselves or by an impartial referee in high stakes games, such as sporting events. With computer games, it becomes possible (and sometimes necessary) for the computer to enforce the rules. This is more than a convenience — it allows for the creation of games much more complex than was traditionally possible, because now the players don't have to memorize all the rules about what is and is

not possible — they just try things in the game, and see what works and what doesn't work — they don't have to memorize it all, or look it up. In a sense, what used to be a "rule" now becomes a physical constraint of the game world. If a piece isn't allowed to move a certain way, it simply doesn't move that way. Many of the game rules are enforced by the design of the space, the objects, and the actions. A game like *Warcraft* could conceivably be a board game, but there would be so many rules to remember and state to keep track of that it would quickly become a dreary experience. By offloading the dull work of rules enforcement onto the computer, games can reach depths of complexity, subtlety, and richness that are not possible any other way. But proceed with caution — if the rules of your videogame are so complex that a player can't even form a rough idea of how the game works, they will be overwhelmed and confused. You must make the rules of a complex videogame something that players can discover and understand naturally — not something they have to memorize.

The Most Important Rule

Games have a lot of rules — how to move and what you can and cannot do — but there is one rule at the foundation of all the others: The Object of the Game. Games are about achieving goals — you must be able to state your game's goal, and state it clearly. Often, there is not just one goal in a game, but a sequence of them — you will need to state each, and how they relate to one another. A clumsy statement of your game's goal can be off-putting to players right from the beginning — if they don't completely understand the purpose of their actions, they cannot proceed with any certainty. Newcomers to chess are often stymied when someone awkwardly tries to explain the object of the game: "Your goal is to put the other king in checkmate… that means you move your pieces so he can't move without being in check… which, uh, means that one of your pieces could potentially capture him, except that, um, it's against the rules to capture the king." As a boy, I often wondered why a game considered to be so elegant could have such an inelegant goal. I played the game for years before I realized that the goal of chess is actually quite simple: "Capture your opponent's king." All the folderol about check and checkmate is simply there to politely warn your opponent that they are in imminent danger. It is remarkable how more interested a potential chess player becomes when you tell them that simple four-word goal. The same is true for any game you create — the more easily players understand the goal, the more easily they can visualize achieving it, and the more likely they are going to want to play your game.

Good game goals have three important qualities, they are

1. **Concrete**. Players understand and can clearly state what they are supposed to achieve.

2. **Achievable**. Players need to think that they have a chance of achieving the goal. If it seems impossible to them, they will quickly give up.

3. **Rewarding**. A lot goes into making an achieved goal rewarding. If the goal has the right level of challenge, just achieving it at all is a reward in itself. But why not go further? You can make your goal even more rewarding by giving the player something valuable upon reaching the goal — use the Lens of Pleasure to find different ways to reward the player, and really make them proud of their achievement. And while it is important to reward players that achieve a goal, it is equally (or more) important that players appreciate that the goal is rewarding *before* they have achieved it, so that they are inspired to attempt to achieve it. Don't overinflate their expectations, though, for if they are disappointed with the reward for achieving a goal, they will not play again!

And while it is important that each of the goals in your game have these qualities, it is also important that you have a good balance of goals in your game, with some short-term, and some much longer term. This balance of goals will make your players feel they know what to do immediately and that ultimately they will achieve something important and magnificent.

It is easy to focus so much on the action of a game that you forget about the goals. To help us remember the importance of goals, let's add this lens to our toolbox.

Lens #25: The Lens of Goals

To ensure the goals of your game are appropriate and well-balanced, ask yourself these questions:

- What is the ultimate goal of my game?
- Is that goal clear to players?
- If there is a series of goals, do the players understand that?
- Are the different goals related to each other in a meaningful way?
- Are my goals concrete, achievable, and rewarding?
- Do I have a good balance of short- and long-term goals?
- Do players have a chance to decide on their own goals?

It can be fascinating to pick up the Lens of the Toy, the Lens of Curiosity, and the Lens of Goals at the same time to see how these aspects of your game influence each other.

Wrapping Up Rules

Rules are the most fundamental of all game mechanics. A game is not just defined by its rules, a game *is* its rules. It is important to view your game from a rules perspective, and that is Lens #26.

Lens #26: The Lens of Rules

To use this lens, look deep into your game, until you can make out its most basic structure. Ask yourself these questions:

- What are the foundational rules of my game? How do these differ from the operational rules?
- Are there "laws" or "house rules" that are forming as the game develops? Should these be incorporated into my game directly?
- Are there different modes in my game? Do these modes make things simpler, or more complex? Would the game be better with fewer modes? More modes?
- Who enforces the rules?
- Are the rules easy to understand, or is there confusion about them? If there is confusion, should I fix it by changing the rules or by explaining them more clearly?

There is a common misconception that designers make games by sitting down and writing a set of rules. This usually isn't how it happens at all. A game's rules are arrived at gradually and experimentally. The designer's mind generally works in the domain of "operational rules," occasionally switching to the perspective of "foundational rules" when thinking about how to change or improve the game. The "written rules" usually come toward the end, once the game is playable. Part of the designer's job is to make sure there are rules that cover every circumstance. Be sure to take careful notes as you playtest, because it is during these tests that holes in your rules will appear — if you just patch them quickly and don't make a note, the same hole will just show up again later. A game is its rules — give them the time and consideration that they deserve.

Mechanic 5: Skill

In virtute sunt multi ascensus.

(There are many degrees in excellence.)

– Cicero

The mechanic of **skill** shifts the focus away from the game and onto the player. Every game requires players to exercise certain skills. If the player's skill level is a

good match to the game's difficulty, the player will feel challenged and stay in the flow channel (as discussed in Chapter 8).

Most games do not just require one skill from a player — they require a blend of different skills. When you design a game, it is a worthwhile exercise to make a list of the skills that your game requires from the player. Even though there are thousands of possible skills that can go into a game, skills can generally be divided into three main categories:

1. **Physical Skills**. These include skills involving strength, dexterity, coordination, and physical endurance. Physical skills are an important part of most sports. Effectively manipulating a game controller is a kind of physical skill, but many videogames (such as *Dance Dance Revolution* and the *Sony Eyetoy*) require a broader range of physical skills from players.

2. **Mental Skills**. These include the skills of memory, observation, and puzzle solving. Although some people shy away from games that require too much in the way of mental skills, it is the rare game that doesn't involve some mental skills, because games are interesting when there are interesting decisions to make, and decision making is a mental skill.

3. **Social Skills**. These include, among other things, reading an opponent (guessing what he is thinking), fooling an opponent, and coordinating with teammates. Typically we think of social skills in terms of your ability to make friends and influence people, but the range of social and communication skills in games is much wider. Poker is largely a social game, because so much of it rests on concealing your thoughts and guessing the thoughts of others. Sports are very social, as well, with their focus on teamwork and on "psyching out" your opponents.

Real vs. Virtual Skills

It is important to draw a distinction here: When we talk about skill as a game mechanic, we are talking about a **real skill** the player must have. In videogames, it is common to talk about your character's skill level. You might hear a player announce "My warrior just gained two points on his sword fighting skill!" But "sword fighting" is not a real skill required of the player — the player is really just pushing the right buttons on the control pad at the right time. Sword fighting, in this context, is a **virtual skill** — one that the player is pretending to have. The interesting thing about virtual skills is that they can improve even though the player's actual skill does not. The player might be just as sloppy at mashing the controller buttons as he ever was, but by mashing them enough times, he might be rewarded with a higher level of virtual skill, which allows his character to become a faster, more powerful swordfighter. Virtual skills are a great way to give a player a feeling of power. Taken too far, it can feel hollow — some critics of massively multiplayer

games complain that there is too much emphasis on virtual skills, and not enough on real skills. Often, the key to a fun game is finding the right mix of real and virtual skills. Many novice designers confuse the two — it is important that you draw a clear distinction between them in your mind.

Enumerating Skills

Making a list of all the skills required in your game can be a very useful exercise. You might make a general list: "my game requires memory, problem solving, and pattern matching skills." Or you might make it very specific: "my game requires players to quickly identify and mentally rotate specific two-dimensional shapes in their heads, while solving a grid-based packing problem." Listing skills can be very tricky — one interesting example comes from the game *RC Pro Am*, a racing game for the NES. In it, players steer the car with the joypad (left thumb), accelerate with the A button (right thumb), and fire weapons at opponents with the B button (also right thumb). To master this game, two surprising skills were required — the first was problem solving. Generally on NES games, you only push one button at a time — you take your thumb off of the A button when you want to push the B button. But in *RC Pro Am*, this is disastrous — it means that if you want to fire a rocket (the B button), you have to release the car's accelerator (the A button), and your opponent quickly speeds away! How to solve this problem? Some players try using a thumb for one button and finger for the other, but this is awkward, and makes the game too hard to play. The best solution seems to involve a new grip on the controller: you hold your thumb sideways on the A button, so that when you want to occasionally push the B button, you can roll it down onto the B button smoothly, without releasing the accelerator. Once the player has solved this problem, they then need to practice this very specific physical skill. And of course, there are many other skills involved in the game — managing resources (missiles and mines, so you don't run out), memorizing race courses, reacting to sharp turns and unexpected road hazards, and many more. The point is that even a game that seems somewhat simple might require many different skills from a player. As a designer, you need to know what these are.

It is easy to fool yourself into thinking your game is about one skill, when other skills are actually more important. Many action-based videogames seem, on the surface, to be mainly about quickly reacting to opponents, when in truth there is a lot of puzzle solving required to figure out the right way to react to them, and a lot of memorization required to avoid being surprised next time you play a given level. Designers are often disappointed to realize that a game they thought was about quick decisions and thinking on your feet is really about memorizing which enemies pop out at what time — a very different experience for the player. The skills that a player exercises go a long way toward determining the nature of that player's experience, so you must know what these are. Viewing your game from this perspective is Lens #27.

Lens #27: The Lens of Skill

To use this lens, stop looking at your game, and start looking at the skills you are asking of your players.

Ask yourself these questions:

- What skills does my game require from the player?
- Are there categories of skill that this game is missing?
- Which skills are dominant?
- Are these skills creating the experience I want?
- Are some players much better at these skills than others? Does this make the game feel unfair?
- Can players improve their skills with practice?
- Does this game demand the right level of skill?

Exercising skills can be a joyful thing — it is one of the reasons that people love games. Of course, it is only joyful if the skills are interesting and rewarding, and if the challenge level strikes that ideal balance between "too easy" and "too hard." Even dull skills (such as pushing buttons) can be made more interesting by dressing them up as virtual skills and providing the right level of challenge. Use this lens as a window into the experience the player is having. Because skills do so much to define experience, the Lens of Skill works quite well in conjunction with Lens #1: The Lens of Essential Experience.

Mechanic 6: Chance

Our sixth and final game mechanic is **chance**. We deal with it last because it concerns interactions between all of the other five mechanics: space, objects, actions, rules, and skills.

Chance is an essential part of a fun game because chance means uncertainty, and uncertainty means surprises. And as we have discussed earlier, surprises are an important source of human pleasure, and the secret ingredient of fun.

We must now proceed with caution. You can never take chance for granted, for it is very tricky — the math can be difficult, and our intuitions about it are often wrong. But a good game designer must become the master of chance and probability, sculpting it to his will, to create an experience that is always full of challenging decisions and interesting surprises. The challenges of understanding chance are well-illustrated by a story about the invention of the mathematics of probability — invented, not surprisingly, for the express purpose of game design.

The Invention of Probability

Il est tres bon ésprit, mais quel dommage, il n'est pas geometre.

(He's a nice guy, but unfortunately, no mathematician.)

– Pascal to Fermat regarding the Chevalier de Méré

It was the year 1654, and French nobleman Antoine Gombauld, the Chevalier de Méré (pronounced "Shevulyay duh Mayray"), had a problem. He was an avid gambler and had been playing a game where he would bet that if he rolled a single die four times, at least one time it would come up as a six. He had made some good money from this game, but his friends got tired of losing, and refused to play it with him any further. Trying to find a new way to fleece his friends, he invented a new game that he believed had the same odds as the last one. In his new game, he would bet that if he rolled a pair of dice twenty-four times, a twelve would come up at least once. His friends were wary at first, but soon grew to like his new game, because the Chevalier started losing money fast! He was confused, because by his math, both games had the same odds. The Chevalier's reasoning was as follows:

First Game: In four rolls of a single die, the Chevalier wins if at least one six comes up.

The Chevalier reasoned that the chance of a single die coming up 6 was 1/6, and therefore rolling a die four times should mean the chance of winning was

$4 \times (1/6) = 4/6 = 66\%$, which explained why he tended to win

Second Game: In twenty-four rolls of a pair of dice, the Chevalier wins if at least one 12 comes up.

The Chevalier determined that the chance of getting a 12 (double sixes) on a pair of dice was 1/36. He reasoned, then, that rolling the dice 24 times meant the odds should be

$24 \times (1/36) = 24/36 = 2/3 = 66\%$. The same odds as the last game!

Confused and losing money, he wrote a letter to mathematician Blaise Pascal, asking for advice. Pascal found the problem intriguing — there was no established mathematics to answer these questions. Pascal then wrote to his father's friend, Pierre de Fermat, for help. Pascal and Fermat began a lengthy correspondence about this and similar problems, and in discovering methods of solving them, established probability theory as a new branch of mathematics.

What are the real odds of the Chevalier's games? To understand that, we have to get into some math — don't fret, it's easy math that anyone can do. Fully covering the mathematics of probability is not necessary for game design (and beyond the scope of this book), but knowing some of the basics can be quite handy. If you are

a math genius, you can skip this section, or at least read it smugly. For the rest of us, I present:

Ten Rules of Probability Every Game Designer Should Know

Rule #1: Fractions are Decimals are Percents

If you are one of those people who has always had a hard time with fractions and percents, it's time to face up and deal with them, because they are the language of probability. Don't stress — you can always use a calculator — no one is looking. The thing you have to come to grips with is that fractions, decimals, and percents are all the same thing, and can be used interchangeably. In other words, ½ = 0.5 = 50%. Those aren't three different numbers; they are just three ways of writing exactly the same number.

Converting from fractions to decimals is easy. Need to know the decimal equivalent of 33/50? Just type 33 ÷ 50 into your calculator, and you'll get 0.66. What about percents? They're easy too. If you look up the word "percent" in the dictionary, you'll see that it really means "per 100." So, 66% really means 66 per 100, or 66/100, or 0.66. If you look at the Chevalier's math above, you'll see why we need to convert back and forth so often — as humans, we like to talk in percents, but we also like to talk about "one chance in six" — so we need a way to convert between these forms. If you are the kind of person who suffers from math anxiety, just relax, and practice a few of these on the calculator — you'll have the hang of it in no time.

Rule #2: Zero to One — and That's It!

This one's easy. Probabilities can only range from 0 to 100%, that is, from 0 to 1 (see Rule #1), no less, and no more. While you can say there is a 10% chance of something happening, there is no such thing as a −10% chance, and certainly no such thing as a 110% chance. A 0% chance of something happening means it won't happen, and a 100% chance means it definitely will. This all might sound obvious, but it points out a major problem with the Chevalier's math. Consider his first game with the four dice. He believed that with four dice, he had a 4 × (1/6), or 4/6, or 0.66 or 66% chance of having a six come up. But what if he had seven dice? Then he would have had 7 × (1/6) or 7/6 or 1.17 or 117% chance of winning! And that is certainly wrong — if you roll a die seven times, it might be likely that a six will come up one of those times, but it is not guaranteed (in fact, it is about a 72% chance). Anytime you calculate a probability that comes up greater than 100% (or less than 0%) you know for certain that you've done something wrong.

Rule #3: "Looked For" Divided By "Possible Outcomes" Equals Probability

The first two rules lay some basic groundwork, but now we are going to talk about what probability really is — and it is quite simple. You just take the number of

times your "looked for" outcome can come up, and divide by the number of possible outcomes (assuming your outcomes are equally likely), and you've got it. What is the chance of a six coming up when you roll a die? Well, there are six possible outcomes, and only one of them is the one we are looking for, so the chance of a six coming up is 1 ÷ 6, or 1/6, or about 17%. What is the chance of an even number coming up when you roll a die? There are 3 even numbers, so the answer is 3/6, or 50%. What is the chance of drawing a face card from a deck of cards? There are twelve face cards in a deck, and fifty-two cards total, so your chances of getting a face card are 12/52, or about 23%. If you understand this, you've got the fundamental idea of probability.

Rule #4: Enumerate!

If Rule #3 is as simple as it sounds (and it is), you might wonder why probability is so tricky. The reason is that the two numbers we need (the number of "looked for" outcomes, and the number of possible outcomes) are not always so obvious. For example, if I asked you what the odds of flipping a coin three times and getting "heads" at least twice, what is the number of "looked for" outcomes? I'd be surprised if you could answer that without writing anything down. An easy way to find out the answer is to enumerate all the possible outcomes:

1. HHH
2. HHT
3. HTH
4. HTT
5. THH
6. THT
7. TTH
8. TTT

There are exactly eight possible outcomes. Which ones have heads at least twice? #1, #2, #3, and #5. That's 4 outcomes out of 8 possibilities, so the answer is 4/8, or a 50% chance. Now, why didn't the Chevalier do this with his games? With his first game, there were four die rolls, which means 6 × 6 × 6 × 6, or 1296 possibilities. It would have been dull work, but he could have enumerated all the possibilities in an hour or so (the list would have looked like: 1111, 1112, 1113, 1114, 1115, 1116, 1121, 1122, 1123, etc.), and then counted up the number of combinations that had a six in them (671), and divided that by 1296 for his answer. Enumeration will let you solve almost any probability problem, if you have the time. Consider the Chevalier's second game, though: 24 rolls of 2 dice! There are 36 possible outcomes for 2 dice, and so enumerating all 24 rolls would have meant writing down 36^{24} (a number 37

digits long) combinations. Even if he could somehow write down one combination a second, it would have taken longer than the age of the universe to list them all. Enumeration is handy, but when it takes too long, you need to take shortcuts — and that's what the other rules are for.

Rule #5: In Certain Cases, OR Means Add

Very often, we want to determine the chances of "this OR that" happening, such as, what are the chances of drawing a face card OR an ace from a deck of cards? When the two things we are talking about are mutually exclusive; that is, when it is impossible for both of them to happen simultaneously, you can add their individual probabilities to get an overall probability. For example, the chances of drawing a face card are 12/52, and the chances of drawing an ace are 4/52. Since these are mutually exclusive events (it is impossible for them both to happen at once), we can add them up: 12/52 + 4/52 = 16/52, or about a 31% chance.

But what if we asked a different question: What are the chances of drawing an ace from a deck of cards or a diamond? If we add these probabilities, we get 4/52 + 13/52 (13 diamonds in a deck) = 17/52. But, if we enumerate, we see this is wrong — the right answer is 16/52. Why? Because the two cases are not mutually exclusive — I could draw the ace of diamonds! Since this case is not mutually exclusive, "or" does not mean add.

Let's look at the Chevalier's first game. He seems to be trying to use this rule for his die rolls — adding up four probabilities: 1/6 + 1/6 + 1/6 + 1/6. But he gets the wrong answer, because the four events are not mutually exclusive. The addition rule is handy, but you must be certain the events you are adding up are mutually exclusive from one another.

Rule #6: In Certain Cases, AND Means Multiply

This rule is almost the opposite of the previous one! If we want to find the probability of two things happening simultaneously, we can multiply their probabilities to get the answer — but ONLY if the two events are NOT mutually exclusive! Consider two die rolls. If we want to find the probability of rolling a six on both rolls, we can multiply together the probabilities of the two events: The chance of getting a six on one die roll is 1/6, and also 1/6 for a second die roll. So the chance of getting two sixes is 1/6 × 1/6 = 1/36. You could also have determined that by enumeration, of course, but this is a much speedier way to do it.

In Rule #5, we asked for the probability of drawing an ace OR a diamond from a deck of cards — the rule failed, because the two events were not mutually exclusive. So what if we asked about the probability of drawing an ace AND a diamond? In other words, what is the probability of drawing the ace of diamonds? It should be fairly intuitive that the answer is 1/52, but we can check that with Rule #6, since we know the two events are not mutually exclusive. The chance of getting an ace is

4/52, and the chance of a diamond is 13/52. Multiplying them: 4/52 × 13/52 = 52/2704 = 1/52. So, the rule works, and matches our intuition.

Do we have enough rules yet to solve the Chevalier's problems? Let's consider his first game:

First Game: In four rolls of a single die, the Chevalier wins if at least one six comes up.

We've already established that we could enumerate this, and get the answer 671/1296, but that would take an hour. Is there a quicker way, using the rules we have?

(I'll warn you now — this gets a little hairy. If you don't really care that much, save yourself the headache, and just skip to Rule #7. If you do care, then press on — you will find it worth the effort.)

If the question was about the chances of rolling a die four times and getting four sixes, that would be an AND question for four events that are not mutually exclusive, and we could just use Rule #6: 1/6 × 1/6 × 1/6 × 1/6 = 1/1296. But that isn't what is asked. This is an OR question for four events that are not mutually exclusive (it is possible for the Chevalier to get multiple sixes on the four rolls). So what can we do? Well, one way is to break it down into events that are mutually exclusive, and then add them up. Another way to phrase this game is:

What are the chances of rolling four dice, and getting either:

a. Four sixes, OR

b. Three sixes and one non-six, OR

c. Two sixes and two non-sixes, OR

d. One six and three non-sixes

That might sound a little complicated, but it is four different mutually exclusive events, and if we can figure the probability of each, we can just add them up and get our answer. We've already figured out the probability of (a), using Rule #6: 1/1296. So, how about (b)? Really, (b) is four different mutually exclusive possibilities:

1. 6, 6, 6, non-six

2. 6, 6, non-six, 6

3. 6, non-six, 6, 6,

4. Non-six, 6, 6, 6

The probability of rolling a six is 1/6, the probability of rolling a non-six is 5/6. So, the probability of each of those is 1/6 × 1/6 × 1/6 × 5/6 = 5/1296. Now, if we add up all four, that comes to 20/1296. So, the probability of (b) is 20/1296.

How about (c)? This one is the same as the last, but there are more combinations. It is tricky to figure out how many ways there are for exactly two sixes and two non-sixes to come up, but there are six ways:

1. 6, 6, non-six, non-six
2. 6, non-six, 6, non-six
3. 6, non-six, non-six, 6
4. non-six, 6, 6, non-six
5. non-six, 6, non-six, 6
6. non-six, non-six, 6, 6

And the probability of each of these is $1/6 \times 1/6 \times 5/6 \times 5/6 = 25/1296$. Adding up all six of them comes to 150/1296.

This leaves only (d), which is the inverse of (b):

a. Non-six, non-six, non-six, 6
b. Non-six, non-six, 6, non-six
c. Non-six, 6, non-six, non-six
d. 6, non-six, non-six, non-six

The probability of each is $5/6 \times 5/6 \times 5/6 \times 1/6 = 125/1296$. Adding up all four gives 500/1296.

So, we have now calculated the probability of the four mutually exclusive events:

a. Four sixes — (1/1296)
b. Three sixes and one non-six — (20/1296)
c. Two sixes and two non-sixes — (150/1296)
d. One six and three non-sixes — (500/1296)

Adding up those four probabilities (as Rule #5 allows), gives us a total of 671/1296, or about 51.77%. So, we can see that this was a good game for the Chevalier — by winning more than 50% of the time, he eventually was likely to make a profit, but the game was close enough to even that his friends believed they had a chance — at least for a while. It certainly is a very different result than the 66% chance of winning the Chevalier believed he had!

This is the same answer we could have gotten from enumeration, but much faster. Really, though, we did a kind of enumeration — it is just that the rules of addition and multiplication let us count everything up much faster. Could we do the same thing to get the answer to the Chevalier's second game? We could, but with 24 rolls of two dice, it would probably take an hour or more! This is faster than

159

enumeration, but we can do even better by being tricky — that's where Rule #7 comes in.

Rule #7: One Minus "Does" = "Doesn't"

This is a more intuitive rule. If the chance of something happening is 10%, the chance of it not happening is 90%. Why is this useful? Because often it is quite hard to figure out the chance of something happening, but easy to figure out the chance of it NOT happening.

Consider the Chevalier's second game. To figure out the chance of double-sixes coming up at least once on twenty-four die rolls would be nightmarish to figure out, because you have so many different possible events to add together (1 double-sixes, 23 non-double-sixes; 2 double-sixes, 22 non-double-sixes; etc.). On the other hand, what if we ask a different question: What are the chances of rolling two dice twenty-four times, and NOT getting double sixes? That is now an AND question, for events that are not mutually exclusive, so we can use Rule #6 to get the answer! But first we'll use Rule #7 twice — watch.

The chance of double sixes coming up on a single roll of the dice is 1/36. So, by Rule #7, the chance of not getting double sixes is 1 — 1/36, or 35/36.

So, using Rule #6 (multiplication), the chances of not getting double sixes 24 times in a row is 35/36 × 35/36 twenty-four times, or as we say, $(35/36)^{24}$. You would not want to do this calculation by hand, but using a calculator, you find the answer is around 0.5086, or 50.86%. But that is the chance of the Chevalier losing. To find the chance of the Chevalier winning, we apply Rule #7 again: 1 — 0.5086 = 0.4914, or about 49.14%. Now it is clear why he lost this game! His chances of winning were close enough to even that it was hard for him to tell if this was a winning or losing game, but after playing many times, he was very likely to lose.

Even though all probability problems can be solved through enumeration, Rule #7 can be a really handy shortcut. In fact, we could have used the same rule to solve the Chevalier's first game!

Rule #8: The Sum of Multiple Linear Random Selections is NOT a Linear Random Selection!

Don't panic. This one sounds hard, but it is really easy. A "linear random selection" is simply a random event where all the outcomes have an equal chance of happening. A die roll is a great example of a linear random selection. If you add up multiple die rolls, though, the possible outcomes do NOT have an equal chance of happening. If you roll two dice, for example, your chance of getting a seven is very good, while your chance of getting a twelve is small. Enumerating all the possibilities shows you why:

	1	2	3	4	5	6
1	2	3	4	5	6	7
2	3	4	5	6	7	8
3	4	5	6	7	8	9
4	5	6	7	8	9	10
5	6	7	8	9	10	11
6	7	8	9	10	11	12

Look at how many sevens there are, and only one little twelve! We can show this in a graph, called a probability distribution curve, to visually see the chances of each total coming up:

FIGURE
10.15

Rule #8 might seem like a very obvious rule, but I frequently find novice game designers make the mistake of adding together two randomly selected numbers without realizing its effect. Sometimes, it is exactly the effect you want — in the game *Dungeons and Dragons*, players generate (virtual) skill attributes with values ranging from 3 to 18 by rolling three six-sided dice. As a result, you see a lot of attribute values around 10 or 11, but very few at 3 or 18, and this is exactly what the designers wanted. How would the game be different if players simply rolled a single twenty-sided die to get their attributes?

Game designers who want to use mechanic of chance as a tool in their games must know what kind of probability distribution curve they want, and know how to get it. With practice, probability distribution curves will be a very valuable tool in your toolbox.

Rule #9: Roll the Dice

All the probability we've been talking about so far is **theoretical probability**, that is, mathematically, what *ought to* happen. There is also **practical probability**, which is a measure of what *has* happened. For example, the theoretical probability of getting a 6 when I roll a die is a perfect 1/6, or about 16.67%. I could find the practical probability by rolling a six-sided die 100 times and recording how many times I get a six. I might record 20 sixes out of 100. In that case, my practical probability is 20%, which is not too far from the theoretical probability. Of course, the more trials I do, the closer I would expect the practical probability to get to the theoretical probability. This is sometimes known as the "Monte Carlo" method, after the famous casino.

The great thing about the Monte Carlo method of determining probability is that it doesn't involve any complex math — you just repeat the test over and over again, and record how it comes out. It can sometimes give more useful results than theoretical probability too, because it is a measure of the real thing. If there is some factor that your mathematics didn't capture (perhaps your die is slightly weighted toward sixes, for example), or if the math is just so complicated that you can't come up with a theoretical representation of your case, the Monte Carlo method can be just the thing. The Chevalier could easily have found good answers to his questions by just rolling the dice again and again, counting up wins, and dividing by the number of trials.

And here in the computer age, if you know how to do a little bit of programming (or know someone who can — see Rule #10), you can easily simulate millions of trials in just a few minutes. It isn't too hard to program simulations of games and get some very useful probability answers. For example, in Monopoly, which squares are landed on most frequently? It would be nearly impossible to figure this out theoretically — but a simple Monte Carlo simulation allows you to answer the question quickly by using a computer to roll the dice and move the pieces around the board a few million times.

Rule #10: Geeks Love Showing Off (Gombauld's Law)

This is the most important of all the probability rules. If you forget all the others, but remember this one, you'll get by just fine. There are many more difficult aspects of probability that we won't get into here — when you run into them, the easiest thing to do is to find someone who considers themselves a "math whiz." Generally, these people are thrilled to have someone actually needing their expertise, and they will bend over backwards to help you. I have used Rule #10 to solve hard game design probability questions again and again. If there aren't any experts around you, post your question on a forum or mailing list. If you really want a fast response, preface it with "This problem is probably too difficult for anyone to solve, but I thought I would ask anyway," for there are many math experts who love the ego boost of solving a problem that others think is impossible. In a sense, your hard problem is a game for them — why not use game design techniques to make it as attractive as possible?

You might even be doing your geek a favor! I like to call Rule #10 "Gombauld's Law," in honor of Antoine Gombauld, the Chevalier de Méré, who, through his awareness of this principle, not only solved his gambling problem (his mathematical one, anyway), but inadvertently initiated all of probability theory.

You might be afraid of exercising Rule #10, because you are afraid of asking stupid questions. If you feel that way don't forget that Pascal and Fermat owed the Chevalier a great debt — without his stupid questions, they never would have made some of their greatest discoveries. Your stupid question might lead to a great truth of its own — but you'll never know unless you ask.

Expected Value

You will use probability in many ways in your designs, but one of the most useful will be to calculate **expected value**. Very often, when you take an action in a game, the action will have a value, either positive or negative. This might be points, tokens, or money gained or lost. The expected value of a transaction in a game is the average of all the possible values that could result.

For example, there might be a rule in a board game that when a player lands on a green space, he can roll a six-sided die, and get that many power points. The expected value of this event is the average of all the possible outcomes. To get the average in this case, since all the probabilities are equal, we can add up all the possible die rolls: $1 + 2 + 3 + 4 + 5 + 6 = 21$, and divide by 6, which gives us 3.5. As a game designer, it is very useful for you to know that each time someone lands on a green space, they will, on average, get 3.5 power points.

But not all examples are so simple — some involve negative outcomes, and outcomes that aren't evenly weighted. Consider a game where a player rolls two dice. If they get a seven, or an eleven, they win $5, but if they get anything else, they lose $1. How do we figure out the expected value of this game?

The chance of rolling a 7 is 6/36.

The chance of rolling an 11 is 2/36.

Using Rule #8, the chance of rolling anything else is $1 - 8/36$, or 28/36.

So, to calculate the expected value, we multiply the probabilities by the values for each, and add them all up, like this:

Outcome	Chance × Outcome	Value
7	6/36 × $5	$0.83
11	2/36 × $5	$0.28
Everything else	28/36 × − $1	−$0.78
Expected value		$0.33

So, we see that this is a good game to play, because in the long run, you will, on average, win thirty-three cents each time you play. But, what if we changed the game, so that only sevens are winning numbers, and elevens make you lose a dollar, just like all the other numbers? This changes the expected value, like so:

Outcome	Chance × Outcome	Value
7	6/36 × $5	$0.83
Everything else	30/36 × − $1	−$0.83
Expected value		$0.00

An expected value of zero means that this game is just as good as flipping a coin in the long run. Wins and losses are completely balanced. What if we change it again, so that this time, only elevens win?

Outcome	Chance × Outcome	Value
11	2/36 × $ 5	$ 0.28
Everything else	34/36 × − $ 1	−$ 0.94
Expected value		−$ 0.86

Ouch! As you might expect, this is a losing game. You'll lose, on average, about eighty-six cents each time you play it. Of course, you could make it into a fair game, or even a winning game, by increasing the payoff for getting an eleven.

Consider Values Carefully

Expected value is an excellent tool for game balancing, which we will discuss more in the next chapter — but if you aren't careful about what the true value of an outcome is, it can be very misleading.

Consider these three attacks, that might be part of a fantasy role-playing game:

Attack Name	Chance of Hitting	Damage
Wind	100%	4
Fireball	80%	5
Lightning bolt	20%	40

What is the expected value of each of these? Wind is easy — it always does exactly 4 damage, so the expected value of that attack is 4. Fireball hits 80% of the time, and

misses 20% of the time, so it's expected value is $(5 \times 0.8) + (0 \times 0.2) = 4$ points, the same as the wind attack. The lightning bolt attack doesn't hit very often, but when it does, it packs a wallop. Its expected value is $(40 \times 0.2) + (0 \times 0.8) = 8$ points.

Now, based on those values, one might conclude that players would always use the lightning bolt attack, since on average it does double the damage of the other two attacks. And if you are fighting an enemy that has 500 hit points, that might be correct. But what about an enemy with 15 hit points? Most players would not use lightning bolt in that case — they would opt for something weaker, but surer. Why is this? Because even though the lightning bolt can do 40 damage points, only 15 of them are of any use in that situation — the real expected value of the lightning bolt against an enemy with 15 HP is $(0.2 \times 15) + (0.8 \times 0) = 3$ points, which is lower than both the wind and the fireball attack.

You must always take care to measure the real values of actions in your game. If something gives a benefit that a player can't use, or contains a hidden penalty, you must capture that in your calculations.

The Human Element

You must also keep in mind that expected value calculations do not perfectly predict human behavior. You would expect players to always choose the option with the highest expected value, but that is not always the case. In some cases, this is due to ignorance — because players did not realize the actual expected value. For example, if you didn't tell players the respective chances of wind, fireball, and lightning bolt, but left it to them to discover them through trial and error, you might find that players who tried lightning bolt several times and never got a hit reached the conclusion that "lightning bolt never hits," and therefore has an expected value of zero. The estimates that players make about how often an event happens are often incorrect. You must be aware of the "perceived probabilities" that players have arrived at, because it will determine how they play.

But sometimes, even with perfect information, players still will not choose an option with the highest expected value. Two psychologists, Kahneman and Tversky, tried an interesting experiment, where they asked a number of subjects which of the two games they would like to play:

Game A:

66% chance of winning $2400

33% chance of winning $2500

1% chance of winning $0

Game B:

100% chance of winning $2400

These are both pretty great games to play! But is one better than the other? If you do the expected value calculations:

Expected Value of Game A: $0.66 \times \$2400 + 0.33 \times \$2500 + 0.01 \times \$0 = \2409

Expected Value of Game B: $1.00 \times 2400 = \$2400$

You can see that Game A has a higher expected value. But only 18% of the subjects they surveyed picked A, while 82% preferred playing Game B.

Why? The reason is that the expected value calculation does not capture an important human element: regret. People not only seek out options that create the most pleasure, they also avoid the ones that cause the most pain. If you played Game A (and we're assuming you only get to play it once), and were unlucky enough to get that 1% and $0, it would feel pretty bad. People are often willing to pay a price to eliminate the potential of regret — "buying peace of mind," as the insurance salesmen say. Not only are they willing to pay a price to avoid regret, they are willing to take risks. This is why a gambler who has lost a little money is often willing to take more risks to try to get the money back. Tversky puts it this way: "When it comes to taking risks for gains, people are conservative. They will make a sure gain over a problem gain. But we are also finding that when people are faced with a choice between a small, certain loss and a large, probable loss, they will gamble."

In some cases, the human mind inflates some risks completely out of proportion. In one study, Tversky asked people to estimate the likelihood of various causes of death, and obtained the following results:

Cause of Death	Estimated Chance	Actual Chance
Heart disease	22%	34%
Cancer	18%	23%
Other natural causes	33%	35%
Accident	32%	5%
Homicide	10%	1%
Other unnatural causes	11%	2%

What is particularly interesting here is that the subjects making estimates *under-estimated* the top three categories (natural causes of death), and significantly *over-estimated* the bottom three (unnatural causes of death). This distortion of reality seems to be a reflection of the fears of the respondents. What bearing does this have on game design? As a designer, you must have not only a grasp of the actual probabilities of events in your game, but also the *perceived* probabilities, which may be quite different for a number of reasons.

You will need to consider both actual and perceived probabilities when calculating expected values, which provide such useful information that they make Lens #28.

Lens #28: The Lens of Expected Value

To use this lens, think about the chance of different events occurring in your game, and what those mean to your player.

Ask yourself these questions:

- What is the actual chance of a certain event occurring?

- What is the perceived chance?

- What value does the outcome of that event have? Can the value be quantified? Are there intangible aspects of value that I am not considering?

- Each action a player can take has a different expected value when I add up all the possible outcomes. Am I happy with these values? Do they give the player interesting choices? Are they too rewarding, or too punishing?

Expected value is one of your most valuable tools for analyzing game balance. The challenge of using it is finding a way to numerically represent everything that can happen to a player. Gaining and losing money is easy to represent. But what is the numerical value of "boots of speed" that let you run faster, or a "warp gate" that lets you skip two levels? These are difficult to quantify perfectly — but that doesn't mean you can't take a guess. As we'll see in Chapter 11, as you go through multiple iterations of game testing, tweaking parameters and values in your game, you will also be tweaking your own estimations of the values of different outcomes. Quantifying these less tangible elements can be quite enlightening, because it makes you think concretely about what is valuable to the player and why — and this concrete knowledge will put you in control of the balance of your game.

Skill and Chance Get Tangled

As tricky as probability and the difference between actual and perceived values might be, the game mechanic of chance has more tricks up its sleeve. As much as we like to think that chance and skill are completely separate mechanics, there are important interactions between them that we cannot ignore. Here are five of the most important skill/chance interactions for a game designer to consider.

1. **Estimating chance is a skill**. In many games, what separates the skilled players from the unskilled is their ability to predict what is going to happen next, often

through calculating probabilities. The game of blackjack, for example, is almost entirely about knowing the odds. Some players even practice "card counting," which is the practice of keeping track of what cards have already been played, since each card played changes the odds of what subsequent cards can appear. The perceived probabilities in your game can vary a great deal between players who are skilled estimators and those who are not.

2. **Skills have a probability of success**. Naively, one might think that completely skill based games, such as chess or baseball, have no aspects of randomness or risk in them. But from a player's point of view, this simply isn't true. Every action has some level of risk, and players are constantly making expected value decisions, deciding when to play it safe, and when to take a big risk. These risks can be difficult to quantify (What are the odds that I can successfully steal a base, or that I can trap my opponent's queen without him noticing?), but they are still risks. When designing a game, you need to make sure they are balanced just as you would balance "pure chance" game elements, like drawn cards or die rolls.

3. **Estimating an opponent's skill is a skill**. A big part of a player's ability to determine the chances of success for a particular action rests on their ability to estimate their opponent's skill. A fascinating part of many games is trying to fool your opponent into thinking your skills are greater than they are, to prevent him from trying anything too bold, and to make him uncertain of himself. Likewise, sometimes the opposite is true — in some games it is a good strategy to make a player think your skills are less than they really are, so that your opponent will not notice your subtle strategies, and will perhaps try actions that would be risky against a skilled player.

4. **Predicting pure chance is an imagined skill**. Humans look for patterns, consciously and subconsciously, to help predict what is going to happen next. Our mania for patterns often leads us to look for and find patterns where none exist. Two of the most common false patterns are the "lucky streak fallacy" (I've had several wins in a row, and therefore another is likely) and its opposite, the "gambler's fallacy" (I've had several losses, so I must be due for a win). It is easy to scoff at these as ignorant, but in the all-important mind of the player, detecting these bogus patterns feels like the exercise of a real skill, and as a designer, you should find ways to use that to your advantage.

5. **Controlling pure chance is an imagined skill.** Not only do our brains actively seek patterns, but they also actively and desperately seek cause-and-effect relationships. With pure chance, there is no way to control the outcome — but that doesn't stop people from rolling the dice a certain way, carrying lucky charms, or engaging in other superstitious rituals. This feeling that it might be possible to control fate is part of what makes gambling games so exciting. Intellectually, we know it isn't possible, but when you are up there rolling the dice, saying "come on, come on..." it certainly feels like it might be possible, especially when you get lucky! If you try playing games of pure chance, but completely disengage

yourself from the idea that anything you think or do can influence the outcome, much of the fun suddenly drains away. Our natural tendency to try to control fate can make games of chance feel like games of skill.

Chance is tricky stuff, because it intertwines hard math, human psychology, and all of the basic game mechanics. But this trickiness is what gives games their richness, complexity, and depth. The last of our six basic game mechanics gives us Lens #29.

Lens #29: The Lens of Chance

To use this lens focus on the parts of your game that involve randomness and risk, keeping in mind that those two things are not the same.

Ask yourself these questions:

- What in my game is truly random? What parts just feel random?
- Does the randomness give the players positive feelings of excitement and challenge, or does it give them negative feelings of hopelessness and lack of control?
- Would changing my probability distribution curves improve my game?
- Do players have the opportunity to take interesting risks in the game?
- What is the relationship between chance and skill in my game? Are there ways I can make random elements feel more like the exercise of a skill? Are there ways I can make exercising skills feel more like risk-taking?

Risk and randomness are like spices. A game without any hint of them can be completely bland, but put in too much and they overwhelm everything else. But get them just right, and they bring out the flavor of everything else in your game. Unfortunately, using them in your game is not as simple as sprinkling them on top. You must look into your game to see where elements of risk and randomness naturally arise, and then decide how you can best tame them to do your bidding. Don't fall into the trap of thinking that elements of chance only occur around die rolls or randomly generated numbers. On the contrary, you can find them wherever a player encounters the unknown.

At long last, we have made it through all six of the basic game mechanics. Soon, we will move onto more advanced mechanics that are built from these, such as puzzles and interactive story structures. But first we need to explore methods of bringing these basic elements into balance.

Game Mechanics Must be in *Balance*

FIGURE
11.1

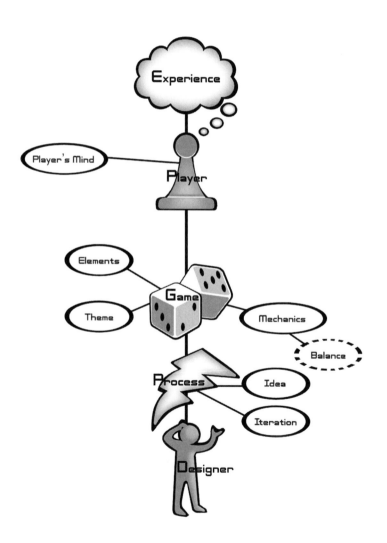

A false balance is an abomination to the Lord.

<div align="right">– Proverbs 11:1</div>

Have you ever looked forward to playing a game that you were certain was going to be incredibly fun, only to be terribly disappointed? This game had a story that sounded interesting, the kind of gameplay action that is your favorite, cutting edge technology, and beautiful artwork — but somehow the play was monotonous, confusing, and frustrating. This is a game that is out of balance.

To novice designers, the business of balancing a game seems quite mysterious — but really, balancing a game is nothing more than adjusting the elements of the game until they deliver the experience you want. Balancing a game is far from a science; in fact, despite the simple mathematics that is often involved, it is generally considered the most artful part of game design, for it is all about understanding subtle nuances in the relationships between the elements of your game and knowing which ones to alter, how much to alter them, and which ones to leave alone.

Part of what makes game balancing so difficult is that no two games are alike, and every game has many different factors that need to be in balance. As a designer, you must discern what elements in your game need to be balanced, and then experiment with changing them until you have them generating exactly the experience you want your players to have.

Think of it like creating a new recipe — it is one thing to determine the ingredients you need, but another to decide how much of each to use, and how they should be combined. Some of the decisions you make will be based in hard mathematics (1.5 teaspoons of baking powder leavens 1 cup of flour), but others, like how much sugar to use, are often a matter of personal taste. A skilled chef can make the simplest of recipes a delight to eat for the same reason a skilled game designer can make the simplest of games a delight to play — they both know how to balance the ingredients.

Game balancing can come in a variety of forms, because every different game has different things that must be brought into balance. Still, there are some patterns of balance that occur over and over again. Balancing a game is all about examining it carefully, so this chapter will be rich with many lenses.

The Twelve Most Common Types of Game Balance

Balance Type #1: Fairness

Symmetrical Games

One quality that players universally seek in games is fairness. Players want to feel that the forces working against them do not have an advantage that will make them impossible to defeat. One of the simplest ways to ensure this is to make your game is **symmetrical**; that is, to give equal resources and powers to all players.

Most traditional board games (such as checkers, chess, and Monopoly) and almost all sports use this method to be sure that no player has an unfair advantage over another. If you want to put players in direct competition with each other, and you expect them to have roughly equal levels of skill, symmetric games are a great choice. They are particularly good systems for determining which player is the best, since all things in the game are equal but for the skill and strategy that the individual players bring to the game. In these games, perfect symmetry is not always possible as there is often some minor issue, such as "who goes first?" or "who starts with the ball?" that gives one side a small advantage over the other. Generally, random selection, such as a coin toss or die roll, is the solution. Though it gives one player a small advantage, over many games the advantage is distributed evenly. In some cases, the way this asymmetry is remedied is by giving the advantage to the player with the least skill — such as "youngest player goes first." This is an elegant way to use the natural imbalance of the game to help balance the skill levels of the players.

Asymmetrical Games

It is also possible, and often desirable, to give opponents different resources and abilities. If you do, be aware that you have a significant balancing task ahead of you! Here are some of the reasons you might create an asymmetrical game:

1. **To simulate a real-world situation.** If the point of your game is to simulate the battle between Axis and Allied forces during World War II, a symmetrical game does not make sense, since the real-world conflict was not symmetrical.

2. **To give players another way to explore the gamespace.** Exploration is one of the great pleasures of gameplay. Players often enjoy exploring the possibilities of playing the same game with different powers and resources. In a fighting game, for example, if two players have ten different fighters to choose from, each with different powers, there are ten times ten different pairings, each of which requires different strategies, and effectively you have turned one game into one hundred games.

3. **Personalization.** Different players bring different skills to a game — if you give the players a choice of powers and resources that best matches their own skills, it makes them feel powerful — they have been able to shape the game to emphasize the thing they are best at.

4. **To level the playing field.** Sometimes, your opponents have radically different skill levels. This is especially true if you have opponents that are computer controlled. Consider the game of *Pac Man*. It would be more symmetrical if there were just one ghost chasing *Pac Man*, not four. But if that was the case, the player would win easily for a human can easily outwit a computer when it comes to navigating a maze. But to outwit four computer-controlled opponents at once brings the game into balance and gives the computer a fair chance of defeating the player. Some games are customizable in this regard — a golf

handicap, for instance, lets players of different levels compete at the challenge levels they will both enjoy. Whether to introduce this kind of balancing depends on whether your game is meant to be a standard measure of player's skill, or whether the goal is to provide challenge to all players.

5. **To create interesting situations.** In the infinite space of all the games that can be created, many more of them are asymmetrical than are symmetrical. Pitting asymmetrical forces against each other can often be interesting and thought provoking for the players, since it is not always obvious what the right strategies will be to win the game. Players become naturally curious about whether one side or another has an advantage, and they will often spend a great deal of time and thought to try to decide whether the game is truly fair. The game of Bhaga Chall (the official board game of Nepal) is an excellent example of this. In this game, not only do the players have unequal forces, they also have different goals! One player controls five tigers, while the other controls twenty goats. The tiger player wins by eating five goats, and the goat player wins by positioning the goats so that no tiger can move. Though it is generally acknowledged by experienced players that the game is balanced, novices to the game spend a great deal of time discussing whether one side or the other has particular advantage, and playing the game over and over trying to determine the best strategies and counter strategies.

It can be quite difficult to properly adjust the resources and powers in an asymmetrical game to make them feel evenly matched. The most common method of doing so is to assign a value to each resource or power and make sure that the sum of the values is equal for both sides. See the following section for an example.

Biplane Battle

Imagine a game of biplane dogfight combat. Each player gets to choose one of the following planes:

Plane	Speed	Maneuverability	Firepower
Piranha	Medium	Medium	Medium
Revenger	High	High	Low
Sopwith Camel	Low	Low	Medium

Are these planes equally balanced? It is hard to say. At first glance, though, we might evaluate all three categories by saying: Low = 1, Medium = 2, and High = 3. This gives us new information:

Plane	Speed	Maneuverability	Firepower	Totals
Piranha	Medium (2)	Medium (2)	Medium (2)	6
Revenger	High (3)	High (3)	Low (1)	7
Sopwith Camel	Low (1)	Low (1)	Medium (2)	4

Looked at from this point of view, the player with the Revenger seems to have an unfair advantage over the others. And that may be the case. But, after playing the game a little, maybe we notice that the Piranha and the Revenger seem evenly matched, but players who fly the Sopwith Camel generally lose. This might lead us to speculate that Firepower is more valuable than the other categories — maybe twice as valuable. In other words, for the Firepower column, Low = 2, Medium = 4, and High = 6. This gives us a new table:

Plane	Speed	Maneuverability	Firepower	Totals
Piranha	Medium (2)	Medium (2)	Medium (4)	8
Revenger	High (3)	High (3)	Low (2)	8
Sopwith Camel	Low (1)	Low (1)	Medium (4)	6

This gives us totals that match our observation of the game in action. We may now have a model that shows us how to balance the game to make it fair. To test our theory, we might change the Firepower for the Sopwith Camel to be High (6), giving us a new table:

Plane	Speed	Maneuverability	Firepower	Totals
Piranha	Medium (2)	Medium (2)	Medium (4)	8
Revenger	High (3)	High (3)	Low (2)	8
Sopwith Camel	Low (1)	Low (1)	High (6)	8

It would appear that, if our model is correct, these three planes are equally balanced. But that's only a theory. The way we find out is by playtesting the game. If we play and determine that gameplay feels roughly fair no matter which plane you use, then our model is correct. But what if we play and realize that the Sopwith Camel is still losing battles? In that case, we will have to make a new speculation, change our model, rebalance, and try playing again.

It is important to note that the act of balancing and developing a model of how to balance go hand in hand. As you balance, you learn more about relationships in the game, and you can make a better mathematical model that represents these relationships. And as you change the model, you learn more about the right way to balance your game. The model informs the balance, and the balancing informs the model.

Also note that balancing a game can only really begin once the game is playable. Many a game has suffered in the marketplace because all the time in the schedule got used up just getting the game to work, and not enough time was allotted to balance the game before it needed to go to market. There is an old rule of thumb that it takes six months to balance your game after you have a completely working

version, but this varies a great deal depending on the type and scope of your game. Certainly, the more new gameplay elements you have, the longer it will take you to balance it properly.

Rock, Paper, Scissors

One simple way to balance elements for fairness is to make sure that whenever something in your game has an advantage over something else, yet another thing has an advantage over that! The iconic example of this is the game of Rock, Paper, Scissors where:

- Rock breaks scissors
- Scissors cut paper
- Paper covers rock

None of the elements can be supreme, because there is always another that can defeat it. It is a simple way to ensure that every game element has both strengths and weaknesses. Fighting games particularly like to use this technique to help ensure none of the warriors a player might choose are undefeatable.

Balancing your game to make it feel fair is one of the most fundamental types of game balancing. You will surely want to use the Lens of Fairness on any game you create.

Lens #30: The Lens of Fairness

To use the Lens of Fairness, think carefully about the game from each player's point of view. Taking into account each player's skill level, find a way to give each player a chance of winning that each will consider to be fair.

Ask yourself these questions:

- Should my game be symmetrical? Why?
- Should my game be asymmetrical? Why?
- Which is more important: that my game is a reliable measure of who has the most skill, or that it provide an interesting challenge to all players?
- If I want players of different skill levels to play together, what means will I use to make the game interesting and challenging for everyone?

Fairness can be a slippery subject. There are some cases where one side has an advantage over the other, and the game still seems fair. Sometimes this is so that players of unequal skill can play together, but there can be other reasons.

In the game *Alien vs. Predator*, for example, it is generally recognized that in multiplayer mode, Predators have a significant advantage over the Aliens. Players do not consider it to be unfair, however, because it is in keeping with the *Alien vs. Predator* story world, and they accept that if they play as an Alien, they will be at a disadvantage and will need to compensate for that with extra skill. It is a badge of pride among players to be able to win the game when playing as an Alien.

Balance Type #2: Challenge vs. Success

Let us revisit this diagram from Chapter 9.

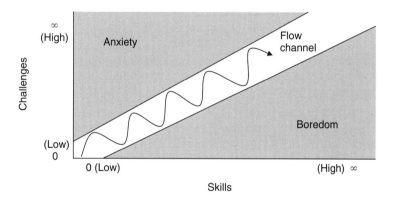

FIGURE
11.2

We know that keeping the player in the flow channel is desirable. If play is too challenging, the player becomes frustrated. But if the player succeeds too easily, they can become bored. Keeping the player on the middle path means keeping the experiences of challenge and success in proper balance. This can be particularly difficult since players may have all different levels of skill. What one player finds boring, another may find challenging, and yet another may find frustrating. Some common techniques for striking a proper balance include:

- **Increase difficulty with each success.** This is a very common pattern in videogames — each level is harder than the last. Players build their skill until they can complete a level, only to be presented with one that challenges them yet again. Don't forget, of course, to use the tense and release pattern shown above.

- **Let players get through easy parts fast.** Assuming your game has some method of gradually increasing the difficulty, you do yourself a service by allowing skilled

players to finish a level quickly if they can easily master it. This way, skilled players will blow through easy levels, quickly getting to a challenge that is more interesting to them, while less skilled players will be challenged by the early levels. This lets every player quickly get to the part of the game that is a challenge. If you arrange it differently, such that each level takes one hour to play, regardless of skill level, skilled players may quickly grow bored from lack of challenge.

- **Create "layers of challenge."** A popular pattern in games is to give a grade at the end of each level or mission. If you get a "D" or "F" you must repeat the level, but if you get a "C" or better, you can continue. This creates a situation with a lot of flexibility in how you can play it. Novice players are thrilled to get a "C", and unlock the next level. As they gain experience, and have unlocked all the levels, they may set themselves a new challenge — to earn an "A" (or even "A+"!) on earlier levels.

- **Let players choose the difficulty level.** A tried and true method is to let players choose to play on "easy, medium, or hard" modes. Some games (many Atari 2600 games, for example) even let you change the difficulty level mid-game. The upside of this is that players can quickly find the appropriate challenge level for their skill level. The downside is that you have to create and balance multiple versions of your game. Also, it can detract from the "reality" of your game — players will argue over which version is the "real" one, or be left feeling unsure whether any of them are "real."

- **Playtest with a variety of players**. Many designers fall into a trap of only testing with people who are constantly exposed to the game and end up designing a game that is too frustrating for novices. Others fall into the opposite trap and only test their game with people who have never played before. They end up designing a game that experienced players quickly grow bored with. Wise designers playtest with a mix of skilled and novice players, to be sure that their game is fun at first, fun after a while, and fun much, much later.

One of the toughest challenges in game balancing is deciding how difficult the game should get over time. Many designers are so afraid of players beating their game too easily that they make later levels so fiendishly difficult to win that 90% of players eventually give up on the game in frustration. These designers hope that the increased challenge will extend the play time — and there is something to that — if you have expended forty hours to get through level nine, you will probably be willing to work pretty hard to defeat level ten. But in truth, there are so many competing games to play, many players just give up in frustration. As a designer, it makes sense to ask yourself "What percentage of players do I want to be able to complete this game?" and then design for that.

And don't forget: Just learning to play a game at all is a challenge! For this reason, the first level or two of a game are often incredibly simplistic — the player is so challenged just trying to understand the "controls and goals" that any additional

challenge might push them right into frustration. Not to mention the fact that a few early successes can do a lot to build a player's confidence — and a confident player will give up less easily on a game.

Challenge is a core element of gameplay, and can be so difficult to balance that it merits its own lens.

Lens #31: The Lens of Challenge

Challenge is at the core of almost all gameplay. You could even say that a game is defined by its goals and its challenges. When examining the challenges in your game, ask yourself these questions:

- What are the challenges in my game?

- Are they too easy, too hard, or just right?

- Can my challenges accommodate a wide variety of skill levels?

- How does the level of challenge increase as the player succeeds?

- Is there enough variety in the challenges?

- What is the maximum level of challenge in my game?

Balance Type #3: Meaningful Choices

There are many different ways to give a player choices in a game. Meaningful choices for a player lead them to ask themselves questions, such as:

- Where should I go?

- How should I spend my resources?

- What should I practice and try to perfect?

- How should I dress my character?

- Should I try to get through the game quickly or carefully?

- Should I focus on offense or defense?

- What strategy should I use in this situation?

- Which power should I choose?

- Should I play it safe, or take a big risk?

A good game gives the player meaningful choices. Not just any choices, but choices that will have a real impact on what happens next, and how the game turns out. Many designers fall into the trap of offering the player meaningless choices; for

example, in a racing game, you might have 50 vehicles to choose from, but if they all drive the same way, it is like having no choice at all. Other designers fall into a different trap — offering choices that no one would want. You might offer a soldier ten guns, all different, but if one of them is clearly better than the rest, again it is like having no choice at all.

When choices are offered to a player, but one of them is clearly better than the rest, this is called a **dominant strategy**. Once a dominant strategy is discovered, the game is no longer fun, because the puzzle of the game has been solved — there are no more choices to make. When you discover that a game you are working on has a dominant strategy, you must change the rules (balance things) so that this strategy no longer dominates, and meaningful choice can be restored to the game. The previous Biplane Battle example is an example of just that — a designer trying to balance a game to remove a dominant strategy and restore meaningful choice to the players. Hidden dominant strategies that are discovered by players are often referred to as "exploits," since they can be exploited by players to take a shortcut to success that the designer never intended.

In early development of a game, dominant strategies abound. As the game continues development, these strategies start to get properly balanced. Paradoxically, this often throws novice designers into a panic: "Yesterday, I understood the right way to play this game — but with these new changes, I'm not sure about the right way to play it!" They feel like they have lost their handle on their own game. But in reality, the game has just taken a big step forward! It no longer has a dominant strategy, and now there are meaningful choices to be made. Instead of fearing this moment, you should cherish it, and take the opportunity to see if you can understand why the current configuration of rules and values is putting your game into balance.

But this leads to another question: How many meaningful choices should we give to a player? Michael Mateas points out that the number of choices a player seeks is dependent on the number of things they desire.

- If Choices > Desires, then the player is overwhelmed.
- If Choices < Desires, the player is frustrated.
- If Choices = Desires, the player has a feeling of freedom and fulfillment.

So, to properly determine the number of choices, you need to figure out the types and number of things the player would like to do. In some situations, the player wants only a small number of meaningful choices (choosing to take the left or right fork in the road is interesting — choosing to take one of 30 side roads is overwhelming). Other times, a huge number of choices are desired (for example, a clothes shopping interface in the Sims).

Meaningful choices are the heart of interactivity, and having a lens to examine them is quite useful.

Lens #32: The Lens of Meaningful Choices

When we make meaningful choices, it lets us feel like the things we do matter. To use this lens, ask yourself these questions:

- What choices am I asking the player to make?

- Are they meaningful? How?

- Am I giving the player the right number of choices? Would more make them feel more powerful? Would less make the game clearer?

- Are there any dominant strategies in my game?

Triangularity

One of the most exciting and interesting choices for a player to make is whether to play it safe, and go for a small reward, or take a big risk, to try for a big reward. This is a hard decision to make, if the game is balanced properly. I find that about eight out of ten times someone comes to me asking for help on a game prototype that "just isn't fun," the game is missing this kind of meaningful choice. You could call this "balanced asymmetric risk," since you are balancing a low risk with low reward against a high risk for high reward, but that is kind of a mouthful. This relationship comes up so often, and is so important, that I like to give it a shorter name: **triangularity**. The player is one point of the triangle, the low risk choice is the second point, and the high risk choice is the third.

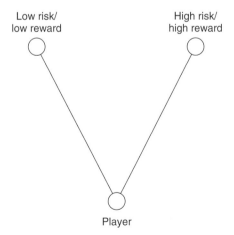

FIGURE
11.3

An example of a game that has good triangularity is Space Invaders. Most of the time in the game you are shooting at low point aliens near your ship worth 10, 20, and 30 points. They are slow-moving and easy to shoot, and shooting them

makes you safer because it stops them from dropping bombs on you. Every once in a while, however, a little red flying saucer flies across the top of the screen. It poses no threat, and it is quite difficult and dangerous to shoot. It is difficult because it is moving and far away, and dangerous because to properly aim at it, you have to take your eyes off your ship to look at it, and you risk getting hit by a bomb. However, it is worth between 100 and 300 points! Without the flying saucer, Space Invaders gets quite tedious, because your choices are few — you just shoot and shoot and shoot. With the flying saucer, you occasionally have a very difficult, meaningful choice to make — should you play it safe, or take a risk and go for the big points? Triangularity is so important that it gets its own lens.

Lens #33: The Lens of Triangularity

Giving a player the choice to play it safe for a low reward, or to take a risk for a big reward is a great way to make your game interesting and exciting. To use the Lens of Triangularity, ask yourself these questions:

- Do I have triangularity now? If not, how can I get it?

- Is my attempt at triangularity balanced? That is, are the rewards commensurate with the risks?

Once you start looking for triangularity in games, you will see it everywhere. A dull, monotonous game can quickly become exciting and rewarding when you add a dash of triangularity.

A good way to make sure your triangularity is balanced is to use Lens #28: The Lens of Expected Value. The classic game of Qix provides an interesting example of balancing with expected values. In it, you try to draw rectangular shapes to surround territory on a blank game board. While you do this, a blob of lines, called the Qix, floats around the board at random. If the Qix touches one of your rectangles before you finish drawing it, you die. But if you finish drawing the rectangle, then you claim that area of the board. When you have covered 75% of the board, you win the level.

The designers of the game give the player a very explicit choice — each time he draws a rectangle, he can either move quickly (drawing a blue rectangle) or at half speed (drawing an orange rectangle). Since moving at half speed is twice as dangerous, rectangles drawn at half speed are given double the points. This works because if we assume that the chance of successfully drawing a fast, blue rectangle is 20%, and it is worth 100 points, then the expected value of attempting to

draw one is 100 points \times 20% = 20 points. We also know that that drawing a rectangle at half speed has half the chance of succeeding, so, we get a table that looks like:

Speed	Chance of Success	Points	Expected Value
Fast (blue)	20%	100	20
Slow (orange)	10%	?	20

We want the game to be balanced, so we keep the expected value constant. It is pretty easy to see that if we want the game to be balanced, the point value should be 200 points for the same size slow rectangle. The difficult part with this kind of thing is figuring out the chance of success — we often have to estimate — but this is another case where the model informs the prototype, and testing the prototype informs the model, creating a virtuous circle where eventually the model is correct, and the game is balanced.

Balancing Type #4: Skill vs. Chance

In Chapter 10, we talked in detail about the mechanics of skill and chance. In a real sense, these are two opposing forces in any game design. Too much chance negates the effects of player skill and vice versa. There is no easy answer for this one — some players prefer games with as few elements of chance as possible, and other players prefer the opposite. Games of skill tend to be more like athletic contests — systems of judgment that determine which player is best. Games of chance often have a more relaxed, casual nature — after all, much of the outcome is up to fate. To strike the balance, you must use Lens #16: The Lens of the Player, to understand how much skill and how much chance will be the right amount for the audience of your game. Differences in preference are sometimes determined by age or gender, and sometimes even by culture; for example, German board game players seem to prefer games that minimize the effects of chance more so than, say, American players.

One very common method of balancing these is to alternate the use of chance and skill in a game. For example, dealing out a hand of cards is pure chance — but choosing how to play them is pure skill. Rolling a die to see how far you move is pure chance — deciding where to move your piece is pure skill. This can create an alternating pattern of tension and relaxation that can be very pleasing to players.

Choosing how to balance skill and chance will determine the character of your game. Examine it closely with this lens.

Lens #34: The Lens of Skill vs. Chance

To help determine how to balance skill and chance in your game, ask yourself these questions:

- Are my players here to be judged (skill), or to take risks (chance)?
- Skill tends to be more serious than chance: Is my game serious or casual?
- Are parts of my game tedious? If so, will adding elements of chance enliven them?
- Do parts of my game feel too random? If so, will replacing elements of chance with elements of skill or strategy make the players feel more in control?

Balancing Type #5: Head vs. Hands

This type of balancing is quite straightforward: How much of the game should involve doing a challenging physical activity (be it steering, throwing, or pushing buttons dexterously) and how much of it should involve thinking? These two things are not as separate as they might seem on the surface — many games involve constant strategizing and puzzle solving while simultaneously pulling off feats of speed and dexterity. Other games alternate the two types of gameplay for variety. Consider the "action platform" game genre — you work your way through a level, dexterously guiding your avatar to jump over obstacles, and maybe shooting at enemies, occasionally pausing to solve some small puzzle that prevents you from clearing the level. Often, the intensity is increased at the end of a level by a "boss monster," who can only be defeated through a mix of puzzle-solving ("Oh! I have to jump on his tail, and that makes him drop his shield for a second!") and dexterity ("I only have a second to shoot an arrow into that narrow gap!").

It is important, though, to understand what your target market prefers in a game — more thinking or more dexterity? And it is equally important that your game clearly communicate what balance you have chosen to put into it. Consider the very unusual game *Pac Man 2: The New Adventures* for the Sega Genesis. The name suggested that it would be a game of action and a little strategy, like the original Pac Man. But a quick glance at the box told another story — this appeared to be a 2D platform game, like *Super Mario Brothers*, or *Sonic the Hedgehog*, which meant action plus a little puzzle solving. But actually playing the game revealed something completely different! Though it visually looked like an action platform game, it was really a game of strange psychological puzzles, where you subtly guided Pac Man into different emotional states to get him to get past various obstacles. Players expecting mostly action and little thinking were disappointed — players looking for

a game about puzzle solving generally didn't play the game, rejecting it based on its "action-based" appearance.

When *Games Magazine* reviews a videogame, they give it a ranking on a sliding scale where one end is "fingers," and the other end is "brain." It can be easy to forget that a game with a lot of button pushing can still involve a lot of thought and strategy. Use Lens #27: The Lens of Skill to understand the different skills in your game, and then use this lens to balance those skills.

Lens #35: The Lens of Head and Hands

Yogi Berra once said "Baseball is 90% mental. The other half is physical." To make sure your game has a more realistic balance of mental and physical elements, use the Lens of Head and Hands. Ask yourself these questions:

- Are my players looking for mindless action, or an intellectual challenge?
- Would adding more places that involve puzzle-solving in my game make it more interesting?
- Are there places where the player can relax their brain, and just play the game without thinking?
- Can I give the player a choice — either succeed by exercising a high level of dexterity, or by finding a clever strategy that works with a minimum of physical skill?
- If "1" means all physical, and "10" means all mental, what number would my game get?

This lens works particularly well when used in conjunction with Lens #16: Lens of the Player.

Balance Type #6: Competition vs. Cooperation

Competition and cooperation are basic, animal urges. All higher animals are driven to compete against others partly for survival, and partly to establish their status in the community. Opposite of that, there is also a basic instinct to cooperate with others, since a team, with its many eyes and hands, and its diverse abilities, is always more powerful than an individual. Competition and cooperation are so important to our survival that we need to experiment with them — partly to get better at them, and partly to learn about our friends and family — so we get a better sense of who is good at what, and how we can work together. Games provide a very socially safe way to explore how the people around us behave in stressful situations — this is a secret reason we like to play games together.

When it comes to games, competitive games are more common than cooperative ones, though some very interesting cooperative games have been created. *Cookie and Cream* for the Playstation2 is an action platform puzzle game where two players play side by side on parallel paths trying to get through a level. And Reiner Knizia's Lord of the Rings board game is a fascinating example of a game where the players do not compete at all, but instead coordinate their efforts in an attempt to win the game together.

Some games find interesting ways to blend competition and cooperation. The arcade game *Joust* can be played solo, where a player competes against many computer-controlled enemies, or it can be played in a two-player mode, where both players compete against enemies together in the same arena. There is a tension between competition and cooperation in *Joust* that is very interesting: On the competitive side, the players get points based on how many enemies they defeat, and they can battle each other if they choose. But on the cooperative side, players can get higher scores overall if they coordinate their attacks and protect each other. It is up to the players to decide whether they are trying to beat each other (getting the highest relative score) or trying to beat the game (trying to get the highest absolute score). The game plays up this tension: some levels are designated "Team Wave" — if both players can survive the level, they each get 3000 bonus points. Other levels are designated "Gladiator Wave" — the first player who defeats another gets 3000 bonus points. This interesting alternation between cooperation and competition gives the game a lot of variety, and lets players explore whether their partner is more interested in cooperation or competition.

And while competition and cooperation are polar opposites, they can be quite conveniently combined into a situation where you get the best of both. How? Through team competition! Common in athletic sports, the rise of networked gaming has allowed team competition to grow and thrive in the world of videogames.

Competition and cooperation are so important that we need three lenses to examine them properly.

Lens #36: The Lens of Competition

Determining who is most skilled at something is a basic human urge. Games of competition can satisfy that urge. Use this lens to be sure your competitive game makes people want to win it. Ask yourself these questions:

- Does my game give a fair measurement of player skill?
- Do people want to win my game? Why?
- Is winning this game something people can be proud of? Why?
- Can novices meaningfully compete at my game?
- Can experts meaningfully compete at my game?
- Can experts generally be sure they will defeat novices?

Lens #37: The Lens of Cooperation

Collaborating and succeeding as a team is a special pleasure that can create lasting social bonds. Use this lens to study the cooperative aspects of your game. Ask these questions:

- Cooperation requires communication. Do my players have enough opportunity to communicate? How could communication be enhanced?

- Are my players friends already, or are they strangers? If they are strangers, can I help them break the ice?

- Is there synergy ($2 + 2 = 5$) or antergy ($2 + 2 = 3$) when the players work together? Why?

- Do all the players have the same role, or do they have special jobs?

- Cooperation is greatly enhanced when there is no way an individual can do a task alone. Does my game have tasks like that?

- Tasks that force communication inspire cooperation. Do any of my tasks force communication?

Lens #38: The Lens of Competition vs. Cooperation

Balancing competition and cooperation can be done in many interesting ways. Use this lens to decide whether they are balanced properly in your game. Ask these questions:

- If "1" is Competition and "10" is Cooperation, what number should my game get?

- Can I give players a choice whether to play cooperatively or competitively?

- Does my audience prefer competition, cooperation, or a mix?

- Is team competition something that makes sense for my game? Is my game more fun with team competition, or with solo competition?

As more and more games go online, more opportunities for different types of competition and collaboration become available, from casual multiplayer games of chess between two people to competing guilds of thousands of players in MMORPGs. But the psychological forces that drive us to enjoy competition and cooperation have not changed — the better you can understand and balance these forces, the stronger your game will become.

Balance Type #7: Short vs. Long

One important thing to balance in every game is the length of the gameplay. If the game is too short, players may not get a chance to develop and execute meaningful strategies. But if the game goes on too long, players may grow bored, or they may avoid the game because playing it requires too much of a time commitment.

The things that determine the length of a game are often subtle. The game of Monopoly, for example, when played by the official rules, often ends in about ninety minutes. But many players find these rules too harsh, and modify them to give out cash jackpots, and ease the restrictions on when you must purchase properties, which as a side effect makes the game last much longer, typically three hours, or even more.

The main factors that determine when a game ends are the win or lose conditions. By altering these conditions, you can dramatically change the length of the game. The designers of the arcade game *Spy Hunter* came up with a very interesting system to balance the length of their game. In *Spy Hunter*, you drive a car that fires machine guns at enemies on a highway. In early prototypes, when your car was destroyed three times, the game was over. The game is very challenging, particularly for novice players, and the designers found that these players were having very short games, and feeling frustrated — so they introduced a new rule: For the first ninety seconds of gameplay, the player has an unlimited supply of cars — they cannot lose the game during this time. After that time is up, they only have a few cars, and when they are destroyed, the game is over.

The designers of *Minotaur* (who later went on to make *Halo*) had another interesting method of balancing the length of their game. *Minotaur* was a networked game where up to four players would run around a maze, gathering weapons and spells, and try to destroy the other players in the maze. The game ends when only one player is left alive. The designers saw a problem where a stalemate could result if players don't confront each other, and the game would run the risk of becoming boring. One way to solve the problem would be to set a time limit, and declare a winner based on a point system, but instead they did something much more elegant. They created a new rule: After twenty minutes, a bell sounds, and "Armageddon" begins: all surviving players are suddenly transported to a small room filled with monsters and other hazards, where no one can survive for long. This way, the game is guaranteed to end in less than 25 minutes, in a rather dramatic fashion, and one player can still be declared the winner.

To properly balance the length of your games, you will want to use the Lens of Time.

Balance Type #8: Rewards

Why is it that people will spend so much time playing a videogame, just to get a good score? We have talked earlier about how games are structures of judgment, and that people want to be judged. But people don't just want any judgment — they

Lens #39: The Lens of Time

It is said that "timing is everything." Our goal as designers is to create experiences, and experiences are easily spoiled when they are too short or too long. Ask these questions to make yours just the right length:

- What is it that determines the length of my gameplay activities?

- Are my players frustrated because the game ends too early? How can I change that?

- Are my players bored because the game goes on for too long? How can I change that?

- Setting a time limit can make gameplay more exciting. Is it a good idea for my game?

- Would a hierarchy of time structures help my game? That is, several short rounds that together comprise a larger round?

Timing can be very difficult to get right, but it can make or break a game. Often, it makes sense to follow the old vaudevillian adage of "Leave 'em wanting more."

want to be judged favorably. Rewards are the way the game tells the player "you have done well."

There are several common types of rewards that games tend to give. Each is different, but they all have one thing in common — they fulfill the player's desires.

- **Praise**. The simplest of rewards, the game just tells you that you did good work, either through an explicit statement, a special sound effect, or even an in-game character speaking to you. It all amounts to the same thing: the game has judged you, and it approves. Nintendo games are famous for giving players lots of secondary praise via sounds and animations for every reward they get.

- **Points**. In many games, points serve no purpose than a measure of the player's success, be it through skill or luck. Sometimes these points are a gateway to another reward, but often, this measurement of your success is enough — particularly if others can see it on a high score list.

- **Prolonged Play**. In many games (pinball, for example), the goal of the game is to risk resources (in pinball, your ball) to rack up as many points as possible without losing what you have put at risk (your ball down the drain). In games with this structure of "lives," the most valuable reward a player can get is an extra life. Other games that have time limits reward players by adding time to their play session, which really amounts to the same thing. Prolonged play is desirable

because it allows for a higher score and a measure of success, but it also taps into our natural human drive for survival.

- **A Gateway**. While we have a desire to be judged favorably, we also have a desire to explore. Game structures that reward success by moving you to new parts of the game satisfy this basic urge. Anytime you earn access to a new level, or win a key to a locked door, you have received a gateway reward.

- **Spectacle**. We like to enjoy beautiful and interesting things. Often, games will play music or show animations as a simple reward. The "intermission" at the end of level 2 in *Pac Man* was probably the first example of this in a videogame. This kind of reward seldom satisfies players on its own, so it tends to be paired with other types of rewards.

- **Expression**. Many players like to express themselves within a game with special clothes or decorations. Even though these often have nothing to do with a goal in the game, they can be great fun for a player, and satisfy a basic urge to make a mark on the world.

- **Powers**. Becoming more powerful is something that everyone desires in real life, and in a game, becoming more powerful is likely to improve the game's judgment of a player's success. These powers can come in many forms: Getting "kinged" in checkers, becoming tall in *Super Mario World*, speeding up in *Sonic the Hedgehog*, getting special weaponry in *Quake*. The thing all powers have in common is that they give you a way to reach your goal more quickly than you could before.

- **Resources**. While casino games and lotteries reward the player with real money, videogames more frequently reward the player with resources they can only use in the game (e.g., food, energy, ammunition, hit points). Some games, instead of giving resources directly, give virtual money that the player can choose how to spend. Usually the things that one can buy with this money are resources, powers, prolonged play, or expression.

- **Completion**. Completing all the goals in a game gives a special feeling of closure to players that they seldom get from solving problems in real life. In many games, this is the ultimate reward — when you have reached this point, there is often no point in playing the game any further.

Most of the rewards you will encounter in games fall into one or more of the above categories, though these categories are often combined in interesting ways. Many games reward the player with points, but when the points reach a certain score, the player gets a bonus reward of an extra life (resource, prolonged play). Often, players will get a special item (resource) that lets them do something new (powers). Other games let a player enter their name or draw a picture (expression) if they get a high score (points). Some games show a special animation (spectacle) at the end (completion) if the player unlocks every area in the game (gateway).

But how to balance these rewards? That is, how many should be given out, and which ones? This is a difficult question, and the answer is different for almost every

game. Generally, the more types of rewards you can work into your game, the better. Two other reward rules of thumb from the world of psychology include:

- People have a tendency to get acclimated to rewards the more they receive them, and what was rewarding an hour ago is no big deal now. One simple method many games use to overcome this is to gradually increase the value of the rewards as the player progresses in the game. In a way, this is a cheesy trick, but it works — even when you know the designer is doing it and why, it still feels very rewarding to suddenly get bigger rewards in conjunction with getting to a new part of a game.

- A good way to keep people from getting acclimated to rewards is to make them variable instead of fixed. In other words, if every monster you defeat gives you ten points, that gets predictable and boring pretty quickly — but if every monster you defeat has a 2/3 chance of giving you zero points, but a 1/3 chance of giving you thirty points, this stays rewarding for a much longer time, even though you are giving out the same number of points on average. It's like bringing donuts to work — if you bring them every Friday, people will come to expect them and take them for granted. But if you bring them every now and then on random days, they are a delightful surprise each time.

Lens #40: The Lens of Reward

Everyone likes to be told they are doing a good job. Ask these questions to determine if your game is giving out the right rewards in the right amounts at the right times:

- What rewards is my game giving out now? Can it give out others as well?

- Are players excited when they get rewards in my game, or are they bored by them? Why?

- Getting a reward you don't understand is like getting no reward at all. Do my players understand the rewards they are getting?

- Are the rewards my game gives out too regular? Can they be given out in a more variable way?

- How are my rewards related to one another? Is there a way that they could be better connected?

- How are my rewards building? Too fast, too slow, or just right?

Balancing rewards is different for every game. Not only does a designer have to worry about giving out the right ones, but giving them at the right times in the right amounts. This can only be determined through trial and error — even then, it probably won't be right for everyone. When trying to balance rewards, it is hard to be perfect — you often have to settle for "good enough."

Balance Type #9: Punishment

The idea of a game that punishes the player can seem a little strange — aren't games supposed to be fun? Paradoxically, though, punishment used properly can increase the enjoyment that players get from games. Here are some reasons that a game might punish players:

- **Punishment creates endogenous value**. We've talked about the importance of creating value within a game (Lens #5: The Lens of Endogenous Value). Resources in a game are worth more if there is a chance they can be taken away.

- **Taking risks is exciting**. Particularly if the potential rewards are balanced against the risks! But you can only take risks if there are negative consequences or punishments. Giving players a chance to risk terrible consequences makes success much, much sweeter.

- **Possible punishment increases challenge**. We've discussed the importance of challenging players — when failure means a punishing setback in the game, the challenge of play increases. Increasing the punishment that comes with failure can be one way to increase the challenge.

Here are some common types of punishment used in games. Many of them are simply rewards in reverse.

- **Shaming**. The opposite of praise, this is simply the game telling you that you are doing a bad job. This can happen with explicit messages (e.g., "Missed" or "Defeated!"), or with discouraging animations, sound effects, and music.

- **Loss of points**. Players find this type of punishment so painful, that it is relatively rare in videogames or even in traditional games and sports. Maybe it is less an issue of it being painful, and more the fact that when players can lose points, it cheapens of the value of earned points. Points that can't be taken away are very valuable — points that could be subtracted on the next bad move have less endogenous value.

- **Shortened Play**. "Losing a life" in a game is an example of this kind of punishment. Some games that work on a timer will shorten play by taking time off the clock.

- **Terminated Play**. Game over, man.

- **Setback**. When, after dying, a game returns you to the start of a level, or to the last checkpoint, this is a setback punishment. In games that are all about proceeding to the end, a setback is a very logical punishment. The balancing challenge is to figure out exactly where the checkpoints belong to make the punishments seem meaningful, but not unreasonable.

- **Removal of Powers**. The designer must tread carefully here — players greatly treasure the powers they have earned, and to have them taken away may feel

unfair to them. In Ultima Online, players who were killed in battle turned into ghosts. To come back to life they had to find their way to a shrine. If they took too long getting there, they would lose valuable skill points that had taken weeks to earn. Many players felt this was too harsh a punishment. One way to remove powers fairly is to take them away temporarily. Some amusement parks feature bumper car battle tanks that shoot tennis balls at each other. The tanks have targets on each side, and if an opponent hits one of your targets with a tennis ball, your tank goes into an uncontrolled spin for five seconds, and your gun becomes inoperable during that time.

- **Resource Depletion**. Loss of money, goods, ammunition, shields, or hit points fall into this category. This is one of the most common types of game punishment.

One thing that psychological study has shown is that reward is always a better tool for reinforcement than punishment. Whenever possible, if you need to encourage a player to do something, it is better to use a reward than a punishment, if you can. One great example from Blizzard's game *Diablo* is the business of gathering food in games. Many game designers at one time or another get the idea that they would like to make a game with a "realistic" system of food gathering. That is, if you do not gather food, your character suffers from diminished powers because of hunger. Blizzard implemented this, and found that players considered it a nuisance — they must perform a fairly boring activity, or suffer a penalty. So, Blizzard turned it around, and implemented a system where your player never gets hungry, but if they do eat food, they get a temporary boost in abilities. Players liked this much better. By changing a punishment into a reward, they were able to turn the same activity from a negative to a positive.

When punishment is necessary, however, how much to use is a delicate question. When developing Toontown Online, we had to face the question of what was to be the harshest punishment in a light, fun, MMORPG for kids. We ultimately decided on a combination of light punishments for "dying," which in Toontown is called "becoming sad," for the game is so lighthearted that players do not have a life meter, but rather a laff meter, and the enemy's goal is not to kill the player outright, but just to make him sad enough to stop acting like a cartoon character. When your laff meter goes to zero in Toontown, these things happen:

- You are teleported from the battle area back to a playground zone (setback). This setback is very minor — the distance is usually only a minute's walk.

- All the items you are carrying disappear (resource depletion). This is also minor — the items are inexpensive, and can be earned again in about 10 minutes of play.

- Your character hangs his or her head sadly (shame).

- For about 30 seconds, your character walks at a painfully slow pace and is unable to leave the playground zone or engage in any meaningful gameplay (temporary removal of powers).

193

- Your laff meter (hit points) goes to zero (resource depletion), and the player will probably want to wait for it to increase (it increases over time in a playground zone) before exploring again.

This combination of light punishments is just enough to make players use caution in battles. We tried lighter versions, and it made battles boring — there was no risk in them. We tried tougher versions, and it made players too cautious in battles. Eventually we settled on a combination which struck an appropriate balance between encouraging caution and risk in the players.

It is crucial that all punishment in a game is for things that the player is able to understand and prevent. When punishment feels random and unstoppable, it makes the player feel a complete lack of control, which is a very bad feeling, and the player will quickly label the game "unfair." Once this happens, a player is seldom willing to engage in a game further.

Players dislike punishment, of course, and you must be thoughtful about whether there are tricky ways that players can avoid your punishment. Richard Garriot's game *Ultima III*, though greatly beloved, contained very strict punishment. It was a game that took close to one hundred hours to complete, and if your four characters perished while you were playing, your game state was completely erased, and you had to begin the game again! Players generally felt this was unfair, and as a result, it was common practice if your characters were near death to shut off the computer before the game had a chance to erase the saved game, effectively dodging the punishment.

It is worth mentioning that there is a certain class of player that lives for games that are insanely challenging and loves games that have strong punishments, because they can feel so proud about having beaten such a difficult game. These players are a fringe group, though, and even they have their limits. They will quickly call a game "unfair" if they cannot see how to prevent punishment.

Lens #41: The Lens of Punishment

Punishment must be used delicately, since after all, players are in a game of their own free will. Balanced appropriately, it will give everything in your game more meaning, and players will have a real sense of pride when they succeed at your game. To examine the punishment in your game, ask yourself these questions:

- What are the punishments in my game?
- Why am I punishing the players? What do I hope to achieve by it?
- Do my punishments seem fair to the players? Why or why not?
- Is there a way to turn these punishments into rewards and get the same, or a better effect?
- Are my strong punishments balanced against commensurately strong rewards?

Balance Type #10: Freedom vs. Controlled Experience

Games are interactive, and the point of interactivity is to give the player control, or freedom, over the experience. But how much control? Giving the player control over everything is not only more work for the game developer; it can also be boring for the player! After all, a game isn't meant to be a simulation of real life, but rather more interesting than real life — this sometimes means cutting out boring, complex, or unnecessary decisions and actions. One simple kind of game balance that every designer must consider is where to give the player freedom, and how much freedom to give.

In *Aladdin's Magic Carpet VR Adventure*, we were faced with a very difficult problem in the final scene within the Cave of Wonders. To make the conflict with Jafar, the villain, be as exciting as possible, we needed to take control of the camera. But we didn't want to compromise the freedom that players felt in the scene. Observing players during playtests, though, they all wanted to do the same thing — fly to the top of the hill where Jafar was standing. After several experiments, we made a bold decision — we would take away freedom from the players in this scene so they could have a perfect flight up the hill to confront Jafar. This was in sharp contrast to the rest of the experience, where players could fly wherever they wanted with no restrictions. In our tests, not a single one of our playtesters noticed we had taken away their freedom, because the game had trained them that they could go wherever they wanted, and this scene happened to be arranged such that everyone who viewed it wanted the same thing. We decided that this was a case where the balance should fall on the side of controlled experience instead of freedom, because it made for a better experience for the player.

Balance Type #11: Simple vs. Complex

Simplicity and complexity of game mechanics can seem very paradoxical. Calling a game "simple" can be a criticism, such as "so simple it is boring." It can also be a compliment: "so simple and elegant!" Complexity can also be a double-edged sword. Games are criticized as "overly complex and confusing," or complimented as "richly and intricately complex." To make sure your game has the "good simplicity" and the "good complexity," but not the bad, we need to look at the nature of simplicity and complexity in games and how to strike the right balance between them.

So much praise is heaped on classic games for being ingeniously simple that it might make you think that making a complex game is a bad thing. Let's look at the different kinds of complexity that show up in games:

- **Innate complexity**. When the very rules of the game get very complex, I call this innate complexity. This is the kind of complexity that often gets a bad name. It generally arises either because the designer is trying to simulate a complex real-world situation, or because extra rules need to be added to a game in order to

balance it. When you see a ruleset with lots of "exception cases," this is generally a ruleset that is innately complex. Games like this can be hard to learn, but some people really enjoy mastering the complex rulesets.

• **Emergent complexity**. This is the kind of complexity that everyone praises. Games like *Go* that have a very simple ruleset that gives rise to very complex situations are said to have emergent complexity. When games are praised for being simple and complex at the same time, it is the emergent complexity that is being praised.

Emergent complexity can be difficult to achieve, but is worth the effort. Ideally, one can create a simple ruleset out of which emerges the thing every game designer strives for: *balanced surprises*. If you can design a simple game that becomes a factory for a never-ending stream of balanced surprises, people will play your game for centuries to come. The only way to find out whether you have achieved this is to keep playing and changing your game over and over until the surprises start to come. Of course, using Lens #23: The Lens of Emergence can help, too.

So, if emergent complexity is so great, why would anyone make a game that is innately complex? Well, sometimes you need the innate complexity to simulate a real-world situation, such as re-creating a historical battle. Other times, you add more innate complexity to balance your game a little better. The pawns in chess have movement rules that are innately complex: When they move, they can only move forward one square, into an unoccupied space, *unless* it is their first move, in which case they can move one or two spaces. One exception to this is when they are capturing another piece; in that case, they can only move diagonally forward, but only one square, even if it is their first move.

This rule has some innate complexity (some keywords of innate complexity: "unless," "except," "exception," "but," and "even if"), but it is one that evolved gradually in an attempt to make sure pawns had a behavior that was well-balanced and interesting. And, in fact, it is well worth it, for this small amount of innate complexity blossoms into a great deal more emergent complexity — particularly because the pawns can only move forward, but capture diagonally — that leads to fascinatingly complex pawn structures that can form on the board that would never be possible with a simpler ruleset.

Lens #42: The Lens of Simplicity/Complexity

Striking the right balance between simplicity and complexity is difficult and must be done for the right reasons. Use this lens to help your game become one in which meaningful complexity arises out of a simple system. Ask yourself these questions:

• What elements of innate complexity do I have in my game?

- Is there a way this innate complexity could be turned into emergent complexity?
- Do elements of emergent complexity arise from my game? If not, why not?
- Are there elements of my game that are too simple?

Natural vs. Artificial Balancing

Designers must be careful when adding innate complexity in an attempt to balance a game, however. Adding too many rules to get the behavior you want is sometimes called "artificial balancing" as opposed to the "natural balancing" that can come when a desired effect arises naturally from the interactions in a game. Consider *Space Invaders*: It has a wonderful balance of increasing difficulty that forms very naturally. The invaders adhere to a very simple rule — the fewer there are, the faster they go. From this some very desirable properties emerge:

1. The game starts slow, and speeds up the more the player succeeds.
2. It is easy to hit targets in the beginning, but the more the player succeeds, the harder it is to hit targets.

Those two properties are not the result of innate rules, but rather, nicely balanced properties that emerge from a single simple rule.

Elegance

We call simple systems that perform robustly in complex situations *elegant*. Elegance is one of the most desirable qualities in any game, because it means you have a game that is simple to learn and understand, but is full of interesting emergent complexity. And while elegance can seem somewhat ineffable and hard to capture, you can easily rate the elegance of a given game element by counting the number of purposes it has. For example, the dots in *Pac Man* serve the following purposes:

1. They give the player a short-term goal: "Eat the dots close to me."
2. They give the player a long-term goal: "Clear all the dots from the board."
3. They slow the player down slightly when eating them, creating good triangularity (safer to go down a corridor with no dots, riskier to go down one with dots).
4. They give the player points, which are a measure of success.
5. They give the player points, which can earn an extra life.

Five different purposes, just for those simple dots! This makes them very elegant. You can imagine a version of *Pac Man* where the dots did not do all those things; for example, if the dots didn't slow the player down, and didn't award points or extra lives, they would have less purpose, and be less elegant. There is an old Hollywood rule of thumb: If a line in a script doesn't serve at least two purposes, it should be cut. Many designers, when they find their game doesn't feel right, first think, "Hmm... what do I need to add?" Often, a better question is "What do I need to remove?" One thing I like to do is look for all the things in my game that are only serving one purpose and think about which of them can be combined.

In working on *Pirates of the Caribbean: Battle for the Buccaneer Gold*, we originally planned to have two main characters: a friendly host at the start of the game whose only job was to explain how to play, and a villain at the end of the game, whose only purpose was to engage in a dramatic final battle. This was a short (five minute) game for Disneyworld, and it felt strange to have to use up time to introduce both of these two characters, and it was a strain on the budget as well to make them both look good. We started talking about just cutting either the tutorial at the beginning, or the battle at the end, but they were both very important for a fulfilling game. Then we hit on an idea: What if the host at the beginning also was the villain at the end? This not only saved us development time, but saved game time since we only needed to introduce one character. Further, it made the character seem more interesting and a more credible pirate (since he tricks the player), and it also created a surprising plot twist! By giving this one character several purposes, it made for a game structure we felt was very elegant indeed.

Lens #43: The Lens of Elegance

Most "classic games" are considered to be masterpieces of elegance. Use this lens to make your game as elegant as possible. Ask yourself these questions:

- What are the elements of my game?
- What are the purposes of each element? Count these up to give the element an "elegance rating."
- For elements with only one or two purposes, can some of these be combined into each other, or removed altogether?
- For elements with several purposes, is it possible for them to take on even more?

Character

As important as elegance is, though, there is such a thing as honing a thing down too far. Consider the leaning tower of Pisa. Its significant tilt serves no purpose — it is an accidental flaw. The lens of elegance would have us remove its tilt and

turn it into the perfectly straight tower of Pisa. But who would want to visit that? It might be elegant, but it would be boring — it would have no *character*. Think of the tokens in Monopoly: a hat, a shoe, a dog, a statue, a battleship. They have nothing to do with a game about real estate. Arguably, they should be themed as little landlords. But no one would do that, because it would strip Monopoly of its character. Why is Mario a plumber? It has almost nothing to do with what he does or the world he lives in. But this weird inconsistency gives him character.

Lens #44: The Lens of Character

Elegance and character are opposites. They are like miniature versions of simplicity and complexity, and must be kept in balance. To make sure your game has lovable, defining quirks, ask yourself these questions:

- Is there anything strange in my game that players talk about excitedly?
- Does my game have funny qualities that make it unique?
- Does my game have flaws that players like?

Balance Type #12: Detail vs. Imagination

As we discussed in Chapter 9, the game is not the experience — games are simply structures that engender mental models in the mind of the player. In doing so, the games provide some level of detail, but leave it to the player to fill in the rest. Deciding exactly what details should be provided and which should be left to the player's imagination is a different, but important kind of balance to strike. Here are some tips for how to do it well.

- **Only detail what you can do well**. Players have rich, detailed imaginations. If there is something you need to present that is of lower quality than your players will be able to imagine, don't do it — let the imagination do the heavy lifting! Let's say you would like to play recorded dialog for your whole game, but you don't have the budget for quality voice actors, or you don't have the storage space for all that dialog. An engineer might suggest trying speech synthesis; that is, letting the computer speak for the characters. After all, it is cheap, requires no storage space, and can be tuned somewhat to sound like different characters, right? All that is true — but also, it will make everyone sound like a robot, and unless you are making a game about robots, your players will not be able to take it seriously. An even cheaper alternative is to use subtitles. Some people might claim that this means there is no voice at all! But that isn't true. The player's imagination will fill in a voice — a voice far better than the one you will be able to synthesize. This same idea goes for just about everything in the game: scenery, sound effects, characters, animations, and special effects. If you can't do it well, try to find a way to leave it to the player's imagination.

- **Give details the imagination can use**. Players have a lot to learn when they come to a new game — any clear details you can give them that make the game easier to understand will be welcome. Consider the game of chess. It is mostly a somewhat abstract game, but some interesting details have been filled in. The game is set in a medieval era, and the pieces, which could easily could have been numbered, or just made as abstract shapes, are given the roles of people in a medieval court. It isn't a lot of detail — the kings, for example, don't have names, and we know nothing about their kingdoms or their policies — but none of that matters. In fact, if this were to be a real simulation of an army between two kingdoms, the rules of movement and capture would make no sense at all! What matters about the "kings" in chess is that the tallest of the chess pieces has movements that are slightly evocative of a real king. He is important, and must move slowly, and must be carefully guarded. Any other details can be left to the imaginations of the players to fill in as they see fit. Similarly, picturing the "knights" as horses helps us remember that they can jump around the board in ways the others cannot. By giving details that help our imaginations better grasp their functionality the game becomes much more accessible to us.

- **Familiar worlds do not need much detail**. If you are creating a simulation of something that the player is likely to know very well, such as a city street, or a house interior, you have little need to simulate every little detail — since the player already knows what these places are like, they will quickly fill them in with imagination, if you give them a few relevant details. If the point of your game, though, is to educate someone about a place they have never been before, imagination will be of little help, and you will find it necessary to fill in a great deal of detail.

- **Use the binocular effect**. When spectators bring binoculars to an opera or a sporting event, they use them mostly at the beginning of the event, to get a close-up view of the different players or performers. Once this close-up view has been put into memory, the glasses can be set aside, for now the imagination goes to work, filling in the close-ups on the tiny distant figures. Videogames replicate this effect all the time, often by showing a close-up of a character at the beginning of the game who is going to be an inch-high sprite for the rest of the experience. It is an easy way to use a little detail to get a lot of imagination.

- **Give details that inspire imagination**. Again, chess is a great example. To be able to control all the members of a royal army is a fantasy that the mind quickly takes to — and of course, it is a fantasy — it only has to be tied to reality by a thin thread. Giving players situations they can easily fantasize about lets their imagination take wing, and all kinds of imaginary details will quickly crystallize around one little detail that the designer provided.

We will talk more about the balance between detail and imagination in Chapter 18, since deciding what to leave to the imagination is a key question when it comes to characters in games. Because the imagination of the player is where the game playing experience takes place, the Lens of Imagination is an important tool.

Lens #45: The Lens of Imagination

All games have some element of imagination and some element of connection to reality. Use this lens to help find the balance between detail and imagination. Ask yourself these questions:

- What must the player understand to play my game?
- Can some element of imagination help them understand that better?
- What high-quality, realistic details can we provide in this game?
- What details would be low quality if we provided them? Can imagination fill the gap instead?
- Can I give details that the imagination will be able to reuse again and again?
- What details I provide inspire imagination?
- What details I provide stifle imagination?

Game Balancing Methodologies

We have discussed a great number of things that can be balanced within games. Let us now turn our attention to general methods of balancing that can be broadly applied to many types of balancing. You may find you can use some of these together, but others are contradictory — this is because different designers prefer different methods. You must experiment to find the method that is right for you.

- **Use the Lens of the Problem Statement**. Earlier, we discussed the importance of clearly stating your design problems before jumping to solutions. An out-of-balance game is a problem that will benefit greatly from a clear problem statement. Many designers end up making a mess of their games by jumping in with balancing solutions before they have thought clearly about what the problem really is.
- **Doubling and halving**.

You never know what is enough unless you know what is more than enough.

– William Blake, *Proverbs of Hell*

The rule of doubling and halving suggests that when changing values to balance your game, you will waste time by changing them by small amounts. Instead, start by doubling or halving your values in the direction they need to go. For example, if a rocket does 100 points of damage, and you think that perhaps that is too much, don't decrease it by 10 or 20, but rather set the damage value to 50, and see how that works. If that is too low, then try a number halfway between 50 and 100. By pushing the values farther than your intuition tells you, the limits of good balance start to become clear more quickly.

This rule is often attributed to Brian Reynolds, Chief Designer and Creative Director at Big Huge Games. I contacted him to ask about it, and he had this to say:

"That's indeed a principle I regularly use (and espouse), but the original credit for it goes to none other than the illustrious Sid Meier. I often tell the story of how he took me aside as a young designer (when he caught me repeatedly changing something by 10%, I'm sure) back in the early 90s when we were working on *Colonization*, and it's probably through the retelling of the story that it got associated with me. The point of the rule is to change something so that you can actually feel the difference right away. That gives you a much clearer idea of the workings of the variable you are changing, and saves you getting lost in the weeds wondering if you have even had an effect (or worse, seeing a change where none has really been accomplished, perhaps because of an unusual series of random numbers)."

- **Train your intuition by guessing exactly.** The more game design you do, the better your intuition will become. You can train your intuition for better game balancing by getting in the practice of guessing exactly. For example: if a projectile in your game is moving at 10 feet per second, and you get the feeling that is too slow, concentrate on what the exact number might be. Maybe your intuition tells you that 13 is too low, but 14 is a little too high. "13.7? No... Maybe 13.8. Yes — 13.8 just feels right." Once you have arrived at this intuitive guess, plug it in and see. You might find it is too low, or too high, or maybe even exactly right. Regardless, you will have just given your intuition some excellent data for when you guess next time. You can experience the same thing with your microwave oven. It is hard to know exactly what time to put in when reheating leftovers. And if you just make rough guesses, rounded to 30 seconds, you'll never get much better at guessing. But if you guess exactly every time you put food in the microwave (1:40? Too hot... 1:20? Too cold... 1:30? Hmm... no, 1:32 seems right), in a couple months you will be able to make surprisingly accurate guesses because you will have trained your intuition.

- **Document your model**. You should write down what you think the relationships are between the things you are balancing. This will help clarify your thoughts and give you a framework to record the results of your game balancing experiments.

- **Tune your model as you tune your game**. As was mentioned in the "asymmetrical game" section near the start of this chapter, as you experiment with balancing your game, you will develop a better model about how things are related within the game. With each balancing experiment that you try, you should not only note whether it improved your game, but whether the experiment matches your model for how game mechanics are related. Then you should alter your model if it doesn't match what you expected. Writing down your observations and your model helps a great deal!

- **Plan to balance**. You know you are going to have to balance your game. As you are designing it, you might have a pretty good idea of what aspects of it you will

need to balance. Take advantage of that, and put in systems that make it easy to change the values you expect to have to balance. If you can change these values while the game is running, that is even better! The Rule of the Loop is in full force while you are game balancing.

- **Let the players do it**. Every once in a while you will run in to a designer who has this bright idea: "Let's let the players balance the game! That way they can pick the values that are right for them!" This sounds good in theory (who wouldn't want a game that was custom tailored for a personalized level of challenge?) but tends to fail in practice because players have a conflict of interest. Yes, they want the game to give them a challenge, but at the same time, they want to win the game as easily as they can! And when all the values are set that way (Look at me! I have a million lives!), it is a quick rush of fun that quickly gets boring since there is no challenge left. Worst of all, returning from an overpowered game to a reasonable game balance is a little like trying to kick heroin — the lack of power makes the ordinary game feel limiting and dull. The Monopoly example serves us well again: People who play with the player-created rule that you get a jackpot when you land on Free Parking complain that the game goes on too long, but if you convince them to play by the official rules (that have no such jackpots), they often complain that it seems less exciting than the old way. There are times when letting the players balance the game is a good idea (usually through difficulty levels), but mostly, balancing the game is better left to the designers.

Balancing Game Economies

One of the more challenging structures to balance in any game is a "game economy." The definition of a game economy is simple. We talked earlier about how to balance meaningful decisions, and that is just what any economy is defined by — two meaningful decisions; namely

- How will I earn money?
- How will I spend the money I have earned?

Now, "money" in this context can be anything that can be traded for something else. If your game lets players earn skill points, and then spend them on different skills, those skill points are money. What is important is that players have the two choices described above — that is what makes an economy. What makes for a meaningful economy is the depth and meaning in those two choices. And these two choices are usually in a loop, because usually players spend their money in ways that will help them earn more money, which will give them more opportunities to spend money, etc.

Balancing economies, particularly in large online multiplayer games, where players can buy or sell items to each other, can be very difficult, because you are really balancing many of the things we have already discussed at once:

- **Fairness**: Do any players get unfair advantage by buying certain things, or earning a certain way?
- **Challenge**: Can players buy something that makes the game too easy for them? Is earning money to buy what they want too hard?
- **Choices**: Do players have enough ways to earn money? To spend money?
- **Chance**: Is earning money more skill-based or chance-based?
- **Cooperation**: Can players pool their funds in interesting ways? Can they collude in a way that exploits "holes" in the economy?
- **Time**: Does it take too long to earn money, or is it earned too quickly?
- **Rewards**: Is it rewarding to earn money? To spend money?
- **Punishment**: How do punishments affect a player's ability to earn and spend money?
- **Freedom**: Can players buy what they want, and earn the way they want?

There are many different ways to balance economies in games, from controlling how much money is created by the game, to controlling the different ways to earn and spend it. But the goals of balancing a game economy are the same as balancing any other game mechanics — to be sure the players can enjoy a fun, challenging game.

Lens #46: The Lens of Economy

Giving a game an economy can give it surprising depth and a life all its own. But like all living things, it can be difficult to control. Use this lens to keep your economy in balance:

- How can my players earn money? Should there be other ways?
- What can my players buy? Why?
- Is money too easy to get? Too hard? How can I change this?
- Are choices about earning and spending meaningful ones?
- Is a universal currency a good idea in my game, or should there be specialized currencies?

Dynamic Game Balancing

Dreamy young game designers frequently speak of their desire to create a system that will "adjust to the player's skill level on the fly." That is, if the game is too easy or too difficult for a player, the game will detect this, and change the difficulty until it is at the right level of challenge for the player. And this is a beautiful dream. But it is a dream that is rife with some surprising problems.

- **It spoils the reality of the world**. Players want to believe, on some level, that the game world they are playing in is real. But if they know that all of their opponents' abilities are not absolute, but relative to the player's skill level, it damages the illusion that these opponents are fixed challenges to be met and mastered.

- **It is exploitable**. If players know the game will get easier when they play badly, they may choose to play badly just to make an upcoming part of the game easy to get through, completely defeating the purpose of the self-balancing system.

- **Players improve with practice**. *The Incredible Hulk* for the Playstation 2 caused some controversy by making the enemies get easier if you were defeated by them more than a certain number of times. Many players felt insulted by this, and others felt disappointed — they wanted to keep practicing until they could master the challenge, and the game took away that pleasure.

This is not to say that dynamic game balancing is a dead end. I only mean to point out that implementing such a system is not so straightforward. I suspect that advances in this area will involve some very clever, counter-intuitive ideas.

The Big Picture

Game balancing is a big topic both in breadth and depth. I have tried to cover as many major points as possible, but each game has unique things that need to be balanced, so it would be impossible to cover everything. Use the Lens of Balance to look for any balancing problems the other lenses might have missed.

Lens #47: The Lens of Balance

There are many types of game balance, and each is important. However, it is easy to get lost in the details and forget the big picture. Use this simple lens to get out of the mire, and ask yourself the only important question:

- Does my game feel right? Why or why not?

TWELVE

Game Mechanics Support *Puzzles*

FIGURE
12.1

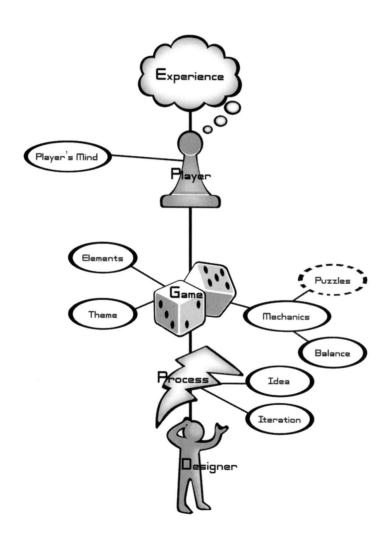

Puzzles are wonderful mechanisms that form key parts of many games. Sometimes they are very visible, and other times they are so enmeshed into the gameplay as to make them hidden, but what all puzzles have in common is that they make the player *stop and think*. Examining with the Lens #35: The Lens of Head and Hands, puzzles are firmly on the "head" side. It can be argued that any time a player stops during gameplay to think, they are solving a puzzle. The relationship between puzzles and games is tricky. In Chapter 3, we talked about how every game is "a problem-solving activity, approached playfully." Puzzles, too, are problem-solving activities — does this make them games? In this chapter we will explore how to make good puzzles, and the best ways incorporate puzzles into games. But first, we too should stop and think, to better understand the puzzle-game relationship.

The Puzzle of Puzzles

There is much debate about whether puzzles are "really games." Certainly, puzzles are often part of games, but does that mean they *are* games? In a sense, puzzles are just "fun problems." If you go back and review Chapter 3, you will find that, surprisingly, "fun problem" meets the many qualifications that we listed for the definition of a game. So, maybe each puzzle is really a kind of game?

Something bothers people about calling puzzles games. A jigsaw puzzle doesn't feel like a game, nor does a crossword puzzle. Would you call Rubik's Cube a game? Probably not. So, what is missing from puzzles that we are inclined to exclude them from our definition of games? First of all, most puzzles are just single-player, but that can hardly be an objection — many things we immediately classify as games, from solitaire to *Final Fantasy*, are single-player. They still have conflict, it is just between the player and system, not between player and player.

A young Chris Crawford once made the bold statement that puzzles are not even really interactive, since they don't actively respond to the player. This is questionable, partly because some puzzles do indeed respond to the player, particularly puzzles in videogames. Some people have suggested that any game that has both an ending and is guaranteed to give the same output to a player who always gives the same input is really a puzzle, and not a game. This would mean many story-based adventure games, such as *Zork*, *Zelda*, or *Final Fantasy* might not qualify as games at all, but only as puzzles. But this doesn't really ring true.

Perhaps puzzles are kind of like penguins. The first explorers to see penguins must have been kind of surprised, and probably at a loss as to how to classify them, thinking something like "Well, they kind of look like birds, but they can't be birds, because birds can fly. They must be something else." But further examination leads to the conclusion that penguins are indeed birds: just birds that can't fly. So what is it that puzzles can't do?

Puzzlemaster Scott Kim once said that "A puzzle is fun, and has a right answer." The irony of that is that once you find that right answer, the puzzle ceases to be fun. Or as Emily Dickinson once put it:

The Riddle we can guess
We speedily despise —
Not anything is stale so long
As Yesterday's surprise.

The thing that really seems to bother people about calling puzzles games is that they are not replayable. Once you figure out the best strategy, you can solve the puzzle every time, and it is no longer fun. Games are not usually this way. Most games have enough dynamic elements that each time you play you are confronted again with a new set of problems to solve. Sometimes this is because you have an intelligent human opponent (checkers, chess, backgammon, etc.), and sometimes it is because the game is able to generate lots of different challenges for you, either through ever-advancing goals (setting a new high score record) or through some kind of rich challenge-generation mechanism (solitaire, Rubik's Cube, *Tetris*, etc.)

In Chapter 10, we gave a name to the situation when a single strategy will defeat a game every time: a "dominant strategy." When a game has a dominant strategy, it doesn't cease to be a game, it just isn't a very good game. Children like tic-tac-toe until they find the dominant strategy. At that point, the puzzle of tic-tac-toe has been solved, and the game ceases to be interesting. So usually, we say games that have dominant strategies are bad. Unless, of course, the whole point of the game is to find that dominant strategy. This leads to an interesting definition of a puzzle:

A puzzle is a game with a dominant strategy.

From this point of view, puzzles are just games that aren't fun to replay, just as penguins are birds that cannot fly. This is why both puzzles and games have problem-solving at their core — puzzles are just miniature games whose goal is to find the dominant strategy.

Aren't Puzzles Dead?

When I discuss the importance of puzzles with students, there is always someone who asks "Aren't puzzles old-fashioned? I mean, sure they were a part of adventure games twenty years ago, but modern videogames are based on action, not puzzles, right? Besides, with all the walkthroughs on the Web, everyone can get the answers to puzzles easily — so what's the point?"

And this is an understandable point of view. In the 1980s and even early 1990s, adventure games (*Zork, Myst, Monkey Island, King's Quest*, etc.) were very

popular, and these usually featured very explicit puzzles. With the rise of console gaming, games that slid a bit more toward the "hands" side of the spectrum and away from the "head" side became more popular. But did the puzzles go away? No. Remember — a puzzle is anything that makes you stop and think, and mental challenges can add significant variety to an action-based game. As game designers grew more experienced, and games developed more fluid and continuous control schemes, the puzzles became less explicit and more woven into the fabric of the gameplay. Instead of completely stopping play, and demanding that the player slide around pieces of a puzzle before they could continue, modern games integrate the puzzles into their environment.

For example, *The 7th Guest*, a popular game released in 1992, featured puzzles that, though interesting, were often completely incongruous. While walking through a house, you find cans on a shelf, and you need to rearrange them so that the letters on them form a sentence. Then you would suddenly find a giant chessboard and be told that to continue in the game, you must find a way to exchange the positions of all the black pieces and the white pieces. Then you would look through a telescope and do a puzzle about connecting planets with lines.

Contrast that to *Legend of Zelda: The Wind Waker*, which has as many puzzles, but smoothly integrates them into environments in the game. When confronted with a river of lava, you have to figure out how to throw water jugs in the right pattern so that you can cross the river. When you are in a dungeon where the doors are opened and closed by a complex series of switches, you must figure out how to use items found in the dungeon (statues, etc.) to flip the switches so you can successfully get through all the doors. Some of these are quite complex; for example, some enemies in the dungeon are paralyzed when light falls on them. To get the doors open, you must lure the enemies onto the right switches, and then shoot flaming arrows near enough to paralyze them to keep the door open so you can run out. But in all cases, the puzzle elements are natural parts of the environment, and the goals of solving the puzzle are direct goals of the player's avatar.

This gradual change from explicit, incongruous puzzles to implicit, well-integrated ones is less because of a change in the tastes of the gaming audience, and more because game designers have matured in their skills. Look at the 7th Guest and Zelda puzzles with Lens #43: The Lens of Elegance, and notice how many more purposes the implicit puzzle serves as opposed to the explicit one.

Our two examples were adventure games. Can other genres include puzzles? Absolutely. When you play a fighting game, and you have to stop and think about which strategies are going to work best against a particular opponent, you are solving a puzzle. When you play a racing game, and trying figure out where on the track to use your turbo booster to finish the race in under a minute, you are solving a puzzle. When you play a first person shooter, and you think about which order you should shoot the enemies so that you take the least damage, you are solving a puzzle.

But what about walkthroughs on the Web? Haven't they spoiled videogame puzzles forever? They have not. We'll see why in the next section.

Good Puzzles

Okay — so, puzzles are everywhere. The thing we really care about is how to create good puzzles that will improve our games. Here are ten principles of puzzle design that can be useful in any game genre.

Puzzle Principle #1: Make the Goal Easily Understood

To get people interested in your puzzle at all, they have to know what they are supposed to do. Consider this puzzle:

FIGURE
12.2

© Paul Eibe, produced by Bits and Pieces

Just looking at it, it isn't at all obvious what the goal is. Is it about color matching? Is the goal to take it apart? Or maybe to put it back together? It isn't easy to tell for sure. Contrast that to this puzzle:

FIGURE
12.3

© Oskar van Deventer, produced by Bits and Pieces

Almost anyone can look at this and tell that the goal is to get the disk off of the shaft, even though they have never seen this before. The goal is clear.

The same thing applies to puzzles in videogames. If players aren't sure what they are supposed to do, they will quickly lose interest, unless figuring out what to do is actually fun. And there are a lot of puzzles where figuring out what to do is part of the puzzle. But you must use caution with these kind of puzzles — generally, only diehard puzzle fans like that kind of challenge. Consider the fate of Hasbro's *Nemesis Factor*. This ingenious puzzle is much revered by puzzle fanatics for being creative, interesting, and challenging — it challenges the player with one hundred

puzzles, gradually increasing in difficulty. Its design is incredible, and Hasbro surely hoped they might have another Rubik's Cube on their hands. But sadly, it did not sell well. Why? It violated our first puzzle principle — the goal was not clear. Its curious stair-step design made it difficult to guess the goal, or even guess how you might interact with it at all, just by looking at it. Even after you have purchased it, the game still tells you little about what you are supposed to do. The player must figure out the goal of each puzzle, and then try to solve it, and each of the one hundred puzzles has a different goal. It's the sort of thing that hardcore puzzle freaks love, but a more general audience finds frustrating, because it is a very open-ended kind of problem that gives little feedback about whether you are on the right track.

When designing puzzles, make sure to view them through Lens #25: The Lens of Goals, and make sure that you are clear to the player about what you want them to know about the goals of your puzzle.

Puzzle Principle #2: Make It Easy to Get Started

Once a player understands the goal of your puzzle, then they need to get started solving it. With some puzzles, it is quite clear how to begin. Consider Sam Loyd's famous "15 Puzzle," whose goal is to slide the tiles back into numerical order from 1 to 15.

FIGURE
12.4

Although the series of moves to solve the puzzle is not obvious, how you would get started manipulating it is very clear to most players. Contrast that to this puzzle, where the goal is to figure out which digit each letter represents:

FIGURE
12.5

Like the 15 puzzle, the goal is very clear. However, most players are at a complete loss as to how to begin solving a puzzle like this. Hardcore puzzle solvers will likely begin a lengthy trial-and-error session to figure out how they might approach it, but most players will just abandon it as "too hard."

Another piece of wisdom from Scott Kim is "To design a good puzzle, first build a good toy." And it makes sense to pull out Lens #15: The Lens of the Toy when designing your puzzle, for good toys make it obvious how to manipulate them. More than that, the player is drawn toward manipulating them. This is one of the things that made Rubik's Cube so successful: even someone who has no intention of trying to solve the puzzle wants to see what it feels like to touch it, hold it, and twist it.

Lens #48: The Lens of Accessibility

When you present a puzzle to players (or a game of any kind), they should be able to clearly visualize what their first few steps would be. Ask yourself these questions:

- How will players know how to begin solving my puzzle, or playing my game? Do I need to explain it, or is it self-evident?

- Does my puzzle or game act like something they have seen before? If it does, how can I draw attention to that similarity. If it does not, how can I make them understand how it does behave?

- Does my puzzle or game draw people in, and make them want to touch it and manipulate it? If not, how I can I change it so that it does?

Puzzle Principle #3: Give a Sense of Progress

What is the difference between a riddle and a puzzle? In most cases, the big difference is progress. A riddle is just a question that demands an answer. A puzzle also demands an answer, but frequently involves manipulating something so that you can see or feel yourself getting closer to the solution, bit by bit. Players like this sense of progress — it gives them hope that they may actually arrive at an answer. Riddles are not this way — you just have to think and think, and maybe start making guesses, which are either right or wrong. In early computer adventure games, riddles were frequently encountered, since they were so easy to put into a game — but the "stone wall" they give to the player is so frustrating that they are virtually absent from modern adventure games.

But there is a way to turn a riddle into a puzzle — it's a game we call "Twenty Questions." This is the game where one player thinks of a thing or a person, and

the other player gets to ask twenty yes/no questions in an attempt to learn what the first player is thinking of.

The great thing about the game of Twenty Questions is the sense of progress that a player gets. By using their questions to gradually narrow down the space of possible answers, they can get closer and closer to a solution — after all, 2^{20} is over one million, and this means that twenty well-crafted yes/no questions could home in on one answer out of a million possibilities. When players get frustrated playing Twenty Questions, it is because they feel like they aren't getting any closer to an answer.

One of the things that made players persistently try to solve Rubik's Cube is the sense of progress it gives. Gradually, a novice player is able to add more and more colors to one side, until, *voila!* An entire side is completed! This is a clear sign of progress, and something that makes players quite proud! Now they just have to do that five more times, right?

Visible progress is so important in puzzles that it becomes our next lens.

Lens #49: The Lens of Visible Progress

Players need to see that they are making progress when solving a difficult problem. To make sure they are getting this feedback, ask yourself these questions:

- What does it mean to make progress in my game or puzzle?
- Is there enough progress in my game? Is there a way I can add more interim steps of progressive success?
- What progress is visible, and what progress is hidden? Can I find a way to reveal what is hidden?

Puzzle Principle #4: Give a Sense of Solvability

Related to a sense of progress is a sense of solvability. If players begin to suspect that your puzzle is not solvable, they will become afraid that they are hopelessly wasting their time and give up in disgust. You need to convince them that it is solvable. Visible progress is a good way to do this, but so is outright stating that your puzzle has an answer. Returning to Rubik's Cube, it had a very elegant method of making it clear to the player that it was a solvable puzzle — when purchased, it is already in the solved state — the player then scrambles it up, usually by twisting it about a dozen times. At this point, it is quite obviously solvable — in as many moves as it took to scramble it, just backwards! But of course, most players find that solving it takes many more twists than that. But as frustrated as they may get, they never have any doubt that it can be solved.

Puzzle Principle #5: Increase Difficulty Gradually

We've already discussed the fact that difficulty in games should increase gradually (Lens #31: The Lens of Challenge), and successful puzzles also adhere to this maxim. But how can a puzzle increase in difficulty? Isn't it either solved or not solved? Most puzzles are solved by taking a series of actions that are often small steps toward a chain of goals that leads to solving the puzzle. It is these actions that should gradually increase in difficulty. The classic jigsaw puzzle provides a naturally balanced series of these steps. A player who tries to solve a jigsaw puzzle doesn't just start sticking pieces together until it is solved; instead they usually follow this sequence of steps:

1. Flip all the pieces so that the picture side is up (mindlessly easy)
2. Find the corner pieces (very easy)
3. Find the edge pieces (easy)
4. Connect the edge pieces into a frame (a slight challenge, rewarding when completed)
5. Sort the remaining pieces by color (easy)
6. Start assembling sections that are obviously near each other (a moderate challenge)
7. Assemble the pieces that could go anywhere (a significant challenge)

This gradual increase in difficulty is part of what gives jigsaw puzzles lasting appeal. Now and then, someone releases a jigsaw puzzle that is meant to be tougher than normal, and they usually do it by changing the properties of the puzzle so that some (or all) of steps 1 through 6 are eliminated.

One Tough Puzzle, shown below, does just that. And while it is interesting as a novelty, the only interesting part about it is how immediately difficult it is. The pleasing nature of gradually increasing difficulty that makes jigsaw puzzles a perennial favorite is absent.

FIGURE
12.6

215

One easy way to ensure that difficulty increases gradually is to give the players control over the order of the steps to your puzzle. Consider the crossword puzzle — players have dozens of questions to answer, with each one answered giving hints about the unanswered ones. Players naturally gravitate toward answering the questions that are easiest for them and slowly work their way up toward harder questions. Giving the player this kind of choice is called *parallelism*, and it has another excellent property.

Puzzle Principle #6: Parallelism Lets the Player Rest

Puzzles make a player stop and think. A real danger is that the player will be unable to think their way past your puzzle and, unable to make progress, will abandon the game entirely. A good way to safeguard against this is to give them several different related puzzles at once. This way, if they get tired of banging their head on one of them, they can go off and try another for a while. In the process of doing that, they will have taken a break from the first puzzle, and they may be ready to try it again with the renewed vigor that a break can provide. The old saying that "A change is as good as a rest" applies perfectly here. Games like crossword puzzles and Sudoku do this naturally. But videogames can do it as well. It is the rare RPG that gives puzzles and challenges to a player one at a time — much more common is to give two or more parallel challenges at once, since the player is much less likely to grow frustrated this way.

Lens #50: The Lens of Parallelism

Parallelism in your puzzle brings parallel benefits to the player's experience. To use this lens, ask yourself these questions:

- Are there bottlenecks in my design where players are unable to proceed if they cannot solve a particular challenge? If so, can I add parallel challenges for a player to work on when this challenge stumps them?

- If parallel challenges are too similar, the parallelism offers little benefit. Are my parallel challenges different enough from each other to give players the benefit of variety?

- Can my parallel challenges be connected somehow? Is there a way that making progress on one can make it easier to solve the others?

Puzzle Principle #7: Pyramid Structure Extends Interest

One more thing that parallelism lends itself to is pyramid puzzle structure. This means a series of small puzzles that each give some kind of clue to a larger

puzzle. A classic example is the Jumble scrambled word game frequently seen in newspapers.

FIGURE
12.7

This puzzle could be made simpler by just asking you to unscramble the four words. But by having each unscrambled word give a few more letters for a more difficult scrambled phrase, the game combines short- and long-term goals. It gradually increases difficulty, and most important, a pyramid has a point: this game has a single clear and meaningful goal — to figure out the punch line of the joke presented by the cartoon.

Lens #51: The Lens of the Pyramid

Pyramids fascinate us because they have a singular highest point. To give your puzzle the allure of the ancient pyramids, ask yourself these questions:

- Is there a way all the pieces of my puzzle can feed into a singular challenge at the end?

- Big pyramids are often made of little pyramids — can I have a hierarchy of ever more challenging puzzle elements, gradually leading to a final challenge?

- Is the challenge at the top of my pyramid interesting, compelling, and clear? Does it make people want to work in order to get to it?

Puzzle Principle #8: Hints Extend Interest

"Hints?! What is the point of even having a puzzle if we are going to give hints?" I hear you cry. Well, sometimes when a player is about to give up on your puzzle in frustration and disgust, a well-timed hint can renew their hope and their curiosity.

And while it "cheapens" the puzzle-solving experience somewhat, solving a puzzle with a hint is much better than not solving it at all. One thing Hasbro's *Nemesis Factor* did brilliantly was to include a hint system. It featured a "hint" button, and the player who presses it gets to hear a brief one- or two-word hint about the puzzle they are currently working on like "staircase" or "music." Pushing it a second time gives another less cryptic hint. To help balance this hint system, there is a slight points penalty for asking for hints, but generally players are willing to take the hit and get a hint than give up on the puzzle altogether!

Today, with walkthroughs of virtually every game available on the Internet, you can argue that hints are not really necessary for hard videogame puzzles. But still, you might consider them, since solving a puzzle based on a hint can be more enjoyable than just cribbing the answer from someone else.

Puzzle Principle #9: Give the Answer!

No, seriously, hear me out on this one. Ask yourself this question: What is it that is so pleasurable about solving puzzles? Most people answer that it is the "Aha!" experience you get when you figure out the answer. But the funny thing is that experience is triggered not by solving the puzzle, but by *seeing the answer*. Sure, it's a little sweeter if you solved it yourself, but if you have given serious consideration to a problem, your problem-solving brain is primed for a rush of pleasure at merely seeing or hearing the answer. Think about mystery novels — they are just big puzzles in book form. And sometimes readers guess the ending ahead of time, but more often, they are surprised (Oh! The butler did it! I see now!), which is just as pleasurable, or weirdly, *more* pleasurable than if they had figured it out themselves.

So, how can you put this into practice? In the age of the Internet, you probably won't have to — if your game is known at all, answers to your puzzles will quickly be posted online. But why not consider saving your players the trouble, and give them a way to find out the answers to your puzzles from within your game, if they are truly stumped?

Puzzle Principle #10: Perceptual Shifts are a Double-Edged Sword

Consider this puzzle:

Can you arrange six matchsticks so they form four equilateral triangles?

No, seriously, consider it. And by that, I mean, try to solve it.

Need a hint? You can find one at www.artofgamedesign.com if you need it.

I'm guessing one of three things happened. Either (A) you've seen this one before, and solving it involved no pleasurable "Aha," although maybe there was a

little pleasurable smugness; or (B) you had a "perceptual shift," that is, a big leap in your assumptions, and came up with the right answer, which was very exciting; or (C) someone told you the answer, and you had a little bit of "Aha!" combined with a little bit of shame for not figuring it out yourself; or (D) you gave up in frustration, feeling kind of ashamed.

The point I want to make with this is that puzzles like this, that involve a perceptual shift where "either you get it or you don't," are a problematic double-edged sword. When a player is able to make the perceptual shift, they receive a great deal of pleasure and solve the puzzle. But if they are not able to make the perceptual shift, they get nothing. Puzzles like this involve almost no possibility of progress or gradual increase in difficulty — just a lot of staring, and straining for inspiration to come. They are almost like riddles in this way, and generally, you will find they should be used sparingly in videogames or in any other medium where the player expects to be able to make continual progress.

A Final Piece

This concludes the ten principles of puzzle design. There are certainly others, but these ten can take you a long way if you use them in your designs. Puzzles can add a meaningful mental dimension to any game. Before we move on to a new topic, I'll leave you with a final lens that is useful to see if your game has enough puzzles of the right kind.

Lens #52: The Lens of the Puzzle

Puzzles make the player stop and think. To ensure your puzzles are doing everything you want to shape the player experience, ask yourself these questions:

- What are the puzzles in my game?
- Should I have more puzzles, or less? Why?
- Which of the ten puzzle principles apply to each of my puzzles?
- Do I have any incongruous puzzles? How can I better integrate them into the game? (Use Lens #43: The Lens of Elegance to help do this).

In the last few chapters, we have focused on game internals — it is now time to consider an external element — the interface of the game.

CHAPTER THIRTEEN

Players Play Games
Through an *Interface*

FIGURE
13.1

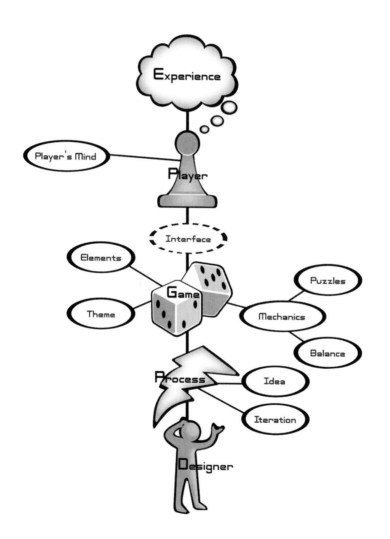

Between Yin and Yang

FIGURE
13.2

Remember in Chapter 9 when we talked about the strange relationship between player and game? Specifically, that the player puts their mind inside the game world, but that game world really only exists in the mind of the player? This magical situation, which is at the heart of all we care about, is made possible by the game interface, which is where player and game come together. Interface is the infinitely thin membrane that separates white/yang/player and black/yin/game. When the interface fails, the delicate flame of experience that rises from the player/game interaction is suddenly snuffed out. For this reason, it is crucial for us to understand how our game interface works, and to make it as robust, as powerful, and as invisible as we can.

Before we proceed, though, we should consider the goal of a good interface. It isn't "to look nice" or "to be fluid," although those are nice qualities. The goal of an interface is to make players feel in control of their experience. This idea is important enough that we should keep a lens around for frequent examination of whether a player feels in control.

Lens #53: The Lens of Control

This lens has uses beyond just examining your interface, since meaningful control is essential for immersive interactivity. To use this lens, ask yourself these questions:

- When players use the interface, does it do what is expected? If not, why not?

- Intuitive interfaces give a feeling of control. Is your interface easy to master, or hard to master?

- Do your players feel they have a strong influence over the outcome of the game? If not, how can you change that?

- Feeling powerful = feeling in control. Do your players feel powerful? Can you make them feel more powerful somehow?

Breaking it Down

Like many things we encounter in game design, interface is not simple or easily described. "Interface" can mean many things — a game controller, a display device, a system of manipulating a virtual character, the way the game communicates information to the player, and many other things. To avoid confusion, and to understand it properly, we need to separate it out into component parts.

Let's work from the outside in. Initially, we know that we have a player, and a game world.

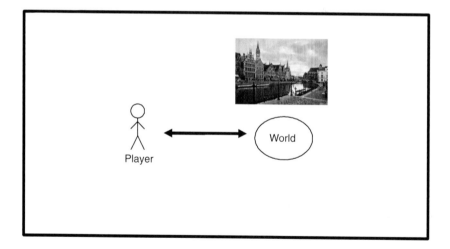

FIGURE
13.3

On the simplest level, the interface is everything that is in between them. So, what is in there? There is some way that the player touches something to make changes in the world. This could be by manipulating pieces on a game board, or by using a game controller or keyboard and mouse. Let's call this **physical input**. And similarly, there is some way the player can see what is going on in the game world.

It could be by looking at a game board, or it could be some kind of display screen with audio or other sensory output. Let's call this **physical output**. So we have:

FIGURE
13.4

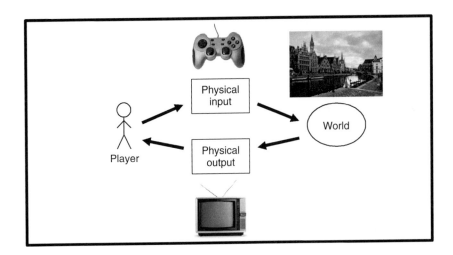

This looks pretty simple, and is the way most people naively think about game interface. But some important things are missing from this picture. While there are times when the physical input and output are directly connected to elements in the game world, there are other times that there is some amount of intermediate interface. When you play *Pac Man*, and there is a score display at the top of the screen, this is not really part of the game world — it is really part of the interface. The same goes for menus and buttons on mouse-based interfaces, or when you hit an enemy for ten points of damage and a stylized "10" floats out of his body. When you play most 3D games, you do not see the entire world, but instead you see a view into the world from a virtual camera with a position in the virtual space of the game world. All these things are part of a conceptual layer that exists between the physical input/output and the game world. This layer is usually called **virtual interface**, and has both input elements (such as a virtual menu where the player makes a selection) and output elements (such as a score display) (see Figure 13.5).

Sometimes, the virtual layer is so thin it is almost non-existent, but other times it is very dense, full of virtual buttons, sliders, displays, and menus that help the player play the game, but aren't part of the game world.

And that makes a pretty complete picture of the major interface elements involved in a game. But we've left out something crucial to the design of any game interface: **mapping**. On every arrow on the right side of the diagram, some special things are happening — it is not as if data are simply passed through — rather, these data go through a special transformation based on how the software is designed. Every one of the arrows on the game side represents a separate piece of computer code. How all this behaves together in composite defines the interface for

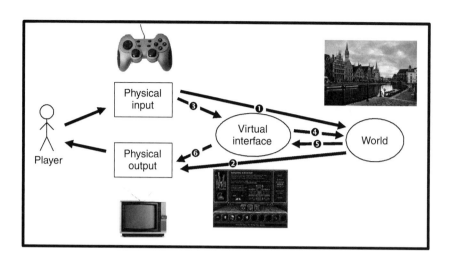

FIGURE
13.5

your game. Some quick examples of the kinds of logic that can be contained in each of those six arrows:

1. **Physical Input → World**: If pushing a thumbstick makes my avatar run, the mapping tells how fast it will run, and how quickly it will slow down if I let go. If I push the thumbstick harder, does my character run faster? Will my character accelerate over time? Will "double tapping" the thumbstick make my character dash?

2. **World → Physical Output**: If you cannot see the entire world at once, what parts of it can you see? How will it be shown?

3. **Physical Input → Virtual Interface**: In a mouse-based menu interface, what does clicking do? What does double clicking do? Can I drag parts of the interface around?

4. **Virtual Interface → World**: When the player manipulates the virtual interface, what effect does this have on the world? If they select an item in the world, and use a pop-up menu to take an action on it, does that action take effect immediately, or after some delay?

5. **World → Virtual Interface**: How are changes in the world manifested in the virtual interface? When do scores and energy bars change? Do events in the world lead to special pop-up windows or menus, or mode changes in the interface? When players enter a battle, will special battle menus appear?

6. **Virtual Interface → Physical Output**: What data are shown to the player, and where does it go on the screen? What colors will it be? What fonts? Will hit points pulse or make a sound when they are very low?

For close examination of these six types of connections, we introduce two new lenses.

Lens #54: The Lens of Physical Interface

Somehow, the player has a physical interaction with your game. Copying existing physical interfaces is an easy trap to fall into. Use this lens to be sure that your physical interface is well-suited to your game by asking these questions:

- What does the player pick up and touch? Can this be made more pleasing?
- How does this map to the actions in the game world? Can the mapping be more direct?
- If you can't create a custom physical interface, what metaphor are you using when you map the inputs to the game world?
- How does the physical interface look under the Lens of the Toy?
- How does the player see, hear, and touch the world of the game? Is there a way to include a physical output device that will make the world become more real in the player's imagination?

The world of videogames occasionally goes through dry spells where designers feel it is not feasible to create custom physical interfaces. But the marketplace thrives on experimentation and novelty, and suddenly specially crafted physical interfaces, like the *Dance Dance Revolution* mat, the *Guitar Hero* guitar, and the Wiimote appear, bringing new life to old gameplay by giving players a new way to interact with old game mechanics.

Lens #55: The Lens of Virtual Interface

Designing virtual interfaces can be very tricky. Done poorly, they become a wall between the player and the game world. Done well, they amplify the power and control a player has in the game world. Ask these questions to make sure that your virtual interface is enhancing player experience as much as possible:

- What information does a player need to receive that isn't obvious just by looking at the game world?
- When does the player need this information? All the time? Only occasionally? Only at the end of a level?
- How can this information be delivered to the player in a way that won't interfere with the player's interactions with the game world?

- Are there elements of the game world that are easier to interact with using a virtual interface (like a pop-up menu, for instance) than they are to interact with directly?
- What kind of virtual interface is best suited to my physical interface? Pop-up menus, for example, are a poor match for a gamepad controller.

Of course, these six kinds of mapping cannot be designed independently — they must all work in unison to create a great interface. But before we move on, we must consider two other important kinds of mapping, represented by the arrows that come and go from the player, or more specifically, from the player's imagination. This is when a player becomes immersed in a game, no longer pushing buttons and watching a TV screen, instead, they are running, jumping, and swinging a sword. And you can hear this in a player's language. A player generally won't say "I controlled my avatar so he ran to the castle, and then I pressed the red button to make him throw a grappling hook, then I started tapping the blue button to make my avatar climb up." No, a player describes the gameplay this way: "I ran up the hill, threw my grappling hook, and started climbing the castle wall." Players project themselves into games, and on some level disregard that the interface is there at all, unless it suddenly becomes confusing. A person's ability to project consciousness into whatever they are controlling is almost alarming. But it is only possible if the interface becomes second nature to the player, and this gives us our next lens.

Lens #56: The Lens of Transparency

The ideal interface becomes invisible to the player letting the player's imagination be completely immersed in the game world. To ensure invisibility, ask yourself these questions:

- What are the players desires? Does the interface let the players do what they want?
- Is the interface simple enough that with practice, players will be able to use it without thinking?
- Do new players find the interface intuitive? If not, can it be made more intuitive, somehow? Would allowing players to customize the controls help, or hurt?
- Does the interface work well in all situations, or are there cases (near a corner, going very fast, etc.) when it behaves in ways that will confuse the player?

- Can players continue to use the interface well in stressful situations, or do they start fumbling with the controls, or missing crucial information? If so, how can this be improved?

- Does something confuse players about the interface? On which of the six interface arrows is it happening?

FIGURE
13.6

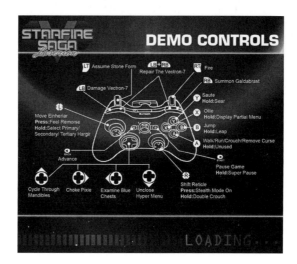

www.penny-arcade.com. Used with permission.

This interface, a parody from the Web comic Penny Arcade, is probably not transparent.

The Loop of Interaction

Information flows in a loop from player to game to player to game, round and round. It is almost like this flow pushes a waterwheel that generates experience when it spins. But it can't be just any information that flows around this loop. The information that is returned to the player by the game dramatically affects what the player will do next. This information is generally called **feedback**, and the quality of this feedback can exert a powerful influence on how much the player understands and enjoys what is happening in your game.

The importance of good feedback is easily overlooked. One example is the net on a basketball hoop. The net does not affect the gameplay at all — but it slows the ball as it descends from the hoop, so that all players can clearly see that it went in.

A less obvious example is the Swiffer (Figure 13.7), a simple device designed to be a better solution for cleaning floors than the traditional broom/dustpan combination.

FIGURE
13.7

Some people who have attempted to redesign the broom and dustpan have merely modified the existing solution. It would appear that the designers of the Swiffer used Lens #12: The Lens of the Problem Statement to invent a brand new solution. If we look at some of the problems with the broom/dustpan solution:

Problem #1: It's impossible to sweep all the dust into the dustpan.

Problem #2: When standing, the dustpan is hard to use. When crouching, the broom is hard to use.

Problem #3: The broom doesn't really get all the dust.

Problem #4: Your hands get kind of dirty when you try to sweep dust into the dustpan.

Problem #5: Transferring the dirt from the dustpan to the trash is perilous — it often spills or blows around.

We see that the Swiffer, with its disposable cloth, solves these problems fairly well:

Problem #1: No dustpan is needed.

Problem #2: There is no need to crouch when using the Swiffer.

Problem #3: The Swiffer cloth captures far more dust than a broom can.

Problem #4: Your hands stay clean.

Problem #5: The cloth is easily disposed of.

So, the Swiffer solves a lot of problems, which makes it very appealing. But it has an appeal beyond these practical things. It has a strong psychological

appeal — frankly, it is fun to use. Why? Because the design addresses problems that most people wouldn't state as problems. For example:

> Problem #6: The user gets little feedback about how well they have cleaned the floor.

Unless a floor is really dirty, it is hard to see whether your sweeping is making any difference just by looking at the floor. You might say, "Who cares? All that matters is how well it cleans, right?" But this lack of feedback can make the entire task feel somewhat futile, which means that the user enjoys it less, and will clean their floor less often. In other words, less feedback = dirtier floor. But the Swiffer solves this problem very well:

> Problem #6: The dirt you have removed from the floor is clearly visible on the cleaning cloth when you are done.

This feedback shows the user quite clearly that what they have done makes a real difference in how clean the floor is. This triggers all kinds of pleasures — satisfaction of having done something useful, the pleasure of purification, and even the pleasure of having secret knowledge that others cannot see. And though this feedback doesn't come until the end of the task, the user comes to anticipate it and looks forward to seeing this concrete evidence of a job well done.

Lens #57: The Lens of Feedback

The feedback a player gets from the game is many things: judgment, reward, instruction, encouragement, and challenge. Use this lens to be sure your feedback loop is creating the experience you want by asking these questions at every moment in your game:

- What do players need to know at this moment?
- What do players want to know at this moment?
- What do you want players to feel at this moment? How can you give feedback that creates that feeling?
- What do the players want to feel at this moment? Is there an opportunity for them to create a situation where they will feel that?
- What is the player's goal at this moment? What feedback will help them toward that goal?

Using this lens takes some effort, since feedback in a game is continuous, but needs to be different in different situations. It takes a lot of mental effort to use this lens in every moment of your game, but it is time well spent, because it will help guarantee that the game is clear, challenging, and rewarding.

FIGURE
13.8

Experiences without feedback are frustrating and confusing. At many cross-walks in the United States, pedestrians can push a button that will make the DON'T WALK sign change to a WALK sign so they can cross the street safely. But it can't change right away, since that would cause traffic accidents. So the poor pedestrian often has to wait up to a minute to see whether pressing the button had any effect. As a result, you see all kinds of strange button-pressing behavior: some people push the button and hold it for several seconds, others push it several times in a row, just to be safe. And the whole experience is accompanied by a sense of uncertainty — pedestrians can often be seen nervously studying the lights and DON'T WALK sign to see if it is going to change, because they might not have pushed the button correctly.

What a delight it was to visit the United Kingdom, and find that in some areas the crosswalk buttons give immediate feedback in the form of an illuminated WAIT sign that comes on when the button has been pushed, and turns off when the WALK period has ended (Figure 13.9)! The addition of some simple feedback turned an experience where a pedestrian feels frustrated into one where they can feel confident and in control.

Generally, it is a good rule of thumb that if your interface does not respond to player input within a tenth of a second, the player is going to feel like something is wrong with the interface. A typically problematic example of this often appears when you make a game with a "jump" button. If the animator working on the jump animation is new to videogames, he is very likely to put a "wind up" or "anticipa-tion" on the jump animation, where the character crouches down, getting ready to

FIGURE
13.9

Helpful Feedback

jump, for probably one-quarter to one-half a second. This is sound animation prac-tice, but because this breaks the tenth of a second rule (I push the jump button, but my character doesn't actually end up in the air until a half second later), it drives players crazy with frustration.

But let's return to our sweeping example: A dirty cloth is not the only feedback that the Swiffer gives the user. Let's consider another problem with the broom and dustpan that most people would be unlikely to state.

Problem #7: Sweeping is boring.

Well, of course it is! It's sweeping! But what do we mean by boring? We need to break this down further. Specifically:

- Sweeping is repetitive (same motion over and over).
- It requires you to focus your attention on something with no surprises (if you don't monitor that little pile of dust, it goes everywhere).

How does the Swiffer meet this challenge?

Solution #7 : Using the Swiffer is fun!

This may well be the single biggest selling point of the Swiffer. In television advertisements for the Swiffer, they show people joyously dancing through houses cleaning floors, and some ads featured people picking up the Swiffer out of sheer curiosity, and then cleaning the floors while playing with the Swiffer like a child plays with a toy. And the Swiffer does very well under Lens #15: The Lens of the Toy — it is fun to play with... but why? It's just a cloth on a stick, right? Yes, in one sense, but the base of the Swiffer, where the cloth goes is attached to the stick with a special sort of hinge, so that when you rotate your wrist, even slightly, the base that holds the cloth rotates dramatically. A little motion from my wrist makes the cleaning mechanism move easily, fluidly, and powerfully — getting into exactly the position you want it to be in with a minimum of effort. Using it feels kind of like running a magic race car around the floor of your house. The motion that the cleaning base shows is **second-order motion**; that is, motion that is derived from the action of the player. When a system shows a lot of second-order motion that a player can easily control, and that gives the player a lot of power and rewards, we say that it is a **juicy** system — like a ripe peach, just a little bit of interaction with it gives you a continuous flow of delicious reward. Juiciness is often overlooked as an important quality in a game. To avoid overlooking it, use this lens.

Lens #58: The Lens of Juiciness

To call an interface "juicy" might seem kind of silly — although it is very common to hear an interface with very little feedback described as "dry." Juicy interfaces are fun the moment you pick them up. To maximize juiciness, ask yourself these questions:

- Is my interface giving the player continuous feedback for their actions? If not, why not?

- Is second-order motion created by the actions of the player? Is this motion powerful and interesting?

- Juicy systems reward the player many ways at once. When I give the player a reward, how many ways am I simultaneously rewarding them? Can I find more ways?

We discussed in Chapter 3 how the difference between work and play is one of attitude. I chose this non-game example of the Swiffer as an illustration because the feedback it gives is so powerful that it changes work into play. And it is important for your interface to be fun, if possible — since your game is meant to be fun, and you run the risk of creating inner contradictions and a self-defeating experience if you put a dry, painful interface as the player's gateway to your supposedly fun

experience. Remember, fun is pleasure with surprises, so if your interface is going to be fun, it should give both.

Channels of Information

One important goal of any interface is to communicate information. Determining the best way for your game to communicate necessary information to the player requires some thoughtful design, since games can often contain a great deal of information, and often much of it is needed at the same time. To figure out the best way to present the information in your game, try following these steps. Referring back to our interface data flow diagram from the beginning of the chapter, we are mostly talking about arrows 5 (World → Virtual Interface) and 6 (Virtual Interface → Physical Output).

Step 1: List and Prioritize Information

A game has to present a lot of information, but it is not all equally important. Let's say we were designing the interface for a game similar to the classic NES game, *Legend of Zelda*. We might begin by listing all of the information the player needs to see. A simple unprioritized list might look like

1. Number of rubies
2. Number of keys
3. Health
4. Immediate surroundings
5. Distant surroundings
6. Other inventory
7. Current weapon
8. Current treasure
9. Number of bombs

Now, we might sort these by importance:
Need to know every moment:

4. Immediate surroundings

Need to glance at from time to time while playing:

1. Number of rubies
2. Number of keys

3. Health

5. Distant surroundings

7. Current weapon

8. Current treasure

9. Number of bombs

Need to know only occasionally:

6. Other inventory

Step 2: List Channels

A channel of information is just a way of communicating a stream of data. Exactly what the channels are varies from game to game — and there is a lot of flexibility in how you choose them. Some possible channels of information might be

- The top center of the screen
- The bottom right of the screen
- My avatar
- Game sound effects
- Game music
- The border of the game screen
- The chest of the approaching enemy
- The word balloon over a character's head

It can be a good idea to list out the possible channels that you think you might use. In *Legend of Zelda*, the main channels of information the designers settled on were

- Main display area
- Dashboard of information at the top of the screen

Also, they decided there would be a "mode change" the player could activate by hitting the "select" button (we'll discuss mode changes later in the chapter), which has different channels of information:

- Auxiliary display area
- Dashboard of information at the bottom of the screen

Step 3: Map Information to Channels

Now, the difficult task comes of mapping the types of information to the different channels. This is usually done partly by instinct, partly by experience, and mostly by trial and error — drawing lots of little sketches, thinking about them, and then redrawing them, until you think you have something worth trying out. In Zelda, the mapping is as follows:

Main display area:

4. Immediate surroundings

Dashboard of information at the top of the screen:

1. Number of rubies
2. Number of keys
3. Health
5. Distant surroundings
7. Current weapon
8. Current treasure
9. Number of bombs

Auxiliary display area:

6. Other inventory

Taking a look at the main screen and sub-screen, you can see other interesting choices that were made:

FIGURE
13.10

FIGURE
13.11

Note that the dashboard information is so important to gameplay that it needs to be shown all the time on both the main and sub-screens. And the contents of that dashboard really involve seven different channels of information. Notice how they split them up — health was deemed so important that it got nearly one-third of the interface. Rubies, keys, and bombs, though their functions are different, each have to communicate a two-digit number, so they are all grouped together. The weapon and treasure you are holding are so important that they have little boxes around them. The "A" and "B" are reminders to the player about which buttons to hit in order to use these items.

Also note on the inventory screen how extra space was used to give the player some instruction on how to use it.

You can see that even though this is a relatively simple interface compared to more modern games, there were many decisions the designer made about how to lay it out, and these decisions made a significant impact on the game experience.

Step 4: Review Use of Dimensions

A channel of information in a game can have several dimensions. For example, if you have decided to map "damage to an enemy" to "numbers that fly out of that enemy," you have several dimensions you can work with on that channel. Some of these might be

- The number you display
- The color of the number
- The size of the numerals
- The font of the numerals

237

Now you have to decide which of these dimensions, if any, you want to use. Surely you will use the first one, the number. But will the color mean anything? Perhaps you will use the other dimensions as **reinforcers** of the information — numbers under 50 will be white and small, numbers from 50 to 99 will be yellow and medium-sized, but numbers over 100 will be red and very large and in a special font to emphasize the amount of damage.

And while using multiple dimensions on a channel to reinforce a piece of information is a way to make the information very clear (and also kind of juicy), you could also take a different approach and decide to put different pieces of information on the different dimensions. For example, you might decide to color the numbers to indicate friend (white) or foe (red). Then you might make the size of the numbers indicate how close the character is to defeat — small numerals might mean the character has a lot of hit points left, while large numerals might mean they are about to die. This kind of technique can be very efficient and elegant. By using a single number, you have communicated three different pieces of information. The risk is that you have to educate the player on what these different dimensions on one channel of information represent, which might be difficult for some players to understand or remember. Good use of channels and dimensions is what makes for an elegant, well laid out interface, so we keep a special lens around for this kind of examination.

Lens #59: The Lens of Channels and Dimensions

Choosing how to map game information to channels and dimensions is the heart of designing your game interface. Use this lens to make sure you do it thoughtfully and well. Ask yourself these questions:

- What data need to travel to and from the player?
- Which data are most important?
- What channels do I have available to transmit this data?
- Which channels are most appropriate for which data? Why?
- Which dimensions are available on the different channels?
- How should I use those dimensions?

Modes

What is an interface mode? Simply put, it is a change in one of the mapping arrows (1–6) in our interface diagram. For example, if pressing the B button changes the functionality of the gamepad so that instead of making your avatar run around it makes your avatar aim a water hose instead, that is a mode change — the mapping

on arrow #1 (Physical Interface → World) has just changed. Mode changes can happen as a result of mapping changes on any of the six arrows.

Modes are a great way to add variety to your game, but you must be very careful, since you run a risk of confusing the player if they don't realize that a mode change has occurred. Here are a few tips to avoid getting in trouble with interface modes.

Mode Tip #1: Use as Few Modes as Possible

The fewer the modes, the less chance a player is going to get confused. Having multiple interface modes isn't a bad thing, but you should add modes cautiously, for each one is something new the player is going to have to learn and understand.

Mode Tip #2: Avoid Overlapping Modes

Just as we have channels of information from the game to the player, there are similar channels of information from the player to the game. Each button or thumbstick is a channel of information, for example. Let's say you have a game that lets you change between walking mode (the thumbstick navigates) and throwing mode (the thumbstick aims). Later, you decide to add a driving mode as well (the thumbstick steers a car). What happens if the player changes into throwing mode while they are driving? You could try to allow this, potentially putting you into two modes at once (driving and throwing). And while this might work, it also might be a disaster if the thumbstick is simultaneously steering a car and controlling an aiming interface. It might be wiser to move the aiming, in all cases, to a second thumbstick, if your physical interface has one. By making your modes distinct and non-overlapping, you keep yourself out of trouble. If you find you need to have overlapping modes, make sure they use different channels of information on the interface. For example, the thumbstick could have two navigating modes (flying or walking) and the button have two shooting modes (shoot fireball or lightning bolt). These modes are on completely different dimensions, so they can overlap safely — I can switch between shooting fireballs and shooting lightning bolts while either walking or flying with no confusing effects.

Mode Tip #3: Make Different Modes Look as Different as Possible

In other words, look at your modes with the Lens #57: The Lens of Feedback and Lens #56: The Lens of Transparency. If a player doesn't know what mode they are in, they are going to be confused and frustrated. The old Unix text editing system, *vi* (pronounced "V.I.") was a symphony of confusing modes. Most people would expect that a text editor, when it started up, would be in a mode that would allow you to enter text. But not so for *vi*. It was actually in a mode where each letter of the keyboard would either issue a command, like "delete line," or it would put the editor into a new mode. But hitting these keys would give no feedback about what mode you were in. If you actually wanted to enter text, you had to type a letter "i,"

and then you would be in text insert mode, which looked exactly like command entry mode. It was impossible to figure out on your own, and even seasoned *vi* users would occasionally get confused about what mode they were in.

Some great ways to make your modes look different in video games are listed next.

- **Change something large and visible on the screen.** In *Halo 2*, and most first person shooters, when you change weapons, it is very visible. As a side note, the amount of ammo you have left is given through an interesting channel — it is right on the back of your gun.

- **Change the action your avatar is taking**. In the classic arcade game *Jungle King*, you go from a vine swinging mode to a swimming mode. Because your avatar is doing something so obviously different, it is clear that the mode has changed (also his hair changes color — that might be overkill).

- **Change the on screen data.** In Final Fantasy VII, and most RPGs, when you enter combat mode, many combat statistics and menus suddenly come up, and it is obvious there has been a mode change.

- **Change the camera perspective**. This is often overlooked as an indicator of a mode change, but it can be very effective.

Lens #60: The Lens of Modes

An interface of any complexity is going to require modes. To make sure your modes make the player feel powerful and in control and do not confuse or overwhelm, ask yourself these questions:

- What modes do I need in my game? Why?

- Can any modes be collapsed, or combined?

- Are any of the modes overlapping? If so, can I put them on different input channels?

- When the game changes modes, how does the player know that? Can the game communicate the mode change in more than one way?

Other Interface Tips

Okay — we've covered interface data flow, feedback, channels, dimensions, and modes. That's a good start. But whole books have been written about the topic of interface design, and we have so many other interesting things to discuss, we must move on! But before we do, here are some general tips for making good game interfaces.

Interface Tip #1: Steal

More politely, we would call this the "top down approach" to interface design. If you are designing an interface for a known game genre, say an action/platform game, you can begin with the interface of a known success in this area, and then change it around to suit the things that are unique about your game. This can save you a lot of design time, and has the benefit of being a familiar interface to your users. Of course, if your game has nothing new to offer, this will make it feel like a clone — but it is often surprising how one little change leads to another, which leads to another, and before you know it, your clone interface has morphed into something quite different.

Interface Tip #2: Customize

Also called the bottom up approach, it is the opposite of stealing. With this approach, you design your interface from scratch, by listing out information, channels, and dimensions like we explained earlier. This is a great way to get an interface that looks unique and is custom to your particular game. If your gameplay is novel, you may find this is the only path available to you. But even if your gameplay is nothing new, you may be surprised when you try to build it from the bottom up — you may find that you invent a whole new way to play your game, because everyone else has just been copying what is successful, and you took the time to actually examine the problem, and tried to do a better job.

Interface Tip #3: Theme Your Interface

Often it is a different artist who designs the interface artwork than the one who designs the game world. In Chapter 5 we talked about the importance of theming everything, and interface is no exception. Go over every inch of your interface with Lens #9: The Lens of Unification, and see if you can find a way to tie it all together with the rest of the experience.

Interface Tip #4: Sound Maps to Touch

Usually, when we think of using sound in a game, we think of creating a soundscape to give a sense of place (tweeting birds in a meadow), or to make actions seem more realistic (hearing glass break when you see it break), or to give the player feedback about their progress in the game (a musical glissando when you pick up a treasure). But there is an often overlooked aspect to sound that has a direct bearing on interface: the human mind easily maps sound to touch. This is important, since when we manipulate things in the real world, touch is a central component of

feedback we get about manipulation. In a virtual interface we get little if any information through our touch sense. But you can simulate touch by playing appropriate sounds. First you have to think about what you would like your interface to feel like if it were real, and then you have to decide what sounds will best create that feeling. If you do this successfully, people will marvel at what a pleasure your interface is to use, but they will have difficulty expressing exactly why.

Interface Tip #5: Balance Options and Simplicity with Layers

When designing an interface, you will be confronted by two conflicting desires: the desire to give the player as many options as possible, and the desire to make your interface as simple as possible. As with so many things in game design, the key to success is striking a balance. And one good way to achieve this balance is by creating layers of interface through modes and sub-modes. If you have done a good job of prioritizing your interface, you will have a good head start toward figuring out how to do this. A typical videogame example of this is hiding Inventory and Configuration menus under an infrequently used button, such as "select."

Interface Tip #6: Use Metaphors

A great shortcut to giving a player understanding of how your interface works is by making it resemble something the player has seen before. For example, in designing the game *Toytopia*, my team had a very unusual constraint. In this game, the player issues keyboard commands (go up, go right, etc.) to a small team of windup toys. Since it was a networked game, the plan was to keep things in sync by introducing a delay between when a player issued a command, and when a toy would receive it. This way, we could keep games in sync on different players' machines because the local artificial delay would be the same length as the unavoidable network delay of a signal traveling from one computer to another. Unfortunately (and not surprisingly) players found this to be confusing — they are used to a button push taking action immediately — not taking a half second before something happens. The team was frustrated to the point of considering abandoning the whole scheme, but then someone had the idea that if we showed a visible radio signal traveling from the virtual button to the toy, and accompanied it by a "radio transmission" sound effect, it might help players understand the mechanism better. And it worked! With the new system, the radio transmission metaphor clearly explained the delay in action, and also gave the players some immediate feedback about what was happening. And under Lens #9: The Lens of Unification, this change helped reinforce the theme, which was about radio-controlled toys.

FIGURE
13.12

The *Toytopia* control panel. A "down" message has just been sent to Winnie the Pooh. © Disney Enterprises, Inc.

Interface Tip #7: Test, Test, Test!

No one gets an interface right the first time. New games require new interfaces, and you cannot take it for granted that your new interface is going to be clear, power-giving, and fun unless you have people try it out. Test it as early as possible, and as often as possible. Build prototypes of your interface well before you have a complete playable game. Make paper and cardboard prototypes of any button or menu systems that you have, and get people to act out playing the game and using the interface so that you can see where they are having trouble. Most important, by working with players this way, like an anthropologist, you will start to get better ideas about their intentions from moment to moment, which will inform all of your interface decisions.

Interface Tip #8: Break the Rules to Help Your Player

Since many games are variations on existing themes, there is a lot of copying of interface designs from game to game. So much so, that certain rules of thumb tend to show up for each genre of game. These can be useful, but it is easy to follow them slavishly without thinking about whether they are really a good idea for the players of your game. One example involves PC games using a mouse. The left mouse button is considered the main button, and some games choose to use the right mouse button for other functionality. So, a rule of thumb is that the right mouse button should generally not do anything, unless you are in a special mode where it has a purpose. However, this rule is often taken too far — and in simple games, such as children's games, where the right mouse button isn't used at all, most designers tend to leave it completely disabled, so that all gameplay happens

through the left mouse button. But when children use a mouse, they frequently click the wrong mouse button because their hands are small. Smart designers break this rule of thumb, and make the left and right mouse buttons both map to the same action, so that either button can be pressed successfully. Really, why wouldn't you do this for every game that only needs one mouse button?

The game interface is indeed the gateway to the experience. Let us pass now through that gateway, and look more closely at the experience itself.

FOURTEEN

Experiences Can be Judged by Their *Interest Curves*

FIGURE
14.1

My First Lens

When I was sixteen, I landed my first job working as a professional entertainer. It was in a show troupe at a local amusement park. I had hopes of being a part of shows where I could make good use of my much-practiced juggling skills, but my job ended up being a mix of a lot of things — puppeteering, wearing a raccoon costume, working the mixing board backstage, and hosting audience participation comedy shows. But one day the head of the troupe, a magician named Mark Tripp, came to me, explaining "Listen — that new stage on the east side of the park is almost finished. We're going to move the music revue over there, and I'm going to be putting on a magic show. On my days off, we need some other show to fill the gap. Do you think you and Tom could put together a juggling show?"

Naturally, I was very excited — Tom and I had been practicing together every chance we could get, hoping that we might get an opportunity to do our own show. We talked it over, and put together a rough script, with brief descriptions of the various tricks we could do, and the patter and jokes that would link them together. We practiced it until we felt it was ready for a trial run. In a couple days, our big moment came, and we got to try the show in front of an audience. We opened with a balancing routine, followed by some ring juggling, then club juggling, then club passing, and ending with five ball juggling, which we felt was our hardest trick. It was exhilarating to be performing our very own show. At the end we took our bows and went backstage triumphantly.

Mark was backstage waiting for us. "Well, what did you think?" we asked proudly.

"Not bad," he said, "but it could be a lot better."

"Better?" I said, surprised, "but we didn't drop anything!"

"True," he replied, "but were you listening to that audience?"

I thought back. "Well, they were a little slow to warm up, I guess, but they really liked the club passing routine!"

"Yes, but how about the five ball juggling — your last routine?"

We had to admit that didn't go over as big as we thought it would.

"Let me see your script," he said. He read it over carefully, sometimes nodding, sometimes squinting at it. He thought for a moment, and said, "You have some good stuff in this act, but the progression isn't quite right." Tom and I looked at each other.

"Progression?" I asked.

"Yeah," he responded, picking up a pencil, "See, your show right now is kind of shaped like this," and he sketched this shape on the back of the script:

FIGURE
14.2a

He went on. "Audiences generally prefer to see a show shaped more like this."

FIGURE
14.2b

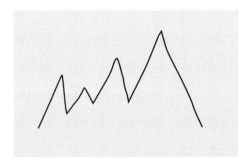

"See?"

I didn't see. But I had the feeling I was looking at something very important.

"It's simple. You need to start with more of a bang — to get their attention. Then you back off, and do something a little smaller, to give them a chance to relax, and get to know you. Then you gradually build up with bigger and bigger routines, until you give them a grand finale that exceeds their expectations. If you put your ring routine first, and your club passing routine last, I think you'll have a much better show."

The next day, we tried the show again, changing almost nothing but the order of the routines — and Mark was absolutely right. The audience was excited from the very beginning, and then their interest and excitement slowly built up over the course of the show to a grand climax with our club passing routine. Even though we dropped things a couple times in the second show, the audience response was twice what we had at the first show, with a few people jumping to their feet and shouting at the climax of the final routine.

Mark was waiting for us backstage, smiling this time. "It seems like it went better today," he said. Tom replied, "After you suggested that we change the show, it seemed so obvious. It's weird that we couldn't see it on our own."

"It's not weird at all," said Mark. "When you are working on a show, you are thinking about all the details, and how one thing links to another. It requires a real change in perspective to rise above the show, and look at it as a whole from the audience's point of view. But it makes a real difference, huh?"

"It sure does!" I said, "I guess we have a lot to think about."

"Well, don't think about it now — you two have a puppet show in five minutes."

Interest Curves

Since my time at the amusement park, I have found myself using this technique again and again when designing games, and have always found it useful. But what are these graphs, really? Let's take a moment and examine them in detail.

The quality of an entertainment experience can be measured by the extent to which its unfolding sequence of events is able to hold a guest's interest. I use the

FIGURE
14.3

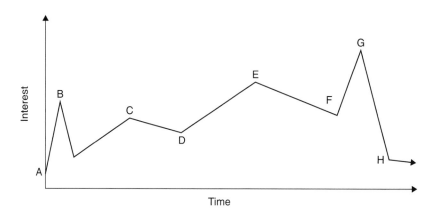

term "guest" instead of "player" because it is a term that works with games as well as more general experiences. The level of interest over the course of the experience can be plotted out in an interest curve. Figure 14.3 shows an example of an interest curve for a successful entertainment experience.

At point (A), the guest comes into the experience with some level of interest; otherwise they probably wouldn't be there. This initial interest comes from preconceived expectations about how entertaining the experience will be. Depending on the type of experience, these expectations are influenced by the packaging, advertisements, advice from friends, etc. While we want this initial interest to be as high as possible to get guests in the door, overinflating it can actually make the overall experience less interesting.

Then the experience starts. Quickly we come to point (B), sometimes called "the hook." This is something that really grabs you and gets you excited about the experience. In a musical it is the opening number. In the Beatles song *Revolution*, it is the screaming guitar riff. In Hamlet, it is the appearance of the ghost. In a videogame, it often takes the form of a little movie before the game starts. Having a good hook is very important. It gives the guest a hint of what is to come and provides a nice interest spike, which will help sustain focus over the less interesting part where the experience is beginning to unfold and not much has happened yet.

Once the hook is over, we settle down to business. If the experience is well-crafted, the guest's interest will continually rise, temporarily peaking at points like (C) and (E), and occasionally dropping down a bit to points like (D) and (F), only in anticipation of rising again.

Finally, at point (G), there is a climax of some kind, and by point (H), the story is resolved, the guest is satisfied, and the experience is over. Hopefully, the guest goes out with some interest left over, perhaps even more than when they came in. When show business veterans say "leave them wanting more," this is what they are talking about.

Of course, not every good entertainment experience follows this exact curve. But most successful entertainment experiences will contain some of the elements that our picture of a good interest curve displays.

FIGURE
14.4

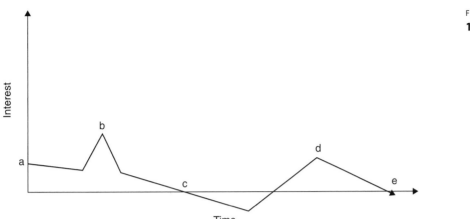

This diagram, on the other hand, shows an interest curve for a less successful entertainment experience. There are lots of possibilities for bad interest curves, but this one is particularly bad, although not as uncommon as one might hope.

As in our good curve, the guest comes in with some interest at point (a), but is immediately disappointed, and due to the lack of a decent hook, the guest's interest begins to wane.

Eventually, something somewhat interesting happens, which is good, but it doesn't last, peaking at point (b), and the guest's interest continues its downhill slide until it crosses, at point (c), the interest threshold. This is the point where the guest has become so disinterested in the experience that he changes the channel, leaves the theater, closes the book, or shuts off the game.

This dismal dullness doesn't continue forever, and something interesting does happen later at point (d), but it doesn't last, and instead of coming to a climax, the experience just peters out at point (e) — not that it matters, since the guest probably gave up on it some time ago.

Interest curves can be a very useful tool when creating an entertainment experience. By charting out the level of expected interest over the course of an experience, trouble spots often become clear and can be corrected. Further, when observing guests having the experience, it is useful to compare their level of observed interest to the level of interest that you, as an entertainer, anticipated they would have. Often, plotting different curves for different demographics is a useful exercise. Depending on your experience, it might be great for some groups, but boring for others (e.g., "guy movies" vs. "chick flicks"), or it might be an experience with "something for everyone," meaning well-structured curves for several different demographic groups.

Patterns Inside Patterns

Once you start thinking about games and entertainment experiences in terms of interest curves, you start seeing the pattern of the good interest curve everywhere.

You can see it in the three-act structure of a Hollywood movie. You can see it in the structure of popular songs (musical intro, verse, chorus, verse, chorus, bridge, big finish). When Aristotle says that every tragedy has a complication and a denouement, you can see it there. When comedians talk about the "rule of three," you can see the interest curve. Anytime someone tells a story that is interesting, engaging, or funny, the structure is there, like in this "High Dive Horror" story, which was sent in by a girl to the "Embarrassing Moments" column of a teen magazine:

> High Dive Horror
> I was at an indoor pool, and my friends had dared me to jump off the highest diving board. I'm really afraid of heights, but I climbed all the way up anyway. I was looking down, trying to convince myself to jump, when my stomach just turned over and I barfed — right into the pool! Even worse, it fell on a group of cute guys! I climbed down as fast as I could and hid in the bathroom, but everyone knew what I'd done!

You can even see the pattern quite concretely in the layout of a rollercoaster track. And naturally, this pattern shows up in games. The first time I found myself using it was when I was working on the Mark 2 version of Aladdin's Magic Carpet virtual reality experience for Disneyland. Some of us on the team had been discussing how, although the experience was a lot of fun, it seemed to drag a little bit at one point, and we were talking about how to improve that. It occurred to me that drawing an interest curve of the game would probably be a good idea. It had a shape roughly like this:

FIGURE
14.5

And suddenly it was very clear to me that the flat part was a real problem. How to fix it wasn't obvious. Simply putting more interesting moments in it might not be enough — since if the interest level was too high, it would diminish the interest of what was to come later. I finally realized that it might make the most sense to cut the flat part from the game entirely. Talking to the show director, he was opposed to cutting it — he felt we'd put too much work into it to cut it now, which was understandable because we were pretty late in development at this point. Instead, he suggested putting a shortcut at the beginning of the flat part so that some players could bypass that area if they wanted. We put the shortcut in (a merchant's tent

you could fly into that magically transported you to the heart of the city), and it was clear that players who knew about it preferred to take it. Observing the game in use after installation, it was common to see the game operators watching the players progress on monitors suddenly lean down to a player and whisper in their ear "go in that tent!" When I first witnessed this, I asked the operator why she told them that, and she replied, "Well, I don't know … they just seem to have more fun when they go that way."

But the Magic Carpet experience was a brief one — only about five minutes long. It makes sense to ask whether this pattern is meaningful at all for longer experiences. Will what works for a five-minute experience still work for one that goes on for hours? As some evidence that it does, consider the game of *Half Life 2*, one of the most critically acclaimed games of all time. Look at this graph of the number of player deaths that happen through a game of *Half Life 2, Episode 1*, which has an average completion time of five hours and thirty-nine minutes.

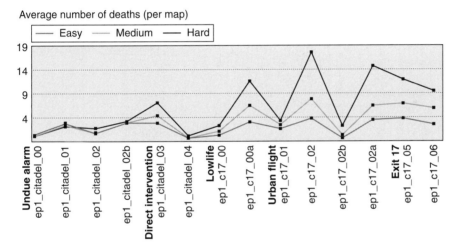

FIGURE
14.6

The three lines indicate the three difficulty settings for the game. Do these shapes look familiar? It can certainly be argued that the number of times a player dies is a good indicator of challenge, which is connected to how interesting the experience is.

But what about even longer experiences like multiplayer games, where a player might play for hundreds of hours? How can the same pattern hold up for a five hundred hour experience? The answer is a little surprising: *Interest curve patterns can be fractal.*

In other words, each long peak, upon closer examination, can have an internal structure that looks like the overall pattern, something like

FIGURE
14.7

A Fractal Interest Curve

And of course, this can go as many layers deep as you like. Typical videogames have this pattern in roughly three levels:

1. **Overall game**: Intro movie, followed by a series of levels of rising interest, ending with a major climax where the player defeats the game.

2. **Each level**: New aesthetics or challenges engage the player at the start, and then the player is confronted with a series of challenges (battles, puzzles, etc.) that provide rising interest until the end of the level, which often ends with some kind of "boss battle."

3. **Each challenge**: Every challenge the player encounters hopefully has a good interest curve in itself, with an interesting introduction, and stepped rising challenges as you work your way through it.

Multiplayer games have to give the player an even larger structure, which we'll discuss further in Chapter 22.

Interest curves will prove to be one of the most useful and versatile tools you can use as a game designer, so let's add them to our toolbox.

Lens #61: The Lens of the Interest Curve

Exactly what captivates the human mind often seems different for every person, but the most pleasurable patterns of that captivation are remarkably

established fantasy world. The toys let them spend more time in that world, and the longer they spend imagining they are in the fantasy world, the greater their projection into that world and the characters in it becomes. We will talk more about this idea in Chapter 17.

Interactive entertainment has an even more remarkable advantage, in terms of projection. The guest can *be* the main character. The events actually happen to the guest and are all the more interesting for that reason. Also, unlike story-based entertainment, where the story world exists only in the guest's imagination, interactive entertainment creates significant overlap between perception and imagination, allowing the guest to directly manipulate and change the story world. This is why videogames can present events with little inherent interest or poetry, but still be compelling to guests. What they lack in inherent interest and poetry of presentation, they can often make up for in projection.

We will discuss projection further in Chapter 18 when we talk about avatars, but let's introduce a lens to examine it now.

Lens #64: The Lens of Projection

One key indicator that someone is enjoying an experience is that they have projected their imaginations into it. When they do this, their enjoyment of the experience increases significantly, in a sort of virtuous circle. To examine whether your game is well-suited to induce projection from your players, ask yourself these questions:

- What is there in my game that players can relate to? What else can I add?

- What is there in my game that will capture a player's imagination? What else can I add?

- Are there places in the game that players have always wanted to visit?

- Does the player get to be a character they could imagine themselves to be?

- Are there other characters in the game that the players would be interested to meet (or to spy on)?

- Do the players get to do things that they would like to do in real life, but can't?

- Is there an activity in the game that once a player starts doing, it is hard to stop?

Interest Factor Examples

To ensure the relationship between the interest factors is clear, let's compare some different entertainment experiences.

Some brave street performers attract attention by juggling running chainsaws. This is an inherently interesting event. It is hard not to at least look up when it is going on around you. The poetry with which it is presented, however, is usually somewhat limited. There is some projection, though, as it is easy to imagine what it would be like to catch the wrong end of a chainsaw. When you witness the act in person, the projection is even greater.

FIGURE
14.9

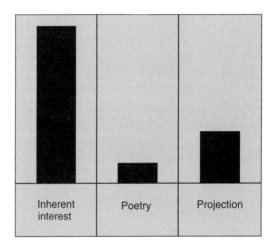

How about a violin concerto? The events (two sticks rubbed together) are not that inherently interesting, and the projection is usually not very notable. In this case, the poetry has to carry the experience. If the music isn't beautifully played, the performance will not be very interesting. Now, there are exceptions. The inherent interest can build up when the music is well-structured, or when the evening's program is well-structured. If the music makes you feel as if you are in another place, or if you feel a particular empathy for the musician, there may be significant projection (see Figure 14.10).

Consider the popular videogame, *Tetris*. The game mainly consists of an endless sequence of falling blocks. This leaves little room for inherent interest or poetry of presentation; however, the projection can be intense. The guest makes all the decisions, and success or failure is completely contingent on the guest's performance. This is a shortcut that traditional storytelling is unable to take. In terms of an

interesting entertainment experience, the large amount of projection makes up for what is lacking in poetry or inherent interest (see Figure 14.11).

FIGURE
14.10

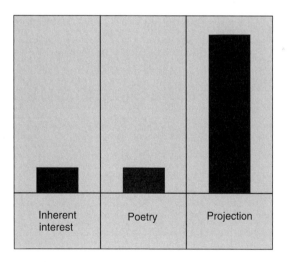

FIGURE
14.11

Putting It All Together

Some people find it useful to qualify the types of interest that happen at different points in their experience, letting you see which types of interest are holding the audience's interest at different times, creating graphs that look something like:

FIGURE
14.12

However you do it, examining the interest that a player has in a game is the best way to measure the quality of the experience you are creating. Opinions sometimes differ about what shapes are best for an interest curve, but if you don't take a step back and draw an interest curve of your experience, you risk not being able to see the forest for the trees. If you get in the habit of creating interest curves, though, you will have insights into design that others are likely to miss.

But a problem looms up before us. Games do not always follow the same pattern of experience. They are not linear. If that is true, then how can interest curves be of any use to us? To address that question properly, we must first spend some time discussing the most traditional type of linear entertainment experience.

FIFTEEN

One Kind of Experience Is the *Story*

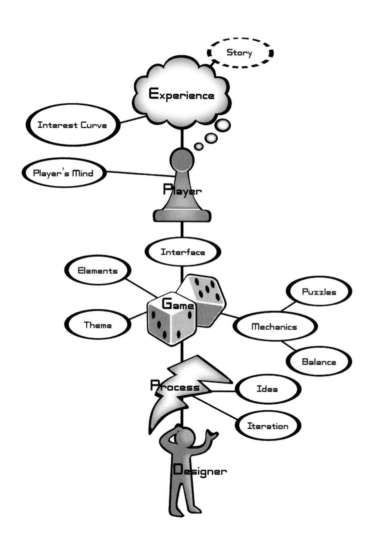

FIGURE
15.1

God never wrote a good play in his life.

– Kurt Vonnegut, *Cat's Cradle*

Story/Game Duality

At the dawn of the twentieth century, physicists started noticing something very strange. They noticed that electromagnetic waves and subatomic particles, which had long been thought to be fairly well-understood phenomena, were interacting in unexpected ways. Years of theorizing, experimenting, and theorizing again led to a bizarre conclusion: Waves and particles were the same thing ... both manifestations of a singular phenomenon. This "wave-particle duality" challenged the underpinnings of all that was known about matter and energy, and made it clear that we didn't understand the universe quite as well as we had thought.

Now it is the dawn of the next century, and storytellers are faced with a similar conundrum. With the advent of computer games, story and gameplay, two age-old enterprises with very different sets of rules, show a similar duality. Storytellers are now faced with a medium where they cannot be certain what path their story will take, just as the physicists found that they could no longer be certain what path their electrons would take. Both groups can now only speak in terms of probabilities.

Historically, stories have been single-threaded experiences that can be enjoyed by an individual, and games have been experiences with many possible outcomes that are enjoyed by a group. The introduction of the single-player computer game challenged these paradigms. Early computer games were simply traditional games, such as tic-tac-toe or chess, but with the computer acting as the opponent. In the mid-1970s, adventure games with storylines began to appear that let the player become the main character in the story. Thousands of experiments combining story and gameplay began to take place. Some used computers and electronics, others used pencil and paper. Some were brilliant successes, others were dismal failures. The one thing these experiments proved was that experiences could be created that had elements of both story and gameplay. This fact seriously called into question the assumption that stories and games are governed by different sets of rules.

There is still much debate about the relationship between story and gameplay. Some people are so story-oriented that they believe that adding gameplay is guaranteed to ruin a good story. Others feel the opposite — that a game with strong story elements has been cheapened somehow. Still others prefer a middle-of-the-road approach. As game designer Bob Bates once told me: "Story and gameplay are like oil and vinegar. Theoretically they don't mix, but if you put them in a bottle and shake them up real good, they're pretty good on a salad."

Setting theory aside, and taking a good look at the game titles that people really enjoy, there can be no doubt that stories must do something to enhance gameplay, since most games have some kind of strong story element, and it is the rare game

that has no story element at all. Some stories are thick, epic tales, like the elaborate multi-hour storytelling of the *Final Fantasy* series. Others are incredibly subtle. Consider the game of chess. It could be a completely abstract game, but it isn't — it has a gossamer thin layer of story about two warring medieval kingdoms. And even games with no story built in them at all tend to inspire players to make up a story to give the game context and meaning. I played Liar's Dice with some school–age kids recently, which is a completely abstract dice game. They liked the game, but after a few rounds, one of them said, "Let's pretend we are pirates — playing for our souls!" which was greeted with enthusiasm all around the table.

Ultimately, of course, we don't care about creating either stories or games — we care about creating experiences. Stories and games can each be thought of as machines that help create experiences. In this chapter we will be discuss how stories and games can be combined and what techniques work best for creating experiences that neither a gameless story or a storyless game could create on its own.

The Myth of Passive Entertainment

Before we go any further, I want to deal with the persistent myth that interactive storytelling is completely different from traditional storytelling. I would have thought that by this day and age, with story-based games taking in billions of dollars each year, this antiquated misconception would be obsolete and long-forgotten. Sadly, it seems to spring up, weed-like, in the minds of each new generation of novice game designers. The argument generally goes like this:

Interactive stories are fundamentally different from non-interactive stories, because in non-interactive stories, you are completely passive, just sitting there, as the story plods on, with or without you.

At this point, the speaker usually rolls back his eyes, lolls his tongue, and drools to underline the point.

In interactive stories, on the other hand, you are active and involved, continually making decisions. You are doing things, not just passively observing them. Really, interactive storytelling is a fundamentally new art form, and as a result, interactive designers have little to learn from traditional storytellers.

The idea that the mechanics of traditional storytelling, which are innate to the human ability to communicate, are somehow nullified by interactivity is absurd. It is a poorly told story that doesn't compel the listener to think and make decisions during the telling. When one is engaged in any kind of storyline, interactive or not, one is continually making decisions: "What will happen next?" "What should the hero do?" "Where did that rabbit go?" "Don't open that door!" The difference only comes in the participant's ability to *take* action. The *desire* to act and all the thought and emotion that go with that are present in both. A masterful storyteller knows how to create this desire within a listener's mind, and then knows exactly how and when

(and when not) to fulfill it. This skill translates well into interactive media, although it is made more difficult because the storyteller must predict, account for, respond to, and smoothly integrate the actions of the participant into the experience.

In other words, while interactive storytelling is more challenging than traditional storytelling, by no means is it fundamentally different. And since story is an important part of so many game designs, game designers are well-served to learn all they can about traditional storytelling techniques.

The Dream

"But wait!" I hear you cry out. "I have a dream of beautiful interactive storytelling — a dream that rises above mere gameplay, a dream where a wonderfully told story is completely interactive, and makes the participant feel like they are in the greatest movie ever made, while still having complete freedom of action, thought, and expression! Surely this dream can't be achieved if we continue to imitate past forms of story and gameplay."

And I admit that it is a beautiful dream — one that has spurred the creation of many fascinating experiments in interactive storytelling. But so far, no one has come anywhere close to realizing this dream. But this hasn't stopped people from creating interactive storytelling experiences that are truly wonderful, enjoyable, and memorable, despite the fact that they are somewhat limited in the structure and in the freedom they give the participant.

Shortly, we'll discuss the reasons this dream hasn't become a reality, and may never become a reality. But first, let's talk about what actually works.

The Reality

Real World Method 1: The String of Pearls

For all the grand dreams of interactive storytelling, there are two methods that dominate the world of game design. The first and most dominant in videogames is commonly called the "string of pearls" or sometimes the "rivers and lakes" method. It is called this because it can be visually represented like this:

FIGURE
15.2

The idea is that a completely non-interactive story (the string) is presented in the form of text, a slideshow, or an animated sequence and then the player is given a period of free movement and control (the pearl) with a fixed goal in mind. When the goal is achieved, the player travels down the string via another non-interactive sequence, to the next pearl, etc. In other words, cut scene, game level, cut scene, game level...

Many people criticize this method as "not really being interactive," but players sure do enjoy it. And really there should be little wonder at that. The string of pearls method gives the player an experience where they get to enjoy a finely crafted story, punctuated with periods of interactivity and challenge. The reward for succeeding at the challenge? More story and new challenges. Though some snobs will scoff, it is a neat little system that works very well, and it strikes a nice balance between gameplay and storytelling.

Real World Method 2: The Story Machine

To understand this method, we have to take a good look at what a story is. It is nothing more than a sequence of events that someone relates to someone else. "I was out of gum, so I went to the drugstore" is a story. Just not a very interesting one. A good game, however, tends to generate series of events that are interesting, often so interesting that people want to tell someone else what happened. From this point of view, a good game is like a story machine — generating sequences of events that are very interesting indeed. Think of the thousands of stories created by the game of baseball or the game of golf. The designers or these games never had these stories in mind when they designed the games, but the games produced them, nonetheless. Curiously, the more pre-scripting the designer puts into their game (like with the string of pearls), the fewer stories their game is likely to produce. Some videogames, such as *The Sims* or *Roller Coaster Tycoon*, are specifically designed to be story generators, and are very effective in this regard. Some critics say that these games don't really count as "interactive stories," because the stories have no author. But we don't care about that, because all we care about is creating great experiences — if someone experiences something they consider a great story, and it has no author, does that diminish the impact of the experience? Certainly not. In fact, it's an interesting question to consider which is more challenging — to create a great story or to create a system that generates great stories when people interact with it. Either way, this is a powerful method of interactive storytelling, and one that should not be ignored or taken for granted. Use this lens to determine how to make your game a better story generator.

Lens #65: The Lens of the Story Machine

A good game is a machine that generates stories when people play it. To make sure your story machine is as productive as possible, ask yourself these questions:

- When players have different choices about how to achieve goals, new and different stories can arise. How can I add more of these choices?
- Different conflicts lead to different stories. How can I allow more types of conflict to arise from my game?
- When players can personalize the characters and setting, they will care more about story outcomes, and similar stories can start to feel very different. How can I let players personalize the story?
- Good stories have good interest curves. Do my rules lead to stories with good interest curves?
- A story is only good if you can tell it. Who can your players tell the story to that will actually care?

In terms of methods of interactive storytelling, these two methods surely cover 99% of all games ever created. What is interesting is how opposite they are from each other. The string of pearls requires a linear story to be created ahead of time, and the story machine thrives when as little story as possible has been created ahead of time. "But surely there is something in between!" I hear the dreamer cry. "Neither of these methods are the real, true dream of interactive storytelling! The first method is basically a linear path, and the second one isn't really storytelling at all — it's just game design! What about my vision of a wonderfully branching story tree, full of AI characters, and dozens of satisfying endings, so that a participant will want to enjoy it over and over?"

And this is a good question. Why isn't this vision a reality? Why isn't it the dominant form of interactive storytelling? The usual suspects (conservative publishers, a weak-minded mass audience, lazy designers) are not to blame. The reason that this vision isn't a reality is because it is riddled with many challenging problems that haven't been successfully solved yet — and may never be solved. These problems are real and serious, and deserve careful consideration.

The Problems

Problem #1: Good Stories Have Unity

Really, it is a simple thing to make an interactive story tree. Just keep making choices that lead to more choices that lead to more choices. Do that, and you'll get all kinds of stories. But how many of them will be enjoyable? What kind of interest

curve will they have? One thing that we know about good stories is that they have intense unity — the problem that is presented in the first five minutes of the story is a driving force that has meaning all the way until the end. Imagine an interactive Cinderella story. "You are Cinderella. Your stepmother has told you to clean out the fireplace. Do you: (a) do it or (b) pack your bags, and leave? If Cinderella leaves, and say, gets a job as an administrative assistant, it isn't the Cinderella story anymore. The reason for Cinderella's wretched situation is so that she can rise out of it dramatically, suddenly, and unexpectedly. No ending you could write for the Cinderella story can compare with the ending that it already has, because the whole thing is crafted as a unit — the beginning and ending are of a piece. To craft a story with twenty endings and one beginning that is the perfect beginning for each of the twenty is challenging, to say the least. As a result, most interactive stories with many branching paths end up feeling kind of watery, weak, and disconnected.

Problem #2: The Combinatorial Explosion

I fear there are too many realities.

– John Steinbeck, *Travels with Charley*

It seems so simple to propose: I'll give the player three choices in this scene, and three in the next, and so on. But let's say your story is 10 choices deep — if each choice leads to a unique event, and three new choices, you will need to write 88,573 different outcomes to the choices the player will make. And if 10 choices sounds kind of short, and you want to have 20 opportunities for three choices from the beginning to the end of the story, that means you'll need to write 5,230,176,601 outcomes. These large numbers make any kind of meaningful branching storytelling impossible in our short life spans. And sadly, the main way that most interactive storytellers deal with this perplexing plethora of plotlines is to start fusing outcomes together — something like:

FIGURE
15.3

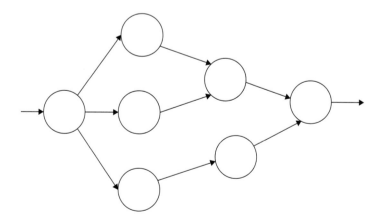

And this certainly makes the storytelling more manageable, but look at what has just happened. For all the choices the player had (well, not that many here, really), they all end up at the same place. How meaningful can these choices have been if they all lead to the same conclusion? The combinatorial explosion is frustrating because it leads to compromises on top of Band-Aids on top of compromises, and ultimately a weak story. And you still have to write a lot more scenes than the player will ever see.

Problem #3: Multiple Endings Disappoint

One thing that interactive storytellers like to fantasize about is how wonderful it is that a story can have multiple endings. After all, this means the player will be able to play again and again with a different experience every time! And like many fantasies, the reality tends to disappoint. Many games have experimented with having multiple endings to their game story. Almost universally, the player ends up thinking two things when they encounter their first ending in one of these.

1. **"Is this the real ending?"** In other words, the happiest ending, or the ending that is most unified with the story beginning. We all like to dream that we can find a way to write equally valid endings, but because good stories have unity, this generally doesn't happen. And when players start to suspect they may be on the wrong track, they stop experiencing the story and start thinking about what they should have done instead, which defeats any attempt at storytelling. The string of pearls has a tremendous advantage here — the player is always on the correct story path, and they know it — any problem-solving action is surely a path toward a rewarding ending.

2. **"Do I have to play this whole thing again to see another ending?"** In other words, the multiple endings go against the idea of unity, and as much as we would like to dream that the gameplay would be significantly different if the player made different choices, it almost never is, and so the player now has to go on a long repetitive trudge to explore the story tree, which probably will not be worth the effort and tedium, since there is likely a lot of repeated content upon a second playing (in an attempt to manage a combinatorial explosion), which will look pretty bad under Lens #2: The Lens of Surprise. Some games have tried novel approaches to deal with this problem. The infamous game *Psychic Detective* (once summed up in a review as "One of the worst games ever made. Also, a masterpiece") was a continuously moving 30-minute experience that always culminated in a final psychic battle with the villain, in which your powers were determined by the path you took through the game. As a result, to master the game, you had to play it through over and over again. Since most of the game consists of video clips, and the game tree has some significant bottlenecks that you must experience every time, the designers filmed multiple

versions of the bottleneck areas, each with different dialog, but containing the same information. As hard as the designers worked to solve the problem of repeated content (and many other problems), players generally found the process of replaying the interactive story somewhat tedious.

There are exceptions, of course. *Star Wars: Knights of the Old Republic* featured a novel type of player choice — did they want to play the game on the "light side" or "dark side" of the force — that is, with good or evil goals? Depending on which of the paths you choose, you have different adventures, different quests, and ultimately a different ending. It can be argued that this isn't really a case of two different endings on the same story, but two completely different stories — so different that they are each equally valid.

Problem #4: Not Enough Verbs

The things that videogame characters spend their time doing are very different than the things that characters in movies and books spend their time doing:

Videogame Verbs: run, shoot, jump, climb, throw, cast, punch, fly

Movie Verbs: talk, ask, negotiate, convince, argue, shout, plead, complain

Videogame characters are severely limited in their ability to do anything that requires something to happen above the neck. Most of what happens in stories is communication, and at the present time, videogames just can't support that. Game designer Chris Swain has suggested that when technology advances to the point that players can have an intelligent, spoken conversation with computer-controlled game characters, it will have an effect similar to the introduction of talking pictures. Suddenly, a medium that was mostly considered an amusing novelty will quickly become the dominant form of cultural storytelling. Until then, however, the lack of usable verbs in videogames significantly hampers our ability to use games as a storytelling medium.

Problem #5: Time Travel Makes Tragedy Obsolete

Of all the problems that interactive storytelling faces, this final one is quite possibly the most overlooked, the most crippling, and the most insoluble. The question is often asked, "Why don't videogames make us cry?" and this may well be the answer. Tragic stories are often considered the most serious, most important, and most moving type of story. Unfortunately, they are generally off limits to the interactive storyteller.

Freedom and control are one of the most exciting parts of any interactive story, but they come at a terrible price: the storyteller must give up inevitability. In a powerful

tragic story, there is a moment where you can see the horrible thing that is going to happen, and you feel yourself wishing, begging, and hoping that it won't — but you are powerless to stop this path toward inevitable destiny. This rush of being carried along toward certain doom is something that videogame stories simply cannot support, for it is as if every protagonist has a time machine, and anything seriously bad that happens can always be undone. How could you make a game out of *Romeo and Juliet*, for example, where Shakespeare's ending (they both commit suicide) is the "real" ending for the game?

Not all good stories are tragic of course. But any experience that met the qualifications of the dream of interactive fiction should at least have the potential for tragedy. Instead we get what the narrator in *Prince of Persia: The Sands of Time* intones when your character dies: "Wait — that's not what really happened…" Freedom and destiny are polar opposites. As such, any solution to this problem will have to be very clever indeed.

The Dream Reborn

The problems with the dream of interactive storytelling are not trivial. Perhaps, one day, artificial personalities so realistic that it is impossible to tell them from humans will be intimately involved in our story and game experiences, but even that does not solve all of the problems presented here — anymore than a well-run game of Dungeons and Dragons, where human intelligence is behind every game character, can solve all these problems. No magic solution is likely to solve all five at once. This is not a reason to despair, the reason the dream is a failure is because it is flawed. Flawed because it is obsessed with story, not with experience, and experience is all we care about. Focusing on story structure at the expense of experience is the same sin as focusing too much on technology, on aesthetics, or on gameplay structure at the expense of experience. Does this mean we need to discard our dreams? No — we just need to improve them. When you change your dream to one of creating innovative, meaningful, and mind-expanding experiences, and keep in mind these may need to mix and blend traditional story and game structures in untraditional ways, the dream can come true for you every day. The following tips and Chapter 16 address some interesting ways to make the story elements of your game as interesting and involving as possible.

Story Tips for Game Designers

Story Tip #1: Goals, Obstacles, and Conflicts

It is an old maxim of Hollywood screenwriting that the main ingredients for a story are (1) A character with a goal and (2) obstacles that keep him from reaching that goal.

As the character tries to overcome the obstacles, interesting conflicts tend to arise, particularly when another character has a conflicting goal. This simple pattern leads to very interesting stories because it means the character has to engage in problem-solving (which we find very interesting), because conflicts lead to unpredictable results, in other words, surprises (which we find very interesting), and because the bigger the obstacle, the bigger the potential for dramatic change (which we find very interesting).

Are these ingredients just as useful when creating videogame stories? Absolutely and maybe even more so. We've already discussed Lens #25: The Lens of Goals — the goal of the main character will be the goal of the player, and will be the driving force that keeps them moving along the string of pearls, if you choose to create one. And the obstacles that character meets will be the challenges the player faces. If you want your game to have a solidly integrated story, it is very important that these things line up — if you give the player a challenge that has nothing to do with the obstacles the main character faces, you have just weakened the experience considerably. But if you can find a way to make the challenges of the game meaningful, dramatic obstacles for the main character as well, your story and game structure will fuse into one, which goes a long way toward making the player feel like part of the story. We already have a Lens of Goals — here is its sister lens.

Lens #66: The Lens of the Obstacle

A goal with no obstacles is not worth pursuing. Use this lens to make sure your obstacles are ones that your players will want to overcome.

- What is the relationship between the main character and the goal? Why does the character care about it?

- What are the obstacles between the character and the goal?

- Is there an antagonist who is behind the obstacles? What is the relationship between the protagonist and the antagonist?

- Do the obstacles gradually increase in difficulty?

- Some say "The bigger the obstacle, the better the story." Are your obstacles big enough? Can they be bigger?

- Great stories often involve the protagonist transforming in order to overcome the obstacle. How does your protagonist transform?

Story Tip #2: Provide Simplicity and Transcendence

One thing that game worlds and fantasy worlds tend to have in common is that they offer the player a combination of **simplicity** (the game world is simpler than

the real world) and **transcendence** (the player is more powerful in the game world than they are in the real world). This potent combination explains why so many types of story worlds show up again and again in games, such as the following:

- **Medieval**: The stream of swords and sorcery worlds seems to be never-ending. These worlds are simpler than the world we know, because the technologies are primitive. But they are seldom accurate simulations of medieval times — there is almost always some kind of magic added — this provides the transcendence. The continued success of this genre surely stems from the fact that it combines the simple and the transcendent in such a primal way.

- **Futuristic**: Many games and science fiction stories are set in the future. But these very seldom are any kind of realistic interpretation of the future we are likely to see — one with continued suburban sprawl, safer cars, longer work hours, and ever more complicated cell phone plans. No — the future that we see in these worlds is usually more of a post–apocalyptic future; in other words, a bomb went off, or we are on some strange frontier planet, and the world is much simpler. And of course we have access to sufficiently advanced technologies — which, as Arthur C. Clarke noted, are indistinguishable from magic — at least in terms of transcendence.

- **War**: In war, things are simpler, since all normal rules and laws are set aside. And the transcendence comes from powerful weaponry that lets participants become like gods, deciding who lives and who dies. It is a horror in reality, but in fantasy it gives a player powerful feelings of simplicity and transcendence.

- **Modern**: Modern settings are unusual for game stories, unless the player suddenly has surprisingly more power than normal. This can be accomplished in many ways. The *Grand Theft Auto* series uses criminal life to give both simplicity (life is simpler when you don't obey laws) and transcendence (you are more powerful when you don't obey laws). *The Sims* creates a simplified dollhouse version of human life, and it gives the player transcendent godlike powers to control the characters in the game.

Simplicity and transcendence form a powerful combination that is easily botched. Use this lens to make sure you combine them just right.

Lens #67: The Lens of Simplicity and Transcendence

To make sure you have the right mix of simplicity and transcendence, ask yourself these questions:

- How is my world simpler than the real world? Can it be simpler in other ways?

- What kind of transcendent power do I give to the player? How can I give even more without removing challenge from the game?

- Is my combination of simplicity and transcendence contrived, or does it provide my players with a special kind of wish fulfillment?

Story Tip #3: Consider the Hero's Journey

In 1949, mythologist Joseph Campbell published his first book, *The Hero with a Thousand Faces*. In this text, he describes an underlying structure that most mythological stories seem to share, which he calls the monomyth, or hero's journey. He goes into great detail about how this structure underlies the stories of Moses, Buddha, Christ, Odysseus, Prometheus, Osiris, and many others. Many writers and artists found great inspiration in Campbell's work. Most famously, George Lucas based the structure of *Star Wars* around structures Campbell described, with great success.

In 1992, Christopher Vogler, a Hollywood writer and producer, published a book called *The Writer's Journey*, which was a practical guide to writing stories using the archetypes that Campbell describes. Vogler's book is not as scholarly as Campbell's text, but it serves as a far more accessible and practical guide for writers who would like to use the hero's journey as a framework. The Wachowski brothers, who wrote *The Matrix* (which rather clearly follows the hero's journey model), are said to have used Vogler's book as a guide. As accessible as the text is, it is often criticized for being over-formulaic, and for shoehorning too many stories into a single formula. Nonetheless, many people find it gives them useful insights into the structure of heroic stories.

Because so many videogames revolve around a theme of heroism, it is only logical that the hero's journey is a relevant structure for a powerful videogame story. Since several books and a plethora of Web sites already exist describing how to structure a story around the hero's journey, I will only give an overview of it here.

Vogler's Synopsis of the Hero's Journey

1. **The Ordinary World** — Establishing scenes that show our hero is a regular person leading an ordinary life.

2. **The Call to Adventure** — The hero is presented with a challenge that disrupts their ordinary life.

3. **Refusal of the Call** — The hero makes excuses about why he can't go on the adventure.

4. **Meeting with the Mentor** — Some wise figure gives advice, training, or aid.

5. **Crossing the Threshold** — The hero leaves the ordinary world (often under pressure) and enters the adventure world.

6. **Tests, Allies, Enemies** — The hero faces minor challenges, makes allies, confronts enemies, and learns the workings of the adventure world.

7. **Approaching the Cave** — The hero encounters setbacks and needs to try something new.

8. **The Ordeal** — The hero faces a peak life or death crisis.

9. **The Reward** — The hero survives, overcomes their fear, and gets the reward.

10. **The Road Back** — The hero returns to the ordinary world, but the problems still aren't all solved.

11. **Resurrection** — The hero faces a still greater crisis, and has to use everything he has learned.

12. **Returning with the Elixir** — The journey is now well and truly complete, and the hero's success has improved the lives of everyone in the ordinary world.

By no means do you need to have all twelve of these steps in your heroic story — you can tell a good heroic story with fewer or more, or in a different order.

As a side note, it is an interesting exercise to look at the hero's journey through Lens #61: The Lens of Interest Curve — you will see a familiar form emerge.

Some storytellers take great offense at the idea that good storytelling can be accomplished by formula. But the Hero's Journey is not so much a formula, guaranteed to produce an entertaining story; rather, it is a *form* that many entertaining stories tend to take. Think of it as a skeleton. Just as humans have tremendous variety despite all of us having the same 208 bones, heroic stories can take millions of forms despite some common internal structure.

Most storytellers seem to agree that using the Hero's Journey as a starting point for your writing isn't a very good idea. As Bob Bates puts it:

The Hero's Journey isn't a box of tools you can use to fix every story problem. But it's somewhat similar to a circuit tester. You can clamp the leads around a problem spot in your story and check to see if there's enough mythical current flowing. And if you don't have enough juice, it can help point out the source of the problem.

Better to write your story first, and if you notice that it might have something in common with elements of the monomyth, then spend some time considering whether your story might be improved by following archetypical structures and elements more closely. In other words, use the Hero's Journey as a lens.

Lens #68: The Lens of the Hero's Journey

Many heroic stories have similar structure. Use this lens to make sure you haven't missed out on any elements that might improve your story. Ask yourself these questions:

- Does my story have elements that qualify it as a heroic story?
- If so, how does it match up with the structure of the Hero's Journey?
- Would my story be improved by including more archetypical elements?
- Does my story match this form so closely that it feels hackneyed?

Story Tip #4: Put Your Story to Work!

As we discussed in Chapter 4, it is possible to start a design in any corner of the tetrad — story, gameplay, technology or aesthetics. And many designs begin with a story. Following that story too slavishly, at the expense of the other elements, is a common mistake — and an especially silly one, since story is, in some ways, the most pliable of all the elements! Story elements can often be changed with just a few words, where changing elements of gameplay might takes weeks of balancing, and changing elements of technology might take months of reprogramming.

I once heard some developers of a 3DO game talk about some development headaches they were having. Their game involved flying over a planet in a spaceship and shooting down enemy ships. The game was 3D, and to maintain performance, they could not afford to draw distant terrain. To keep the terrain from looking strange when it popped in, they had planned to use the old trick of making the world foggy. But due to some quirk of the 3D hardware, the only fog they could make was a weird green color that looked completely unrealistic. Initially, the team assumed they would have to scrap this solution, when suddenly, story to the rescue! Someone had the idea that the maybe the evil aliens who had taken over the planet had done so by shrouding it with toxic gas. This little change in the story suddenly made a technical approach that supported the desired gameplay mechanic completely possible. As a side effect, it arguably improved the story, making the alien takeover seem all the more dramatic.

I had a similar experience developing my Mordak's Revenge board game. My initial design for the gameplay required players to travel about the board, collecting five keys. When they had all five, they had to journey to the stronghold of the evil wizard Mordak to unlock the stronghold and battle him. In playtests, it quickly became clear that it would be a better game mechanic if Mordak could somehow come to the player who had collected the keys, since it was more immediate, and it

meant that the battle against Mordak could be fought in a variety of terrains. But I was troubled because then the story didn't make any sense. So, once again, story to the rescue! What if, instead, Mordak had a secret stronghold that no one could find? And instead of collecting keys, the players had to collect five summoning stones? When all five were collected, Mordak could be summoned immediately out of his stronghold and forced to battle the player in whatever terrain the player was currently in. This simple change to the story made the desired gameplay possible. It also was more novel than my somewhat trite "villain in the castle" story.

Always keep in mind how limber, flexible, and powerful story can be — don't be afraid to mold your story to support the gameplay you think is best.

Tip #5: Keep Your Story World Consistent

There is an old French saying that goes:

> *If you add a spoonful of wine to a barrelful of sewage, you get a barrelful of sewage.*
>
> *If you add a spoonful of sewage to a barrelful of wine, you get a barrelful of sewage.*

In some ways, story worlds are fragile like the barrelful of wine. One small inconsistency in the logic of the world, and the reality of the world is broken forever. In Hollywood, the term "jumping the shark" is used to describe a television show that has deteriorated to a point that it can never be taken seriously again. The term is a reference to the popular seventies show *Happy Days*. As a season finale, the writers had Fonzie, the most popular character in the show, jump over a line of school buses on his motorcycle. The episode was greatly hyped and had excellent ratings. In the next season, in an attempt to repeat this success, and to play off the popularity of the film *Jaws*, they had a waterskiing Fonzie jump over a shark. This was so ridiculous, and so far out of Fonzie's character, that fans of the show were repulsed. The problem was not so much that one particular episode had a ridiculous premise, but rather that the character and his world were forever tainted and could never be taken seriously again. One small error in consistency can make the whole world break apart, damaging its past, present, and future.

If you have a set of rules that define how things work in your world, stick with them, and take them seriously. If, for example, in your world you can pick up a microwave oven and put it in your pocket, that might be a little strange, but maybe in your world pockets are magic and can hold all kinds of things. If later, though, a player tries to put an ironing board in their pocket and is told "that is too big for you to carry," the player will be frustrated, will stop taking your story world seriously, and will stop projecting his imagination into it. Invisibly, in the blink of an eye, your world will have changed from a real, live place to a sad, broken toy.

Story Tip #6: Make your Story World Accessible

In Jules Verne's classic tale, *From the Earth to the Moon* (1865), he tells the story of three men who travel to the moon in a spaceship fired from a giant cannon. Despite the fact that the book goes into great detail about the science of the cannon, the premise seems ridiculous to modern eyes because any cannon blast powerful enough to launch a spacecraft would surely kill everyone inside. We know from experience that rockets are a far safer and realistic method of sending people to the moon. One might think that Verne did not use rockets in his story because they had not yet been invented — but this was not the case. Rockets were commonly used as weapons at that time — consider the "rockets' red glare" in the *Star Spangled Banner* (1814), for instance.

So, surely Verne knew about rockets, and he seems to have had enough of a scientific mind to realize that they were a much more reasonable method of putting a craft into space than a cannon would be. So why did he write his story this way? The answer seems to be that it was much more accessible to his audience.

Consider the progressions of military technology over the course of the 19^th century. First, rockets:

1812: William Congreve's Rockets: 6.5" diameter, 42 pounds, two mile range.

1840: William Hale's Rockets: Same as Congreve's, but slightly more accurate.

In nearly thirty years, rockets showed no growth, and only slight improvement.

But now consider cannons:

1855: Dahlgren's Gun: 100 pound shell, three mile range.

1860: Rodman's Columbiad: 1000 pound shell, six mile range.

In a mere five years, the size of a cannon shell had increased by ten times! Keeping in mind that the American Civil War was making international headlines in 1865, it only took a small leap of the imagination to picture even larger and more powerful cannons appearing within the next few years — possibly large enough to fire shells clear to the moon.

Verne surely understood that rockets were the most likely method of man reaching the moon — but he was a storyteller, not a scientist, and he had the good sense to know that when you are telling a story, truth isn't always your friend. What the player will believe and enjoy is more important that what is physically accurate.

When I worked on *Pirates of the Caribbean: Battle for the Buccaneer Gold*, several examples of this principle arose. One was the speed of the boat — initially we took pains to make sure our pirate ship traveled at a realistic speed. But we quickly found that this speed was so slow (or appeared to be, at our height from the water) that players quickly became bored. So, we cast reality to the winds, as it were, and just made the boat go at a speed that felt realistic and exciting, even though it was

not realistic at all. Another example can be clearly seen in this screenshot from the game:

FIGURE
15.4

© Disney Enterprises, Inc. Used with permission.

Look at those boats and consider which way the wind is blowing. Weirdly, it seems to be behind all of them. And indeed it is. To ask players to understand how to sail a ship with the wind was simply too much to ask in an action game — and no player ever asked us about that — they simply assumed that the boats drove like cars or motorboats, because that is what they were familiar with. As a minor detail, consider the flags at the top of the ship masts — they are being blown in the opposite direction as the sails! The modeler of the ships initially had them facing the correct way, but it looked strange to our playtesters, who were more used to seeing a flag flying on a car antenna than on a ship's mast. Our players would frequently ask why the flags pointed the wrong way, and we would explain: "No, see, the wind is blowing from *behind* the ships…" and they would say "Oh… hmm…. I guess that's right." But after a while, we got tired of explaining it, so we just made the flags point the other way, and people stopped asking about them, because now they looked "normal."

There are times, though, that your story requires something strange that the player has never seen before, that can't be made readily accessible. In these cases, it is very important that you call special attention to that thing, and make the players understand what it is, and how it works. I once had a team of students who made a little game about a two hamsters in a pet store who fall in love, but are unable to meet

because they are in separate cages. Their game had the player use a little hamster cannon to try to launch the boy hamster to the girl hamster's cage. It was pointed out to them that there is no such thing as a hamster cannon, and as a result the story seemed kind of strange and hard to believe. One solution would have been to change the cannon to something else that could launch the boy hamster, like perhaps a hamster wheel, but the team wanted to keep the cannon, so they took a different approach. In the establishing shots of the pet shop, they prominently featured signs reading "Special! Hamster Cannons on sale!" This not only served as an intriguing hook for the experience, creating anticipation to see what a hamster cannon would look like, but it introduced this very strange item to the player so that when it showed up, it didn't seem so strange after all — just a natural part of an unusual world. Surreal elements are not at all uncommon in games, and it is important that you understand how to smoothly integrate them. One handy way to do that is to use this lens.

Lens #69: The Lens of the Weirdest Thing

Having weird things in your story can help give meaning to unusual game mechanics — it can capture the interest of the player, and it can make your world seem special. Too many things that are too weird, though, will render your story puzzling and inaccessible. To make sure your story is the good kind of weird, ask yourself these questions:

- What's the weirdest thing in my story?
- How can I make sure that the weirdest thing doesn't confuse or alienate the player?
- If there are multiple weird things, should I may be get rid of, or coalesce, some of them?
- If there is nothing weird in my story, is the story still interesting?

Story Tip #7: Use Clichés Judiciously

One criticism videogame stories seem unable to escape is overuse of cliché. After all, you can only save the world from evil aliens, use your wizardry against an evil dragon, or fight a dungeon full of zombies with a shotgun a certain number of times before it becomes tedious. This drives some designers to avoid any story setting or theme that has been done before — sometimes pushing their story and setting into something so offbeat that players are unable to understand what it is, or relate to it at all.

For all their potential to be abused, clichés have the tremendous advantage of being familiar to the player, and what is familiar is understandable and comprehensible.

It has been said that every successful videogame finds a way to combine something familiar with something novel. Some designers would never make a game about ninjas, because ninjas have been done to death. But what if you made a story about a lonely ninja, or an incompetent ninja, a ninja dog, a robotic ninja, or a third grade girl who leads a secret life as a ninja? All of these storylines have the potential to be something new and different, while having a hook into a world the player already understands.

It is certainly an error to overuse clichés, but it is an equal error to exile them from your toolbox.

Story Tip #8: Sometimes a Map Brings a Story to Life

When we think of writing stories, we generally think of words, characters, and plotlines. But stories can come from unexpected places. Robert Louis Stevenson had no intention of writing what is considered his greatest work: *Treasure Island*. Obligated to entertain a schoolboy during a particularly rainy vacation, he and the boy took turns drawing pictures. On a whim, Stevenson drew a map of a fanciful island, which suddenly took on a life of its own.

> ...as I paused upon my map of 'Treasure Island', the future character of the book began to appear there visibly among imaginary woods; and their brown faces and bright weapons peeped out upon me from unexpected quarters, as they passed to and fro, fighting and hunting treasure, on these few square inches of a flat projection. The next thing I knew I had some papers before me and was writing out a list of chapters.

Most videogames do not happen in world of words, but in a physical place. By making sketches and drawings of this place, often a story will naturally take shape, as you are compelled to consider who lives there, what they do, and why.

So much more can be said about story, we cannot possibly cover it all here. But whatever you create, whether it be an abstract game with only the thinnest veneer of theme and setting, or a vast epic adventure with hundreds of detailed characters, you are wise to make the story elements of your game as meaningful and powerful as possible. So, we end this chapter with a general purpose lens, which can benefit any game as a tool for studying this very important quadrant of the elemental tetrad.

Lens #70: The Lens of Story

Ask yourself these questions:

- Does my game really need a story? Why?
- Why will players be interested in this story?

- How does the story support the other parts of the tetrad (aesthetics, technology, gameplay)? Can it do a better job?
- How do the other parts of the tetrad support the story? Can they do a better job?
- How can my story be better?

SIXTEEN

Story and Game Structures can be Artfully Merged with *Indirect Control*

FIGURE
16.1

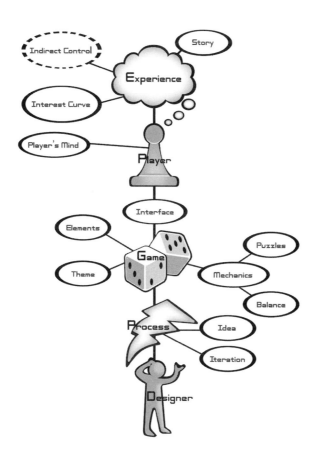

The Feeling of Freedom

In previous chapters, we touched on the conflict between story and gameplay. At its heart, this is a conflict about freedom. The wonderful thing about games and interactive experiences is the freedom that the player feels — this freedom gives the player the wonderful feeling of control, and makes it easy for them to project their imaginations into the world you have created. The feeling of freedom is so important in a game that it merits a new lens.

Lens #71: The Lens of Freedom

A feeling of freedom is one of the things that separates games from other forms of entertainment. To make sure your players feel as free as possible, ask yourself these questions:

- When do my players have freedom of action? Do they feel free at these times?
- When are they constrained? Do they feel constrained at these times?
- Are there any places I can let them feel more free than they do now?
- Are there any places where they are overwhelmed by too much freedom?

And even though it makes it very difficult for us to control the interest curve for the player, when we give them those wonderful feelings of interactivity and control, we have to give them freedom, right?

Wrong.

We don't always have to give the player true freedom — we only have to give the player the feeling of freedom. For, as we've discussed, all that's real is what you feel — if a clever designer can make a player feel free, when really the player has very few choices, or even no choice at all, then suddenly we have the best of both worlds — the player has the wonderful feeling of freedom, and the designer has managed to economically create an experience with an ideal interest curve and an ideal set of events.

But how is such a thing possible? How can one create the feeling of freedom, when no freedom, or very limited freedom exists? After all, a designer has no control over what a player does when they enter a game, right?

No, not right. It is true that the designer does not have direct control over what a player does, but through various subtle means, they can exert *indirect control* over the actions of a player. And this indirect control is possibly the most subtle, delicate, artful, and important technique of any we will encounter.

To understand what I'm talking about, let's look at some of the methods of indirect control. There are many of them, varied and subtle, but generally, these six do most of the work.

Indirect Control Method #1: Constraints

Consider the difference between these two requests:

Request 1: Pick a color: _____

Request 2: Pick a color: a. red b. blue c. green

Both of them give the answerer freedom of choice, and they are both asking for about the same thing. But the difference is tremendous because for Request 1, the answerer could have chosen one of millions of different answers — "fire engine red," "cauliflower blue," "mauvish taupe," "sky blue pink," "no, you pick a color," or just about anything, really.

But for Request 2, the answerer only has three choices. They still have freedom, they still get to choose, but we have managed to cut the number of choices from millions to three! And the answerers who were going to pick red, blue, or green anyway won't even notice the difference. And still others will prefer Request 2 over Request 1, because too much freedom can be a daunting thing — it forces your imagination to work hard. In my amusement park days, I sometimes worked in the candy store, in front of a big display of sixty flavors of old-fashioned stick candy. A hundred times a day, people would come in and ask "What flavors do you have back there?" At first, I thought I would be a smart aleck, and recite all sixty flavors — as I did this, the customer's eyes would get wide with fear, and right around the 32nd flavor they would say, "Stop! Stop! That's enough!" They were completely overwhelmed by so many choices. After a while, I thought of a new approach. When they asked about the flavors, I would say "We have every flavor you can imagine. Go on, name the flavors you would like — I'm sure we have them."

At first they would be impressed with this powerful freedom. But then they would furrow up their brows, think hard, and say, "Uh... cherry? No, wait... I don't want that... Hmm.... peppermint? No... Oh, just forget it," and they would walk away in frustration. Finally I figured out a strategy that sold a lot of candy sticks. When someone would ask about the flavors, I would say "We have just about every flavor you can imagine, but our most popular flavors are Cherry, Blueberry, Lemon, Root Beer, Wintergreen, and Licorice." They were delighted at having the feeling of freedom, but also glad to have a small number of attractive choices; in fact most customers would choose from the "popular six," a list I made up, and a list I would change frequently to help ensure the other flavors didn't get too old on the shelf. This is an example of indirect control in action — by constraining their choices, I made it more likely they would make a choice. But not just any choice — the choices I guided them toward. And despite my tricky methods of constraining their choices, they retained a feeling of freedom, and perhaps felt an enhanced feeling of freedom, since their choices were clearer than when I didn't guide them at all.

This method of indirect control by constraint is used in games all the time. If a game puts a player in an empty room with two doors, the player will almost certainly go through one of them. Which one, we don't necessarily know, but they

285

will surely go through one, since a door is a message that says "open me," and players are naturally curious. After all, there is nowhere else to go. If you ask the player if they had choices, they would say they did, for even two options is a choice. Compare this to putting a player in an open field, out on a city street, or in a shopping mall. In those cases, where they go and what they do is far more open-ended and difficult to predict — unless you use other methods of indirect control.

Indirect Control Method #2: Goals

The most common and straightforward use of indirect control in game design is through goals. If a player has two doors they can go through, I don't really know which one they are going to enter. But if I give them a goal of "go find all the bananas," and one of the doors clearly has bananas behind it, I can make a pretty good guess about where they are going to go.

Earlier, we talked about the importance of establishing good goals to give players a reason to care about your game. Once clear and achievable goals have been established, though, you can take advantage of that fact by sculpting your world around the goals, since your players will only go places and do things that they think will help fulfill the goals. If your driving game is about racing through a city to get to a finish line, you don't have to build a complete street map, because if you clearly mark the fastest route, people will mostly stick to that. You might add a small number of side streets (especially if some are shortcuts!) to give a feeling of freedom, but the goal you have selected will indirectly control players to avoid exploring every little side street. Creating content that players will never see does not give them more freedom — it just wastes development resources that could be used to improve the places that the players will see.

One fascinating real-world example of this can be seen in the men's restrooms of Amsterdam's Schipol Airport. Users of the urinals in these restrooms quickly notice that they contain a fly. This is not an actual fly; rather, it is just an etching in the surface of the porcelain. Why? The designers were trying to solve the problem of "sloppy marksmanship," which results in the need for more janitorial service. The etched fly creates an implicit goal — hit the fly. By placing the fly in the center of the urinal (and slightly to one side to soften the angle of incidence), the bathrooms stay cleaner. The "players" have not had their freedom diminished in the least, but are indirectly controlled toward the behavior that the designers find optimal.

Indirect Control Method #3: Interface

We've already talked about feedback, transparency, juiciness, and important aspects of a good interface. But there is something else to consider about your interface: indirect control. Because players want interfaces to be transparent, they don't really think about the interface, if they can help it. In other words, they set up their expectations

about what they can and cannot do in a game based on the interface. If your "rock star" game has a plastic guitar as the physical interface, your players are probably going to expect to play the guitar, and it probably will not occur to them that they might want to do something else. If you give them a gamepad instead, they might wonder if they can play different instruments, do stage dives, or any number of other things a rock star might do. But that plastic guitar secretly steals away those options — silently limiting the players to a single activity. When we built our virtual pirates attraction with a wooden ship's wheel and thirty-pound spun-aluminum cannons, no guest ever asked whether they could sword fight as part of the game — that option never entered their minds.

And it isn't just the physical interface that has this power — the virtual interface has it, too. Even the avatar you control, which is part of the virtual interface, exerts indirect control over the player. If the player controls Lara Croft, they will try to do certain things. If they control a dragonfly, an elephant, or a Sherman tank, they will try to do very different things. Choice of avatar is partly about who a player will relate to, but it is also about implicitly limiting the player's options.

Indirect Control Method #4: Visual Design

We are led to believe a lie
when we see with, not through, the eye.

– William Blake

Anyone who works in an area of the visual arts knows that layout affects where the guest will look. This becomes very important in an interactive experience, since guests tend to go to what draws their attention. Therefore, if you can control where someone is going to look, you can control where they are going to go. Figure 16.2 shows a simple example.

It is difficult, looking at this picture, for your eyes not to be led to the center of the page. A guest looking at this scene in an interactive experience would be very likely to examine the central triangle before considering what might be at the edges of the frame. This is in sharp contrast to Figure 16.3.

Here, the guest's eyes are compelled to explore the edges of the frame, and beyond. If this scene were part of an interactive experience, it would be a good bet that the guest would be trying to find out more about the objects on the edges, rather than the circle in the middle of the scene. Most likely, they would try to push past the borders of the screen, if they could.

These examples are abstract, but there are plenty of real-world examples that illustrate the same thing. The designers of quilts, for example, think a great deal about how to draw the eye. It is often said that a good quilt design makes the eye flit continuously around the quilt, never letting it come to rest on a single image.

FIGURE
16.2

FIGURE
16.3

Set designers, illustrators, architects, and cinematographers use these principles to guide the eye of their guests and indirectly control their focus. One excellent example is the castle at the center of Disneyland. Walt Disney knew that there was some risk of guests entering the park and milling about at the entrance, unsure of where to go. The castle is placed such that the guests' eyes are immediately drawn to it upon entering the park (similar to the first figure), and their feet are quick to follow. Soon the guests are at the Disneyland hub, with several visual landmarks beckoning them in different directions (similar to the second figure). Indirectly, Walt was able to control guests to do just what he wanted them to do: Move quickly to the center of Disneyland, and then branch out randomly to other parts of the park. Of course, the guests are seldom aware of this manipulation. After all, no one told them where to go. All the guests know is that without much thinking, and with total freedom, they ended up somewhere interesting and had a fun entertainment experience.

Walt even had a name for this kind of manipulation. He called it a visual "weenie," a reference to the way dogs are sometimes controlled on a movie set: A trainer holds a hot dog or piece of meat in the air, and moves it around to control where the dog will look, since nothing draws the attention of a dog better than food.

One of the keys to good level design is that the player's eyes pull them through the level, effortlessly. It makes the player feel in control and immersed in the world. Understanding what pulls the eye of the player can give you tremendous power over the choices players want to make. When the Disney VR Studio worked on the Mark 2 version of *Aladdin's Magic Carpet Ride: VR Adventure*, we faced a significant conundrum. One very important scene was the palace throne room, shown here:

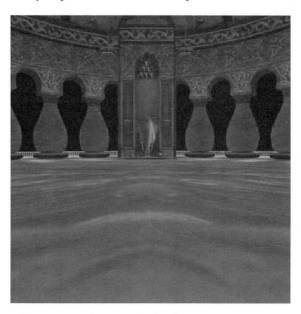

FIGURE
16.4

© Disney Enterprises, Inc. Used with permission.

289

The animation director wanted players to fly into this room, then fly up to that little throne at the base of the elephant statue, and sit for a moment and listen to a message from the Sultan before they continued their gameplay. We had hoped that the little Sultan, dressed in white hopping up and down on that throne, would be enough to draw people over to listen to him — but that didn't happen. These players were on flying carpets! They wanted to fly all around, up to the ceiling, around the pillars, anywhere they could. Their implicit goal was to fly and have fun — visiting the Sultan didn't fit in with that plan. Seeing no other choice, we were all set to implement a system that seized control from the players, dragging them across the room to the Sultan, and gluing them to the spot while he talked. No one liked this idea, since we all knew it meant robbing the players of their precious feeling of freedom.

But then the art director had an idea.

He painted a single red line on the floor, like this:

FIGURE
16.5

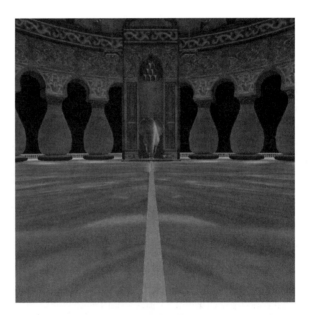

© Disney Enterprises, Inc. Used with permission.

His thinking was that maybe guests would follow the red line. We were all somewhat skeptical, but it was an easy thing for us to prototype. And to our stunned amazement, guests did exactly that! Upon entering the room, instead of flying every which way like we had seen before, they followed the red line like it was some kind of tractor beam, right up to the Sultan's throne. And when he started talking (by that time guests were right up close to him), they waited to hear what he had to say! It didn't work every single time, but it did work over 90% of the time,

which was perfectly adequate for this experience. The most startling part was in the interviews afterwards — upon asking players why they followed the red line in the throne room, they would say "What red line?" It didn't register in their conscious memory at all.

At first this didn't make sense to me: How could a simple red line wipe the idea of flying around the room out of the minds of the players? But then I realized — it was seeing the columns, and the chandeliers that put the idea of flying around into their minds. The red line was so visually dominant in the scene, that it stopped them from noticing these other things, and so the idea to do these other things didn't even occur to them.

Curiously, we faced a new version of this problem in the Mark 3 version of the game. In this version, which was for four simultaneous players, we didn't want them all to go to the Sultan. We wanted them to split up and go different places — we wanted some players to visit the Sultan, and others to fly through doors on the left and right sides of the room. But the tyrannical red line was making all four players fly up to the Sultan. Again we started discussing how we probably had to force the players to split up — but then we had a different thought — could we change the red line to make that happen? We tried this:

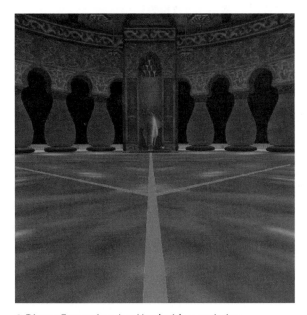

FIGURE
16.6

And it worked beautifully. In most cases, two players would visit the throne, one player would branch left following the line to the left door, and one player would branch right, following the line to the right door.

Indirect Control Method #5: Characters

One very straightforward method of indirectly controlling the player is through computer-controlled characters in the game. If you can use your storytelling ability to make the player actually care about the characters — that is, willingly wanting to obey them, protect them, help them, or destroy them — you suddenly have an excellent tool to control what the player will and will not try to do.

In the game *Animal Crossing*, a mysterious council called the HRA (Happy Room Academy) periodically evaluates how well you have decorated the interior of your house, and awards you points based on how well you have done. Players work very hard to get these points — partly because it is a goal of the game, but I think also partly because it feels embarrassing to think that someone is looking at the inside of your house and shaking their head in disgust, even if they are only imaginary.

In the game *Ico*, your goal is to protect a princess who travels with you. The designers have a very clever timer mechanism in the game — evil spirits appear if you stay still too long, grab the princess, and try to drag her into a hole in the ground. Even though they can't hurt her unless they succeed in carrying her away, and it takes some time for them to actually pull her into the hole, I found myself snapping into action the moment they appeared, for the very idea of them touching her made me feel like I was letting her down.

Characters can be a great way to manipulate the choices the player is trying to make, or how they feel about those choices. But first you have to make the player care about how those imaginary characters feel.

Indirect Control Method #6: Music

When most designers think of adding music to a game, they usually think of the mood they want to create, and the atmosphere of the game. But music can also have a significant effect on what players do.

Restaurants use this method all the time. Fast music makes people eat faster, so during a lunch rush, many restaurants play high energy dance music, because faster eating means more profits. And of course, during a slow period, like three in the afternoon, they do the opposite. An empty restaurant often is a sign of a bad restaurant, so to make diners linger, they play slow music, which slows down the eating and makes customers consider ordering an extra cup of coffee or a dessert. Of course, the patrons don't realize this is happening — they think they have total freedom over their actions.

If it works for restaurant managers, it can work for you. Think about what kind of music you should play to make players

- Look around for something hidden
- Destroy everything possible without slowing down

- Realize they are heading the wrong way
- Move slowly and carefully
- Worry about accidentally hurting innocent bystanders
- Go as far and as fast as possible without looking back

Music is the language of the soul, and as such, it speaks to players on a deep level — a level so deep that it can change their moods, desires, and actions — and they don't even realize it is happening.

These six methods of indirect control can be very powerful ways to balance freedom and good storytelling. To decide whether your game might benefit from some artful indirect control, use this lens.

Lens #72: The Lens of Indirect Control

Every designer has a vision of what they would like the players to do to have an ideal play experience. To help ensure the players do these things of their own free will, ask yourself these questions:

- Ideally, what would I like the players to do?
- Can I set constraints to get players to do it?
- Can I set goals to get players to do it?
- Can I design my interface to get players to do it?
- Can I use visual design to get players to do it?
- Can I use in-game characters to get players to do it?
- Can I use music or sound to get players to do it?
- Is there some other method I can use to coerce players toward ideal behavior without impinging on their feeling of freedom?

Collusion

While designing *Pirates of the Caribbean: Battle for the Buccaneer Gold*, we faced a significant challenge. We had to create a very powerful interactive experience that would only last five minutes. The interest curve had to be excellent, since a family of four could be paying as much as $20 just to play this game one time. But at the same time, we knew this couldn't just be a linear experience, because the very essence of being a pirate involved a feeling of tremendous freedom. Based on our previous experiences, we knew that this was a great opportunity for some indirect control.

Our early prototypes of the game made one thing clear: If we just set people out on the ocean to battle enemies, they had great fun for about two minutes and twenty seconds. Then their zeal would wane, and they would sometimes ask, "so... is this all we do?" Clearly this was an unacceptable interest curve. Players wanted more build up. We thought a way to achieve this would be with some more interesting scenarios. We thought that by putting these scenarios near islands that the players could approach, it would be a great way to guide them to where interesting things were happening — kind of like the castle guides people in Disneyland. So, we drew up an initial map:

FIGURE
16.7

© Disney Enterprises, Inc. Used with permission.

Players would start in the center, where we expected they would fight some enemies, and then they would hopefully sail for one of the islands, each designed to be interesting and visible from a distance. Which island they went to was up to them — they had freedom to choose, for each island had different types of encounters. At one, evil pirates were besieging a burning town. At another, a surprising mining operation was taking place on the side of a volcano. At a third, the royal navy was transporting huge quantities of gold, and guarding their stronghold with catapults that launched fireballs. We were sure that these big islands would draw a lot of player interest.

Boy, were we wrong. Taking a look at Figure 16.8, you can see the problem.

The players have been told that their goal is to sink the pirate ships. Here they are surrounded by large, threatening pirate ships with bright white sails. Look at that poor volcano in the distance. It is hardly noticeable and has nothing to do with the player goals!

We saw right away that this wasn't working. And we started considering the possibility of putting the pirate ship on a fixed path that guided them to the islands.

FIGURE
16.8

But then we had a funny idea. What if the enemy pirate ships didn't act in their own best interest? Up until now, we had been spending a lot of time writing fancy algorithms to make the enemy ships attack with interesting and intelligent strategies. Our new idea was to scrap all that and change the logic of the ships. With the new system, at the start of the game, when the players encounter ships on the open ocean, the ships would attack the players, but then they would start to flee. The players, fixed on their goal of destroying enemy ships, would pursue them. We then tried to time things so that right about when the players destroyed the enemy ships, the ships had arrived at one of the islands (chosen randomly). With the ships sunk, the players would look up to find themselves at an interesting island scenario. They would do battle there, only to be attacked by new ships that again fled — to where? To whatever island the players had not visited yet.

This strategy worked magnificently. With a feeling of total freedom, the players would have a very structured experience: they would start with an exciting battle, followed by a mini-scenario, followed by a new naval battle, followed by another, new mini-scenario. We knew we had to have a big finish, but we couldn't be sure where the players would be. So a little bit after the fourth minute, the big finish came to them, in the form of a sudden fog and an attack by ghost pirates who engaged the players in an epic final battle.

The whole thing was only possible because we did something very unusual — we made the characters in the game have two simultaneous goals. On one hand, their goal is to engage the players in a challenging battle. On the other hand, their goal is to lead the players to interesting places to keep the flow of the experience optimal. I call this principle **collusion**, since the game characters are colluding with the designer to make an experience that will be optimal for the players. It is an interesting form of indirect control that joins methods of using goals, characters, and visual design for a single unified effect.

There is some evidence that this kind of indirect control via collusion may be central to the future of interactive storytelling. The fascinating *Façade* experience, created by Andrew Stern and Michael Mateas, takes this idea to a new level. In *Façade*, you play the role of a guest at a dinner party, hosted by Grace and Trip, a married couple. Your interface is one that mainly consists of speaking through typed text, which offers tremendous freedom and flexibility. As you play, you quickly notice that you are the only guest at the party, and weirdly, it is their anniversary. The situation is very uncomfortable because of their constant bickering, each trying to get you to take sides in their arguments. It is a very unusual game experience with goals that are more like those in a novel or television show than in a videogame.

FIGURE
16.9

Something else is unusual, too. The game seems to play quite differently on different sessions — each time you play, you hear perhaps 10% of the dialog that was recorded. This is not a string of pearls structure, or even a branching structure. This is a simulation where Grace and Trip are artificially intelligent characters who have goals they are trying to achieve. This is done through fairly standard AI models of goals related to behaviors that are triggered by sensors (Figure 16.10).

However, like our tricky pirate ships, Grace and Trip are not just trying to satisfy their own goals. They also are very aware that they are part of a story, and as such, should be trying to make it interesting. As they make their choices about what to say and do, part of their decision concerns whether what they are saying is of the proper tension for this part of the story, and the designers encoded a timeline of what they thought was appropriate tension over time for the experience (Figure 16.11).

Does that graph look familiar? By having Grace and Trip make decisions that follow this tension graph, while simultaneously trying to fulfill the goals they have as characters in the story, their behavior makes sense while keeping the player interested in the sequence of events.

FIGURE
16.10

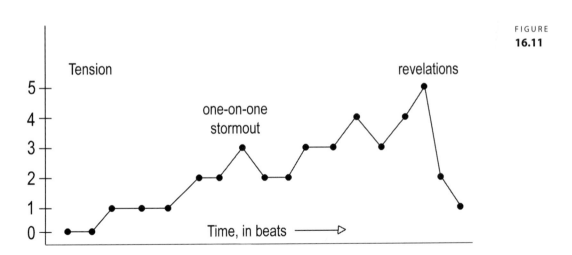

FIGURE
16.11

It would seem that we have only scratched the surface of the type of experiences that might be possible through clever use of collusion. If you'd like to consider how you might use it in your game, use this lens.

Lens #73: The Lens of Collusion

Characters should fulfill their roles in the game world, but when possible, also serve as the many minions of the game designer, working toward the designer's ultimate aim, which is to ensure an engaging experience for the player. To make sure your characters are living up to this responsibility, ask yourself these questions:

- What do I want the player to experience?
- How can the characters help fulfill this experience, without compromising their goals in the game world?

The Chinese philosopher Lao Tzu wrote:

When the best leader's work is done the people say "We did it ourselves!"

Hopefully you will find the subtle techniques of indirect control useful when trying to lead your players to engaging experiences where they will feel control, mastery, and success.

But where is it that these engaging experiences will take place?

SEVENTEEN

Stories and Games
Take Place in *Worlds*

FIGURE
17.1

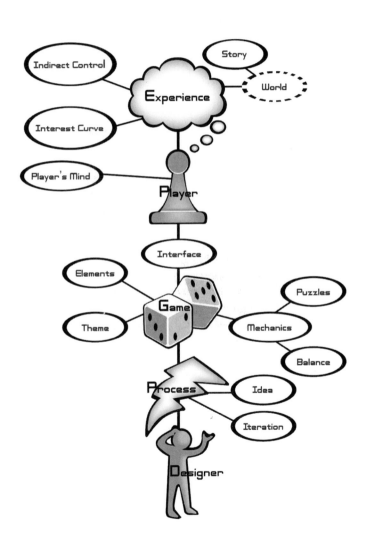

Transmedia Worlds

In May of 1977 the film *Star Wars* premiered. It was a surprise hit with young and old alike, but especially with the young. Children were going to see it again and again. It took nearly a year for Kenner Toys to produce a line of action figures based on the movie characters, but even a year after the film's release, the toys were a tremendous success, selling as fast as they could be produced, and continuing to sell well for years. Other *Star Wars* merchandise was produced — posters, jigsaw puzzles, sleeping bags, paper plates, and just about everything else you can imagine — but nothing was as popular as the action figures.

FIGURE
17.2

Some people believe that selling this kind of merchandise is just a way to cash in on hype, and that ultimately, it cheapens a film. I mean, these toys look kind of cheesy compared to what you see in the movie.

So, why did they sell so many action figures? For some people, they were just a cool decoration — something they could look at, and remember the film. But for most children, they were something else — they were a gateway into the *Star Wars* universe.

For if you observed children playing with them, you would notice something very strange. Seldom would they act out scenes from the movie, as an adult might expect. Instead, they would make up all kinds of stories featuring these characters with only a loose relationship to the plotline from the movie, which was fairly complex, and somewhat difficult for a child to fully comprehend. This might lead you to conclude that it was the characters that were so popular, not the story from *Star Wars*. But often, you would see children give these characters completely different names, and completely different relationships than they had in the film, as they enacted dramas and comedies starring this cast of characters in bedrooms and backyards everywhere in the world.

So, if it wasn't the plotline or the characters that the kids were so excited by, then what was left? The answer is that it was the *world* of *Star Wars* that was so compelling — and the toys provided another gateway into that world — one that was better than the movie, in some ways, since it was interactive, participatory, flexible, portable, and social. And weirdly, these toys made the *Star Wars* world more meaningful for children, not less, because the toys afforded them the ability to visit the world, sculpt it, change it, and make it their own. And as *Star Wars* sequels started to appear, there was great anticipation, but how much of that anticipation was a desire to hear a new story, and how much of it was the excitement of re-entering that world?

Henry Jenkins coined the term *transmedia worlds* to refer to fantasy worlds that can be entered through many different media — print, video, animation, toys, games, and many others. This is a very useful concept, for it really is as if the world exists apart from the media that support it. Many people find this a bizarre concept — they think of books, films, games, and toys as separate things, each standing on their own. But more and more often, the real product that is created is not a story, or a toy, or a game, but a world. But you can't sell a world, so these various products are sold as gateways into this world, each leading to different parts of it. And if the world is well-constructed, the more gateways you visit, the more real and solid the world will become in your imagination. But if these gateways contradict each other or provide inconsistent information, the world crumbles quickly into dust and ashes, and suddenly the products are worth nothing.

Why is this? Why do worlds become so real for us, more real than the media that define them? It is because we want them to be real. Some part of us wants to believe that these worlds aren't just stories in books, sets of rules, or actors on a screen, but that these worlds actually exist, and that maybe, somehow, someday, we can find our way to them.

This is why people so casually throw out magazines, but hesitate before throwing out a comic book — after all, there's a world in there.

The Power of Pokemon

Pokemon is arguably one of the most successful transmedia worlds of all time. Since its introduction, the combined sales of all Pokemon products combined is over $15 billion, making it the second most lucrative videogame franchise of all time, second only to Mario. And though many tried to write it off as a short-term fad, ten years later, new Pokemon games are consistently top sellers. It is worth understanding the history of Pokemon to better understand the power of its transmedia world.

Pokemon began as a game for the Nintendo Gameboy system. Its designer, Tajiri Satoshi, had collected insects as a boy, and seeing the "game link" feature that allowed message passing between two Gameboys in 1991, he had a vision of insects traveling along the cable. He approached Nintendo about the idea, and then he

and his team spent five years developing and perfecting the title. In 1996, "Pocket Monsters" (the direct translation of the Japanese title) as a pair of games (red and green) was launched. It was essentially a traditional RPG (not unlike *Ultima* or *Final Fantasy*), except that you could capture the monsters you fought and make them part of your team.

The graphics and game action were not elaborate or advanced — but the interactions were rich and interesting, since the team had spent five years to properly balance the game. It is important to realize how primitive the graphics really were. The original Gameboy only allowed four shades of olive for the graphics, and two battling Pokemon would basically stand next to each other and wiggle as the player chose attacks from a simple menu.

The game was a huge success — so much so that a comic book and an anime series were soon planned. Unlike many TV shows that are only loosely connected to the videogame they were based on (the dreadful Hanna Barbera Pac Man cartoon, for example), the Pokemon show reflected the intricate rules of the gameplay very closely, and the adventures of the main character were directly based on the quest path through the Gameboy game. The result was a show that so mirrored the mechanics of the game, that watching it players better understood what strategies to use in the game.

But most important, the TV show gave game players a new gateway into the Pokemon universe — one that showed the Pokemon in full color with dramatic animation and sound. When viewers would return to the Gameboy, these vivid images were retained in their imaginations, making the crudeness of Gameboy graphics and sound completely irrelevant. This is sometimes called the "binocular effect," so named because it is like when people take binoculars to a sporting event or opera glasses to the theater. No one watches the whole event through the binoculars. Instead, the binoculars are used early on to give a close-up view of the distant figures. Once someone has seen them close up, they can map that image onto the tiny figures they see on the stage in their visual imagination.

These two gateways had tremendous synergy — wanting to succeed at the game gave reasons to watch the TV show, and watching the TV show made playing the game more vivid and exciting.

And if this wasn't enough, in 1999 Nintendo worked with Wizards of the Coast, the company that produced the breakthrough *Magic: The Gathering* collectible card game, to create a new collectible card game, based on the world of Pokemon. This game, like the TV show, held as closely as possible to the core mechanics of the Gameboy game. This gave players a third method of entry into this world — one that was both portable and very social. Although the Gameboy game featured the game link cable for trading Pokemon, the truth was that players only used it occasionally — most of the time it was played as a solo adventure. Not so with the card game — its low price and accessibility made it very popular with children (especially boys), playing off their interest in competing with their peers, and fitting in naturally with the Pokemon slogan of "Gotta catch 'em all!"

These three complementary gateways into a single solid world made the property a near unstoppable force. People who didn't understand the Pokemon universe were completely bewildered: Is this thing a game, or a TV show, or what? What is it about the storyline that is so great that kids want to spend all this money on it? I was fortunate enough to be at a roundtable discussion in 1999 with the head of a major entertainment company. Someone asked him what he thought of "this Pokemon craze," and he replied, "The movie comes out in a few months, and that'll be the end of it." He was wrong, of course, because he fundamentally did not get the idea of transmedia worlds. He was completely mired in the old Hollywood way of thinking about story worlds — a big Hollywood movie defines the world, then there are toys, games, and TV shows that mimic that. The idea of a world that could be based in the ruleset of a handheld videogame, or a world that could get stronger with each new medium you add to it was completely unfamiliar to him (he is not in charge of that company any longer).

The strength of Pokemon is not just in the game concept, but in the careful and consistent use of multiple media as gateways into a single, well-defined world.

Properties of Transmedia Worlds

Transmedia worlds have several properties that make them interesting.

Transmedia Worlds are Powerful

Successful transmedia worlds exert a powerful effect over fans. It is stronger than just a fan's love of an interesting story. It is almost as if the world becomes a sort of personal utopia that they fantasize about visiting. Sometimes these fantasies are short-term, but for many, they are long-term, lasting on through their lives. For some, these long-term fantasies are something they turn to, now and then, for a sort of mental break. An adult who keeps a Transformer toy around as a decoration might be a good example of this. The toy gives him a convenient mental gateway to the world of Transformers that he can visit occasionally.

But for others, the passion for this personal utopia becomes something they actively engage in every day. Such was certainly the case with Scott Edward Nall, who on his 30th birthday, legally changed his name to Optimus Prime, one of the lead robots in the Transformers Universe. In fact, if you look at "hardcore fans" of any kind of fiction, you will find that in almost all cases, the properties with the most devoted fans are the ones that are the strongest transmedia worlds. *Star Trek, Star Wars, Transformers, Lord of the Rings, Marvel Comics, Harry Potter*, and many other properties that get hardcore fans have a world at their core. More than the enjoyment of a good storyline, or the appreciation of interesting characters, the desire to enter a fantasy world seems to be what propels these fans to such extremes.

303

Transmedia Worlds are Long Lived

Solid transmedia worlds continue for a surprisingly long time. Superman appeared over seventy years ago. James Bond has been around for fifty-five years. *Star Trek* still thrives after forty years. Walt Disney realized the power of transmedia as he started developing comic books to help keep the worlds of his animation properties alive, and created Disneyland to this same end. One of his strongest arguments for investing in such an unusual venture was that it would help keep up the public's interest in Disney films by giving them another gateway into the world of the films. The Copyright Term Extension Act of 1998 extended the length of corporate copyrights from 75 years to 95 years. This was greatly spurred by the fact that some still lucrative properties (such as early Mickey Mouse cartoons) were in danger of falling into the public domain. Right or wrong, some have suggested that one of the reasons that this act passed seems to be that it just feels wrong to let a carefully managed, well-beloved world fall into the wrong hands.

One very good reason to cultivate a strong transmedia world is that if you do it well, it can be profitable for a very long time. This seems particularly true for worlds that appeal to children — when the children grow into adulthood, they often want to share the worlds with their children, creating a cycle that might go on a very long time.

Transmedia Worlds Evolve Over Time

But these worlds do not remain static over time — they evolve. Consider a transmedia world over a hundred years old (and still popular!): the world of Sherlock Holmes. When we think of Sherlock Holmes today, we typically think of him in his trademark deerstalker cap and oversized calabash pipe. But if you read the text of the Sherlock Holmes stories, these items are not mentioned in the text. Nor do they appear in the artwork of Sidney Paget, who did all of the original illustrations for the stories. So where did they come from? Both pipe and cap seem to have been made popular by William Gillette, an actor who portrayed Holmes in a series of plays based on the stories. He chose the unusual hat and the oversized pipe because they would be distinct, and visible even from the back row of a theater. The plays were immensely popular, so much so that future illustrators of the Holmes stories used photos of Gillette as a model for their illustrations. Weirdly, the pipe and cap have become the icons for Sherlock Holmes — icons that his creator, Sir Arthur Conan Doyle, never envisioned. But this is the way of transmedia worlds — as new media provide new gateways to the world, the world itself (or people's perception of it, which amounts to the same thing for an imaginary world) changes to accommodate the new gateways.

Another excellent example of this comes from an even older and more beloved transmedia world — the world of Santa Claus. If ever there was a fantasy utopia that people truly want to be real, it is Santa's world — a world where once a year

a benevolent figure carefully considers your heart's desire, and gives it to you if you are worthy. Consider the many paths of entry to this world: Not only are there stories, poems, songs, and movies, but you can write him letters, and even visit Santa himself! Just think of it — a fictional character comes to your house and eats your cookies and then leaves behind a treasure trove of gifts! We so badly want this world to exist that millions of people go to tremendous expense and feats of deception to make children believe it to be an unquestionable reality.

But who is the author of this world? Like all long-lived transmedia worlds, it was a great collaborative effort. Storytellers and artists continually try to augment Santa's world. Some succeed, like the introduction of Santa's reindeer by Clement Moore in 1823, or the introduction of Rudolph by Robert L. May in 1939. Many others fail. No less a storyteller than L. Frank Baum, the author of the *Wizard of Oz* stories, failed miserably with his 1902 *Life and Adventures of Santa Claus*, which attempted to establish Santa's origin as a mortal selected for immortality by a council of nymphs, gnomes, and demons.

Who decides which new features enter a transmedia world, and which ones are rejected? It somehow happens as part of our collective consciousness. Through some unspoken democratic process, everyone just decides whether a particular feature seems appropriate or inappropriate, and the fictional world changes slightly to accommodate. There is no formal decision — it just happens. If a story feature is well-liked, it takes root. If not, it fades away. In the long run, the world is governed by those who visit it.

What Successful Transmedia Worlds Have in Common

Successful transmedia worlds are powerful and valuable — so what do they have in common?

- **They tend to be rooted in a single medium**. For all of their many gateways, the most successful of the transmedia worlds started out by making a huge splash in just one medium. *Sherlock Holmes* was serialized fiction. *Superman* was a comic book. *Star Wars* was a movie. *Star Trek* was a TV show. *Pokemon* was a handheld game. All of these have appeared in many other forms, but each is at its very strongest when in its original medium.

- **They are intuitive**. When doing research for Toontown Online, I tried to learn as much as I could about the fictional world of Toontown. As I studied the film *Who Framed Roger Rabbit*, I realized that very little about Toontown was really described there. The film didn't need to describe Toontown in great detail because *everyone already knew it existed*. Without anyone ever expressly saying it, it was somehow common knowledge that all cartoon characters live together in a cartoon universe that is very different than ours. The creators of *Superman* and *Batman* surely never had any intention that their characters shared the world

with other superheroes, but it was intuitive to comic readers that these characters lived in the same world — and so now they do.

- **They have a creative individual at their core**. The majority of successful transmedia worlds are rooted in the imagination and aesthetic styling of a single individual. People like Walt Disney, Shigeru Miyamoto, L. Frank Baum, Tajiri Satoshi, and George Lucas are all examples. Occasionally, small, tight teams are able to create successful transmedia worlds, but it is very rare indeed for successful worlds to be created by large teams. There is something about the holistic vision of a world that comes to a single individual that gives it the strength, solidity, integrity, and beauty necessary to survive the pressure of many gateways.

- **They facilitate the telling of many stories**. Successful transmedia worlds are never based around a single plotline. They have a solidity and an interconnectedness that goes far beyond that. They leave room for future stories and for guests to imagine their own stories.

- **They make sense through any of their gateways**. One kiss of death for almost any movie is the phrase "It makes more sense if you read the book." You never know which gateway guests might enter first, so you must make all of them equally inviting and welcoming. Pokemon certainly succeeded in this regard — its TV show, comic, video, and card games were each understandable and enjoyable in their own right. Any of these could be a first encounter with the world of Pokemon that might lead to other ports of entry later on.

 A counterexample would be some of the things that were attempted with the world of the Matrix. *Enter the Matrix*, a critically panned videogame based on the second film, *Matrix: Reloaded*, took the novel approach of not telling the story of the movie, but rather a parallel story that intersected with the movie. This was an interesting idea, but if you didn't see the movie, it was confusing. Similarly, *Animatrix*, a series of animated shorts that happen in the Matrix universe only make sense if the viewer is already intimate with the Matrix universe. This "it only makes sense if you enter through all the gateways" approach was intriguing for a few, but alienating for most.

- **They are about wish fulfillment**. Imagining a fantasy world is a lot of work. Players will not do it unless it is a world that they truly would like to visit — a world that fulfills some deep and important wish.

Transmedia worlds are the future of entertainment. It is no longer sufficient to focus just on creating a great experience in a single medium. Increasingly, designers are asked to create new gateways to existing worlds — not an easy task. But those who can create gateways that excite players by creatively giving them a new perspective on and enjoyment of a known world are much sought after. But even more sought after are those who can invent a successful transmedia world starting with nothing but an understanding of their audience's secret wishes. If you want to create or improve transmedia worlds, use this lens.

Lens #74: The Lens of the World

The world of your game is a thing that exists apart. Your game is a doorway to this magic place that exists only in the imagination of your players. To ensure your world has power and integrity, ask yourself these questions:

- How is my world better than the real world?
- Can there be multiple gateways to my world? How do they differ? How do they support each other?
- Is my world centered on a single story, or could many stories happen here?

Worlds Contain
Characters

FIGURE
18.1

The Nature of Game Characters

If we are to create games that have great stories in them, these stories must contain memorable characters. It is an important question to ask: How are characters in games different than characters in other media? If we examine fictional characters in various media side by side, some differences become apparent. Here are some samples I chose from lists of the best novels, films, and videogames of the twentieth century.

Novel Characters

Holden Caulfield: *The Catcher in the Rye*. Holden is a teenager who wrestles with the phoniness and ugliness of the adult world.

Humbert Humbert: *Lolita*. Humbert is an adult consumed by lust for an adolescent girl.

Tom Joad: *The Grapes of Wrath*. Tom is an ex-convict who tries to help his family after they lose their farm.

Ralph: *Lord of the Flies*. Ralph and many other children are stranded on an island and try to survive the island and each other.

Sethe: *Beloved*. Sethe is a woman who tries to rebuild her life after she and her daughter escape from slavery.

Movie Characters

Rick Blaine: *Casablanca*. Rick must choose between the love of his life and saving the life of her husband.

Indiana Jones: *Raiders of the Lost Ark*. An adventurous archaeologist must rescue the Ark of the Covenant from the Nazis.

Rose DeWitt Bukater: *Titanic*. A young woman falls in love on the ill-fated *Titanic*.

Norman Bates: *Psycho*. A man with an unusual case of schizophrenia commits murders and tries to cover them up.

Don Lockwood. *Singin' in the Rain*. A silent film actor struggles to make the transition to talkies.

Game Characters

Mario: *Super Mario Brothers*. A cartoon plumber battles enemies to rescue a princess from an evil king.

Solid Snake: *Metal Gear Solid*. A retired soldier infiltrates a nuclear weapons disposal facility to neutralize a terrorist threat.

Cloud Strife: *Final Fantasy VII*. A band of rebels tries to defeat an evil megacorporation run by an evil wizard.

Link: *Legend of Zelda*. A young man must recover a magic artifact to rescue a princess from a villain.

Gordon Freeman: *Half-Life 2*. A physicist must battle aliens when an experiment goes horribly wrong.

So, examining these lists, what patterns do we see?

- **Mental → Physical**. The characters in the novels are involved in deep psychic struggles. This makes sense, since in a novel, we spend much of our time listening to the characters' innermost thoughts. The characters in the movies are involved in both emotional and physical struggles, which are resolved through combinations of communication and action. Again, when you consider the medium, this makes sense: We cannot hear the thoughts of film characters, but we can see what they say and do. Finally, the game characters are involved in conflicts that are almost entirely physical. Since these characters mostly have no thoughts (the player does the thinking for them) and are only occasionally able to speak, this again makes perfect sense. In all three cases, the characters are defined by their media.

- **Reality → Fantasy**. The novels tend to be very reality based; the films tend to be rooted in reality, but often pushing towards fantasy, and the game worlds are almost entirely fantasy situations. And the characters reflect this — they are products of their environment.

- **Complex → Simple**. For a variety of reasons, the complexity of the plots and depth of the characters gradually diminishes as we move from novels to games.

From this, one might conclude that games are doomed to have simple fantasy characters engaging mostly in physical actions. And that certainly is the easy path. After all, you can get away with mere action in games when you usually can't in movies or novels. But it doesn't mean it isn't possible to add more depth, more mental conflict, and more interesting character relationships into your games — it just means that it is challenging. Some of the games on this list, *Final Fantasy VII* for instance, have very involved sets of character relationships structured around a simple gameplay structure — as involved as they are, players are crying out for more — they want their games to have richer, more meaningful characters and storylines. For much of this chapter we will be looking at methods that storytellers in other media use to define their characters, and consider how we can adapt these methods to the creation of strong game characters.

Let's start with a very special character: the avatar.

Avatars

There is something magical about the character that a player controls in a game. So magical that we give that character a special name: the avatar. The word is derived from a Sanskrit word that refers to a god magically taking physical form on the earth. And the name is well chosen for a game character, since a similarly magical transformation takes place when a player uses their avatar to enter the world of the game.

The relationship between player and avatar is strange. There are times when the player is distinctly apart from the avatar, but other times when the player's mental state is completely projected into the avatar, to the point that the player gasps if the avatar is injured or threatened. This should not be completely surprising — after all, we have the ability to project ourselves into just about anything we control. When we drive a car, for example, we project our identity into the car, as if it is an extension of ourselves. Examining a parking space, we will often say "I don't think I can fit in there." And if another car collides with our car, we don't say "He hit my car!" Instead we say "He hit *me!*" So it should be no surprise that we can project ourselves into a videogame character that we have direct control over.

Designers often debate about which is more immersive: the first- or third-person view. One argument is that greater projection can be achieved by providing a first-person perspective on a scene with no visible avatar. However, the power of empathy is strong, and when controlling a visible avatar, guests often wince in imagined pain upon seeing their avatar suffer a blow, or sigh in relief upon seeing their avatar escape physical harm. It is almost as if the avatar is a kind of kinesthetic voodoo doll for the guest. Bowlers are another example of this phenomenon, as they try to exert "body English" on a bowling ball as it rolls down the lane toward the pins. These movements are largely subconscious, and are a result of a bowler projecting himself onto the ball. In this sense, the bowling ball serves as the bowler's avatar.

And it is one thing to project ourselves into our avatar as if our avatar is a tool, but the experience of projection can be so much more powerful if we actually relate to the character in some way. So, what kinds of characters are best suited for players to project themselves into?

The Ideal Form

The first type of character that is a good choice as an avatar is the kind that the player has always wanted to be. Characters like this — such as mighty warriors, powerful wizards, attractive princesses, ultra suave secret agents, etc. — exert a pull on the psyche, since the force inside us that pushes us toward being our best finds the idea of projecting ourselves into an idealized form very appealing. Although these characters are not much like our real selves at all, they are people we sometimes dream about being.

The Blank Slate

The second type of character that works well as an avatar is one that is, as Scott McCloud puts it, iconic. In his excellent book, *Understanding Comics*, McCloud makes the interesting point that the less detail that goes into a character, the more opportunity the reader has to project themselves into that character.

FIGURE
18.2

©1993, 1994, *Understanding Comics* by Scott McCloud, pgs. 36 and 43. Reprinted by permission of HarperCollins Publishers

McCloud further points out that in comics, it is often the case that characters or environments that are meant to seem alien, foreign, or scary are given a lot of detail, because more detail makes them more "other." When you combine an iconic character with a detailed world, you get a powerful combination, as McCloud shows below:

FIGURE
18.3

©1993, 1994, *Understanding Comics* by Scott McCloud, pgs. 36 and 43, Reprinted by permission of HarperCollins Publishers

This idea has bearing well beyond the domain of comics. In videogames we see the same phenomenon. Some of the most popular and compelling avatars are ones that are very iconic. Consider Mario: He isn't much of an idealized form, but he is simple, hardly speaks, and is completely non-threatening, so it is easy to project yourself into him.

The idealized form and the blank slate are often mixed. Consider Spider Man, for example. He is an ideal form: a powerful and brave superhero, but the mask that covers his face makes him almost completely iconic — a blank slate that could be almost anyone.

Periodically, gimmicky systems show up that let you take your own photograph and put it on your avatar. I've heard people selling these systems refer to this as "the ultimate dream for any gamer." But these systems, while interesting as a novelty, never take hold in the long-term because people don't play games to be themselves — they play games to be the people they wish they could be.

In Chapter 14 we introduced Lens #64: The Lens of Projection as a tool to examine how well a player was projecting themselves into the imaginary world of the game. We should also add a more specific lens, which examines how well they project themselves into their avatar.

Lens #75: The Lens of the Avatar

The avatar is a player's gateway into the world of the game. To ensure the avatar brings out as much of the player's identity as possible, ask yourself these questions:

- Is my avatar an ideal form likely to appeal to my players?
- Does my avatar have iconic qualities that let a player project themselves into the character?

Creating Compelling Game Characters

The avatar is important in a game, just as the protagonist is important in a traditional story. But we must not forget the other characters. There are dozens of books on scriptwriting and storytelling that can give you good advice on how to make strong, compelling characters. Here I will summarize some of the methods I have found most useful for developing characters in games.

Character Tip #1: List Character Functions

In the process of creating a story, one frequently invents characters as the storyline demands them. But how about when the game demands them? A very useful technique when coming up with the cast of characters in your game is to list all the functions that these characters need to fulfill. Then list the characters you had been thinking of putting in the game, and see how they match up. For example, if you are making an action platform game, your list might look like:

Character Functions:

1. Hero: The character who plays the game

2. Mentor: Gives advice and useful items

3. Assistant: Gives occasional tips

4. Tutor: Explains how to play the game

5. Final Boss: Someone to have the last battle against

6. Minions: Bad guys

7. Three Bosses: Tough guys to battle against

8. Hostage: Someone to rescue

Taking a peek into your imagination, you might have seen these characters:

a. Princess Mouse — Beautiful, but tough and no nonsense

b. Wise Old Owl — Full of wisdom, but forgetful

c. Silver Hawk — Angry and vengeful

d. Sammy Snake — Amoral, and full of wry humor

e. Rat Army — Hundreds of rats with evil red eyes

So, now you have to match the characters to the functions. This is an opportunity to really get creative. The traditional thing would be to make Princess Mouse the hostage. But why not do something different; make her the mentor? Or the hero? Or even the final boss! The Rat Army seem like natural minions — but who knows? Maybe they only have evil red eyes because they have been captured by the evil princess mouse who has hypnotized them, and they are actually the hostages! Hmm... it also seems we don't have enough characters to fill all eight roles — we could make up more characters, or we could give some characters multiple roles. What if your mentor, Wise Old Owl, turns out to be the final boss? It would be an ironic twist, and save you on the cost of developing a new character. Maybe the Assistant and Tutor are both Sammy Snake — or maybe the Silver Hawk, the hostage, mentors you by sending telepathic messages from where he is being held.

By separating the functions of the characters from your vision of the characters, you can think clearly about making sure the game has characters doing all the necessary jobs, and sometimes make things more efficient by folding them together. This method serves as a handy lens.

Lens #76: The Lens of Character Function

To make sure your characters are doing everything your game needs them to do, ask yourself these questions:

- What are the roles I need the characters to fill?
- What characters have I already imagined?
- Which characters map well to which roles?
- Can any characters fill more than one role?
- Do I need to change the characters to better fit the roles?
- Do I need any new characters?

Character Tip #2: Define and Use Character Traits

Let's say we had some dialog between your heroine, Sabu, and her sidekick, Lester — simple expositional stuff, which helps set up the next level. Something like

LESTER: Sabu!
SABU: What is it?
LESTER: Someone has stolen the king's crown!
SABU: Do you realize what this means?
LESTER: No.
SABU: It means the Dark Arrow has returned. We must stop him!

This dialog is pretty flat. While it tells us about the situation (missing crown) and the villain (Dark Arrow), it tells us nothing about Sabu or Lester. Your characters need to say and do things that define them as real people. To do this, you must know their traits.

There are many ways to define traits for your characters. Some advise creating a "character bible," where you list out every possible thing you can think of that defines your character — their loves and hates, how they dress, what they eat, where they grew up, etc. And this can be a useful exercise. But ultimately, you will probably want to boil things down to a simpler essence: a small, distilled list of traits that encapsulate the character. You want to choose traits that are going to stay with your character through many situations that really define them as a person.

Sometimes these can be a little contradictory, but real people have contradictory traits, so why shouldn't characters? Let's say we gave Sabu and Lester these traits:

Sabu: trustworthy, short-tempered, valiant, a fiery lover
Lester: arrogant, sarcastic, spiritual, impulsive

Now, let's rewrite the dialog, trying to imbue it with these traits — preferably with more than one at a time (remember Lens #43: The Lens of Elegance?).

LESTER (exploding into the room): By the Gods! Sabu, I have news! *(impulsive and spiritual)*
SABU: (covering herself) How dare you intrude on my privacy! *(short-tempered)*
LESTER: Whatever. Maybe you don't care that the king's crown has been stolen? *(arrogant and sarcastic)*
SABU (a faraway look in her eye): This means I must do what I promised... *(trustworthy and valiant)*
LESTER: I pray to Vishnu this is not another story of an old flame... *(Lester: spiritual and sarcastic; Sabu: fiery lover)*
SABU: Silence! The Dark Arrow broke my heart, and the heart of my sister — I promised her that if he ever returned, I would risk my life to destroy him. Prepare the chariot! *(short-tempered, fiery lover, trustworthy, valiant)*

It isn't simply dialog that benefits from this treatment. The actions you choose for your character, and how they are carried out, should demonstrate the traits as well. If your character is sneaky, does it show in his jump animation? If your character is depressed, does it show when they run? Maybe a depressed character shouldn't run, but only walk. There is nothing magic about having lists of traits and using them — it just means that you know your characters well.

Lens #77: The Lens of Character Traits

To ensure that the traits of a character show in what they say and do, ask yourself these questions:

- What traits define my character?
- How do these traits manifest themselves in the words, actions, and appearance of my character?

Character Tip #3: Use the Interpersonal Circumplex

Your characters won't be alone, of course — they are going to interact with each other. One tool that social psychologists sometimes use to visualize the relationships between characters is the interpersonal circumplex. It is a simple graph, with

two axes: friendliness and dominance. This complex diagram shows where many traits lie on this graph:

FIGURE
18.4

From the excellent *Better Game Characters by Design*, by Katherine Isbister. Used by permission.

This looks kind of overwhelming, but it can be a simple tool to use. Let's say we wanted to show how other *Star Wars* characters related to Han Solo. Since friendliness and dominance are relative characteristics, we always need to make them relative to a particular character. So Figure 18.5 is how you might graph out the characters relative to Han.

Laying the characters out on a graph like this gives a good way to visualize character relationships. Notice how extreme Darth Vader, Chewbacca, and C3PO are on the graph — these extremes are part of what make them interesting. Also notice that the people he communicates with the most are the closest to him on the graph. What does the fact that there are no characters in the lower left quadrant tell us

FIGURE
18.5

about Han? Consider how different the graphs would be for Luke, or for Darth Vader.

The circumplex is not a be-all or end-all tool, but it can be a useful for thinking about character relationships because of the questions it can prompt. So, let's put it in our toolbox.

Lens #78: The Lens of the Interpersonal Circumplex

Understanding the relationships between your characters is crucial. One way to do this is to create a graph with one axis labeled hostile/friendly, and the other labeled submissive/dominant. Pick a character to analyze, and put them in the middle. Plot out where other characters lie relative to that character, and ask yourself these questions:

- Are there any gaps in the chart? Why are they there? Would it be better if the gaps were filled?

- Are there "extreme characters" on the graph? If not, would it be better if there were?

- Are the character's friends in the same quadrant, or different quadrants? What if that were different?

Character Tip #4: Make a Character Web

The circumplex is a nice visual way to see some character relationships. But there can be many other factors in the relationships between your characters. The character

web is a good way to explore how the characters feel about each other, and why. The idea is simple: To analyze a character, write down what that character thinks of all the other characters. Here's an example from the world of Archie comics:

Archie

- **Veronica**: Archie is lured by her elegance and beauty. Though she is rich, Archie doesn't care much about that.
- **Betty**: Archie's true love, but her insecurity constantly gives him mixed signals, so he doesn't pursue her as forcefully as he might.
- **Reggie**: Archie shouldn't trust Reggie, but he often does, because Archie always tries to be a nice guy, and Archie is kind of gullible.
- **Jughead**: Archie's best friend. What they have in common is that they are both underdogs.

Veronica

- **Archie**: Veronica finds Archie attractive, but sometimes she seeks to date him to frustrate Betty, and because she can always feel superior around him.
- **Betty**: Veronica trusts Betty as a friend because they were friends as little girls. Veronica likes how she can always feel superior to Betty in terms of wealth and class, but it really frustrates Veronica that Betty is a better person.
- **Reggie**: Reggie is an attractive buffoon who appreciates wealth, but Veronica gets frustrated that Reggie doesn't really respect or love her.
- **Jughead**: A nauseating freak — Veronica can't understand why Archie is friends with him. Veronica often bribes him with food to get what she wants.

Betty

- **Archie**: Her true love. She is shy, though, about telling him how she really feels, because Betty has low self-esteem.
- **Veronica**: Betty's BFF. She can be mean sometimes, and she is too money crazy, but friends are friends forever, so Betty stays with Veronica.
- **Reggie**: Betty is intimidated by his wealth and showy attempts at class. She feels like she is supposed to like him, but secretly she is repelled by him.
- **Jughead**: Betty thinks he's cute and funny, and glad that he's such a good friend to her true love.

Reggie

- **Archie**: Reggie's archrival. Reggie can't imagine what anyone sees in such a dopey nice guy. Occasionally, Reggie envies Archie's popularity, but he always thinks he can find a tricky way to outdo Archie.
- **Veronica**: Reggie finds her attractive and rich — he likes the power of her wealth.
- **Betty**: Reggie finds her attractive, and though her low self-esteem is a turnoff, to be able to win her would show his superiority over Archie.
- **Jughead**: Reggie sees him as a total loser who deserves to be bullied, especially since he is friends with Archie.

Jughead

- **Archie**: Jughead's best friend, and the only one who understands and appreciates Jughead's love of food.
- **Veronica**: The mean girl that Archie likes.
- **Betty**: The nice girl that Archie likes.
- **Reggie**: A bully.

You can see that this takes a little time, but it can be well worth the effort because of the questions it raises about character interactions you might not have thought about. It's a very handy lens for giving your characters more depth.

Lens #79: The Lens of the Character Web

To flesh out your characters' relationships better, make a list of all your characters, and ask yourself these questions:

- How, specifically, does each character feel about each of the others?
- Are there any connections unaccounted for? How can I use those?
- Are there too many similar connections? How can they be more different?

Character Tip #5: Use Status

Most of the character tips we've seen so far come from writers. But there is another profession that knows just as much about creating compelling characters, if not more — actors. Many people have drawn parallels between the unpredictable nature of interactive storytelling, and the unpredictable nature of improvisational theater;

indeed, the techniques of the improvisational actor can prove quite useful to game designers. These techniques are many and are well-described in several books, but there is one, for me, that stands out above all others. It is really not so much a technique, but a lens described impeccably well by Keith Johnstone in his classic book *Impro* — it is the Lens of Status.

Whenever people meet or interact, there is a hidden negotiation that constantly takes place. We are mostly not conscious of it, since it predates our ability to speak. It is our negotiation of status; that is, who is in charge of the current interaction? Status is not a matter of who you are, status is something you do. Johnstone illustrates this quite well with this bit of dialog:

> TRAMP: 'Ere! Where are you going?
> DUCHESS: I'm sorry, I didn't quite catch...
> TRAMP: Are you deaf as well as blind?

The tramp, who you might expect to be very low status, is taking on an attitude of very high status. Any time two or more people interact in any setting — whether friends or enemies, collaborators or competitors, masters or servants — a negotiation of status takes place. We do this almost entirely subconsciously with posture, tone of voice, eye contact, and dozens of other detailed behaviors. What is surprising is how consistent these behaviors are across all cultures.

- **Typical low status behaviors include**: fidgeting, avoiding eye contact, touching one's own face, and generally being tense.
- **Typical high status behaviors include**: being relaxed and in control, making strong eye contact, and, weirdly, not moving your head while you speak.

A typical improv exercise is to split the group of actors into two groups, who then intermingle — individuals in the first group (low status) make brief eye contact, then look away, while the second group (high status) makes and holds eye contact with others. Most actors who try this exercise quickly realize that this isn't just playing pretend — the actors in the low-status group quickly find that they feel inferior and start unconsciously taking on other low-status characteristics. The actors in the high status group start to feel superior, and take on high-status characteristics. Even if you are by yourself, try talking without moving your head at all, and see how it makes you feel — or try the opposite — talking while turning your head frequently, and you will quickly get the idea.

Status is a relative thing, not absolute to an individual. Darth Vader takes on high status behavior when he deals with Princess Leia, but he takes on low status when he deals with the Emperor.

Status can be conveyed in surprising ways — slow motion, for example, gives high status, as we've seen in *The Six Million Dollar Man*, *The Matrix*, and countless shampoo commercials. The way characters occupy space is also very telling of status. Low-status characters go to places where they are less likely to

encounter others, or be noticed. High status characters are in the most important place in the room.

Status is like a secret language that we all know so well we don't know we're speaking it. The problem with it being so subconscious is that when we create artificial characters, it doesn't occur to us to give them these behaviors, because generally we aren't aware that we do these things. But if you do give these behaviors to your characters, you will quickly find that they seem aware of each other in a way that most videogame characters are not.

The game *Munch's Oddysee* has great examples of character status interactions. In it, you control two different characters, one of whom is a slave, and the other is bound to a wheelchair (low status). Throughout the game you face arrogant (high-status) enemies and get help from slavish (low-status) followers. The interactions between all these are quite interesting to see, and a great deal of comedy comes from unexpected status reversals, such as the followers mouthing off at Munch or at the enemies. The characters in this game show an awareness of each other's presence that, while crude, is a step above many other games.

Status is a largely unexplored area in interactive entertainment. Brenda Harger, who first introduced me to the concept of status, is an excellent improv actress and a researcher at the Entertainment Technology Center at Carnegie Mellon University. She and her students have done some fascinating work on creating artificially intelligent characters that are aware of their status and of the status of other characters, and automatically adopt appropriate postures, actions, and personal space. Right now, most videogame characters behave the same way no matter who is around. It seems likely that the next generation of interactive game characters will seem more alive because they are aware of status.

In Chapter 14, we talked about how important things that change dramatically are inherently interesting. Status is one of those important things. During arguments, people are vying to have the highest status (either by raising their own or lowering the status of their opponent), and this seesaw of status is what makes arguments interesting.

Status isn't just about dialog, though — it is also about movement, eye contact, territory, and what characters do. It is a way of looking at the world, so let's put it in our toolbox.

Lens #80: The Lens of Status

When people interact, they take on different behaviors depending on their status levels. To make your characters more aware of each other, ask yourself these questions:

- What are the relative status levels of the characters in my game?
- How can they show appropriate status behaviors?

- Conflicts of status are interesting — how are my characters vying for status?
- Changes of status are interesting — where do they happen in my game?
- How am I giving the player a chance to express status?

Of course, having an understanding of status does more than give you insights into how to make realistic characters — it helps you understand and control real-life situations, like design meetings and client negotiations, but we'll discuss those in later chapters.

Character Tip #6: Use the Power of the Voice

The human voice is an incredibly powerful thing, which can affect us at a deep subconscious level. This is why talking pictures elevated the cinema from a novelty to the dominant art form of the twentieth century. It is only in the past few years that technology has permitted videogames to make serious use of voice acting. Even now, the voice acting in games seems primitive compared to the powerful performances in films.

Partly this is true because game developers are often inexperienced when working with voice talent. Directing a voice actor is a delicate art that takes a certain knack and years of practice to do well. But there is another reason for weak voice acting in games — it is because we do the process backwards. In animated films, a script is written first, then voice actors are brought in to record it. As they do, lines are changed, improvisations are made, and the good ones are incorporated into the script. Once the recordings are in place, the characters get designed (often incorporating facial features of the actors), and animation commences. In videogames we do this the other way — the characters are often designed and modeled first, then the script is written, often basic animations are created, and then the voice acting is added last. This diminishes the power of the voice actor, who is now just trying to imitate what he sees, instead of rightly expressing how he truly feels his idea of the character would act and behave. The voice actor becomes peripheral to the creative process, not central, and the power of voice is weakened.

Why do we do this backwards? Because the process of game development is so volatile, it is expensive to create characters around their voices, since the script continues to change throughout the entire process. But perhaps, with time, we will develop techniques that will allow voice actors to become more central to game character design, and reclaim the power of voice.

Character Tip #7: Use the Power of the Face

It is often said that the eyes are the windows to the soul. A huge percentage of our brains is taken up with custom hardware for processing facial expression. We have

the most complex and expressive faces in the entire animal kingdom. Notice, for example, our eye whites — other animals do not have visible eye whites. It would appear we evolved them as a method of communication. We are also the only animal that blushes, and the only animal that cries.

Despite all this, few videogames give facial animation the attention it deserves. Game designers are so focused on the actions of the characters, they give little thought to their emotions. When a game does have meaningful facial animation (such as *Legend of Zelda: The Wind Waker*), it often garners a lot of attention. The designers of *OnLive Traveler*, an early 3D chat room, had very strict polygon budgets for their characters. As they built and tested prototypes, they would ask their users each time "Do the characters need more details?" and every time, the answer would come back, "Yes — in the face." After five or six rounds of this, the bodies dwindled away to nothing, leaving the characters as eerie floating heads — but this was what the users preferred, since this was an activity about self-expression, and faces are the most expressive tool that exists.

FIGURE
18.6

Facial animation doesn't have to be expensive — you can get tremendous power out of simple animated eyebrows or eye shapes. But you do have to have a character face that will be visible to the player. Avatar faces generally are not visible to the

player. The designers of *Doom* found a way to change that by putting a small picture of the avatar's face on the bottom of the screen. Since we can notice facial expression in our peripheral vision more easily than we can discern numbers, they wisely made the facial expression correspond to the health meter, so that players got a sense of how injured they were without having to take their eyes off of their enemies.

Character Tip #8: Powerful Stories Transform Characters

One distinguishing feature of great stories is how their characters change. Video game designers seldom consider this, to their detriment. There is a tendency to treat game characters as fixed types — the villain is always the villain, the hero was born a hero. This makes for very boring storytelling. A few games, such as *Fable* and *Star Wars: Knights of the Old Republic* became famous because of the fact that they do what nearly every successful movie or book does — let events change the main character over time.

It is certainly true that meaningful character change is not possible for the main character in every game. But perhaps character change can happen to other characters in the game such as the sidekick or the villain. A great way to visualize the potential for character change in your game is to make a character transformation chart, with characters on the left side, and the different sections of your story along the top. Then, mark down the places where a character undergoes some kind of change. For example, consider the changes in the story of *Cinderella*:

<table>
<tr><td colspan="2"></td><td colspan="5">SCENES</td></tr>
<tr><td colspan="2"></td><td>At home</td><td>The invitation</td><td>The night of ball</td><td>The next day</td><td>At last</td></tr>
<tr><td rowspan="3">C
H
A
R
A
C
T
E
R
S</td><td>Cinderella</td><td>A sad, suffering servant</td><td>Hopeful, then disappointed</td><td>A beautiful princess</td><td>Suffering and sad again</td><td>Happily ever after</td></tr>
<tr><td>Her step-sisters and step-mother</td><td>Superior and mean</td><td>Ecstatic and arrogant</td><td>Disappointed at getting no attention</td><td>Hopeful that they might fit the slipper</td><td>Disgraced and incredulous</td></tr>
<tr><td>The Prince</td><td>Lonely</td><td>Still lonely</td><td>Fascinated with a mystery woman</td><td>Desperately searching</td><td>Happily ever after</td></tr>
</table>

By looking at each character over time, instead of just the story thread, we get a unique perspective that helps us to better understand our characters. Some transformations are temporary and small, others are great and permanent. By considering

how your characters should change and making the most of that, your game will tell a far more powerful story than if they pass through the story untouched by it. This perspective of character transformation is our final character lens.

Lens #81: The Lens of Character Transformation

Powerful stories are able to change their characters. To ensure your characters are transforming in interesting ways, ask yourself these questions:

- How does each of my characters change throughout the game?
- How am I communicating those changes to the player? Can I communicate them more clearly, or more strongly?
- Is there enough change?
- Are the changes surprising and interesting?
- Are the changes believable?

Character Tip #9: Avoid the Uncanny Valley

Japanese roboticist Masahiro Mori noted something interesting about human response to robots and other artificial characters. If you think about how people empathize, you might notice that the closer something is to seeming human, the more they can empathize with it. You might even lay this out on a graph like:

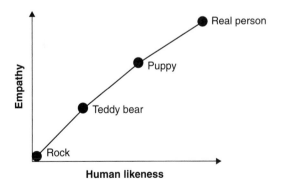

FIGURE
18.7

And this makes perfect sense. The more something is like a person, the more empathy we give it. But Mori noted an interesting exception, as he worked on robots that tried to mimic humans — as soon as they started to get too human, perhaps moving

from a metal face (think C-3PO) to one with artificial skin, people suddenly found them repulsive. It made the graph look like this:

FIGURE
18.8

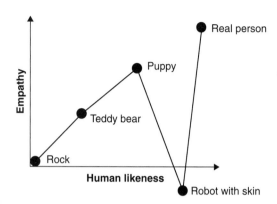

Mori referred to this surprising dip in the curve as "the uncanny valley." The cause of this uneasy feeling may be that when we see things that almost look like people, our brains register them as "diseased people" who might be dangerous to be around. Zombies are a canonical example of the creepy things that live at the bottom of the uncanny valley.

The uncanny valley shows up in videogames and animation all the time. Every frame of films such as *Final Fantasy* and *Polar Express* look gorgeous and natural — when you just look at one frame. But when the films are in motion, there is something about the computer-generated humans that many people find creepy — somehow, they don't move quite right — they got too close to the valley and fell in. Contrast those characters to the cartoony characters (fish, toys, cars, robots) in Pixar films that have no problem generating empathy, because they stay to the left side of the valley, where that puppy dog is.

Videogame characters can easily have the same problems — especially in games that try to mimic reality. The day may come where videogame characters are so human-looking that they can safely exist on the right side of the valley, but until then, use caution — it's a long way down.

Characters definitely make a world more interesting, but for it to be a world at all, it needs something else — a space to exist.

CHAPTER NINETEEN

Worlds Contain *Spaces*

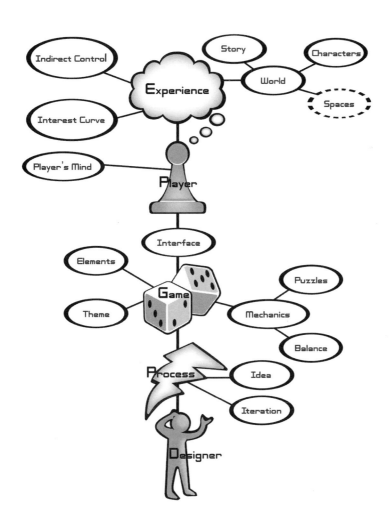

FIGURE
19.1

Wait a minute — didn't we cover the idea of space in Chapter 10? Yes and no. We discussed the idea of functional space — but functional space is only the skeleton of the game space. In this chapter, we will examine the fleshed-out space the player actually experiences.

The Purpose of Architecture

Yes, build a Frank Lloyd house if you don't mind camping in the front yard when it rains.

– Aline Barnsdall

What do you think of when you hear the word "architecture?" Most people think of grand buildings, particularly modern buildings with unusual shapes. People some-times seem to think that the primary job of the architect is to sculpt the outer shape of a building, and that appreciation of good architecture means enjoying these building shapes like one might enjoy sculptures in a museum.

And while the outer shape of a structure is one aspect of architecture, it has little to do with the primary purpose of architecture.

The primary purpose of architecture is to control a person's experience.

If all the experiences we wanted to have were to be found easily in nature, there would be no point to architecture. But those experiences aren't always there, so architects design things to help us have the experiences we desire. We want to expe-rience shade and dryness, so we put up shelters. We want to experience safety and security, so we build walls. We build houses, schools, malls, churches, offices, bowl-ing alleys, hotels, and museums not because we want to look at those buildings, but because there are experiences we want to have that these buildings make possible. And when we say one of these buildings is "well-designed," we aren't talking about what it looks like on the outside. What we are talking about is how well it creates the kind of experience we want to have when we are inside.

For this reason, architects and game designers are close cousins. Both cre-ate structures that people must enter in order to use. Neither architects nor game designers can create experiences directly — instead, both must rely on the use of indirect control to guide people into having the right kind of experience. And most important, both create structures which have no point other than to engender expe-riences that make people happy.

Organizing your Game Space

There is a more obvious connection between game designers and architects as well — both have to create spaces. And while game designers can learn a lot about creating meaningful and powerful spaces from architects, by no means do game

designers have to follow every rule of architecture, since the spaces they create are not made of bricks and mortar, but are completely virtual structures. And while this sounds like a wonderful freedom (it is), it can also be a burden. The lack of physical constraints means almost anything is possible — and if anything is possible, where do you begin?

One way to begin is to decide on an organizing principle for your game space. If you already have a pretty good idea how your game will be played, this should be pretty easy. Just look at your game through Lens #21: The Lens of Functional Space (from Chapter 10), and use that as the skeleton for the space you will build.

But maybe you are still figuring out your functional space — perhaps your game design is still very early, and you are hoping that by creating a map, you might get a better sense of how your game works. In that case, here are five common ways that designers organize their game spaces.

1. **Linear**. A surprising number of games are arranged on a linear game space where a player can only move forward and (maybe) back along a line. Sometimes the line has two ends, other times it loops back on itself. Some well-known linear game spaces:

 - Candyland
 - Monopoly
 - *Super Mario Brothers*
 - *Crash Bandicoot*
 - *Guitar Hero*

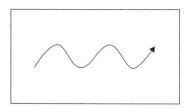

2. **Grid**. Arranging your gamespace on a grid has a lot of advantages. It can be easy for players to understand, it makes it easier to ensure that things line up, it keeps things in proper proportion, and of course, grids are very easy for computers to understand. Your grid need not be a grid of squares — it can also be of rectangles, hexagons (popular in war games), or even triangles. Some well-known grid-based games:

 - Chess
 - *Advance Wars*

- *Settlers of Catan*
- *Legend of Zelda (NES)*
- *Quake*

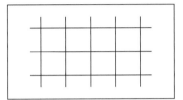

3. **Web**. A web arrangement is achieved by marking several points on a map and connecting them with paths. This is useful when you have several places you want players to visit, but you want to give them a number of different ways to get to them. Sometimes there is meaningful travel along the paths, but other times travel is instantaneous. Some examples of web-based gamespaces:

- Fox and Geese
- Trivial Pursuit
- *Zork*
- *Club Penguin*
- *Toontown Online*

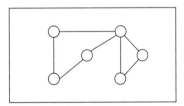

4. **Points in Space**. This somewhat uncommon type of gamespace is usually for games that want to evoke something like wandering a desert and occasionally returning to an oasis, like one does in an RPG. It also is common for games where players get to define the gamespace themselves. Some examples of this kind of spatial organization:

- Bocce
- Thin Ice (a board game involving wet marbles and a napkin)

- Polarity (magnetic board game)
- *Final Fantasy*

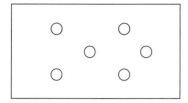

5. **Divided Space**. This kind of space is most like a real map and is common in games that are trying to replicate a real map. It is achieved by carving the space up into sections in an irregular way. Some examples of games that have divided space:

- Risk
- Axis and Allies
- *Dark Tower*
- *Zelda: Ocarina of Time*
- *Spore*

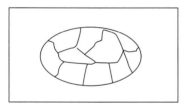

These different organizing principles are often combined to make interesting new types of gamespaces. The game of Clue is a combination of the grid and divided space patterns. Baseball is a combination of a linear structure and points in space.

A Word About Landmarks

One very important thing to consider whenever you organize a space: What are the landmarks? The very first text adventure game, *Colossal Cave*, had two different mazes. In one, every area was described as "You are in a maze of twisty passages, all alike." Just as confusing though, was the opposite maze, in which every area was described as "You are in a maze of twisty passages, all different." For it is certainly true that too much chaos is just as monotonous as too much order. Players of *Colossal Cave* learned to drop items in the mazes, forming landmarks that helped

them find their way. Any good gamespace has built-in landmarks, which help the players find where they are going, and also make the space interesting to look at. Landmarks are what players remember and what they talk about, for they are what make a space memorable.

Christopher Alexander is a Genius

Christopher Alexander is an architect who has devoted his life to studying how places make us feel. His first book, *The Timeless Way of Building* (1979), tries to describe how there is a unique quality shared by spaces and objects that are truly well-designed. As he puts it:

> *Imagine yourself on a winter afternoon with a pot of tea, a reading light, and two or three huge pillows to lean back against. Now make yourself comfortable. Not in some way which you can show to other people, and say how much you like it. I mean so that you really like it, for yourself.*

> *You put the tea where you can reach it: but in a place where you can't possibly knock it over. You pull the light down, to shine on the book, but not too brightly, and so that you can't see the naked bulb. You put the cushions behind you, and place them, carefully, one by one, just where you want them, to support your back, your neck, your arm: so that you are supported just comfortably, just as you want to sip your tea, and read, and dream.*

> *When you take the trouble to do all that, and you do it carefully, with much attention, then it may begin to have the quality which has no name.*

It is hard to put a finger on exactly what this quality is, but most people know it when they experience it. Alexander notes that things that have the nameless quality usually have these aspects:

- They feel **alive**, as if they hold energy.
- They feel **whole**, like nothing is missing.
- They feel **comfortable**, it is pleasing to be around them.
- They feel **free**, not constrained unnaturally.
- They feel **exact**, as if they are just how they are supposed to be.
- They feel **egoless**, connected to the universe.
- They feel **eternal**, as if they have always been, and always will be.
- They are **free from inner contradictions**.

The last of those, "free from inner contradictions," is tremendously important to any designer, because inner contradictions are at the heart of any bad design. If a

device is supposed to make my life easier, and it is hard to use, that is a contradiction. If something is supposed to be fun, and it is boring or frustrating, that is a contradiction. A good designer must carefully remove inner contradictions, and not get used to them, or make excuses for them — so let's add a tool for removing them in our toolbox.

Lens #82: The Lens of Inner Contradiction

A good game cannot contain properties that defeat the game's very purpose. To remove those contradictory qualities, ask yourself these questions:

- What is the purpose of my game?
- What are the purposes of each subsystem in my game?
- Is there anything at all in my game that contradicts these purposes?
- If so, how can I change that?

Alexander also explains that only through iteration and observation about how something is used can one arrive at a truly excellent design. In other words, the Rule of the Loop holds in architecture as well as game design. A concrete example of this is the system he describes for laying paths between buildings in a complex: Lay no paths at all. Merely plant grass. Then come back a year later, see where people have worn paths in the grass, and only then begin to pave.

Alexander's next book, *A Pattern Language*, is his most famous and influential work. In it, he describes 253 different architectural patterns that seem to have the nameless quality. They range from large-scale patterns like "DISTRIBUTION OF TOWNS" and "AGRICULTURAL VALLEYS" to small-scale patterns such as "CANVAS ROOFS" and "WINDOWS WHICH OPEN WIDE." The scope and striking detail of *A Pattern Language* changes the reader's viewpoint about how they interact with the everyday world. Many game designers have stories to tell about how the book inspired them. Personally, I was baffled about how to structure the world of Toontown Online until I read this text, and suddenly much of it seemed obvious. Will Wright is said to have designed Sim City based on a desire to experiment with the patterns listed in the book. The entire "Design Patterns" movement in computer science stems from the power of this text as well. What will you create when you read it?

Alexander was not content to leave the nameless quality nameless. In his later books, he makes a deeper study of what truly gives something that special feeling. He did this by cataloging thousands of different things that did, or did not, have that feeling, and then looked for similarities between them. In doing so, he gradually distilled out fifteen fundamental qualities that these things shared, as detailed in *The Phenomenon of Life*. The book gets its title from an insight he had about the nameless quality: The reason some things seem special to us is that they have some

of the same qualities that living things have. As living beings ourselves, we feel connected to things and places that have qualities special to living things.

Delving into detail about these properties is well beyond the scope of this book, but it can be fascinating and useful to reflect on whether your game contains them. It is excellent mental exercise just to think about how these patterns, which mostly are about spatial and textural qualities, apply to games at all.

Alexander's Fifteen Properties of Living Structures

1. **Levels of Scale**. We see levels of scale in "telescoping goals," where a player has to satisfy short-term goals to reach mid-term ones and to eventually reach long-term goals. We see it in fractal interest curves. We also see it in nested game world structures. *Spore* is a symphony of levels of scale.

2. **Strong Centers**. We see this in visual layout, certainly, but also in our story structure. The avatar is at the center of our game universe — and generally we prefer strong avatars over weak ones. Also, we prefer strong centers when it comes to our purpose in the game — our goal.

3. **Boundaries**. Many games are primarily about boundaries! Certainly any game about territory is an exploration of boundaries. But rules are another kind of boundary, and a game with no rules is no game at all.

4. **Alternating Repetition**. We see this on the pleasing shape of the chessboard, and we see it too in the cycle of level/boss/level/boss that comes up in so many games. Even tense/release/tense/release is an example of pleasing alternating repetition.

5. **Positive Space**. What Alexander means here is that the foreground and background elements both have beautiful, complementary shapes, like Yin and Yang. In a sense a well-balanced game has this quality — allowing multiple alternate strategies to have an interlocked beauty.

6. **Good Shape**. This is as simple as it sounds — a shape that is pleasing. We certainly look for this in the visual elements of our games. But we can see and feel it, too, in level design. A good level feels "solid" and has a "good curve."

7. **Local Symmetries**. This is different from an overall symmetry, like a mirror image; instead referring to multiple small, internal symmetries in a design. *Zelda: The Wind Waker* has this feeling throughout its architecture — when you are within a room or area, it seems to have a symmetry, but it is connected to other places in a way that feels organic. Rule systems and game balance can have this property as well.

8. **Deep Interlock and Ambiguity**. This is when two things are so tightly intertwined that they define each other — if you took one away, the other wouldn't be itself any longer. We see this in many board games, such as Go. The position of the pieces on the board is only meaningful relative to the opponent's pieces.

9. **Contrast**. In games we have many kinds of contrast. The contrast between opponents, between what is controllable and what is not, and between reward and punishment. When opposites in our game are strongly contrasted, the game feels more meaningful and more powerful.

10. **Gradients**. This refers to qualities that change gradually. The gradually increasing challenge curve is an example of this, but so are appropriately designed probability curves.

11. **Roughness**. When a game is too perfect, it has no character. The handmade feeling of "house rules" often makes a game seem more alive.

12. **Echoes**. Echoes are a kind of pleasing, unifying repetition. When the boss monster has something in common with his minions, we are experiencing echoes. Good interest curves have this property, especially fractal ones.

13. **The Void**. As Alexander says, "In the most profound centers which have perfect wholeness, there is at the heart a void which is like water, infinite in depth, surrounded by and contrasted with the clutter of the stuff and fabric all around it." Think of a church, or the human heart. When boss monsters tend to be in large, hollow spaces, we are experiencing the void.

14. **Simplicity and Inner Calm**. Designers talk endlessly about how important it is for a game to be simple — usually with a small number of rules that have emergent properties. Of course, these rules must be well-balanced, which gives them the inner calm that Alexander describes.

15. **Not-Separateness**. This refers to something being well-connected to its surroundings — as if it was part of them. Each rule of our game should have this property, but so should every element of our game. If everything in our game has this quality, a certain wholeness results that makes the game feel very alive indeed.

Alexander's approach to architecture can be quite useful when designing a game-space. But as you see, the qualities he describes for a good space apply to many other aspects of game design as well. I have only been able to scratch the surface of Alexander's approach to design here. Reading his many delightful books will surely give you new insights into game design. As a reminder of his thoughtful perspective, take this lens.

Lens #83: The Lens of The Nameless Quality

Certain things feel special and wonderful because of their natural, organic design. To ensure your game has these properties, ask yourself these questions:

- Does my design have a special feeling of life, or do parts of my design feel dead? What would make my design feel more alive?

- Which of Alexander's fifteen qualities does my design have?
- Could it have more of them, somehow?
- Where does my design feel like my *self*?

Real vs. Virtual Architecture

Alexander's "deep fundamentals" perspective on architecture is useful, but it is also useful to look in detail at some of the peculiarities special to virtual architecture. When we study some of the spaces that have been made for popular videogames, they are often very strange. They have huge amounts of wasted space, weird and dangerous architectural features, no real relationship with their outside environment, and sometimes areas even overlap with themselves in physically impossible ways.

FIGURE
19.2

No one would build this in the real world

These sorts of bizarre building constructs would be considered madness by real-world architects. Look at those weird hollow spaces, and all that water. So why is it that when we play videogames, we don't notice how strange the building layouts are?

It is because the human mind is very weak when it comes to translating 3D spaces into 2D maps. If you don't believe me, think of a familiar place, somewhere

you go all the time like your home, school, or workplace, and try to draw a map of it. Most people find this quite difficult — this simply isn't how we store spaces in our minds — we think of them relatively, not absolutely. We know which doors go to which rooms, but as for what is behind a wall with no doors, we aren't always quite sure. For that reason, it is not important that 3D spaces have realistic 2D blueprints. All that matters is how the space feels when the player is in it.

Know How Big

When we are in real spaces, a sense of scale comes naturally to us, because we have so many cues — lighting, shadows, textures, stereo vision, and most important, the presence of our own bodies. But in virtual spaces, scale is not always so clear. Because so many real-world cues are missing, it is very easy to create a virtual space that is really much bigger or smaller than it looks. This can be very confusing and disorienting for players. I frequently have conversation with students and other novice world builders that go something like this:

Virtual Architect: My world looks funny... but I don't know why...

Me: Well, things seem out of scale — that car is too big for the street, and those windows are too small for that building. How big is that car, anyway?

Virtual Architect: I don't know... Maybe five units?

Me: So how big is a unit?

Virtual Architect: I don't know. It's all virtual... why does it matter?

And in one sense, he's right — as long as everything in your world is in proper proportion, your virtual units could be feet, meters, cubits, or smurf hats, and it doesn't matter. But the moment that anything is out of scale, or you suspect it might be out of scale, it becomes a very important question, because then you have to relate things back to the real world. For this reason, it is wise to make your game units something that you are intimately familiar with in the real world — for most people, feet or meters. This will save a lot of time and confusion, because if your units are feet, and your car is 30 units long, you will quickly know what the problem is.

But sometimes the elements of your world are properly proportioned, but to the players things look out of scale. The typical culprits in this case include:

- **Eye height**: If you have a first-person game with the virtual camera very high (more than seven feet off the ground) or very low (less than five feet off the ground), it will distort the view of the world, since people tend to assume an eye height similar to their own.

- **People and doorways**: Two of the strongest cues for scale are people and doorways (which of course, are designed to accommodate people). If you have a

world of giants or little people, it can confuse the player about scale; similarly, if you have decided that doorways are very large or very small in your game, that can be similarly confusing. If you have no people, doorways, or other commonly sized man-made objects, players often can get a little confused about scale.

- **Texture scaling**: An easy error to make when designing a world is to have textures that are not at the proper scale, such as a brick texture on the wall that is too large, or a floor tile texture that is too small. Be sure that the textures you use match the scale of textures in the real world.

Third-Person Distortion

There is another special peculiarity of designing virtual spaces. Each of us has developed a natural sense of the relationship of how our bodies fit into the world that we see. When we play a third-person videogame, where we can see our body, our brain does an amazing thing; it somehow lets us be in two places at once — in the body of our character, but also floating eight feet behind our body — all the while letting this strange perspective feel very natural. And while we get tremendous benefits from being able to see our virtual body in a game, something very odd happens to our sense of proportion. In wide open, outdoor scenes we mostly don't notice this. But when we try to control a character who is in a normal-sized interior space, the space feels frustratingly crowded, like we are driving around a house in a car.

FIGURE
19.3

*The Problem: A room that is too
crowded for a 3rd person viewpoint*

Weirdly, most players do not identify this as a problem with the third-person avatar system, but they think the room too small. Is there a way to distort the room so that when it is experienced in this peculiar perspective, it looks normal?

FIGURE
19.4

Solution 1: Bigger room and furniture

Solution 1: Scale up the room and the furniture. If you scale up all the walls and furniture, it does make more room to move around, but gives a weird feeling of your avatar being tiny like a small child, as normal sized objects like chairs and sofas become too big to sit on.

FIGURE
19.5

Solution 2: Bigger room, normal furniture

Solution 2: Scale up the room, but leave the furniture normal size. Now you have a cavernous room with furniture huddled together in lonely looking clusters.

FIGURE
19.6

Solution 3: Bigger room, normal furniture spread out

Solution 3: Scale up the room, leave the furniture normal size, but spread the furniture out. This works a little better — the room no longer seems such a cavern, but it leaves the room looking strangely sparse, with unnaturally large spaces between objects in the room.

FIGURE
19.7

*Solution 4: Bigger room, slightly bigger
furniture spread out.*

Solution 4: Scale up the room, scale up the furniture a little bit, and spread the furniture out. This solution, pioneered by the designers of *Max Payne*, works very well. In a first-person view, this looks kind of strange, but in a third-person view, it does a very good job of counteracting the distortion caused by the eye-point being far from the body.

Level Design

We're nearly at the end of this chapter, and we haven't yet talked about level design. Or have we? In truth, we have been covering it all along! Not just in this chapter, but through the entire book. All a level designer does is arrange the architecture, props, and challenges in a game in ways that are fun and interesting — that is, making sure there is the right level of challenge, the right amount of reward, the right amount of meaningful choice, and all the other things that make a good game. Level design is just game design exercised in detail — and it isn't easy, for the devil is in the details. Level design is different for every game, because every game is different. But if you use everything you know about game design when you design your level, examining it carefully through many lenses, the best level design choices will start to become clear.

CHAPTER TWENTY

The Look and Feel of a World Is Defined by Its *Aesthetics*

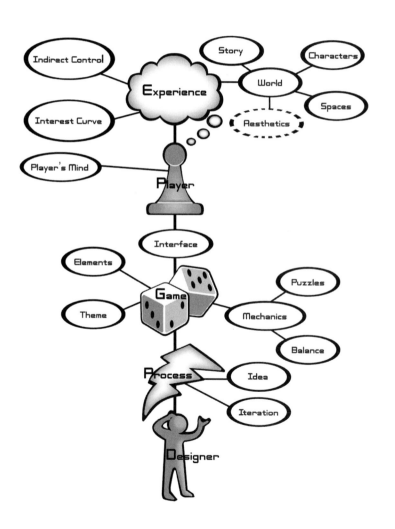

FIGURE
20.1

Monet Refuses the Operation

Doctor, you say that there are no haloes
around the streetlights in Paris
and what I see is an aberration
caused by old age, an affliction.
I tell you it has taken me all my life
to arrive at the vision of gas lamps as angels,
to soften and blur and finally banish
the edges you regret I don't see,
to learn that the line I called the horizon
does not exist and sky and water,
so long apart, are the same state of being.
Fifty-four years before I could see
Rouen cathedral is built
of parallel shafts of sun,
and now you want to restore
my youthful errors: fixed
notions of top and bottom,
the illusion of three-dimensional space,
wisteria separate
from the bridge it covers.
What can I say to convince you
the Houses of Parliament dissolve
night after night to become
the fluid dream of the Thames?
I will not return to a universe
of objects that don't know each other,
as if islands were not the lost children
of one great continent. The world
is flux, and light becomes what it touches,
becomes water, lilies on water,
above and below water,
becomes lilac and mauve and yellow
and white and cerulean lamps,
small fists passing sunlight
so quickly to one another
that it would take long, streaming hair
inside my brush to catch it.
To paint the speed of light!
Our weighted shapes, these verticals,
burn to mix with air
and changes our bones, skin, clothes
to gases. Doctor,

*if only you could see
how heaven pulls earth into its arms
and how infinitely the heart expands
to claim this world, blue vapor without end.*

– Lisel Mueller

The Value of Aesthetics

Aesthetics is the third quadrant of the elemental tetrad. Some game designers have disdain for aesthetic considerations in a game, calling them mere "surface details" that have nothing to do with what they consider important — the game mechanics. But we must always remember that we are not designing just game mechanics, but an entire experience. And aesthetic considerations are part of making any experience more enjoyable. Good artwork can do wondrous things for a game:

- It can draw the player into a game they might have passed over.
- It can make the game world feel solid, real, and magnificent, which makes the player take the game more seriously and increases endogenous value. Consider the Axis and Allies story in the "pleasure of sensation" section in Chapter 8.
- Aesthetic pleasure is no small thing. If your game is full of beautiful artwork, then every new thing that the player gets to see is a reward in itself.
- Just as the world often ignores character flaws in a beautiful woman or a handsome man, players are more likely to tolerate imperfections in your design if your game has a beautiful surface.

You already have many of the tools you need to evaluate aesthetics in your game. Obviously Lens #63: The Lens of Beauty is useful, but you can also improve and integrate your aesthetics by using these other lenses in a new way. Stop for a moment, and consider how you might use each of these lenses not to observe the mechanics of your game, but the artwork in your game.

- Lens #1: Essential Experience
- Lens #2: Surprise
- Lens #4: Curiosity
- Lens #9: Unification
- Lens #10: Resonance
- Lens #11: Infinite Inspiration
- Lens #15: The Toy

- Lens #16: The Player
- Lens #17: Pleasure
- Lens #40: Reward
- Lens #42: Simplicity/Complexity
- Lens #43: Elegance
- Lens #45: Imagination
- Lens #48: Accessibility
- Lens #49: Visible Progress
- Lens #54: Physical Interface
- Lens #55: Virtual Interface
- Lens #59: Channels and Dimensions
- Lens #64: Projection
- Lens #67: Simplicity and Transcendence
- Lens #72: Indirect Control
- Lens #74: The World
- Lens #75: The Avatar
- Lens #80: Status
- Lens #82: Inner Contradiction
- Lens #83: The Nameless Quality

Learning to See

It makes sense to view your game artwork through many lenses, because the key to creating great artwork is in your ability to see. Not just to see a salt shaker and say "that's a salt shaker," but to really see it — see its shapes, colors, proportions, shadows, reflections, and textures — to see its relationship to its environment and to the people who use it, and to see its function, and to see its meaning (see Figure 20.2). This kind of deep seeing is a visual equivalent of the deep listening we discussed at the beginning of the book.

It is amazing how difficult it can be to actually see things as they really are. The reason for this is efficiency — if we just stared in awe at everything we saw, taking in every little visual and audible detail, our minds would be so absorbed we would never get anything done. So, for efficiency, our brains, at a low level, categorize things before they enter our consciousness. We see a salt shaker or a dog, and our left brain just slaps a label on it, because it is easier to think about a label than to actually deeply see the thing itself in all its detail and uniqueness. When you are looking at and thinking about artwork in your game, you must learn to get your left brain to

FIGURE
20.2

take a little break, and let your right brain come out and play, for the right brain is able to see details that the left brain cannot. Betty Edwards' excellent book, *Drawing on the Right Side of the Brain,* is a marvelous text on this subject that is designed to teach anyone to draw by teaching them how to see. This is a fascinating virtuous circle — really seeing helps you draw properly, and drawing helps you see properly.

How to Let Aesthetics Guide your Design

Some people mistakenly believe that it doesn't make sense to get artists involved in a game project until the game design is near completion. But our minds are very visual, and it is often the case that an illustration or pencil sketch can completely change the course of a design, because the way a game looks in your mind's eye is often very different from the way it looks when it is drawn on paper. Sometimes, an inspiring piece of concept art can provide the uniting vision of the experience a game is trying to achieve. Other times an illustration can make clear whether an interface idea is possible or not. And occasionally, a little doodle done as a joke to poke fun at a design suddenly proves to become the central theme of a game. Game designs are abstract — illustrations are concrete. In the painful process of converting your abstract design into a concrete game, illustrations can serve as a simple, effective way to ground your design in reality at the very start of a project.

If you have some artistic skill, it can be a great boon to you as a game designer — because you can sketch, people will think your creative vision is as clear in your mind as it is on the paper. More than that, it might make you famous.

There are only two categories of famous game designers: first, ones who design "god games," such as Will Wright, Peter Molyneux, and Sid Meier, presumably because it is easy to imagine a designer of a world as its god; and second, ones who have a very distinct visual style, such as Shigeru Miyamoto and American McGee. So, if you have a distinct and appealing art style, you should seriously consider basing your games around it.

But what if (like me) artistic talents do not come naturally to you? What if you have neither the major nor minor gift when it comes to drawing? In this case, the best thing you can do is to find an artistic partner. For if you can find a talented artist with whom you communicate well, your nebulous idea can become a concrete vision very quickly. Partnerships like this can be golden, for a pretty picture is nice for a moment, and a good idea is nice in theory, but a well-rendered image of a good idea is compelling in a way that few people can resist. Strong game designs that have good concept art will:

- Make your idea clear to everyone (you didn't think anyone would actually *read* your design document, did you?)
- Let people see, and imagine entering, your game world
- Make people excited about playing your game
- Make people excited about working on your game
- Allow you to secure funding and other resources to develop your game

Now, you might think that the idea of having some detailed art at the beginning of a project goes against the idea of rapid prototyping, where often the game elements are completely abstract. But it isn't so — an illustration is just another kind of prototype. It is almost like riding a seesaw — the abstract prototype gives you ideas for how the game should look, which drives you to make more concept art, and the concept art can give you ideas for how the game should play, which drives you to make new abstract prototypes. If you keep cycling this way, eventually you will arrive at a beautiful game that is fun to play, and in which the artwork and gameplay complement each other perfectly, because they grew up together.

How Much Is Enough?

But this raises an important question — what is the right amount of detail for your concept art? Most artists want to make everything they do look absolutely gorgeous — but beautiful art takes time, and sometimes rough sketches or rough models are enough to do the job. Young artists, especially, are afraid of doing rough sketches and showing them, for they fear that the rough quality will make people misjudge their talent. Creating sketches that are simple, rough, and useful is a valuable skill that must be practiced.

But of course, there are other times when only gorgeous full-color renderings will do to show the true feel of the game. One artist I used to work with had a great trick — he would create rough pencil sketches that were large and elaborate, and then pick one corner of the picture, and render some elements there with full color, clean lines, and nice shading. This was a marvelous balance — the viewer could see the scope and complexity of what he was presenting, but also the quality of finished detail. The viewer could easily imagine what the whole image would look like if it were finished to the level of detail of that one little corner.

Even in your finished product, you need to be judicious about where to put detail, for a few details in the right places can make your game world seem far larger and richer than it is. John Hench, one of the great Disney Imagineers, would often say that anyone can make things look good from far away — it's making them also look good close up that is hard. An example is Cinderella's castle at Disney World. People see it from a distance and are drawn to it because it is so beautiful. If when they got close they found it was crudely painted fiberglass, they would be filled with disappointment. Instead, they find that close up it has gorgeous mosaics and beautiful stone crafting, which exceeds their expectations, making it seem deep, beautiful, and real.

J.R.R Tolkien's worlds are famous for being deep and rich — one way he achieves this is through a trick he referred to as "distant mountains." Throughout his books, he gives names to distant places, people, and events that are never actually encountered in the book. The names and brief descriptions make it seem like the world is larger and richer than it is. When fans would ask him why he didn't add more detail about these things, he would reply that he could tell them all about the distant mountains, but if he did that he'd need to create more distant mountains for those distant mountains.

Use Audio

It is very easy to fall into the trap of only thinking of visual art when you think about the aesthetics of your game. But audio can be incredibly powerful. Audio feedback is much more visceral than visual feedback, and more easily simulates touch. A study was once performed where two groups of players were asked to rate the graphics of a game, and only the graphics. Both players played the same game, but for one difference: The first group had low-quality audio, and the second group had high-quality audio. Surprisingly, though the graphics were identical for both games, the "high-quality audio" group rated the graphics of the game more highly than the "low-quality audio" group.

One serious error that game developers often fall into is to not add music or sound to their game until the very end. A technique I learned from Kyle Gabler is to choose music for your game at the very beginning of your process, as early as possible — possibly before you even know what the game is! If you are able to choose a piece of music that feels the way you want your game to play, you have already

efficiently made a great many subconscious decisions about what you want your game to feel like. Like a theme, the music can channel the design of your game — if you ever find that part of your game is conflicting with the music that you feel is so right, it is a good indication that part of the game should change.

Balancing Art and Technology

The tight integration of art and technology in modern videogames makes for some very challenging design problems. The artists are simultaneously empowered by and restrained by technology, and the engineers are similarly empowered and restrained by art. So much of the art in games seems hi-tech that it is tempting to just let the engineers loose to create the artistic vision of the game — something they are often all too ready to do. Don't let this happen! Talented artists have trained for a lifetime to imagine and define glorious, integrated artistic visions. They see the world differently from the rest of us, as Lisel Mueller's poem illustrated so vividly at the start of this chapter. Whenever possible, let them drive the aesthetic bus. Am I saying you should ignore the engineers' aesthetic participation? By no means! Make the engineers the navigators and mechanics — let them recommend new routes and shortcuts, and let them soup up the bus, but let the artists decide the destination, and let their talented hands steer the way to a beautiful game. Don't just let the engineers include whatever shadow algorithm is the flavor of the month — instead, let the artists draw and paint the kind of shadows and textures they would want to see, and then challenge the engineers to match that vision.

One thing you should consider carefully is finding a technical artist for your team. This unusual individual has the eye of an artist and the mind of a computer programmer. A talented technical artist can build bridges between the art team and the engineering team by being able to fluently speak both of their languages and by helping to build tools that make the artists feel in command of the technology and the engineers feel in command of the art. This balance is not something to be taken lightly — when it is not right, it feels like your game is cracked down the middle — but when you achieve it, your game is gorgeous and powerful in ways your players will have never seen before.

CHAPTER TWENTY-ONE

Some Games are Played with *Other Players*

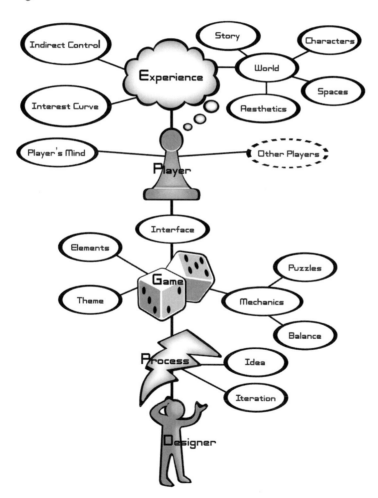

FIGURE
21.1

We Are Not Alone

No one ever said on their deathbed, "Gee, I wish I had spent more time alone with my computer."

– Dani Bunten Berry

Man is a social animal. Humans generally avoid being alone whenever possible. In most cases, we don't like to eat alone, sleep alone, work alone, or play alone. Prisoners who behave badly are put in solitary confinement, because although being trapped in a cage with a dangerous criminal is bad, being alone is worse.

And, if you look back over the centuries, the history of game design reflects this. The majority of all games created are designed to be played with other players, or against other players. Before the advent of computers, solo games, such as solitaire, were rare.

So what happened with videogames? Why is it that the majority of the ones created thus far are single-player experiences? Is there something about the technology that makes us want to give up our natural human tendency to socialize? Of course not. In fact, the trends are clear — each year, more videogames have a multiplayer or community component of some kind. The single-player phenomenon appears to have been a temporary abnormality, born partly because of the novelty of single-player interactive worlds, and partly because of the technological limitations of game software and hardware. Now that more and more game platforms are going online and becoming connected, it is becoming the case that games featuring no multiplayer component are once again becoming the rare case. The more technology advances and technological novelty wears off, the more electronic games start to fit the ancient social molds humans have had for thousands of years.

Does this mean that a day will come when there are no single-player games? Certainly not. There are plenty of times that humans do want to be alone for a time — reading books, exercising, meditating, and doing crossword puzzles are all delightful solitary pleasures, and videogames have elements in common with all of these. But humans tend to spend more time social than solitary, and in the long run, games will do the same.

Why We Play With Others

Clearly, playing with other people is natural, and in fact, the preferred way for us to play games. But why? In this book so far, we have discussed dozens of reasons people play games: for pleasure, for challenge, for judgment, for rewards, for flow, for transcendence, and many more. Although some of those are enhanced by the presence of other players, none of them require that presence. What is it that we

specifically seek when playing games with other people? There seem to be five main reasons:

1. **Competition**. When we think of multiplayer games, competition is usually the first thing that comes to mind — and for good reason. It simultaneously fills several kinds of needs and desires for us. All at once, it:

 - Allows for a balanced game on a level playing field (Lens #30: The Lens of Fairness).

 - Provides us with a worthy opponent (Lens #31: The Lens of Challenge and Lens #36: The Lens of Competition).

 - Gives us an interesting problem to solve (Lens #6: The Lens of Problem Solving).

 - Fulfills a deep inner need to determine our skill level relative to someone else in our social circle (Lens #20: The Lens of Judgment and Lens #80: The Lens of Status).

 - Allows for games involving complex strategy, choices, and psychology, all possible because of the intelligence and skill of our human opponent (Lens #32: The Lens of Meaningful Choice, Lens #27: The Lens of Skill, and Lens #71: The Lens of Freedom).

2. **Collaboration.** The opposite of competition, this is the "other way" we like to play together. Collaborative games are enjoyable to us because they:

 - Allow us to partake in game actions and employ game strategies that are impossible with just one person. One-on-one baseball makes almost no sense, for example.

 - Let us enjoy the (presumably evolved) deep pleasures that come from group problem solving and being part of a successful team.

 And while some people think of collaborative games as experimental, that is only the case when players are collaborating against an automated opponent. Most collaborative games follow the mold of team sports, which allow all the pleasures of collaboration and the pleasures of competition at the same time.

3. **Meeting Up.** We like to get together with our friends, but it can be socially awkward to just show up and be forced to make conversation on a regular basis. Games, like food, give us a convenient reason to be together, give us something to share, and give us something to focus on that won't make anyone in the room uncomfortable. Many are the friendships held together by a weekly game of chess, golf, tennis, bridge, bingo, basketball, or more recently, *Warcraft*, *Battlefield*, or *Guitar Hero*.

4. **Exploring our Friends**. And while it is great to have an excuse to meet up with our friends, games let us do something else that we can't do so easily with just

conversation — explore the minds and souls of our friends. In a conversation, we hear a friend's opinions about likes and dislikes, and their stories about the way they and other people have behaved. But these things are all filtered through the friend's conception of what they think we want to hear. When we play a game with them, however, we get a glimpse of something more like the unvarnished truth. We get to see them solving problems. We get to see them making tough decisions under stress. We get to see them make decisions about when to cut someone a break, and when to stab them in the back. We learn who we can trust, and who we can't. As Plato said, "You can learn more about a man in an hour of play than a year of conversation."

5. **Exploring Ourselves.** Alone, games let us test the limits of our abilities, finding out what we enjoy, and learning what we want to improve at. But when we are with others, we get to explore how we will behave in complex social situations, under stress. Do we have a tendency to let our friends win when they have a bad day, or to crush them unconditionally? Who do we prefer to team with, and why? How do we feel when publicly defeated, and how do we cope with that? How do our strategies differ from others, and why? Who do we choose to imitate, or find ourselves imitating? All these questions, and many others, are explored when we play games with other people. These are not trivial things — they are important things, close to the heart of how we see ourselves, and how we relate to other people.

Although multiplayer gameplay is important, you must employ it carefully and wisely, because it can be a lot of work, and hard to control. Generally, it is safe to assume that a multiplayer online game will take four times the effort and expense to create compared to a similar single-player game. This is because multiplayer games are much more difficult to debug and to balance. The payoffs can be worth it, though — if the reasons for having the multiplayer gameplay are clear and certain. If the reason to add it is "because multiplay is cool," you should probably think it through a little more.

There are many different, powerful reasons that we like to play games with other people. One additional reason, more powerful than the ones listed here, is the topic of Chapter 22.

CHAPTER TWENTY-TWO

Other Players Sometimes Form *Communities*

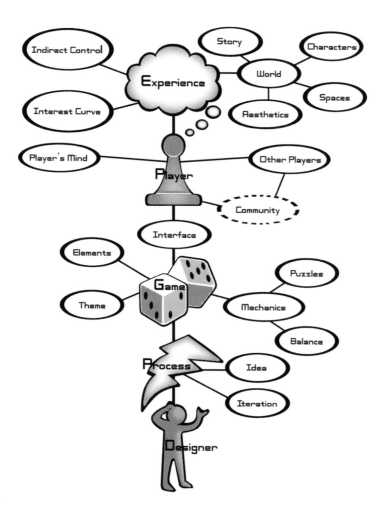

FIGURE
22.1

357

More than just Other Players

Games are something that inspire real passion in players, so it is not surprising that frequently, communities arise around games. These can be communities of **fans**, as in professional sports, or communities of **players**, as in *World of Warcraft*, or communities of **designers**, as in *The Sims*. These communities can be very powerful forces, extending the life of a game by many years by constantly drawing in new players.

But what is a community, really? The answer is not so simple. It is not merely a group of people who know each other, or who do the same thing. You might ride the train with the same people every day, but never feel a sense of community in doing so. But you might feel a sense of community with total strangers who are fans of the same esoteric TV series that you love. There is a special feeling that goes with being part of a community. It is hard to describe, but we know it when we feel it. Two psychologists who set out to better understand this sense of community found that it has four primary elements:

1. **Membership**. Something distinct makes it clear you are part of this group.

2. **Influence**. Being part of this group gives you power over something.

3. **Integration and Fulfillment of Needs.** Being part of this group does something for you.

4. **Shared Emotional Connection.** You have some guarantee of sharing emotions about certain events with others in the group.

And while these four are unquestionably important aspects of community, I find I sometimes prefer designer Amy Jo Kim's succinct definition of community: a group of people with a shared interest, purpose, or goal who get to know each other better over time.

But why, as a game designer, do you want communities to form around your game? There are three main reasons:

1. **Being part of a community fills a social need**. People need to feel a part of something, and as Lens #19: The Lens of Needs shows us, social needs are very powerful.

2. **Longer "period of contagion."** The personal recommendation of a friend is the most influential factor when purchasing a game. Game designer Will Wright once pointed out that if we truly believe that interest in a game spreads like a virus, it makes sense to study epidemiology. And one thing that we know from epidemiology is that when the period of contagion doubles, the number of people who catch the disease can increase by ten times. "Catching the disease" in our case means buying the game. But what does "period of contagion" for a game mean? It is the time when a player is so excited about a game that they

are talking about it constantly with everyone they know. Players who become part of a game community are likely to "stay contagious" for a long time, as the game will become a deeper part of their lives, giving them a lot to talk about.

3. **More hours of play.** It is often the case that players start to play a game for the game's pleasures, but stay with it over a long period for the community's pleasures. I took a mountain vacation with a friend and his extended family once, and on the way there he told me about a card game that his family loved playing. That evening, after dinner, the whole clan gathered around a big table to play, and I was quite eager to learn what it was about this unfamiliar game that they liked so well. They explained the rules, which were mind bogglingly simple — they basically consisted of passing cards to the right until all the cards were sorted in order. There were few decisions to make, and almost no skill whatever was required. Sometimes, it was hard even to say who won. I was incredibly disappointed, but as I looked around the table, I was the only one. Everyone else was talking, joking, and laughing as they played — and suddenly I realized that it didn't matter that the game wasn't perfect — what mattered was that it held them at the table and let them enjoy each other's company, keeping their hands busy, but their minds free. A game that has the ability to engender community will get played for a long, long time, no matter how lacking its other qualities might be. If the financial success of your game relies on subscription renewals or selling sequels, the fact that community makes people want to play it longer becomes very important.

Ten Tips for Strong Communities

Community is complex, and involves many different interrelated psychological phenomena, but there are some basic things you can do to help foster a community around your game.

Community Tip #1: Foster Friendships

The idea of online friendships seems simple. Just like real friendships, but online, right? But what do we really understand about the nature of friendship? And how can we translate it to a game environment? To have a meaningful online relationship with another person requires three things:

1. **The ability to talk**. This sounds obvious. But a surprising number of online games have been created that offer players no ability to talk to each other — the designers hoping that some kind of nonverbal communication would happen through play, and that would be enough. It is not enough. For a community to form, players must be able to speak to each other freely.

359

2. **Someone worth talking to**. You cannot assume that all your players will want to talk to each other, any more than you can assume that strangers on a bus will mingle. You must have a clear understanding of who your players want to talk to, and why. This varies a great deal depending on your demographics. Adults often want to talk to others who can relate to their problems. Teenagers often seek members of the opposite sex, or other people more interesting than their regular friends. And children generally have little interest in strangers — they would prefer to socialize with friends from real life. But understanding these age-based generalizations is not enough — you must understand the types of socialization that are specific to your game. Do your players seek competitors? Collaborators? Assistants? Quick chats, or long-term relationships? If players can't find the people they are interested in talking to, they will quickly drift away.

3. **Something worth talking about.** The first two items could be satisfied by a good chat room. Games that foster community give the players a steady stream of things to talk about. This can come from the depth of strategy inherent in the game (strategy discussion is a prime topic for chess communities, for example), or from events, or rule changes that are introduced over time (typical topics of conversation in MMOs and CCGs). It is common to hear people say that "good online games are more community than game," but this isn't really true. Good online games must have a solid balance of community and game. If the game isn't interesting enough, the community doesn't have anything to talk about. On the other hand, if the community support for your game isn't good enough, players will enjoy the game, but eventually wander off.

If you have all of these things, does it guarantee that friendships will form? Not necessarily. Friendships have three distinct phases, and your game must also have good support for each of them if you want friendships to blossom and survive.

- **Friendship phase 1: Breaking the Ice**. Before two people can become friends, they first must meet. Meeting people for the first time is awkward. Ideally, your game will have a way that people can easily find the kind of people they might like to be friends with, and then have some way to engage with them that is low in social pressure, but allows them to express themselves a little, so others can see what they are like.

- **Friendship phase 2: Becoming Friends**. The moment when two people "become friends" is mysterious and subtle — but it almost always involves conversation about something both of them care about. And in games, that conversation is often about a gameplay experience the two friends just shared. Giving players opportunities to chat with each other after an intense play experience is one of the best ways to encourage the formation of friendships. It can be a good idea to create a friend-making ritual in your game, such as inviting another player to be on your "friends list."

- **Friendship phase 3: Staying Friends.** Meeting people and making friends is one thing — staying friends is another. To stay friends with someone, you must be able to find them again to continue your friendship. In the real world this is mostly up to the friends, but in online games, you need to give people some way they can find each other again. This might be through friends' lists, or guilds, or even through memorable nicknames. Whatever works! But you have to do something, or your game misses out on the power of friendship, which is the glue that holds communities together.

Do keep in mind that different people are interested in different kinds of friendships. Adults are often most interested in making friends with similar interests, while kids are more interested in playing games with their real-life friends. Friendship is so crucial to community, and to game playing in general, that it deserves its own lens.

Lens #84: The Lens of Friendship

People love to play games with friends. To make sure your game has the right qualities to let people make and keep friendships, ask yourself these questions:

- What kind of friendships are my players looking for?
- How do my players break the ice?
- Do my players have enough chance to talk to each other? Do they have enough to talk about?
- When is the moment they become friends?
- What tools do I give the players to maintain their friendships?

Community Tip #2: Put Conflict at the Heart

Online game pioneer Jonathan Baron makes the point that conflict is at the heart of all communities. A sports team becomes a strong community because they have conflict with other teams. A Parent/Teacher Association becomes a community when they are fighting for better schools. A group of vintage car fanatics become a community in their shared battle against entropy. Fortunately for us, conflict is a natural part of games. But not all game conflict results in community. The conflict in solitaire, for example, doesn't do much to create a community. The conflict in your game must either spur players to demonstrate that they are better than everyone else (conflict against other players), or it must be the kind of conflict that is more likely to be resolved when people work together (conflict against the game).

Many games build community on both of these kinds of conflict: Collectible card games, for example, are all about being the very best player in your community, but their strategies are so complex, that players spend a lot of time sharing and discussing strategies.

Community Tip #3: Use Architecture to Shape your Community

In some neighborhoods, people don't really know their neighbors. In others, everyone knows everyone else, and the whole neighborhood has a sense of community. Is this because the people are different? No. It is usually a side effect of how the neighborhoods are designed. Neighborhoods that are designed to be walkable (and with meaningful destinations to walk to) give neighbors a chance to communicate. And neighborhoods with a lot of dead-end streets tend not to have a lot of through traffic, so that when you see someone passing by, there is a good chance you will know them. In other words, there are frequent opportunities to see and talk with the same people over and over again. Online worlds can support these same design features, partly through buddy lists and guilds, but partly by creating places where people are likely to see each other again and again, and still have time to talk. Many MMOs have areas where people tend to casually congregate and chat — these areas are often at a place where many players pass by regularly on their way to some important game business.

Community Tip #4: Create Community Property

When you can create things in your game that are not just owned by an individual player, but are owned by several, it can really encourage players to band together. Perhaps, for example, no individual player can afford to buy a ship in your game, but a group could team up and own it together. This group practically becomes an instant community, since they have to communicate frequently and be friendly to each other. The property you create doesn't need to be so tangible — a guild's status, for example, is a type of community property.

Community Tip #5: Let Players Express Themselves

Self-expression is very important in any multiplayer game. And while it is certainly true that players can express themselves through their gameplay strategies and styles of play, why stop there? You are, after all, creating a fantasy world where players can be whatever they would like to: Why not let them express that? Rich, expressive avatar creation systems are much beloved by players of online games.

So are systems of conversation that allow players to convey emotion or choose colors and styles for their text to display.

Player expression is not limited to online games — consider the expressive power in Charades or Pictionary. Game designer Shawn Patton once created a board game all about being a kid trying to have fun without getting dirty. Whenever you got dirty, you had to color your dirt onto your character card. Players had great fun making up stories about how they got dirty, and coloring their characters to match the story. Even Monopoly allows the players expression — although it is for only 2–8 players, the game has 12 different playing pieces, because it is an easy way to make sure players get a chance to express themselves.

Self-expression is extremely important, but easily overlooked. Keep this lens so you remember to let players express themselves.

Lens #85: The Lens of Expression

When players get a chance to express themselves, it makes them feel alive, proud, important, and connected. To use this lens, ask yourself these questions:

- How am I letting players express themselves?
- What ways am I forgetting?
- Are players proud of their identity? Why or why not?

This lens is important and overdue. It works very well in combination with other lenses, such as Lens #63: The Lens of Beauty and Lens #80: The Lens of Status.

Community Tip #6: Support Three Levels

It is important to realize that when designing a game community, you are really designing three separate games for players at different levels of experience. Some might argue there are even more, but there are at the minimum these three:

1. **Level 1: The Newbie.** Players who are new to game communities are often overwhelmed. They aren't yet challenged by the game itself — they are challenged just by learning to play the game. In a sense, learning to play the game *is* the game for them — and so you are obligated to design that learning process so that it is as rewarding as possible. If you don't, newbies will give up on the game before they really get into it, and you will significantly limit your audience. One of the best ways to make newbies feel rewarded and connected to the game is to create situations where they get to interact meaningfully with more experienced players. Some experienced players like greeting and teaching newbies for their own enjoyment, but if not enough of your players tend to do this,

then why not give in-game rewards for helping newbies? An online version of *Battletech* did this indirectly in an interesting way — experienced players took the role of generals, and had to recruit their own armies. Newbies were honored to be asked, and further honored to be placed right where the action is — on the front line, a place more experienced players learned to avoid. Even though the newbies would generally get slaughtered, it was win-win, in a way — the generals got lots of "cannon fodder," and the new players got a taste of the action right away.

2. **Level 2: The Player**. The player is past the newbie stage. They completely understand the game and are immersed in the game activities and in figuring out how to master them. Most of the design that goes into the game is aimed at this group.

3. **Level 3: The Elder**. For many games, particularly for any online game involving some kind of "leveling" system, there comes a point where the game itself is no longer interesting. Most of the secrets have been discovered, and many of the game pleasures have been squeezed dry. When players reach this state, they tend to leave, seeking a new game with new secrets. Some games, however, manage to retain these elder players by giving them an entirely different game to play — one that befits their level of skill, expertise, and devotion to the game. There is tremendous benefit to keeping elders around, since they are often some of the most vocal advertisers of your game, and further, they are experts about your game, often able to teach you how to improve it. Some typical "elder games" include:

 - **A More Difficult Game**. Often, particularly in MMOs, the middle game is about gradual, clear progression toward a goal. When the goal is reached, then what? Sometimes a different kind of game is presented to the higher level players that is much more difficult — so difficult, in fact, that no one can ever consistently master it. In Toontown Online, "Cog Headquarters" areas that featured a new, platform-based gameplay and new battle system served this purpose. Some games let you rise in the ranks from soldier to general. Other games change from pitting you against the computer to pitting you against the other players. There are many ways to add a more difficult game — but you are always left with the question: What to do when elders get tired of it?

 - **Governance Privileges**. Some games give the elder players special levels of responsibility, such as deciding the rules of the game. Many MUDs gave elder players these kind of powers. It is a great way to keep the elders involved, and make them feel special, although you run some risk if you hand them too much control. Collectible card communities often have formal systems where experienced players can take tests to become official judges at game tournaments.

 - **The Joy of Creation**. Players who truly love a game often fantasize about extending it in new ways, particularly when they have grown tired of it. So,

why not let them? Games like *The Sims* and *Unreal Tournament* have built strong communities by letting players create and share their own content. Many elders get to the point where they play the games only occasionally, but spend most of their time creating new content. For them, the new game becomes one of status: Can they become the most popular and respected designer?

- **Guild Management**. When players form groups, these groups often benefit from having organizers. Elders will often do this on their own, but if you give them a strong set of tools to help run their guild, the activity will be all the more appealing to them.

- **A Chance to Teach**. Just as many experts in "real-world" activities enjoy a chance to teach, so do game experts. If you can give them both permission and encouragement to do so, some of them will enjoy serving as ambassadors to the newbies, and guides to the regular players. Some online games give elders who would like to teach special outfits noting them as experts and teachers, which gives them a special status they are generally very proud of.

These three levels might sound like a lot of work, but really, they can often be implemented quite simply. Every year at Easter, for example, my neighborhood hosts an egg hunt for all the kids who live there. Quite naturally, they have found that it works best to have three levels of play:

- **Level 1 — Ages 2–5 (newbies)**: These kids hunt for eggs in a separate area from the older kids, so there is no concern about having to compete with them. All the eggs are placed in plain sight — not really hidden at all. For these preschoolers, though, just navigating the space, spotting the eggs, and picking them up is plenty of challenge. There are plenty of eggs, and no pushy big kids to spoil the fun.

- **Level 2 — Ages 6–9 (players)**: These kids enjoy a standard egg hunt over a large area, with eggs hidden in places that are sometimes tricky. There are enough eggs for everyone, but kids still need to move fast and look carefully.

- **Level 3 — Ages 10–13 (elders)**: These older children are given the task of hiding the eggs. They are very proud of this job — they find it challenging and fun, feel honored with the responsibility, and enjoy the status it gives them, compared to the younger kids. They also often enjoy giving hints to the kids who are having trouble.

Community Tip #7: Force Players to Depend on Each Other

Conflict alone cannot create community. The conflict situation must be one where getting aid from other players will help resolve the conflict. Most videogame designers have been conditioned to create games that are playable by a single player

alone, even in a multiplayer game. The logic is something like "We don't want to exclude players who would prefer to play alone." And this is a valid concern. But when you create a game that can be mastered when playing solo, you diminish the value of community. If, on the other hand, you create situations where players must communicate and interact to succeed, you give community real value. This often involves the counter-intuitive step of taking something away from the players. For example, in Toontown Online, our team decided on an unusual rule: players cannot heal themselves during a battle — they can only heal other players. There was a great deal of concern that some players would find the rule frustrating, but after we implemented it, this did not seem to be the case. Instead, it achieved its objectives well. It forced people to communicate ("I need a Toon-up!"), and encouraged them to help each other. And really, people want to help each other — helping another person is a deeply satisfying feeling, even when it is just helping them win a videogame. But we are often shy about helping others, for fear we might insult them with our offer of help. But if you can create situations where players need each others help, and can easily ask for it, others will quickly come to their aid, and your community will be the stronger for it.

Community Tip #8: Manage Your Community

If you believe that community is important to your game experience, you need to do more than just cross your fingers and hope it will happen. You need to create appropriate tools and systems to let your players communicate and organize, and you may need to have professional community managers who build and maintain a strong feedback loop between designers and players. Think of these managers like gardeners. They don't create the communities directly, but they plant the seeds for them and encourage them to grow by observing and catering to their specific needs. This is a role of nurturing, listening, and encouraging, so not surprisingly, many of the best community managers are female. Amy Jo Kim's aforementioned book, *Community Building on the Web*, has some excellent advice about how to carefully manage online communities by striking the right balance between a "hands-on" and "hands-off" approach.

Community Tip #9: Obligation to Others is Powerful

In parts of aboriginal Australia, it is considered rude to give a gift unexpectedly, because doing so creates a burden to give a return gift. This may be a cultural extreme, but obligation to others is something deeply felt in all cultures. If you can create situations where players can make promises to each other ("Let's meet up at 10 p.m. Wednesday to fight some trolls"), or owe each other favors ("That healing spell saved my life! I owe you one!") players will take them seriously. Many *World of Warcraft* players report that obligation to their guild is one of the strongest forces

in getting them to play on a regular basis. This is partly because they want to enjoy high status in the guild, but often there is another reason — avoiding low status. As we've seen with Lens #20: The Lens of Judgment, no one wants to be negatively judged by other players, and failing to live up to commitments is one of the quickest ways to make people think less of you. Carefully designed systems of player-to-player commitment are an excellent way to get players to play your game on a regular basis, and to help build strong community.

Community Tip #10: Create Community Events

Almost all successful communities are anchored by regular events. In the real world, these can be meetings, parties, competitions, practice sessions, or awards ceremonies. And in the virtual world, it's pretty much the same. Events serve many purposes for a community:

- They give players something to look forward to.
- They create a shared experience, which makes players feel more connected to their community.
- They punctuate time, giving players something to remember.
- They are a guarantee of an opportunity to connect with others.
- The knowledge that events are frequent makes players want to keep checking back to find out about which events are coming up.

Players will often create their own events, but why not create some of your own? With an online game, it can be as simple as creating a simple goal for players, and sending a mass email.

Lens #86: The Lens of Community

To make sure your game fosters strong community, ask yourself these questions:

- What conflict is at the heart of my community?
- How does architecture shape my community?
- Does my game support three levels of experience?
- Are there community events?
- Why do players need each other?

The Challenge of Griefing

Griefing is one issue that any community-based game, particularly an online game, has to deal with eventually. For some players, the game itself isn't as enjoyable as teasing, tricking, and torturing the other players. If you remember Bartle's four player types matched to hearts, spades, diamonds, and clubs (Chapter 8), the griefer would be the Joker.

Recalling Lens #80: The Lens of Status, the griefer sees himself as higher status than the other players because of the power he can wield over them by spoiling a game that they care about and he doesn't.

What can a game designer do about griefing? Some games have created "anti-griefing policies" that ban griefers from the game — this is one way to handle the problem, but it creates the ugly situation of having to police griefing, and then having to maintain a "court of law" to decide which griefing was intentional abuse, and which was just "fooling around." A better idea is to avoid game systems that make griefing easy. These are the systems that are easiest for griefers to exploit:

- **Player vs. Player Combat** — Some games, such as first-person shooters, make player vs. player (PvP) combat the heart of the game. But if you are making a game where PvP combat is not the core activity, you should think carefully about why you are supporting it. While it can be exciting, it can also make players feel constantly threatened and never safe. A typical griefer trick in a game with no limits on PvP is to befriend a player, spending just enough time with them to build up some trust, and then unexpectedly kill the player and steal their inventory. You could argue that this is "just part of the game," but generally the griefers aren't doing it for advantage in the game — they are doing it just for the enjoyment of torturing another human being. Ultimately, this creates an environment where players are afraid to talk to strangers — and what kind of community does that leave you with? If you really feel that PvP combat is an important part of your game, you should consider ways to confine it to special areas or circumstances, which makes it difficult to use it as a griefing opportunity.

- **Stealing** — In many games, items give players a great deal of power. Any opportunity to rob others of this power is very attractive to griefers. This could be through pickpocketing or by "looting" a player after battling them. Being stolen from really makes a player feel violated, and as a result, griefers love doing it. Unless you are planning to make a game that is fun for griefers and frustrating for everyone else, you probably don't want to support features that let players steal from each other. Of course, there are other kinds of stealing than just stealing items. Some games have a problem with "kill stealing." In the initial version of *Everquest*, for example, only the player who dealt the final blow against an enemy would get any experience points for it. Griefers would make a habit of standing nearby a battle, waiting for a powerful monster to be nearly defeated, and then sneak in a killing blow, "stealing" all the experience. Again, few players

did this as a valid strategy, but many did it for the joy of griefing. Creating systems that make it difficult for players to seize things that are not rightfully theirs is one way to make griefing difficult.

- **Trading** — If you give players the opportunity to trade items, you set up the possibility of unfair trades. If players have total information about the items they will receive, it is difficult to use the system for griefing. But if there is any way to misrepresent items that you are trying to trade, griefers will pounce and use it as an opportunity to make unfair trades.

- **Obscenities** — One thing griefers enjoy is using shocking and disturbing language in front of other players. If you set up filters for this kind of language, it will become a game for griefers to find ways around your filtering system, and they almost always can, if you are using a "black list" (certain words are forbidden) or "white list" (only certain words are allowed), or any other kind of automated chat filter, because the human mind is so much better at detecting patterns than any machine. The most successful systems for stopping this kind of griefing are ones that use an automated filter combined with a system that lets players report rude behavior. Another good technique to limit obscene griefing comes from using Lens #57: The Lens of Feedback. Keeping in mind that obscenities are a game to the griefer, you can take the fun out of the game by giving them no feedback about whether the obscenity filter worked or not. Simply let them see the obscenity on their side, and filter the message appropriately to the other players. They can still find ways to beat this system, but it is much more work, and much less fun.

- **Blocking the Way** — One of the simplest and most annoying griefing moves is to bar the way so that players can't get where they are trying to go. Solutions to this problem range from making sure the collision system lets players slip past each other, to creating doorways wide enough that they cannot be blocked by a single player, to allowing players to push other players out of the way. In Toontown Online, we chose this last solution. But, even then, the griefers took advantage! Since players could push each other around, it became a popular prank to find an "abandoned avatar," whose player had stepped away from the keyboard, and push them slowly down the street and into a battle!

- **Loopholes** — Possibly the griefer's greatest joy is to find a loophole in a game system that lets them do something that they shouldn't be able to do. If griefers can disconnect during a battle to deny another player a valuable treasure, they will do it. If they can occasionally crash the server by jumping up and down in a corner for two hours, they will do it. If they can arrange furniture in a public place to spell obscene words, they will do it. Anything they can do to vandalize or annoy will make them feel powerful and important, particularly if other players don't know how to do it. You must be ever mindful of these loopholes and careful to remove them whenever they turn up. Dealing with problems like this is part of why making online multiplayer games is such an arduous process.

Lens #87: The Lens of Griefing

To make sure griefing in your game is minimized, ask yourself these questions:

- What systems in my game are easy to grief?
- How can I make my game boring to grief?
- Am I ignoring any loopholes?

The Future of Game Communities

Game communities have been an important part of life on earth for centuries, mostly via sports teams, both professional and amateur. As we transition into the age of the Internet, new kinds of game communities are becoming important as well. In this new age, a person's online identity becomes something important and intensely personal. Choosing an online handle and identity has become an important rite of passage for children and young teenagers. Most people who create these identities will retain them their entire lives. Most people who created a handle twenty years ago still use the same one today, and have no intention of changing it. Combine this with the fact that the most expressive online experience one can have is through multiplayer game worlds, and one can easily imagine a future where players will create avatars for games as young children that become part of their personal and professional lives as they grow older. Just as people today often have lifelong allegiance to a particular sports team, perhaps the guilds players join as children will influence their personal social networks for the rest of their lives. And what will happen to these online identities and social networks when players die? Perhaps they will be memorialized in some kind of online mausoleum, or perhaps our avatars will outlive us, and be passed on to children and grandchildren, giving our future descendants a strange connection to their ancestors. It is an exciting time to be creating online games, for the new kinds of communities we invent may become permanent elements of human culture for centuries to come.

CHAPTER

TWENTY-THREE

The Designer Usually Works with a *Team*

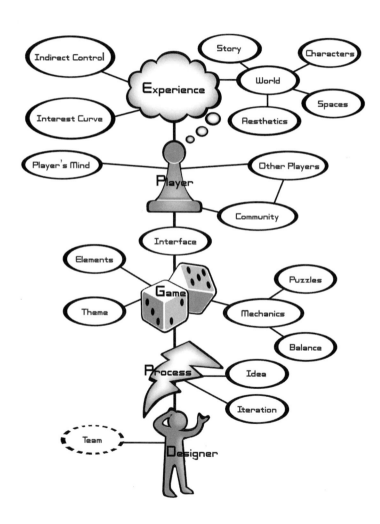

FIGURE
23.1

The Secret of Successful Teamwork

To create a modern videogame, a team of tremendous diversity is required. You need a team of people with a wide variety of artistic, technical, design, and business skills. They generally have very different backgrounds, and value very different things. But if your game is going to be a great one, they will all have to pull together and set aside differences and disagreements to make the game as great as it can be.

And there is a simple secret shared by all teams that have ever successfully collaborated to make something great. It is so simple, that when you hear it, you will likely think I'm not being serious. But this is the most serious thing I will say in this book.

The secret to successful teamwork is love.

No, really.

Now, by this, I don't mean that if the team hold hands, and sings "Kumbaya," that you are going to make a great game. I don't even mean that you have to like the other people on the team, although it wouldn't hurt.

What I mean is that you have to love the game you are making. For if everyone on the team has a deep and true love for the game they are making together, and for the audience they are making it for, all differences and disagreements will be set aside in service of bringing the game into existence and making it be as wonderful as it can possibly be.

Developers lucky enough to have been on a team that truly loves the game they are making will know just what I mean. Everyone on the team feels like children anticipating Christmas when they think about the game getting finished, and they think about that constantly.

Similarly, developers who have been on a team that had some kind of "love deficit" will also know what I mean. There are three main kinds of problems when it comes to team love for their game:

- **Love Problem #1: Team members incapable of loving any game.** Though it is difficult to understand, some people get into the games business even though they have no particular love for games or the people who play them. When someone like this is on your team, it is like carrying deadweight. They often contribute little of use, and constantly waste time arguing with team members who actually love the work. Unfortunately, the team members in charge of management or budget are most likely to have this affliction. Regardless, there is only one cure for a team member with this problem: get them off the team.
- **Love Problem #2: Team members in love with a different game than the one they are making**. This problem comes in many shapes and sizes: A level designer who only loves first-person shooters, forced to work on a role-playing game; an engineer who only loves games with cutting-edge graphics, forced to work on a simple Web-based game; and an artist who loves the work of H. R. Giger, forced to develop a new game featuring the Care Bears. When you find members of your team have this problem, the key is to work with them, to see if there is something

about the current game that they can fall in love with — or perhaps they have some idea for a new feature or element that will take the current game somewhere new and different. On the Pirates game I mentioned in an earlier chapter, we ran into a love problem early on. The animators on the team were eagerly looking forward to animating exciting pirate characters for the game. But as the design proceeded, it became clear that this would be a game about ships — the only people in it would be far away, and so tiny as to be incapable of any meaningful action or emotion. The animators tried to fight this for a while, but gradually realized it was a losing battle, and they clearly began losing their love for the game discussing it in tones of quiet detachment. Several of us on the team saw this as a major problem — we needed the animators to put their heart and souls into making beautiful effects animations, but they seemed so disappointed they wouldn't be able to animate characters, that didn't seem possible. Then, in one meeting, everything changed. One of the animators had a big sheaf of papers. "Look, I've been thinking about this game, and at first I was really bummed that we cut all the characters, but then I started thinking, the stars of this show are the ships — what could I do to make them cool?" He then proceeded to show pages and pages of sketches of how the ships would explode into pieces, how their masts would crack and break and crash into the sea, how their sails would rip and tear and flap when hit with cannonballs — it was truly inspiring to everyone. Immediately, the animators were excitedly competing to see who could come up with the coolest effects. This shift in perspective turned a project they hated into one they loved, and it made a huge difference in game quality.

- **Love Problem #3: Team members in love with different visions of the same game.** This is the most common, and the most challenging, love problem. In this situation, a team is full of people passionate about building a game, but everyone has very different ideas about what the game will be like. The key to avoiding this problem is to get everyone on the same page about what the design is as soon as possible. There will be arguments, and disagreements, but if everyone hears them out, and respectfully considers the ideas that others present, the team can work toward that all important thing — a shared vision of something that all the team members love. But it can only happen with thorough communication and respect. The moment you sense that someone in a meeting doesn't buy into an idea (even if they verbally claim they agree with it), you must stop everything, find out why, and try to find a way to get them on board. If you don't, they may secretly disagree with the direction, and lose their love for the game. And when that happens, the valuable contributions they would have made are lost. No decision should be final until the team agrees that it is final.

If You Can't Love the Game, Love the Audience

Getting others to love the game is part of your responsibility as a designer. But what about that terrible situation when, horror of horrors, you realize that you yourself

do not love the game you are working on? Again, this is not something you can ignore, or hope will remedy itself. Unless you find a way to love your game, the game you create will be mediocre at best, because the insincerity of your contribution will show through. So when your love for your game lapses, you must find a way to restore it. But how?

One way, as mentioned earlier, is to search long and hard, for something in the game that you do love — perhaps it is a moment, or a clever mechanic, or a slick interface. If you can find just one thing that you are excited about, and can be proud of, it can sometimes be enough to make the whole project worthwhile for you — enough to make you love the game and work hard to make the game succeed.

But perhaps you can't find that one thing to love, perhaps because you are not the target audience for the game. In that case, don't think of it as a game for you — think of it as what it really is, a game for the intended audience. Think of a time when you went through a great deal of preparation to give someone you love a special gift. Think how excited you were about seeing the expression on their face when they opened it up and saw it. The anticipation of this moment made you put so much thoughtful energy into the gift choice, the wrapping, and the presentation of it. You carefully designed that moment, because you loved that person, and you wanted to see that moment when they were so happy. And what was it that made them happy? Just the gift? Surely not. What made them so happy was that you loved them so much that you created that special moment just for them. The love you put into that moment shone through, and into their hearts. If you can take that kind of love and put it into the game you are creating for your audience, the love will shine through the game and into the hearts of your audience. The game will feel special to them, as they realize that someone really cared how they would feel when they played the game, and knowing that someone cares about you is a very special feeling. A designer cannot fake this — you must really feel it. As the great magician Henry Thurston once said:

> Long experience has taught me that the crux of my fortunes is whether I can radiate good will toward my audience. There is only one way to do it and that is to feel it. You can fool the eyes and minds of the audience, but you cannot fool their hearts.

If even this does not work for you, if you find that not only do you not love your game, but you have no particular love for your audience, only one thing remains: To pretend. This sounds like an insincere thing to do. Didn't we just say that love cannot be faked? But something strange happens when we pretend to love things — sometimes real love starts to emerge. Have you ever been part of a group that has to do some dreary task together? Perhaps a day of spring cleaning. Everyone is dreading it and moping about it. Then one person says, half-jokingly, "Come on, everybody, this is gonna be awesome! We're going to have so much fun!" Everyone chuckles at the sarcasm, and, just for fun, starts approaching the activity with a pretend "this is going to be awesome" attitude. And just by pretending this, soon the activity does start to become fun — and ironically, everyone starts to love it. If you don't know

how to love something, just ask yourself what kinds of things someone who really loved the game would say and do, and start doing those things. You may be surprised at the transformation that starts to take place within yourself.

Lens #88: The Lens of Love

To use this lens, ask yourself these questions:

- Do I love my project? If not, how can I change that?
- Does everyone on the team love the project? If not, how can that be changed?

Again, I am completely sincere when I say that team love for the game is the most important factor determining whether the team will succeed. Love is not a luxury — it is a necessity if you are to have any hope at all of producing a great game.

Designing Together

If everyone on the team loves the project, that's great! But it gives you a new problem — everyone is going to have opinions about the design! For some designers, this is terrifying — the idea that other members of the team want to contribute design ideas threatens their status as designer, and puts them in a position where they have to argue with others about the "right" design for the game. These designers often choose to withdraw from the team, ignore these opinions, and produce a design completely independent from the rest of the team. The effect is predictable: All the beautiful ideas that each team member had for the game have been crushed, and the love they had for the game dries up and blows away. The designer becomes frustrated with the team because they seem unwilling and unable to realize his glorious vision, and the game, as you might expect, pleases no one.

A much more successful approach is to include the team whenever possible in the design process. If you can set your ego aside, you will quickly realize that most of the people on the team with design ideas don't want to hijack the game design — they just want their ideas to be heard, because they, too, want the game to be great! If you include everyone in the design process, taking every idea and suggestion seriously, you will:

- Have more ideas to choose from
- Weed out flawed ideas quickly
- Be forced to view the game from many perspectives
- Make everyone on the team feel like they own the design

When the whole team participates in the design, your game will be stronger, and everyone will embark on implementation with confidence that they understand the design. This is very important, because not all design decisions get made ahead of time. Hundreds of tiny decisions get made all the time — not by the designer, but by the programmers, artists, and executives working on the game. If all of these people have a solid, shared understanding of the game design, these little decisions will all reinforce the design of the game, and the project will have a unified robustness and solidity that it can't get any other way. It is not uncommon for many different people on a project to feel that their contribution was the most important part of the game — and not unhealthy, either! This just means that many different team members feel personal ownership and responsibility for that game. One great way to amplify this feeling is to avoid "over-fleshing" your designs. If you leave some ambiguity in the detailed design of your game, particularly for parts you aren't sure about, it forces the developers working on that section of the game to think about what that section of the game should be like, and to come up with ideas for how to implement those fine details. Since they are often closest to that part of the game, their instincts about detailed design are often quite good — and if their ideas are good ones, and go into the game, they will feel real pride of ownership of those parts of the game.

Does this mean you have to have everyone involved in the design all the time? Not everyone has the stamina to spend three hours debating the right way to lay out the inventory interface, so for detailed discussions, you will probably want to establish a core design team based on who on the team is both interested and productive at these kinds of sessions. But after this core team has come to consensus about how a design should work, you should inform the rest of the team about these decisions as soon as possible. A typical process looks something like:

1. **Initial Brainstorming**: Involves as much of the team as possible.

2. **Independent Design**: Core design team members think about ideas independently.

3. **Design Discussion**: Core design members bring their independent ideas together to discuss and try to come to consensus on ideas.

4. **Design Presentation**: The core design team presents their progress to the whole team, allowing time for comments and criticism. This often turns into brainstorming, kicking off the next round of the iterative cycle.

It takes both time and energy to involve the whole team in the design, but you will find that it makes the game stronger in the long run, provided your team is able to communicate.

Team Communication

Hundreds of books have been written about how to facilitate good team communication. I'm going to boil it down here to nine key issues that are particularly

pertinent for game design. You might think these things sound basic, and they are — but mastery of the basics is essential for excellence in any field, especially something as complicated as game design by a team. Without further ado, the nine keys to team communication are:

1. **Objectivity**. This one is listed first because it is the most likely to go wrong. In the passionate throes of design ecstasy, it is easy to become attached to an idea that struck you like white lightning from heaven. But if other team members don't like your idea, where are you then? Nowhere, if you are going to fight a war of opinions and gut feelings. The tool that will rescue you is Lens #12: The Lens of the Problem Statement. It can give you the objectivity you need. All team discussion must focus on how well design ideas solve the problems at hand. Personal preferences about these ideas don't matter — all that matters is whether the ideas solve the problem. Don't even talk about the idea as "my idea" or "Sue's idea" — speak objectively: "The spaceship idea." Not only will this separate the ideas from the individuals (giving them over to the team), but it will be clearer, as well. Another nice trick is to phrase alternatives as questions. For example, instead of saying "A is no good. I like B better," simply saying, "What if we did B instead of A?" lets the group collectively discuss the relative merits of B and A. It's a subtle difference, but much about mastering team communication is subtle. If you can develop good habits of objectivity as a designer, everyone will bring you design questions to answer without hesitation, because they know there is no danger of an awkward situation when you "pass judgment" on the design — they will just get honest, objective, useful feedback. Further, people will want to include you in every design session, because by bringing a tone of objectivity to the room, your presence can help defuse tense struggles between people taking a less objective attitude. And best of all, when a team design session has a tone of objectivity, every idea is taken seriously, which means that even shy team members will feel they can speak freely, and many ideas that might have hidden, trembling in the shadows, will confidently come to light.

2. **Clarity**. This one is simple. If communication is not clear, there is going to be confusion. When you explain something, check to see if people understand what you mean. Illustrate your ideas when possible. And if someone else says something that isn't clear, don't *ever* pretend you understand what they are saying. No matter how embarrassed you are, keep asking questions until you understand what they mean. Because if everyone on the design team isn't on the same page, how can there be any meaningful communication? But understanding each other is only half of clarity — the other half is getting concrete and specific. There is a big difference between saying to your producer "I'll design the combat system by Thursday" and "I'll e-mail you a 3–5 page description of the interface for the turn-based combat system by this Thursday at 5 p.m." The first throws wide the door for miscommunication, but the second gives important details about a specific deliverable, leaving little room for misunderstanding.

3. **Persistence**. WRITE THINGS DOWN! There, I said it! Verbal communication is momentary — easily misunderstood and forgotten. Things that are recorded can be checked later by everyone on the team. And you should use every persistent medium that might be useful to you — notebooks, e-mail, forums, mailing lists, fileshares, wikis, printed documents, etc. Make sure someone in every design meeting is taking notes that can be shared with the team. When you do send an e-mail about a design topic, make sure to include everyone on the team. This avoids the danger of people being left out, or even just feeling left out.

4. **Comfort**. I know this one sounds a little silly. What does comfort have to do with communication? Simply this: When people are comfortable, they are less distracted and communicate more freely. Make sure your team has a place to communicate that is quiet, the right temperature, has enough chairs, and has a large writing surface; in short, a place that is physically comfortable. Also, you need to make sure team members aren't hungry, thirsty, or overtired. People who are physically uncomfortable will be terrible communicators. And physical comfort isn't enough — they must also be emotionally comfortable, which leads us to our next item.

5. **Respect**. We have discussed how the secret to being a good designer is to be a good listener. Well, the secret to good listening is to respect the person you are listening to. People who do not feel respected tend to speak little, and when they do speak, they often are not honest about their feelings, for fear they will be judged harshly. People who feel respected speak freely, openly, and honestly. Respecting people is easy, if you can remember to do it. Simply treat them, at every moment, how you would like to be treated. Don't cut them off, or roll your eyes, even if you think what they are saying is foolish. Be polite and patient at all times. Find nice things to say, even if you have to stretch a little. Keep in mind that others are more like you than unlike you — look for things you have in common, for it is easiest to respect people like ourselves. When all else fails, repeat this mantra to yourself: "What if I'm wrong?" If you somehow insult or offend someone, do not rush to defend what you have said. Rush instead to apologize, and do so sincerely. For if you can manage to respect your teammates at all times, they cannot help but respect you. And when everyone feels respected, they will communicate at their best.

6. **Trust**. Respect is impossible without trust — if I can't trust what you say and do, how can I know whether you respect me? Trust is not something that works on faith alone — relationships of trust gradually build up over time. For this reason, quality of communication matters much less than quantity of communication. People who see each other day in and day out, constantly talking, constantly solving problems together, gradually learn how much they can trust each other, and when. A group of people who barely know each other and only meet once a month have no idea who can be trusted with what. This is one area where digital communication isn't good enough — there is something in the nuance of face-to-face communication that allows us to make subconscious decisions

about how and when to trust people. The easiest way to figure out who trusts who on a team is to observe who eats lunch together. Most animals are very selective about who they eat with, and humans are no exception. If the artists eat separately from the programmers, there is a good chance the team has pipeline problems. If the Xbox team eats separately from the Playstation team, there are often porting problems. Give your team every opportunity to be together, and to communicate together, even if it is not about things to do with your project, for the more high-bandwidth communication (about anything!) that your team can have, the more they will learn how to trust each other — this is the reason so few game studios have individual offices, preferring instead to seat teams together in open offices where they can't help but have constant face-to-face communication with one another all day long.

7. **Honesty**. Just as comfort depends on respect, and respect depends on trust, trust depends on honesty. If you have somehow developed a reputation for dishonesty in some area, even if it has nothing to do with game design or development, others will be afraid to be honest with you, which will inhibit team communication. Game development can sometimes get very political, and you will surely have to stretch the truth about some things from time to time — but your team must always feel certain they are getting the truth from you, or team communication will be strained.

8. **Privacy**. Being honest isn't always easy, because sometimes the truth can be painful. And even though we all hope to stay objective in our design work, there are times when personal pride and ego are necessarily tangled up in our work. Talking about these things honestly in a public forum can be difficult or impossible. People will tell you their true feelings in a one-on-one conversation much more easily than in public. Take the time to speak privately with each member of the design team when you can — they will often present ideas, and discuss problems they simply did not feel comfortable discussing publicly. These one-on-one conversations also go a long way to help build trust, as well, creating a virtuous circle: more trust leads to more honest communication, which leads to still more trust, and so on.

9. **Unity**. During the design process, there will be many conflicting opinions and arguments about what is right for the game. This is healthy and natural. Ultimately, though, the team must arrive at a decision everyone agrees upon. Keep in mind that it takes two people to have a disagreement. If one member of the team is stubborn on a particular point, you must treat them with the respect they deserve and work with them until a meaningful compromise can be found. Asking them to explain why this point is so important to them can often make the rest of the team understand why the point is important. When this fails, an excellent question to ask is "What would it take to bring you in?" You may not be able to settle this difference in opinion immediately, but the one thing you cannot do is ignore it. Just as a single cylinder not firing in a car engine cuts performance in half, and ultimately ruins the engine, one team member who

379

does not buy into the design slows the efforts of everyone on the team, and can, in the end, tear the team apart. The final goal of communication is unity.

Lens #89: The Lens of the Team

To make sure your team is operating like a well-oiled machine, ask yourself these questions:

- Is this the right team for this project? Why?
- Is the team communicating objectively?
- Is the team communicating clearly?
- Is the team comfortable with each other?
- Is there an air of trust and respect among the team?
- Is the team ultimately able to unify around decisions?

Game design and development are hard. Unless you are multitalented and your project is tiny, you can't do it alone. People are more important than ideas, because, in the words of Pixar's Ed Catmull, "If you give a good idea to a mediocre group, they'll screw it up. If you give a mediocre idea to a good group, they'll fix it."

You might think that all this team talk has nothing to do with design — that if other people on the team don't do their jobs, it has nothing to do with you as a designer. And that may be true, but it has everything to do with the game that gets created. Since everyone who touches a game exerts some influence on its design, you need everyone on the team to pull together, if the glorious vision you share is ever to come to light.

Now, with all this team communication going on, someone is going to write some documents — and that is the subject of our next chapter.

TWENTY-FOUR

The Team Sometimes Communicates Through *Documents*

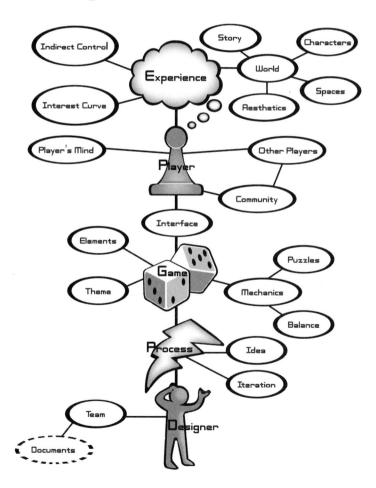

FIGURE
24.1

The Myth of the Game Design Document

Many novice game designers, and other dreamers, have an interesting vision of how the process of game design works. Not being acquainted with the Rule of the Loop, they believe that the process of game design involves a genius game designer sitting down alone at a keyboard and typing out a glorious and perfect Game Design Document. When this masterpiece is complete, all that needs to be done is to hand it to a competent team of programmers and artists and wait for them to turn this shining vision into a reality. "If only," the frustrated would-be designer thinks, "I could find out the proper format for a Game Design Document, I could become a professional game designer too! I'm full of ideas — but without this magic template, there is no way for me to design games."

It is very important for me to be clear about this next point, so I am going to use a very large font. Please listen closely:

The magic template does not exist!

It never has existed, and it never will exist. Does this mean that documents are not a part of game design? No — documents are a very important part of game design. But documents are different for every game, and different for every team. To understand the correct structure of the documents for your game, you must first understand their purpose.

The Purpose of Documents

Game documents have exactly two purposes: **memory** and **communication**.

Memory

Humans have terrible memories. A game design will be full of thousands of important decisions that define how the game works and why. There is a good chance you will not be able to remember them all. When these brilliant ideas are fresh in your mind, you will likely feel that they are impossible to forget. But two weeks, and two hundred design decisions later, it is very easy to forget even the most ingenious of solutions. If you get in the habit of recording your design decisions, it will save you the trouble of having to solve the same problems all over again.

Communication

Even if you are blessed with a perfect memory, though, decisions about the design of your game must be communicated to many other people on the team. Documents are a very effective way to do that. And this communication, as we discussed in

Chapter 23, will not be one-way. It will be a dialog, for as soon as a decision is put on paper, someone will find a problem with it, or come up with a way to make it better. Documents can get more minds on the design faster to more quickly find and fix weaknesses in the game design.

Types of Game Documents

Since the purpose of documents is for memory and communication, the types of documents you will need are defined by what needs to be remembered and what needs to be communicated. It is the rare game where one document serves all necessary purposes — usually it makes sense to create several different kinds of documents. There are six main groups that need to remember and communicate different things, and each generates its own special kind of documents.

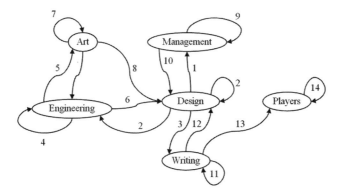

FIGURE

24.2

The figure above shows some possible paths of memory and communication on a game design team. Each arrow could be a document, or more than one document. Let's look at each of the six groups and what documents they might create.

Design

1. **Game Design Overview**. This high-level document might only be a few pages. It is often written primarily for management so that they can understand enough about what this game is, and who it is for, without getting into too much detail. The overview document can be useful for the whole team to get a sense of the big picture of the game.

2. **Detailed Design Document**. This document is the one that describes all the game mechanics and interfaces in great detail. This document usually serves two

purposes: so the designers remember all the little detailed ideas they came up with, and to help communicate those ideas to the engineers who have to code them and the artists who need to make them look nice. Since this document is seldom seen by "outsiders," it is usually a terrible mess with just enough detail to spark discussion and keep important ideas from being forgotten. It is often the thickest of the documents, and is seldom kept up to date. Halfway through the project, it is often abandoned entirely — by that point, the game itself contains most of the important details, and the ones not in there are often exchanged through informal means, such as e-mails or short pages of notes.

3. **Story Overview**. Many games call for professional writers who will create dialog and narration for the game. These writers are often contracted, and often far away from the rest of the team. The game designers often find it necessary to create a short document that describes the important settings, characters, and actions that will take place in the game. Frequently, the writers respond to this with interesting new ideas that change the whole game design.

Engineering

4. **Technical Design Document**. Often, a videogame has many complex systems that have nothing to do with game mechanics and everything to do with getting things to appear on the screen, sending data over networks, and other crunchy technical tasks. Usually, no one outside the engineering team cares much about these details, but if the engineering team is more than one person, it often makes sense to record these details in a document so that when others join the team they can understand how the whole thing is supposed to work. Like the Detailed Design Document, it is rare for this to stay up to date more than half-way through a project, but writing this document is often essential to getting the necessary systems architected and the coding underway.

5. **Pipeline Overview**. Much of the challenging work of engineering a videogame comes from properly integrating art assets into the game. There are often special "do's and don'ts" the artists must adhere to, if the art is to appear properly in the game. This brief document is usually generated by the engineers explicitly for the art team, and the simpler it is, the better.

6. **System Limitations**. Designers and artists are often completely unaware of what is and is not possible on the system they are designing for (or so they pretend). For some games, the engineers find it useful to create documents that make clear certain limits that should not be crossed — number of polygons on the screen at once, number of update messages sent per second, number of simultaneous explosions on screen at once, etc. Often this information is not so cut and dried, but trying to establish it (and get it in writing) can save a lot of time later — and it can help foster discussions about creative solutions to get past these limits.

7. **Art Bible.** If several artists are going to work together on a title to create a single, consistent look and feel, they must have some guidelines to help maintain this consistency. An "art bible" is simply a document that provides these guidelines. These might be character sheets, examples of environments, examples of color usage, examples of interface, or anything else that defines the look of any element in the game.

8. **Concept Art Overview.** There are many people on the team that need to understand what the game is going to look like before it is built. This is the job of concept art. The art alone doesn't usually tell the story, though — it often makes the most sense in a design document, so often the art team works with the design team to come up with a set of images that show how they will look and feel in the context of the game design. These early images end up everywhere — in the Game Design Overview, in the Detailed Design Document, and sometimes even in technical documents, to illustrate the type of look that the technology is striving to achieve.

Management

9. **Game Budget.** While we would all like to just "work on the game until it is done," the economic realities of the game business seldom allow this. Usually, the team is required to come up with a cost to develop the game before they completely understand what they are building. This cost is usually arrived at through a document, usually a spreadsheet, that attempts to list all the work that needs to be done to complete the game, complete with time estimates which translate into dollars. It is impossible for the producer or project manager to come up with these numbers on their own, so they generally work closely with every part of the team to make the estimates as accurate as possible. Often this document is one of the first created, since it is used to help secure the funding for the project. A good project manager will continue to evolve this document throughout the project to ensure that the project does not go over the budget it has been allocated.

10. **Project Schedule.** On a well-run project, this document will be the one most frequently updated. We know the process of game design and development is rife with surprises and unexpected changes. Nevertheless, some kind of planning is necessary, ideally planning that can change on a weekly basis at the least. A good project schedule document lists all the tasks that need to be accomplished, how long each will take, when each task must be completed, and who will do them. Hopefully, this document will take into account the fact that a single person shouldn't do more than 40 hours in a week, and the fact that some tasks can't be started until others are completed. Sometimes this schedule is kept on a spreadsheet, and other times on more formal project management software. Keeping this document up to date can easily be a full-time job on a medium-sized or larger game.

Writing

11. **Story Bible.** While one might think that the story of the game might be determined entirely by the writers (if any) on the project, it is often the case that everyone on the project contributes meaningful changes to the story. The engine programmers might realize that a certain story element is going to be too much of a technical challenge, and they might propose a story change. The artists might have a visual idea for a whole new part of the story that the writers never imagined. The game designers might have some ideas for gameplay concepts that require story changes. A story bible that lays down the law about what is and is not possible in this story world makes it much easier for everyone on the team to contribute story ideas, and ultimately this makes for a stronger story world that is well-integrated with art, technology, and gameplay.

12. **Script.** If the NPCs in the game are going to talk, their dialog has to come from somewhere! This dialog is often written in a script document that is either separate from, or an appendix to, the detailed design document. It is crucial that the game designers review all of the dialog, since it is all too easy for a line of dialog to be inconsistent with a rule of gameplay.

13. **Game Tutorial and Manual.** Videogames are complex, and the players have to learn how to play them somehow. In-game tutorials, Web pages, and printed manuals are how this usually happens. The text that goes into these is important — if players can't understand your game, how can they enjoy it? The details of your game design will likely continue to change up until the last minute of development, so it is important to be sure someone is continually checking this text to make sure it is still accurate with the game implementation.

Players

14. **Game Walkthrough.** The developers aren't the only ones who make documents about the game! If players like a game, they are going to write their own documents about it and post them online. Studying what your players write about your game can be a great way to find out, in detail, what players like and dislike about your game, which parts are too hard, and which are too easy. By the time a player walkthrough is written, of course, it is often too late to change your game — but at least you'll know for next time!

Again, these documents are not a magic template — there is no magic template! Each game is different, and will have different needs in terms of both memory and communication that you will have to discover for yourself.

So, Where Do I Start?

You start simply, just like you did when you started designing your game. Start with a document that is a rough bullet list of the ideas you want to include in your game. As the list grows, questions will arise in your mind about the design — these questions are crucial! Write them down so you don't forget them! "Working on your design" will mostly mean answering these questions, so you don't want to lose the questions. Each time you answer a question to your satisfaction, make a note of the decision, and why you made it. Gradually, your list of ideas, plans, questions, and answers will grow and start to fall naturally into sections. Keep writing down the things you need to remember, and the things you need to communicate. Before you know it, you will have a design document — not one based on a magic template, but one that grew organically around the unique design of your unique game.

Lens #90: The Lens of Documentation

To ensure you are writing the documents you need, and skipping the ones you don't, ask yourself these questions:

- What do we need to remember while making this game?

- What needs to be communicated while making this game?

CHAPTER TWENTY-FIVE

Good Games Are Created Through *Playtesting*

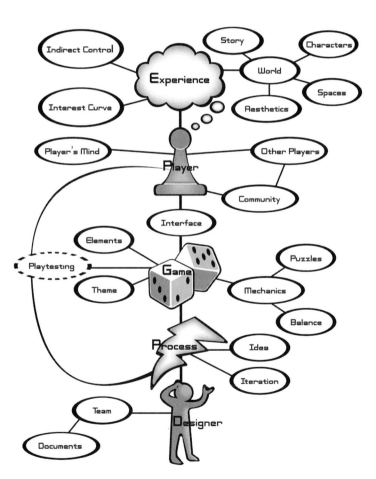

FIGURE
25.1

Playtesting

FIGURE
25.2

It is easy, when developing a game, to fantasize about the player experience and to imagine how great it will be. Playtesting is necessary to serve as a wakeup call and force you to solve the ugly problems you've been putting off. Before we get too deep into this discussion, I want to draw the distinction between four different types of testing: focus groups, QA testing, usability testing, and playtesting.

- **Focus Groups**: This is a term that often causes professional designers to wince. It refers to sessions where potential players are interviewed about their likes and dislikes, often in an attempt to determine whether they like a game idea that a company is considering. Focus groups can be quite useful in the right context (particularly when deciding the relative priority of well-defined features), but they have a bad name because they are so often poorly run and manipulated to kill ideas that management is afraid of.

- **QA Testing**: QA is "Quality Assurance." This testing has *nothing* to do with how enjoyable the game is, and everything to do with looking for bugs.

- **Usability Testing**: This is all about determining whether your interface and systems are intuitive and easy to use. Both of these are necessary for an enjoyable game, but they are not enough. Keep this in mind when someone suggests bringing in a usability expert to make your game more fun.

- **Playtesting**: Separate from the previous three, playtesting is all about getting people to come play your game to see if it engenders the experience for which it was designed. And while the other three types of testing are useful and important,

in this chapter we will focus only on the type of testing designers care about the most, playtesting.

My Terrible Secret

I'm going to admit something now that is profoundly embarrassing. For years I have tried to pretend that it isn't the case, but there is no getting around it. I don't like talking about it, because it makes me a hypocrite, and calls my qualifications as a game designer into serious question.

However, my goal with this book is to help lay out how game design really is, not some idyllic dream version of how it should be. So, here goes. Please try not to judge me too harshly.

I *hate* playtesting.

Does playtesting find problems early, while there is still time to fix them? Yes. Does playtesting build the team's confidence that they are making the right game for the right audience? Yes. Is playtesting essential to making a good game? Yes. Does playtesting fill me with a terror so intense that I can't even think straight? Yes, yes, yes!

It's completely humiliating. I *know* that playtesting is good for my game. Not just good, *necessary*. But when it comes to actually *doing* the playtesting, I find every excuse possible to avoid it. First I delay getting the playtesting organized. When it eventually gets organized, I make excuses why I can't be there. When I actually am there, I find reasons not to observe it directly, getting distracted with anything else that might be nearby. I'm well aware of these tendencies, and I fight them tooth and nail, but still, my fear of playtesting remains.

Why? What am I so afraid of? It's simple. I'm afraid that people won't like my game. I should be above that, I know. But I'm not. When you make a game, you try to put everything you can into it: heart, soul, dreams, blood, sweat, and tears. A game you work hard on becomes a little piece of yourself. To have people engage with that, and then reject it, well, it hurts. A lot. And don't kid yourself — *it is going to happen*.

Having people hate your work is probably one of the most painful parts of being a game designer. And playtesting is like an engraved invitation that reads:

You are cordially invited

to tell me why I suck

Bring a friend – Refreshments Served

Does playtesting have to be so uncomfortable? It does. The whole point of playtesting is to make clear to you that some of the decisions you were completely comfortable with are completely wrong. You need to find these things out as soon as possible, while there is still time to do something about them.

Maybe playtesting comes naturally to you. Maybe you have no fear of people ridiculing your work. If so, congratulations! Your objective viewpoint will be a great boon to you during playtesting sessions. But if you fear and loathe these sessions, like I do, there is only one thing to do: Get over it. People are either going to like your game, or they aren't. If they do, great. If they don't, also great! You have a chance to ask them why they don't like it, so you can fix it. Let go of your fears, and embrace playtesting for what it is: a wonderful opportunity to make your game better.

Every playtest is defined by five key questions: Why, Who, Where, What, and How?

Playtest Question the First: Why?

Do you remember how, in Chapter 7, we discussed how every prototype is designed to answer a question? A playtest is a kind of prototype — not a prototype of the game, but a prototype of the *game experience* (which is what we care about the most!). If you don't enter into your playtest with specific goals in mind, you stand a good chance of wasting your time. The more specific the questions you have when you organize the playtest, the more you will get out of it.

There are millions of questions you might want your playtest to answer. The most obvious one — "Is my game fun?" — is not enough. Generally, you want your questions to be as specific as possible. Examples follow — some general, some specific.

- Do men and women play my game differently?
- Do kids like my game better than adults?
- Do players understand how to play?
- Do players want to play a second time? A third time? A twentieth time? Why?
- Do players feel the game is fair?
- Are players ever bored?
- Are players ever confused?
- Are players ever frustrated?
- Are there any dominant strategies or loopholes?
- Does the game have hidden bugs?
- What strategies do players find on their own?
- Which parts of the game are the most fun?
- Which parts of the game are the least fun?
- Should the "A" button or "B" button be used for jumping?
- Is level three too long?
- Is the asparagus puzzle too hard?

And many others. These are just a few ideas to get you thinking. I often find that using the lenses throughout this book is a great way to come up with good playtesting questions.

Preparing a list of the questions you would like the playtest to answer is a great first step to planning a playtest, because until you have determined the "why," as in "why are we having this playtest?" there is no way to answer the who, where, what, and how.

Playtest Question the Second: Who?

Once you know why you are having a playtest, you can decide who you should be testing. And who you pick is entirely determined by what you would like to learn. Most likely, you want to pick people who are in your target demographic. But even then, there are choices. Here are some common ones:

1. **Developers**. The first people who will get a chance to try your game are the developers, so I'm listing them first.

 - *Pros*: The developers are right there! They can play the game a lot, and for a long time, and give lots of meaningful, thoughtful feedback. Also, you don't need to worry about them filling out non-disclosure agreements (NDAs), since they already know all the confidential information about the game.

 - *Cons*: The developers are too close to the game — closer than any real player ever will be, and this will distort their opinions about the game. Some "design experts" will tell you that it is dangerous to playtest with people who work on the game, and that you shouldn't do it. This extreme position means, though, that you could miss out on some valuable insights. Better to playtest the developers but take what they say with a grain of salt.

2. **Friends**. The next people to try the game will most likely be friends and families of the developers.

 - *Pros*: Friends and families are highly available and comfortable talking to you. If they think of a good idea after the playtest is over, you'll probably still get to hear it.

 - *Cons*: Your friends and family don't want to hurt your feelings — after all, they have to deal with you on a regular basis. This might cause them to bend the truth when they don't like something. Also, since they like you already, they are going to be predisposed to like the game — they will be *trying* to like it, which isn't what will happen in the real world.

2. **Expert Gamers**. Every genre has its "experts" — hardcore players who have played every variety of the type of game you are making. These guys love coming to playtest games still in progress, because it gives their "expert" credentials a boost!

- *Pros*: Having played many, if not all, of the games that are similar to the one you are making, these expert gamers can give you a detailed account, using technical terminology and specific examples, of how your game compares to games that are like it.

- *Cons*: Just as only a small percentage of the eating public are gourmands, only a small percentage of the gaming public are, uh, "ludophiles." Expert gamers are often more jaded and demand more complex and difficult game-play challenges than the average gamer. Many a game has been spoiled by overtuning it for the elite tastes of a niche audience of hardcore enthusiasts.

3. **Tissue Testers**. Ideal testing conditions often include people who have never seen your game before. The industry likes to call them "fresh meat," or "tissue testers" (a reference to the fact that, like a Kleenex tissue, they can only be used once).

- *Pros*: People who have never seen your game before see it with fresh eyes and will notice the things that you have gotten used to. For testing that tries to determine usability questions, communication questions, or questions of "initial appeal," these testers can be very valuable.

- *Cons*: Games are generally played multiple times, over many sessions. If you only test your game with "tissue testers," you run the risk of making a game that has strong first-time appeal, but gets boring after multiple plays.

Again, who you test with will depend entirely on what you are trying to learn. Matching the testers to the questions you are trying to answer is the only way to get meaningful results. Nearly every game will test with some combination of the above testers sometime during the design process — the key is having the right testers at the right times to answer the most questions as thoroughly as possible.

Playtest Question the Third: Where?

This question might seem innocuous, but a lot rests on exactly where you have your playtest. Some different options:

1. **In your studio**: (or whatever you call the place you actually make the games).

- *Pros*: The developers are all there. You are there. The game is there! So, testing in your studio can be super convenient for you. Also, it gives everyone on the team a chance to observe the game being played by real people.

- *Cons*: The playtesters you bring in might not feel completely comfortable. They will be in strange surroundings, and unless they have some kind of private room, they are likely to be afraid to have fun while others are working.

If you host a playtest in your studio, you should go out of your way to make it as comfortable as possible. The last thing you want is playtesters who are afraid to make noise, have fun, and speak their minds. Asking the testers to bring friends helps.

2. **In a playtesting lab:** Some (though, actually, surprisingly few) large game companies have special labs set aside for playtesting. Also, some third-party companies will playtest your game for you in special labs designed for the purpose.

 - *Pros*: The lab is designed for playtesting! It probably has all the things you could wish for: one-way mirrors, cameras on the playtesters, playtesting experts to ask the right questions and take detailed notes, and maybe even a carefully selected group of the right testers!

 - *Cons*: This kind of thing is usually very expensive. But if you can afford it, it may well be worth the investment.

3. **At some public venue:** Could be a shopping mall, an event on a college campus, some kind of fair, or a table on a street corner.

 - *Pros*: It usually doesn't cost much, and you will get a chance to get many testers, if you find the right venue.

 - *Cons*: You may have a hard time finding the "right" testers; that is, ones in your demographic. Also, if there are other things going on in this venue, testers may be distracted, not giving you their full attention.

4. **At the playtester's home:** After people buy your game, they are going to play it in their homes — why not let them play it there now?

 - *Pros*: You have a good chance of seeing your game played in its natural habitat, under real conditions. Your testers are likely to have their friends over, and you stand a chance of seeing real social interaction through your game.

 - *Cons*: Your playtest might be kind of limited. Probably only one or two designers can be there to observe, and you may only be able to test with a small number of people during a given session. You may also need to lug special hardware with you, or at least spend time configuring machines to run your prototype software.

5. **On the Internet:** Why restrict your playtesting to the confines of meatspace?

 - *Pros*: Lots of people will be able to test your game on machines with many different configurations. If the questions you need to answer involve stress testing your game or learning about massively multiplayer play, this may be your best option.

 - *Cons*: Quantity of playtesting comes at the price of quality of playtesting. Though many people may be playing, you won't get the same level of insight when you aren't in the same room with the testers. Also, if you are trying to keep your game a secret, this may be hard to do when you make it available for download.

Where exactly you choose to test depends completely on the questions your test is trying to answer. Choose your test location with your important "why?" questions in mind.

Playtest Question the Fourth: What?

By "What?" I mean "What will you look for in your playtest?" There are two types of things to look for.

The First What: Things You Know You Are Looking For

These come from the questions in your "why?" list. Hopefully, you are going to design your playtest so that you can look for answers to these questions (that's why you listed them!). As you plan your test, make sure that you have a way to get some kind of answer to every question on your list. If there are parts of your game that aren't relevant to these questions, consider making a special version of the game that skips these parts to save time. If the questions can't all be answered by a single test, consider making several mini-tests that will cover the span of things you need to find out.

The Second What: Things You Don't Know You Are Looking For

Anyone can find things they know they are looking for — but only a truly observant designer, who has learned to listen deeply to players, can find the things they don't know they are looking for. The key is to keep your eyes open for *surprises*. To be surprised at a playtest, you must already have ideas about what will happen: players will attack level two a certain way, they will get excited at the start of level three, etc. Whenever anything out of the ordinary happens, good or bad, be ready to jump on it, and find a way to understand it. Do girls like your game more than boys, when you expected the opposite? Does your villain make people laugh when you thought he would be scary? Are players intrigued by something you thought was unimportant? Are they debating strategies you never considered? Find out why! Even if you weren't testing for these things, take advantage of this opportunity to learn the truth about everything you thought you already understood. The insight that comes from understanding these surprises is the sweetest fruit that grows on the playtesting tree.

Playtest Question the Fifth: How?

So — you've figured out why you want to have a playtest, who you will observe, where you will hold it, and even what you are going to look for. Those are great

preliminaries, but the rubber doesn't meet the road until you decide *how* you are going to go about it.

Should You Even Be There?

There is a school of thought that believes it is dangerous to have the developers of a game present when it is tested. The danger is that their emotional investment in the game will cause them to encourage the players to overlook flaws and "infect" the players with an insider's viewpoint. And this danger is very real. If you cannot stay objective during the playtest, and properly police your behavior so that playtesters can remain "pure," you definitely should not be there. If that is the case, it is a shame, because there is so much more you will learn by being present in person at a playtest than you can get from just reading survey data or watching recorded videos. So, though some design theorists might disagree, my advice is to find ways to restrain these corrupting impulses so you can be there in person.

What Do You Tell Them Up Front?

For some tests, you won't tell the players anything at all — you'll let the game speak for itself, particularly if you want to see if they can figure it out by themselves. But for the majority of playtests, you will need to tell players something to get them started. Use extreme caution when you do so — a few misplaced words right before play begins can spoil the entire test. If for example, you tell players that their goal is to defeat the evil Chronos, some players might start looking for him right away, and in doing so, miss out on important details they would have found if you hadn't said that. For this reason, you should take careful note of what you say to testers at the beginning, in case it has unexpected consequences. It can be a good idea to write it down ahead of time, so you can be sure you have prepped all the testers the same way.

Of course, you may find, over the course of several tests, a need to change your introductory speech to clarify certain things. And here is one of the great side benefits of playtesting. When you run multiple playtest sessions in sequence, you will find yourself gradually tuning the instructions you give to the players, trimming a word here, adding a phrase there, until you have a speech that is very clear and very efficient. Write this down! This speech can become the foundation of your in-game tutorial. Many game tutorials are terrible — ones created by this method are likely to have an aura of excellence about them. Having an in-game tutorial that really makes players feel welcome and cared for is a great first impression for your game to make.

Where Do You Look?

Most people who attend a playtest tend to look where the player looks. If it is a videogame, this means at the screen. This makes sense, because this way you see what

the player sees. But it isn't where I look. I spend most of my time during a playtest looking at the players' faces. Sure, I steal quick glances at the screen for context, but mostly, I watch faces, because I don't just want to see what the players are doing, but *how they feel when they are doing it*. Their facial expressions give a wealth of data about the game that will never come out in post-game interviews or survey questions.

I learned to do this when I was a street performer. When you do street shows, the only money you get is what you collect by passing the hat at the end. So, if you want to have dinner that night, it becomes crucial to ensure the crowd you've scared up stays entertained. With practice, I soon found I could "read" the emotions of a crowd quickly, and would tune my performance appropriately — stretching out parts they enjoyed, and moving quickly through parts that bored them. I was quite surprised, when I started making videogames, to find myself reading the emotions of the players as they played and determining how the game should change to improve the quality of the players' emotional experiences. This is something that we are all equipped to do — it just has to be practiced.

Of course, it would be best if our eyes could be everywhere at once: on the game, on the players' faces, and even on their hands, to see if they are using the controls as we would expect. And with modern video technology, you can see it all! Getting a few different cameras set up to feed to a single split-screen image can be a great way to record the game, face, and hands at the same time, so you can go back later and see how all three of these things interrelate.

What Other Data Should You Collect During Play?

Watching with your own eyes and recording video of a play session can give you a lot of useful information, but there is other information you can gather as well. With a little planning, you can find ways to keep logs of important game events during each play session. If your game is digital, you can log all this automatically, but if your game is not, you can just make careful notes when these important events occur. What constitutes an "important event" will vary from game to game of course. Some examples of data you might want to collect:

- How long did players spend in the character creator?
- How many hits did it take to defeat the villain?
- What was the average player score?
- Which weapons were used the most?

The more your game can collect this data automatically, the more useful the data will be to you. Some designers of massively multiplayer games are constantly "data mining" the event logs to look for problems and interesting patterns of gameplay. This new kind of "digital listening" is a subtle art that gives you new opportunities to understand player behavior.

Will I Disturb the Players Mid-Game?

This is a delicate question. When you disturb players mid-game, perhaps to ask them a question about what they are doing, you run the risk of interfering with their natural play patterns. On the other hand, asking the right question at the right moment may give you an insight you would not have had any other way. You might argue that it is best to just make a note of the question you have in mind, and ask the player about it when the play session is over. But by that time, the player is in a different state of mind, and may have no recollection of what you are talking about. It is a difficult trade-off. Most designers seem to favor only interrupting when the player is doing something truly surprising that the designer does not understand.

Experts in human computer interaction often recommend the "think-aloud proto-col" to learn the decision-making process of people interacting with software products. The idea is that you encourage the person using the software to verbalize all their internal thoughts into a kind of stream-of-consciousness ramble. With a game, this might sound something like: "Let's see... I'm supposed to find bananas, but I don't see any... I wonder what's behind that log... Yow! Bad guys! Ouch! Take that! Okay... Hey, is that a banana up on that hill?" etc. With games, this can be tricky. For some people, the act of speaking their thoughts changes the way they behave — often their behavior becomes more thoughtful and careful, so the think-aloud protocol can taint play patterns. Other people become paralyzed trying to play and talk at the same time, and when the gameplay gets stressful, they often stop talking altogether, which is frustrating, because these stressful moments are often when a designer needs the most insight into what a player is thinking. However, for some players, thinking aloud comes very naturally, and can provide very useful information — the trick is identifying these players. I have seen well-meaning inter-action experts completely ruin playtests by constantly peppering players with questions during play in an attempt to elicit think-aloud. When and whether to use this technique is something you will need to decide for yourself.

What Data Will I Collect After the Play Session?

You will gain a tremendous amount of information just by observing players inter-acting with your game. But you can gain even more with meaningful follow-up questions with interviews and surveys. But which should you choose?

Surveys

Surveys are a great way to have players answer straightforward questions about your game that are easily quantified. Some tips for getting the most out of surveys:

- **Use pictures whenever possible**, when asking about game elements or scenes, to help ensure the player knows what you mean.

399

- **Online surveys can save you (and your playtesters) a lot of time**. Systems like "Surveymonkey" are easy to set up and very inexpensive.

- **Don't ask people to rate things on a scale from 1 to 10**. You will get more consistent results if you use a five-point scale, where each of the points is clearly labeled such as:

 1. Terrible
 2. Pretty bad
 3. So-so
 4. Good
 5. Excellent

- **Don't put too many questions on your survey**, or people will start to tune out near the end, and your results won't be worth much.

- **Give them the survey right after they have played**, while things are fresh in their mind.

- **Have someone on hand to answer clarifying questions** that the testers might have about the survey.

- **Note the age and gender of each playtester surveyed**, so you can see if these have a connection to player opinions.

- **Don't take survey data as gospel**. It is unlikely that your survey is truly scientific, and playtesters tend to make things up when they aren't sure.

Interviews

A post-game interview is a great way to ask players questions too complex for a simple survey sheet. It's also a way to get a sense of how they really felt about the game, since you can see emotion in their faces and hear it in their voices. Here are some interview tips:

- **Have a script of questions** ready when you interview people. Leave space so you can write down their responses. Also leave space for general notes when the conversation takes unexpected turns (in other words, be ready for surprises!).

- **Interview people privately**, when possible. People will speak more honestly in a one-on-one situation than in a case where others (particularly people they know) are listening in. If the tester has other friends who are testing, consider doing a group interview *only after* the private interview is done, to see if new information comes out when the close friends are talking to each other.

- **Playtesters will avoid hurting your feelings**, particularly if they know (or think) you helped make the game. Sometimes, staying objective is not enough.

I sometimes make a big show of saying "I need your help. This game has some real problems, but we're not sure what they are. Please, if there is anything at all you don't like about this game, it will be a great help to me if you let me know." This gives a tester permission to speak honestly about their likes and dislikes.

- **Avoid memory tests**. Asking players questions like "On level three, when you got to the yellow butterflies, you flew left instead of right. Why?" will generally get you blank stares. Players are so busy playing the game, they don't always form memories about things that are not immediately relevant to the goal of the game. If you need answers to questions like that, you should ask them while the game is being played.

- **Don't expect playtesters to be game designers**. Questions like "Would the game have been better if level three was harder?" may not get the results you want. In general, players always think they want the game to be easier, so they are likely to say "no" to that question. Most playtesters are not skilled at thinking about and discussing game mechanics. A better way to ask the same thing would be "were any parts of level three boring?," which will probably get you an honest answer and the information you are looking for.

- **Ask for more than you need**. Instead of asking "what was your least favorite part?" why not ask "what were your three least favorite parts?" You'll get more data, and it will be sorted by priority… the thing that stands out most in a player's mind will come first.

- **Set your ego aside**. It can be very hard to sit and listen to someone tell you how bad your game is. You will be sorely tempted to step in and defend your game and tell them how it is supposed to be. Resist this urge. No one cares how the game was supposed to be during this interview. Right now, all that matters is how this playtester feels about the game, and why. When you feel the temptation rise within you, steel yourself, and ask objective questions like "what don't you like about it?" and "Can you tell me more about that?"

Lens #91: The Lens of Playtesting

Playtesting is your chance to see your game in action. To ensure your playtests are as good as they can be, ask yourself these questions:

- **Why** are we doing a playtest?
- **Who** should be there?
- **Where** should we hold it?
- **What** will we look for?
- **How** will we get the information we need?

TWENTY-SIX

The Team Builds a Game with *Technology*

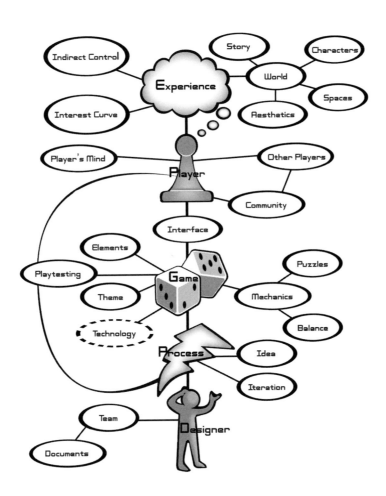

FIGURE
26.1

Tom was making a drawing when Samuel came in. Samuel looked at the drawing. "What is that?"

"I'm trying to work out a gate opener, so a man won't have to get out of his rig. Here's the pull rod to open the latch."

"What's going to open it?"

"I figured a strong spring."

Samuel studied the drawing. "Then, what's going to close it?"

"This bar here. It would slip to this spring, and give tension the other way."

"I see. It might work, too, if the gate was truly hung. And it would only take twice as much time to make and keep up as twenty years of getting out of the rig to open the gate."

Tom protested, "Sometimes with a skittish horse..."

"I know," said his father. "but the main reason is that it's fun."

Tom grinned. "Caught me," he said.

– John Steinbeck, *East of Eden*

Technology, At Last

It may seem strange, in a book that is ostensibly meant to instruct about the design of videogames, to wait until so near the end to talk about technology. But there is a reason. Technology looms large in the lives of game designers. And just as it is hard to study the stars when the sun is out, it is hard to study game design when technology is in the room. Technology is ever novel, ever surprising, and ever presents new puzzles to solve. Of the four elements in the tetrad (technology, story, aesthetics, and mechanics), technology is the most dynamic, most volatile, and most unpredictable. It's like having a drunken billionaire show up at your party — all eyes are on him because no one knows what he might do. Well, at long last it is time for us to plunge into the sun, to introduce ourselves to this drunken billionaire.

So, what is technology, anyway? Do we just mean computers and electronics? No... we mean something much broader. For a game designer, "technology" means the very medium of our game — the physical objects that make it possible. For Monopoly, the technology is a board, slips of paper, tokens, and dice. For hopscotch, it is a piece of chalk and a sidewalk. For Tetris, it is a computer, a screen, and a simple input device. Saying that technology is just the physical things our game is made of might seem obvious, but this idea has deep implications, because of how technology advances at such a rapid rate. Consider how many physical things have been invented since you were born. Ten thousand? A hundred thousand? A million? There are so many, it is hard to say for sure. But many of these new inventions can be used to make new kinds of games. And this is important because the quest of the game designer is forever a quest for the new. As we've said before, people buy new games because they are new. Because of this pressure for novelty, and the

sexiness of new technology, it can be easy to get swept away in the possibilities of what technology can do and forget that our purpose is to create a great game.

Keeping your head about this, and not getting drunk along with the billionaire, can be a challenge for some people. Engineers, in particular, have a natural love of technology and are especially prone to its siren song. Walt Disney had very strong feelings about this, and in the landmark book, *The Illusion of Life*, animators Frank Thomas and Ollie Johnson relate that:

> For some reason, [Walt] had a distrust of engineers as men who designed primarily for themselves without regard to the intended use of the product, and he refused to have anyone on the staff with the title, "Engineer."

This is an extreme position, of course, but it underlines the importance of keeping a level head about the place of technology in the experience on you are creating.

Foundational vs. Decorational

One of the most concrete ways to keep a sane perspective about technology is to understand the difference between *foundational* and *decorational* technologies. Foundational technologies are the ones that make a new kind of experience possible. Decorational technologies just make existing experiences better. I find that this illustration helps to make it clear:

FIGURE
26.2

The cake part of the cupcake is foundational technology. Without it, there couldn't be a cupcake. The cherry and the icing are decorational technology. Adding them doesn't make something fundamentally new, it just makes something old a little nicer. Perhaps some examples from entertainment and games will help make this even clearer.

Mickey's First Cartoon

A common trivia question often pops up on quiz shows: "What was Mickey Mouse's first cartoon?" And most of us know the answer: *Steamboat Willie*. And most of us, it turns out, are wrong. *Steamboat Willie* was predated by *Plane Crazy*, another Mickey cartoon that was released six months earlier. What was so remarkable about *Steamboat Willie* that it is universally remembered as Mickey's premiere? Technology. Specifically, *Steamboat Willie* was the first cartoon to feature synchronized sound. And the sound was not decorational — the entire cartoon was designed around having a synchronized soundtrack. The storyline in *Steamboat Willie* primarily features Mickey and Minnie playing various farm animals as if they were musical instruments. It was cute, clever, and catchy, and without synchronized sound, would have made no sense whatever. The technology was foundational to the experience the cartoon created. Later, synchronized sound was added to *Plane Crazy*, but it was decorational: the sounds of growling airplane engines did little to change the fundamental experience of the cartoon.

Abalone

FIGURE
26.3

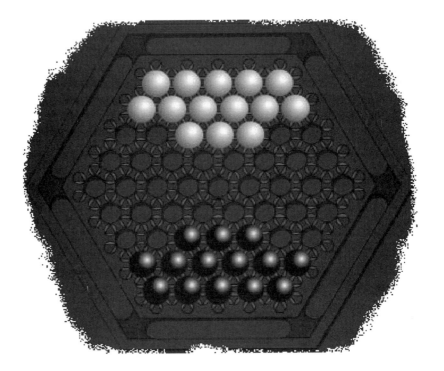

A low-tech example of an interesting foundational technology can be seen in Abalone, a board game invented in 1987 by Laurent Levi and Michel Lalet. The game board looks like the familiar game of Chinese Checkers, but it has an important difference: grooves between the holes make it possible to grab one marble, and push it so that it pushes a whole row of other marbles along the grooves, so they "clunk" into the next holes. Most head-to-head games like this feature game mechanics based on capturing an opponent's piece by landing on it, or by jumping over it. Levi and Lalet realized that a board that allowed for pushing could feature a brand new mechanic, and so they designed a game where you capture a piece by shoving it off the board. The grooves were not a complicated technology, but they served as the foundation for a game experience that was completely new.

Sonic the Hedgehog

The *Sonic the Hedgehog* and *Sonic the Hedgehog 2* games for the Sega Genesis were powerful examples of foundational technology. Sega knew that one of the key differentiators between the Sega Genesis console, and the competition, Super Nintendo, was that Sega's system had an architecture that supported incredibly fast scrolling. The Sonic games (especially Sonic 2 with its lightning fast spin-dash) were designed expressly to exploit this ability. Players had never before played a game that featured such incredibly fast movement, and this is part of what made the games feel exciting and new.

Myst

It is hard today to comprehend how successful *Myst* was in the marketplace. It was the top selling PC game *every month* for five consecutive years. Yow. Anyway, this success came because of a mix of foundational and decorational technologies. The first technology was decorational: gorgeous 3D artwork. At the time (1993) computer-generated 3D artwork was something of a novelty. It had a look that was otherworldly and new. But to deliver these pretty pictures in a game required a more foundational technology: the CD-ROM drive. Before the CD-ROM, the detail of imagery in games was mostly limited to pixel art. The CD-ROM made possible games full of glorious images of photographic quality. And Cyan (the makers of *Myst*) took this very seriously. When CD-ROM drives first came out, they could be very flaky. There were many different manufacturers, many different drivers, and many ways for the software to fail. Cyan made a conscious choice to spend development time making sure their game ran on every possible CD-ROM/PC combination — time that some on the team would rather have spent giving the game a more elaborate ending. But it would seem they made the right decision — for years, nearly everyone who bought a CD-ROM drive for their home bought a copy of *Myst*, because they heard it was beautiful, and unlike many other CD-ROM games, this one was guaranteed to work.

Journey

In the early 1980s, engineers at Bally Midway had a great idea for a new videogame technology: why not put a digital camera onto an arcade machine, so that players who got a high score could do more than just enter their initials, they could pose for a picture! They built a prototype that would take black and white digital photos of winners, and tried it out in a Chicago arcade. They were shocked to visit it the next day to find that several of the winners had "flashed" the camera, making their high score list an exhibit of low-res pornography. No one could think of a way to solve this problem, so management put a halt to further development on the project. But the team didn't give up so easily. They had put a lot of work into the technology and wanted to see something come from it. The result was *Journey: The Arcade Game*, a basic platform game that featured members of the rock band Journey as avatars. These avatars were very strange looking, having tiny cartoon bodies, and grossly large heads that were black and white photos of the band members. The technology, which started as something more foundational, ended up as something purely decorative, and a pretty ugly decoration at that. The fancy technology could not save a boring game, and it flopped.

Ragdoll Physics

A more modern example can be seen when considering the technology of "ragdoll physics." Ragdoll physics is a method of manipulating real-time animated characters so that their bodies can realistically interact with other elements in the game world in a way that is not pre-scripted. Put another way, if you pick up a game character by the arm, and shake him around, his limbs will flop around realistically, with the movements completely calculated by the computer — no animator required. This has been used in countless first-person shooter games as a purely decorative technology: an NPC gets hit with a grenade, and his body flops through the air and onto the ground, using the mathematics of real-time physics to compute the motion. Even though sometimes it doesn't look right (the bodies have bad interaction with some types of terrain), it is a minor novelty and the engineers love it.

Contrast that use with how the same algorithms are used in the game *Ico*. *Ico* was a landmark in storytelling games, partly because of the novelty of the interaction between the main character Ico and the princess he is trying to rescue. For most of the game, Ico must lead the princess around by the hand, helping her through all kinds of dangerous perils. Because of the way the princess follows Ico, responding to every tug of his hand as he runs, climbs, and jumps, she seems alive in a way that is completely new and different. Most of the puzzles in the game are based on the fact that Ico has to lead the princess around, which would be impossible without these algorithms. The engineers and designers behind Ico found a way to take a technology that had been used purely as a decoration, and turn it into the foundation of a game experience the world had never encountered before.

As these examples show, it is a good habit, when encountering a new technology, to ask yourself "How can I make this foundational to my game?"

The Hype Cycle

Another good way to ward off the intoxicating effects of technology is to understand the pattern of that intoxication. This is best described through a model created by Gartner Research, which they refer to as the Hype Cycle.

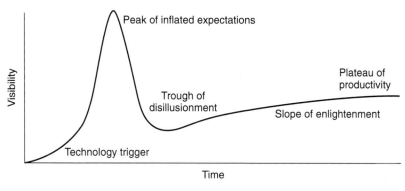

Hype Cycle

FIGURE
26.4

The graph above represents visibility (the number of people talking about it) over time. Gartner suggests that every new technology goes through five phases of hype:

1. **Technology Trigger.** This is when the technology is first discovered or announced.

2. **Peak of Inflated Expectations.** This is when many more people are talking about the technology than have actually experienced it. In other words, "Nobody knows what it's really like, but everyone says it's great." Companies launching a product (like, say, the iPhone) try to make the most of this quirk of human nature to believe that a new technology will make your dreams come true, though this never seems to actually happen.

3. **Trough of Disillusionment.** When the technology can't live up to the incredible hype that surrounded it (like, say, the Segway), and people see it in the cold, harsh, light of reality, it quickly becomes unfashionable, even despised.

4. **Slope of Enlightenment.** Gradually, people and businesses start to figure out the areas where the technology is actually useful and beneficial.

5. **Plateau of Productivity.** At this point, the benefits of the technology are widely understood and accepted. The height of this plateau is dependent on how broadly useful the technology really is.

The funny thing about the Hype Cycle is that it happens *every time*. Somehow, people never seem to learn, and they repeat the same silly behaviors again and again: Assuming the "new thing" will be life-changing, hating it when it isn't, and eventually using it for the things it is good at. As a game designer, you need to know about the Hype Cycle for three big reasons:

1. **Immunity**. If you are aware of the Hype Cycle, you can make yourself immune to its effects and not risk your career on a technology you haven't actually seen work.

2. **Inoculation**. Chances are good that at some point you are going to find yourself surrounded by people who have bought into the hype on some crazy new technology, and they will want you to design a game around it. If you can make them understand about the Hype Cycle, you may be able to save your team from making a dangerous decision.

3. **Fundraising**. There is no pretty way to say this. At some point, you are going to have an opportunity to pitch a design to someone who is fully under the spell of inflated expectations, and they are going to be willing to fund your game not because of its merits, but because they believe that the technological bandwagon they are jumping on is going to make them very rich. You can try to persuade them of the truth, but it won't work. The trick is to get the money before the trough of disillusionment, *and then* to make something great, despite the technology. If you can do this, it will be a roller coaster ride, but you will get the game made.

It can be very interesting to look back at the launch of different games and game systems, and think about their Hype Cycles. I'll leave that as an exercise to the reader, though, because we have a dilemma to discuss.

The Innovator's Dilemma

Another pattern anyone working with new technologies needs to be aware of is the innovator's dilemma (see Figure 26.5), from the book of the same name by Clayton Christensen. The basic idea is that technology companies often fail because they make the mistake of *listening to their customers*. This sounds counter-intuitive — as we've discussed, listening to the people who play your games is very important. But Christensen is talking about a very specific situation: where a new technology has appeared that is different, and not yet good enough to replace the old one. If you ask your customers what they think of the new technology, they will say "not

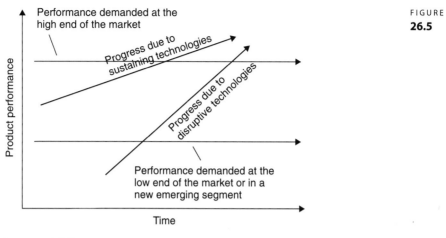

FIGURE
26.5

Innovator's Dilemma

good enough." As a result, you might choose to ignore this new technology and focus on making gradual improvements to your old one. But that new technology is gradually improving, too. And suddenly, almost overnight, the new technology will cross some threshold into the realm of "good enough," and all the customers of the old technology will suddenly jump ship for this new "disruptive technology" that is faster, better, and cheaper.

We've seen this in videogames many times. Makers of retail PC games did not take console gaming seriously for years — consoles just weren't "good enough." And then, suddenly, they were. And in less than a year, PC games went from being mainstream to being fringe. Motion controllers have been around for twenty years, but they were always considered too expensive, or not reliable enough. As a result, most console manufacturers didn't take them seriously. But then, after a series of gradual improvements and innovations, Nintendo released the Wiimote, with a clever motion controller that was "good enough," and nearly took over the console market in the process. And right now, technologies like speech recognition, artificial intelligence, brainwave sensing, and many more are ignored because they aren't "good enough" for games. If you can manage to design games for technologies that are on the verge of "breaking through," you can ride a wave of success that no one else saw coming — provided, of course, the technologies are foundational!

The Singularity

We've all noticed how technology presses into our lives ever more strongly with each passing year. Without a doubt, the pace of technological progress is not just increasing, it is *accelerating*. As it does so, it becomes more and more difficult to

predict the future. A thousand years ago, you could make a pretty good guess at what daily life would be like one hundred years in the future. Now it is difficult for us to make guesses at life just ten years in the future. Some people theorize that as technology continues to accelerate, soon we won't be able to make predictions about what life will be like a year away, a month away, or eventually, in the next ten minutes. The moment where technological progress is so fast that we can make no predictions whatsoever is called the singularity, and some predict it will arrive in our lifetimes.

This may sound farfetched, but there is no doubt that the rapid pace of technological change is good news for game designers, since new technologies mean new game possibilities. Further, it is not out of the question that our techniques of developing engaging virtual worlds, now considered merely an amusing pastime, may blossom into something central to the nature of human experience if the technologies for creating and experiencing virtual realities take sudden leaps forward.

Technology is the medium of your game and one of the four cornerstones of game design. Use this handy lens to examine your technological choices carefully.

Lens #92: The Lens of Technology

To make sure you are using the right technologies in the right way, ask yourself these questions:

- What technologies will help deliver the experience I want to create?
- Am I using these technologies in ways that are foundational or decorational?
- If I'm not using them foundationally, should I be using them at all?
- Is this technology as cool as I think it is?
- Is there a "disruptive technology" I should consider instead?

Look Into Your Crystal Ball

One effect of rapid technological change is that people get so caught up trying to understand the new technology that is here now, they stop thinking about what is coming next. Weary with so much innovation, they have given up on trying to predict the future, believing it to be too difficult. This is to your tremendous advantage — for a great deal of what is to come can be guessed at, if you sit down and carefully think it through. And what a benefit to you, the designer, if you can guess right! You'll be able to prepare for trends and developments that no one else saw coming, except you, because you used logic and reason to see what was coming

before it arrived. You won't always get it right, of course, but each time you get it wrong, you'll realize why, and it will make you a better predictor next time. The very act of trying to predict the future can change the way you see the world. Give it a try with some of these examples:

- What year will the next generation of game consoles come out? How will it differ from the current generation? Be as concrete as possible.
- How about the generation of consoles after that?
- Two years from now, what percentage of games will be downloaded, as opposed to being loaded from a disk or cartridge? Why? How about five years from now?
- Will mobile phones ever become the dominant handheld gaming platform?
- What will the next trend in massively multiplayer games be? Why?
- What will small game studios be working on four years from now?
- What will large game studios be working on four years from now?
- How will sports games be different four years from now?
- How will first-person shooters be different four years from now?
- How will <genre of your choice> be different four years from now?
- What new genres might appear in the next four years? Why?

Answering questions like this can be tough. It helps if you discuss them with others. As you do so, you'll find yourself plotting out things that are likely to happen and using those certainties as a scaffolding for your less confident predictions. It is not the predictions themselves that will be valuable to you, but rather the scaffolding that you create to make them. Further, attempts to predict the future often force you to examine historical trends, which give you insights that you can really use, and that are often correct. With practice, trying to predict the future of technology won't seem like such hard work and will start to become habitual. And who doesn't want to see into the future?

Lens #93: The Lens of the Crystal Ball

If you would like to know the future of a particular game technology, ask yourself these questions, and make your answers as concrete as possible:

- What will _____ be like two years from now? Why?
- What will _____ be like four years from now? Why?
- What will _____ be like ten years from now? Why?

CHAPTER

TWENTY-SEVEN

Your Game Will
Probably Have a *Client*

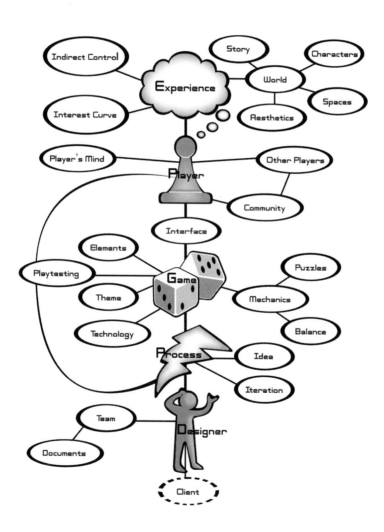

FIGURE
27.1

Form follows function.

> – Louis Sullivan, architect

Form follows fun.

> – Susannah Rosenthal, toy designer

Form follows funding.

> – Bran Ferren, realist

Who Cares What the Client Thinks?

In a perfect world, you, as a game designer, would only have to worry about pleasing two groups of people: (1) your team and (2) your players.

But this is not a perfect world, and in most cases, there is someone else you have to think about: your client.

Sometimes this client is a game publisher, sometimes it is a media company that holds the rights to a popular franchise, and sometimes it is just someone with no entertainment experience who has decided they need a game for some reason. Clients come in all shapes and sizes.

Why do you care what the client thinks? Well, unless you are making your game as a hobby, or you are independently wealthy, the client is probably paying you to make the game. And if they don't like the way things are going, it's literally game over.

Now, you might expect that the client views you as an expert — after all, the client can't make the game themselves — that's why they came to you. And, naturally, you might then assume that the client respects your opinions about what is going to make the best game.

And sometimes that happens.

Or so I have heard.

But most of the time, your client is going to have *very strong opinions* about how the game should look, act, and play. And rightly so — they are paying for it, after all. Your ability to deal with these opinions is critical, and here is why. There are two kinds of game designers in the world: happy ones and cranky ones. The happy ones are either independently wealthy, or are good at dealing with the strong opinions of their clients. The cranky ones are *not* good at dealing with these strong opinions. This might sound glib, but I'm quite serious — your ability to build bridges of compromise that delight both you and your client is possibly the single greatest indicator of whether you will be happy as a game designer in the long term.

But why? What's so bad about the strong opinions of a client? What if the client has smart opinions? This can happen — sometimes clients have opinions that are very thoughtful and wise — and it's a wonderful thing. But there are other times

when the client will have opinions that are so idiotic, so foolish, and so hypocritical that it beggars belief. Some of the stupidest things you will ever hear in your life will come out of your client's mouth, and somehow, you will have to deal with that. And a lot is riding on how you do: your relationship with the client, your reputation as a designer, your happiness, and your game.

Coping with Bad Suggestions

Many designers, when they get a bad suggestion from a client, freeze like a deer in headlights, terrified of what to say. There are three ways to deal with this:

1. Agree to the bad suggestion, for fear of displeasing the client. This is a disservice to your client and your game.

2. Immediately tell the client why their suggestion is bad, so the client will be impressed with how wise you are. This usually backfires.

3. Try to understand why the client is making this suggestion.

Response number three is the right answer. When someone makes a bad suggestion, it doesn't mean they are dumb — it just means they are trying to help. And most of the time, when one of these bad suggestions comes up, it is a solution to an unstated problem. This is a perfect time to pull out our old friend, Lens #12: The Lens of the Problem Statement! Because if you can figure out what problem the client is trying to solve with their suggestion, perhaps you can come up with a solution that does a better job of solving the problem, and the client will be thrilled.

As an example, there was once a racing game that was about halfway through development when the client came in for a review. After toying with the prototype for a few minutes, he looked at the team and said, "These cars need more chrome." The lead artist looked at the designer in a panic — the models were mostly complete, and had been approved by the client months ago. The lead engineer was similarly panicked — performance was tough as it was, and adding shiny chrome meant more drain on an already overworked CPU.

The designer could have said "Yes," and he could have said "No," but instead he said the only wise thing: "Why? Why do they need more chrome?" And the client's response was surprising: "Well, as I was playing, I kind of felt like the cars weren't as fast as they should be. I know changing the car speeds would probably be a lot of work for you guys, so I was just thinking that if you just put more chrome on the cars it would make them *look* faster." Now, this might sound like some pretty strange logic, but set that aside, and take note that *the client was only trying to help!* In fact, the team had the same feeling that the cars felt too slow and were going to bring that up. Their solution was a combination of making the cars move faster (easy) and lowering the camera viewpoint to make the perceived motion faster.

417

They were able to make the changes with the client standing right there. He was thrilled to see the improvement, and also pleased to understand a little more about how a racing game is put together.

This was a straightforward case of the The Lens of the Problem Statement saving the day. People's brains work fast, and they tend to jump to solutions before they even are sure what problem they are solving. Most bad suggestions can be resolved by the magic words "What problem are you trying to solve?"

Not That Rock

A completely different way that clients drive designers crazy is by the opposite of strong opinions: not knowing what they want. This is sometimes known as the game of "Bring Me a Rock." It works like this:

> Client: Bring me a rock.
> Designer: Okay, how about this one?
> Client: No, not that rock.
> Designer: Oh. Uh, how's this?
> Client: No, not that one, either.
> (Repeat two hundred times.)

After ten or twenty rounds of this game, designers often become frustrated, shouting to anyone who will listen, "I can't believe this client! They have no idea what they want!" And that may well be true. But, really, if they knew exactly what they wanted, wouldn't the game already be designed? A big part of the designer's job is to help the client figure out what they want. This is just like listening to your audience — you must get to know the client better than he knows himself. Here's the right way to play "Bring Me a Rock":

> Client: Bring me a rock.
> Designer: What kind of rock?
> Client: I'm not sure... I don't know much about rocks.
> Designer: Well, what are you going to do with it?
> Client: Oh... I was going to put it by my driveway and paint a house number on it.
> Designer: Ah... I think I know a good one... Let me bring you a few to choose from.

When you can manage to help a client figure out what they actually want, you are engaging in the design process, and at the same time, you are empowering your client by giving him an education he needs. If you play the game right, the client will come away feeling smart, and you will have designed a game that meets his needs perfectly.

The Three Layers of Desire

To really give your client what they want, you have to understand what is important to him — you have to care about what they care about, and think how they think. Doing your homework to learn about the client, both personally and professionally, is time well spent. Does he care more about striking it rich quickly, or slowly building a reputation for good games? Is he looking to get into a new market, or to capitalize on an existing one? What does he think makes a good game? You can learn a lot about a client just by talking to him and asking what he wants — but keep in mind that people don't always tell the truth. When trying to figure out what a client wants, keep in mind that everyone has three layers of desire: words, mind, and heart.

For example, a client might come to you and say, with her words: "I want you to make a game for the Rittenhouse Foundation. The game needs to teach algebra to eighth graders."

But in her mind, she might be keeping a secret: "Actually, I want to make a space-themed game that teaches geometry. I've got it all planned out how it should work. I'm only going along with this algebra thing because the Rittenhouse people think it's important."

But in her heart, she might be thinking something else entirely: "I'm tired of being the financial person. I want people to see I have a creative side."

Now, if you simply took her at her word, you might find, as the project proceeds, that she is fighting you on it, and that she is taking it in directions that seem opposed to what the funders want, and overall, her behavior is quite strange. But if you are able to learn what is in her mind, and even better, her heart, you can possibly incorporate elements from this game she has been imagining and maybe find other ways to let her contribute creative ideas, or at least take credit for them. If you are very clever, you can probably find a way to fulfill all three layers of desire —this is not a trivial thing, for when you have fulfilled someone's heart's desire, you may find you have a friend for life.

Firenze, 1498

I'd like to close this chapter with one of my favorite stories about dealing with clients. It happened in Florence, Italy, during the Renaissance. The city, years earlier, had purchased a very large, fine piece of marble for a sculpture, but an inexpert sculptor had set to work on it and gouged a great hole in the marble. The city lost confidence and fired him, and the great piece of marble deteriorated in the cathedral yard, exposed to the elements for many years. But in 1498, the mayor, Piero Soderini, went on a crusade to have something carved from the marble. He approached Leonardo da Vinci, but Leonardo had no interest in working with a damaged piece of marble. Besides, he remembered how the previous sculptor had been treated and wasn't interested in getting the same shabby treatment. But one

sculptor did come forward — a young man of twenty-six named Michelangelo. The mayor was skeptical that someone so young would be qualified, but Michelangelo brought a prototype with him: a model made of wax that showed how he would carefully arrange the legs of the figure to deal with both the fact that the marble was thin and badly gouged. Soderini and the commissioners were impressed and awarded Michelangelo the commission to create a statue of David.

One day, as the statue was nearing completion, the mayor decided to drop by to see how the work was going. The statue of David is very large, fourteen feet tall. This means that to work on it, Michelangelo had to surround it with scaffolding. As Michelangelo was working away high on the scaffold, Soderini came inside the scaffolding for a clear view. Fancying himself an expert, he told Michelangelo that the statue was good, but clearly, the nose was too large.

It was obvious to Michelangelo that Soderini was standing far too close to the statue for a proper viewing angle, because, after all, everyone's nose looks too big when you look straight up at it. But it was also obvious that Soderini's words were not telling the whole story — he had deeper layers of desire. Instead of trying to give Soderini a lesson in perspective, Michelangelo invited him to climb up the scaffold where the two of them could fix the nose together. As Soderini was climbing, Michelangelo scooped up a little bit of marble dust in his pinky finger. When Soderini was at a proper viewing angle, Michelangelo put his chisel near the nose, gave it a few pretend taps with his hammer, and dropped the dust from his pinky to make it look like actual sculpting was in progress. After a couple minutes of this, Michelangelo stepped away, and said, "Look at it now." "I like it better," replied Soderini, "you've made it come alive!"

This may seem like a cruel trick on Soderini. But was it? Clearly he came that day because he wanted some ownership of the statue — he wanted to be a creative partner. And he came away feeling he was. After this, if someone were then to criticize the statue, you can be sure that Soderini would be the first to come to its defense. I tell this story not to suggest that you lie to your clients, but rather to underline the importance of finding ways for them to feel like creative partners on your game. It is possible to do this without compromising your creative vision. Always keep in mind that the client has more to offer than just funding. It may be connections, business expertise, or a special understanding of the audience for your game. You will find that if you listen to your clients — truly, deeply, listen to them — they will listen to you.

Lens #94: The Lens of the Client

If you are making a game for someone else, you should probably know what they want. Ask yourself these questions:

- What does the client say he wants?

- What does the client think he wants?
- What does the client really want, deep down in his heart?

When you are proposing a new idea is when you need the client to listen to you most, and that is the subject of our next chapter.

TWENTY-EIGHT

The Designer Gives
the Client a *Pitch*

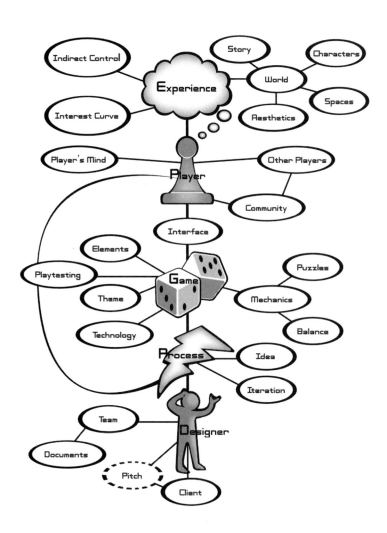

FIGURE
28.1

Why Me?

If you are going to get someone to fund your game, publish your game, or distribute your game, you are going to have to convince them that your game is worth the risk, and this means pitching your game. You might be thinking, "Why me? Isn't it enough that I'm designing it? Couldn't someone else do this?" But, really, who is more qualified than you? The artists? The engineers? Management? As the game's designer, you should know the game and why it is great better than anyone else. And if you don't believe in your game enough to get up in front of people and sing its praises, then why should anyone else believe in it?

So, who will you pitch to, and when? In the beginning you'll be pitching rough ideas to team members and potential partners. When the team has agreed on a concept, you'll be pitching to management to get approval to build a prototype. When the prototype is built, you'll likely be pitching your game to publishers, trying to get a development deal. And during development, when you realize that the game has to change in some important way, you'll be pitching those changes to almost everyone. After the game is done, you might even find yourself pitching it to reporters at game conferences. The highest pressure pitches are the ones where you are trying to get funding for the game, so this chapter will focus a little more on those.

A Negotiation of Power

Before we get into the specifics of putting together a good pitch, we should take a moment to understand exactly what a pitch is. And to understand that, it is necessary to understand what power is. Power does not have to be about wealth or controlling people, although it can be about those things. Power is simply *the ability to get what you want*. If you can get what you want, you are powerful. If you can't get what you want, you are powerless.

But notice that our definition of power has two parts: "the ability to get," and "what you want." Most people focus entirely on the first part, the ability to get. But the second part, what you want, is equally important. For if you don't know what you want, you will find yourself continually grasping and never satisfied. But if you know what you want, you can focus your efforts much more effectively toward getting it, and in doing so, you will become powerful.

And when you pitch your game, you are entering into a negotiation of power, where you are going to try to get what you want, while you convince someone else that your game is going to help them get what they want. For this reason, the foundation of any successful pitch is knowing what you want and knowing what they want, which can be kind of complicated, keeping in mind that you each have three layers of desire.

The Hierarchy of Ideas

Novice designers will frequently be heard to complain, "I can't believe it! I pitched this *really cool* idea, and no one was interested! What is wrong with people?" The answer is that nothing is wrong with people — it is just that cool ideas have a pretty low value on the hierarchy of ideas shown here:

Type of Idea	Description	Value
Idea	Just a plain old idea	$0.083
Cool idea	An idea that captures the imagination	$5
Really cool idea	A cool idea, shouted	$5
Good idea	An idea that someone could actually use	$100
Good idea in the right place at the right time, sold convincingly	Just what it sounds like	$1,000,000+

I know that's silly, but the point is that when you pitch an idea, it won't be judged on its overall merit — it will be judged by how useful it is, right now, to the person you are pitching it to. Those are the ideas that land deals worth millions. When you pitch a good idea, and it gets rejected, don't grind your teeth —take it to someone who can use it, or put it in your back pocket so you have it ready when its time finally comes.

Twelve Tips for a Successful Pitch

So — you've learned about who you are pitching to and have figured out a good idea that they can use now, and you even know what you want them to do for you. Now what?

Pitch Tip #1: Get in the Door

You can't pitch your idea if you can't get in the door. Some doors are easy to get into, some aren't. Game publishers can be very hard to get an audience with. They are like the prettiest girl at school, and they know it. They will often ignore e-mails and messages, and cancel meetings with almost no warning. They have their pick of developers to work with, so unless you can convince them you have something pretty special, it can be hard to even get in the door, especially if you are using the front door; that is, "Uh, hello, is this Big Time Games? I have a game design I want to pitch... who should I talk to?"

A much better approach is to use the back door, if you can; that is, know some-one on the inside who can vouch for you. A publisher who would ignore your e-mail won't ignore the e-mail of someone he works with on a regular basis. I think it is safe to say that the majority of game deals happen this way — a developer and publisher were introduced to each other by a mutual friend. This is why indus-try events like the Game Developers Conference, and local International Game Developer Association (IGDA) meetings are so important — they help you build up networks of contacts so that when your pitch is ready, you can get in the door.

Pitch Tip #2: Show You Are Serious

When I worked at Walt Disney Imagineering there was a remarkable event, held twice a year, called the Open Forum. It was an opportunity to pitch your brilliant idea to the top creative minds in charge of the Disney theme parks. Anyone at all in the entire organization was welcome to come and give their five-minute pitch to this panel of decision makers. They would then deliberate privately for five minutes, and then give you five minutes of feedback. If they liked the idea, it would get taken to the next level and possibly get deployed in the parks! I loved the idea of getting a chance to pitch new ideas, and would take advantage every time I could. Generally, I would be well-prepared, but for one of the sessions, I just didn't have the time. Instead of giving one fully fleshed out idea, I thought maybe I would come in with two less-fleshed out ones. One was a fountain made of soap bubbles, and the other was a mini-campfire for a restaurant so that guests could roast marshmallows right at their tables. When I presented these ideas, the panel had many questions. Would the fountain actually work? Would the mini-campfire be safe? Had I built prototypes to answer these questions? I had to admit that I hadn't. One panel member became indignant: "If you don't care enough about these ideas to try them out, why should we?" It was humiliating, but he was absolutely right.

When you pitch a game, you have to show that you are serious about building it. It used to be that a developer could get a deal with a publisher just with a few sketches and a description of what the game would be like. That kind of deal is increasingly rare now — a working prototype is required in this day and age. But even a proto-type is not enough — you need to show that you have given serious thought to your game, its market, and how it works. This can be with a detailed design document (no one will read it, but they will weigh it), or even better, with a clear presenta-tion that details why the game will sell. Believing that your game *could* be fun isn't enough — you must show you've done the work that proves your game *will* be fun.

Pitch Tip #3: Be Organized

It's real easy to fall into the "creative people aren't organized" trap. Organization is just another way to show someone that you are serious. Also, the more organized you are, having just what you need at your fingertips, the more calm you'll be, and

the more in control you will be. A publisher is going to see an organized designer as a "lower risk" designer, which will make them more likely to trust you.

So — make sure your pitch is well-planned. If you bring handouts (you should), make sure they are easily accessible and that you have enough for everybody. If your presentation involves a computer, a projector, or (gulp) an Internet connection, make sure that they are really going to work — get there early to test, just in case. I once scheduled a very important pitch with someone where we set a date, but forgot to set a time! The day before I was scrambling to get in touch with them, to figure out if our meeting was still on, and when exactly it would be! The whole thing was stressful, embarrassing, and unnecessary.

Organization is not a burden. Organization will set you free.

Pitch Tip #4: Be Passionate!!!!!

Unbelievably to me, I see pitches all the time where the person presenting seems kind of ambivalent about the game they are talking about. You want to get the people you are talking to excited about your game — to do that, *you* must be excited about your game! DO NOT try to fake this — it will come off completely phony. If you are actually, genuinely excited about your game when you talk about it, it will come through in the presentation, and it might even be infectious! And passion represents more than excitement — it also represents drive and commitment to deliver a quality game at any cost. A publisher needs to see this kind of commitment if they are going to entrust you with the millions of dollars it will cost to produce your genius game.

Pitch Tip #5: Assume Their Point of View

In previous chapters, we've talked about the importance of listening to your audience, your game, and your team — the pitch is just one more occasion for listening. So often we assume that selling is all about us — if only we push hard enough, they'll buy it. But no one likes to be confronted with a hard, pushy salesperson. What we like is when someone listens to us and tries to solve our problems. Your pitch should be all about that. Speak with the person you are going to pitch to in advance. Learn what you can about them, and make sure that the game you are planning to pitch is going to be a good fit for them — if it isn't, don't waste their time.

Even though you know the game you are pitching backwards and forwards, you must remember the person you are pitching to has never seen it before, so make sure you explain it in a way that they will easily understand — avoid jargon wherever possible. Practice your pitch on friends and colleagues who aren't familiar with the game idea to see if it makes sense to them.

Also remember that the person you are pitching to has probably seen hundreds of pitches and is very busy. Make sure that you don't waste any time and get straight to the point. If they seem bored with a point you are making, pass over

it and move on. If there is something they want more details about, they will ask questions.

One more way to assume the client's point of view: consider the best-case scenario. That is, they LOVE your pitch. Now what happens? In most cases, a deal can't happen yet. The person you pitched to probably has to pitch it to colleagues or superiors at their company. How easy have you made it for them? Things that make it much easier for a "fan" of your project to pitch it to others:

- Give your idea "handles" — that is, provide short phrases that summarize the idea: "It's a bowling RPG!" "It's Pokemon for grownups!" "It's Nintendogs, with a whole zoo!"

- Give them a professional looking report (both printed and digital) that summarizes what is great about the idea, and, more important, what is great about your company. The IGDA has an excellent white paper, the Game Submission Guide, that details exactly what should go into this document (http://www.igda.org/biz/submission_guide.php).

- If you have a PowerPoint presentation, or design document, you should give them a CD with a copy.

- If you can, make short videos that highlight the gameplay. These are safer than just giving a prototype, which might be buggy, or which they might forget how to play.

Pitch Tip #6: Design the Pitch

The pitch is an experience, right? Why wouldn't you design it at least as well as your game! Lots of lenses from this book will help you do it. Your pitch should be accessible, have surprises, have a good interest curve (a hook, a build, tense and release, a climax), etc. It should have a good aesthetic design, favoring images over words whenever possible. Your pitch should be elegant; focusing primarily on what is unique about your game, why it will succeed against the competition, and why it is a good fit for the person you are pitching it to. You should have thought through every moment that will happen during the entire pitch encounter. Do you have other team members there? When will you introduce them? When will you show your prototype? If you think that "over-planning" will spoil the energy of your pitch, you are wrong. You can always deviate from a plan if you want to, but having a plan will keep your mind free to focus on giving a great pitch, and you won't have to worry about whether you have forgotten something important.

Pitch Tip #7: Know All the Details

During a pitch, you are going to get questions. Experienced, busy publishers aren't going to wait until the end, either — they will break into your carefully planned

presentation and ask detailed questions about the things they think are important. You need to have as many facts as possible at your fingertips. These include:

- **Design details**. You should know your design inside and out. For parts of the design you've been putting off, you should at least have a guess. You should have confident answers for questions like "How many hours of gameplay?" "How long does it take to finish a level?" "How does multiplayer work?" and hundreds more.

- **Schedule details**. You need to know how long it will take to create the game and roughly how long it will take your team to get to each of the important milestones (design document completed, first playable prototype, first alpha, second alpha, beta, gold master). Make sure these times are realistic, or the publisher will lose confidence in you fast. Be ready for the question: "What's the fastest you could get this done?" Expect to be held to your answer.

- **Financial details.** You should know what it will cost to get the game done. This means knowing how many people will be working on the game, how long they'll be working on it, and other costs. Also expect the question: "How many units do you think this will sell?" You should probably base that answer on how comparable titles have sold. Don't just give one number — give what you think are realistic minimums and maximums. Make ABSOLUTELY sure that the minimum number you give still makes the game a profitable venture for the publisher.

- **Risks.** You will be asked what the biggest risks on the project are. You need to be ready to state them clearly and succinctly, along with your plan for managing each one of them whether they are technical, gameplay, aesthetic, marketing, financial, or legal.

You also need to anticipate the questions that the people you are pitching to are going to ask. There is a legend about Imagineer Joe Rohde who was giving the final pitch of the Animal Kingdom theme park to Disney CEO Michael Eisner. Eisner had long wavered about whether this park was a good idea, and Joe was given his last chance to explain why it was. After Joe's detailed presentation, Eisner said, "I'm sorry… I still don't see what is so exciting about live animals." Joe walked out of the meeting and returned, moments later, leading a Bengal tiger into the room. "This," he declared, "is what is so exciting about live animals." The theme park got its funding. When you can anticipate what questions are coming, and give perfect answers, you can be magically persuasive.

Pitch Tip #8: Exude Confidence

While passion is important, confidence is just as important, and not at all the same thing. Being confident means you are sure your game will be perfect for the client, and that your team is the perfect team to pull it off. It means not getting shaken

when you get a tough question. It means knowing all the details. Keep in mind, you aren't just selling the idea, you are selling yourself. If you seem nervous, it's going to make people think you don't believe what you are saying. When you show something impressive, you should act like it was nothing, like it was easy. If your other team members are with you, you should answer questions as a team with each confident about which questions the others can answer best.

And here is a magic word you can use when a tough question tries to shake your confidence: "Absolutely." For questions like: "Do you think this will sell in Europe?" "Can the servers handle the load?" "Can you make a kid's version?" You might be thinking "yes" or "probably," but I guarantee that "absolutely" will sound far more confident. Of course you need to back up that confident answer!

And a quick word about handshakes: if you aren't sure you have a confident handshake, you need to practice until you do. Handshakes are a secret system by which people, mainly men, assess personalities. Your words may sound confident, but if your handshake is not, it will cast doubt on everything you say.

But what if you don't feel confident? What if you get really nervous talking in front of a group? The best thing to do is visualize a time when you were supremely confident. Putting yourself into that past moment will help you remember what confidence feels like, and that you can be a confident person calmly in charge of an important situation.

Pitch Tip #9: Be Flexible

During your pitch, you are going to get curveballs. The person you are pitching to might suddenly reveal they hate your concept — what else do you have? You might have planned on a one-hour meeting only to be told "I only have twenty minutes." You need to handle these kinds of things with coolness and confidence. Game designer Richard Garfield tells a story about how he went to a publisher to pitch RoboRally, an elaborate board game about robots in a factory. Garfield loved his game and gave a detailed pitch to a game publisher who sat patiently through it, and then said, "I'm sorry, but we can't use this. It's too big. We're looking for games that are small and portable. Got anything like that?" Garfield could have walked out, insulted, but instead he stayed objective, and considered that his goal was to get a game published — not necessarily this game. He mentioned that he was working on an idea for a new kind of card game — could he come back and present that? The game he pitched the second time eventually became the megahit *Magic: The Gathering*.

Pitch Tip #10: Rehearse

Planning your pitch is good, rehearsing it is better. The more you get comfortable talking about your game, the more natural your pitch will be. Look for any opportunity to

practice — when your mother asks, "So, what have you been working on?" give her the pitch. Give it to your co-workers, to your hairdresser, to your dog. It isn't that the specific words of your pitch need to be memorized, but the chain of ideas needs to be able to spring forth naturally from you, like a favorite song.

If you are going to show a demo, rehearse that, too. Avoid, at all costs, pitching while you play! It makes you sound mentally deficient and wastes valuable time. Have a colleague play the game while you talk about it and answer questions. Unless they are excited about it, don't expect executives to play your prototype. There is too much danger of them embarrassing themselves or crashing your prototype and embarrassing you.

Pitch Tip #11: Get Them to Own It

In Chapter 28 we heard Michelangelo's clever method of getting a client to own the project. But you don't have to be so sneaky. Ideally, you want them to come away from your pitch thinking of the game as "their game." Having an inside advocate in the group you are pitching to really helps — someone who is pre-sold on the concept and who will defend it to the others. Another way to improve the chances of them taking ownership is to integrate the ideas of the client into the pitch. If, in a previous conversation with them, they said "So, it's a war game, huh? Does it have helicopters? I love helicopters!" you should be darn sure there are helicopters in your pitch somewhere. You can even integrate the client's ideas on the fly, using concepts from their early questions ("Could it have giant rats?") to explain things later in the pitch ("So, say you come upon a room full of giant rats..."). The easier you make it for them to imagine that it is their game, the closer they get to accepting your proposal.

Pitch Tip #12: Follow Up

After your pitch, they will thank you, and promise to get back to you. And they might — but they might just as easily not. This doesn't mean that they didn't like your pitch. They might have liked it very much, but gotten swept up in some other, more pressing emergency. Within a few days of the pitch you should find an excuse to follow up with them by e-mail or phone ("you had asked about details of the texture manager, and I just wanted to get back to you on that") to subtly remind them that you are still around, and that they owe you feedback. You have no good reason to nag them outright for an answer — if you do, you are likely to get an answer quickly: "no thanks." They may need time to think about it, time to discuss internally, or time to review other competing proposals. Just keep following up periodically, not too often, until you get an answer. Never get frustrated if they don't respond — be patient, and understanding. It may be that the time for your idea to be useful just isn't here yet. It is not uncommon to ping a publisher six months after

a pitch, and to hear back, "Hey, I'm glad you contacted me. Remember that pitch you gave? I think we might want to talk to you about it. Can we meet next week?"

A game begins with an idea, but it gets funded with a pitch. Keep this lens so you don't forget to design your pitch as well as you design your game.

Lens #95: The Lens of the Pitch

To ensure your pitch is as good as it can be, ask yourself these questions:

- Why are you pitching this game to this client?
- What will you consider "a successful pitch"?
- What's in it for the people you are pitching to?
- What do the people you are pitching to need to know about your game?

If you are pitching to a publisher, the most important thing to them will be whether the game can make money, and how much. This is the subject of our next chapter.

CHAPTER TWENTY-NINE

The Designer and Client Want the Game to Make a *Profit*

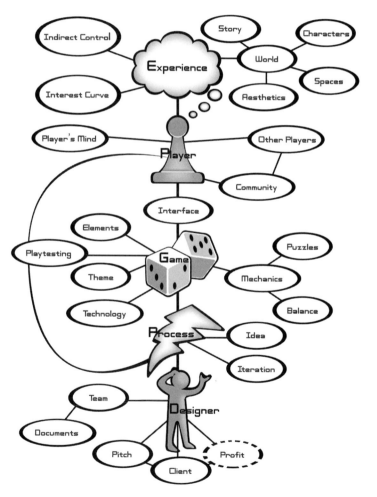

FIGURE
29.1

Indirect Control

Story

Characters

Experience

World

Spaces

Interest Curve

Aesthetics

Player's Mind

Other Players

Player

Community

Interface

Elements

Puzzles

Playtesting

Game

Theme

Mechanics

Technology

Balance

Process

Idea

Iteration

Team

Designer

Documents

Pitch

Profit

Client

Love and Money

It is time to face a painful truth.

I know that you, personally, are designing games out of love for the medium. If there were no way to make money at game design, you would surely continue to do it as a hobby. The very word "amateur" literally means lover.

But money is the fuel that drives the game industry.

If games were not profitable, the industry would wither and die.

And in the real world of the game industry, there are many people who, if they learned today they could make 2% more profit a year selling can openers instead of games, would do so, and feel really proud of their choice.

Perhaps you view these people with a certain contempt. But should you? Profits are necessary to the industry — who better to be in charge of them than people who love money? I mean, you don't want to worry about money all day, do you? You have games to design. Why not let the money people be in charge of the money and the design people be in charge of the design, and everyone will be happy, right?

Sadly, no. Remember "form follows funding"? Decisions that the money people make ("you need to make this game with three million dollars, not the five million you asked for," "we've decided this MMO needs to have microtransactions, not a subscription," "you have to include in-game advertising") can have a tremendous impact on the game design. And the opposite is true — game design decisions will have an enormous impact on profitability. In a weird way, design and management each hold the strings controlling the destiny of the other. Because of this, the money people are going to step in and tell you how to design your game, because they are afraid you might not understand the impacts of your design on profitability. And when there is a conflict between the two of you, who do you think is going to win? Keep in mind the golden rule: The one with the gold makes the rules.

For this reason, it's really important that you understand enough about the business of games so that you can have an intelligent discussion with the money people. This will give you much more creative control, because if you can explain why your precious feature will make more money, in terms they'll understand and believe, you've got a much better shot at having the game turn out the way you know is best.

You might be thinking "I don't know the first thing about business — all this financial stuff is going to be over my head." But you don't have to master it — you just need to know enough to think about it and talk about it. It's certainly simpler than learning about probability, and you seemed to understand that pretty well. I'm sure you've met someone with an MBA who, surprisingly, didn't seem too bright. If that guy can understand it, so can you. And, making money is a lot like a game — when you consider it from that point of view, it can actually be kind of fun to think about.

This chapter isn't going to get into great detail about the business of games — there are other books for that. But we'll talk about things you can do to make it easier to have meaningful conversations with the people who hold the purse strings on your game.

Know Your Business Model

To understand any business, follow the money. If you understand where the money goes and why, you understand the business. For example, when a consumer buys a $50 retail game title, this diagram shows, on average, where the money ends up:

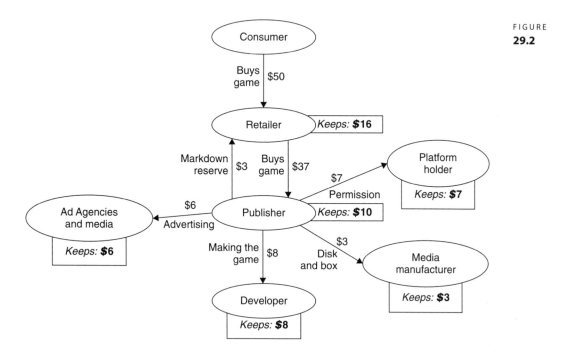

FIGURE
29.2

Seeing this kind of diagram leads to questions like:

Q: What is a platform holder?

A: This is the company that makes a given console (Sony, Nintendo, Microsoft). They don't usually make any money selling the consoles (they often lose money, selling them below cost!). They make their money by "taxing" the publisher for each title made.

Q: Why does the retailer take so much?

A: Doesn't the retailer seem greedy? But they aren't. Retail is a low-margin business where they have to cut every possible corner to survive. It just costs a lot to run a store.

Q: Why does the publisher take so much?

A: Look at everything they have to do! They have to coordinate and bargain with all these different companies, and if anything goes wrong, they are the ones who lose money. If the game doesn't sell, the developer still got paid to make the title,

435

and the retailer will make the publisher buy back the unsold titles. Part of the reason the publisher takes so much is because they have to pay for titles that lose money.

Q: What is a markdown reserve?

A: Eventually, the title will be marked down, sold at a lower price. The retailer makes the publisher absorb some of the loss when this happens. On average, that comes to about $3 a unit.

Now, keep in mind, these numbers are averages. What really happens is much more detailed. I'm sure you have many more questions about this — following the money does that — it raises questions — find the answers, and you'll understand the business model.

Retail isn't the only business model, of course: there are many more: Internet downloads, console downloads, mobile phone games, board and card games, advergames, subscription MMOs, microtransaction MMOs, and many more. Many of these have grown quickly in the last few years, partly in an attempt to escape the high costs of retail. And the peculiarities of each business model exert powerful forces that help define the nature of the games sold through them, which is why you need to understand them.

It isn't hard, really. If you find yourself baffled by a new business model, all you have to do is find a money person, and ask them "Hey, can you show me where the money goes?" and pretty soon you'll know just what questions to ask.

Units Sold

Inevitably, you will find it useful to compare your game to others that have come before. The last thing you want is to be caught in a conversation similar to

YOU: Our game is awesome! It's like *Katamari Damacy*, but in space!

PUBLISHER: (disdainfully) Do you know how many units *Katamari Damacy* actually sold?

YOU: Uh... a lot?

Units sold equals success. Unfortunately, getting your hands on these numbers can be hard. If you are lucky, you can sometimes find them in a Web search or a magazine article. If you are at a big developer or publisher, they may have access to the NPDs retail tracking service (www.npd.com), and you can use that to get the data.

These data are really important, because how well past games sold is going to be how a publisher will estimate how a new game will sell. Units sold is one of those cold hard facts that are hard to argue with — so if you can get data, use it to your advantage.

Breakeven

A really important number for you to figure out is "breakeven." That is, how many units of the game have to be sold before the publisher makes back the money they

put into the game. Because if you proudly explain how your game will surely sell 200,000 units based on how competing titles have sold, and some simple arithmetic shows the publisher that he won't make any money until 400,000 units are sold, you've got trouble. If you aren't sure how a particular publisher calculates breakeven, ask them.

Know the Top Sellers

Try this: make a list, right now, of the top ten best-selling videogames for last year. After you make your list, go on the Web and compare reality to your list. If you had a perfect match, good job. If not, you should think about why you were off base. Did you not realize that titles based on movie franchises were so popular? Did you forget about sports games? Did you think handheld games wouldn't be on the list? Did you assume that the games you liked best were the games everyone else liked? I can guarantee you that any publisher you pitch to can name last year's top ten games. Why? Because the game industry is a hit-driven business. Publishers make their money off of big hits, and so they study the hits scrupulously, in an attempt to understand what made them successful.

If you want to understand how publishers think, you need to analyze the hits. One company, Electronic Entertainment Design and Research (www.eedar.com), is taking this analysis to new levels by breaking games down feature by feature and performing complex mathematical analysis to try to understand which features contributed most to the financial success of each title. How much does multiplayer matter? How much do hours of gameplay matter? etc. This is so developers and publishers can use these data for future titles.

However you do it, find some way to get familiar with the hits in your market and demographic and understand why they were so successful. It will help you build a common understanding with the money people. And if you have special insights as to why certain game designs made so much money, I can guarantee that the money people will want to hear what you have to say.

Learn the Language

Every specialty has jargon, and the economics of games are no exception. Really, though, most of it is pretty standard retail or e-commerce jargon, with a few exceptions. None of it is that hard to learn — mostly just shorthand names for simple concepts.

Some terms you should know:

- **SKU**: Pronounced "skew." Stands for "stock keeping unit." It means a unique inventory item for a store. One game might come out as many SKUs, since each

different console release is a SKU, and each language version (*Halo 3* in French) is a SKU. Publishers often measure themselves in terms of how many SKUs they put out in a year.

- **COGS**: No, not like cogs in a machine. This is Cost of Goods Sold. That is, what does it cost, per unit, to actually make the game.

- **Burn rate**: What does it is cost, per month, to keep your studio open? Salaries, benefits, rent, etc.

- **Sold in vs. Sold through**: When the retailer buys games from the publisher, they are "sold in," that is, sold into the store. But when a customer buys the game, then we say it is "sold through." Since the publisher has to buy back titles the retailer can't sell, the number of sold-in and sold-through titles might be very different. If a boastful publisher brags to you that a title has sold 1.5 million copies, and it's just been out for a week, you can often burst his bubble by asking "sold in or sold through?" In the end, only "sold through" matters.

- **NPV**: This stands for "net present value." The idea is that money in your hand now is worth more than money you will receive in the future. So, if (somehow) I have a game that is guaranteed to make me a million dollars profit a year for five years, it is not worth five million dollars — it is worth less than that. You can look up how to do the calculation — it's pretty simple. If you ever plan to get money from a venture capitalist to make your game, there will be a lot of talk about NPV. The same goes if you are trying to persuade a publisher to spend money on a technology that can be used in many games. The main thing that affects an NPV calculation is your opinion about how much the value of money goes down over time. We call this percentage the "discount rate," and it is usually between 4 and 10%. A good trick, when a money person corners you demanding to know the NPV of your game, is to ask "at what discount rate?" They'll often be stunned into silence by this as they realize that you might know what you are talking about. If they give you a number, write it down, and say "I'll get back to you with the exact figures." Then go figure it out — it isn't that hard.

- **Christmas**: This has nothing to do with the birth of Jesus, and everything to do with the fact that 75% of all games in the United States are sold during the Christmas season.

There's lots more of these, of course, but I list these just to give you a sample. You see they really aren't that complicated. If you can have some familiarity with this kind of language, and are brave enough to ask for explanations when you hear terms you don't know, the money people will start to respect you, because they'll see you care about the things they think are important. And these things are important — without them, game design couldn't be a career, only a hobby. To help you remember, take this lens.

Lens #96: The Lens of Profit

Profits keep the game industry alive. Ask these questions to help your game become profitable.

- Where does the money go in my game's business model? Why?
- How much will it cost to produce, market, and distribute this game? Why?
- How many units will this game sell? Why do I think that?
- How many units need to sell before my game breaks even?

In the next chapter, we'll talk about something far more important than money.

Games *Transform* Their Players

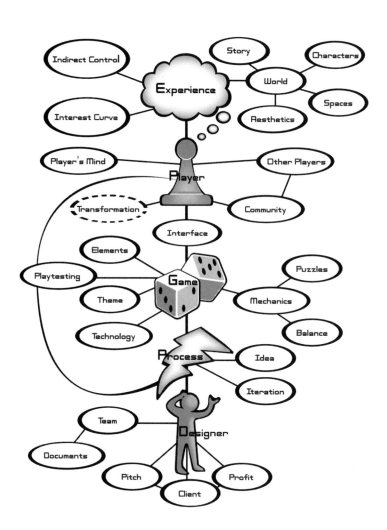

FIGURE
30.1

How Do Games Change Us?

There is much debate about the long-term effect of games on the mind. Some believe that they have no lasting effect — that they just serve as a momentary distraction. Others believe that gameplay can be dangerous, inciting players to violence, or ruining their lives through addiction. Still others believe that games are so good for us that they will become the cornerstone of 21st century education.

How games change us is not a trivial question, for the answer to it is transforming society as we speak — either for the better, or for the worse.

Can Games Be Good For You?

Games come so naturally to humans, and afford so much pleasure, that only someone of a very extreme philosophical orientation would maintain that all gameplay is harmful. Several positive effects are often attributed to games.

Emotional Maintenance

Games are one of many activities that people engage in to try to maintain and control their mood and emotional state. People play games to try to

- **Vent anger and frustration**. Games, particularly sports involving a lot of physical activity (football, basketball) or videogames involving a lot of fast action and battles, can be a cathartic way to "take out your feelings" on someone else in the safe world of the game.
- **Cheer up**. When a person is depressed, whimsical games with funny situations (Cranium, *Mario Party*) can be a way to take your mind off your troubles, and remember that you can still have fun.
- **Gain perspective**. There are times when our troubles loom large on us, and little things seem like they are the end of the world. Playing games gives us some distance from our real-world problems, so when we return we more easily see them for what they are.
- **Build confidence**. After a few real-life failures, it is easy to start to feel like you aren't good at anything, which can lead to a feeling that everything in your life is beyond your control. Playing a game where your choices and actions can lead to a successful outcome can give a feeling of mastery that helps remind you that you can succeed, that you have some control over your destiny.
- **Relax**. Sometimes we are simply unable to let go of our worries, either because of their size or their sheer number. Games force our brains to engage with something completely unconnected to our worries, letting us escape them for a while, and giving us a much needed "emotional rest."

And while it is true that efforts to play games for these reasons sometimes backfire — if the game proves just as frustrating as real life, for example — in general games serve the above tasks fairly well, acting as tools that help maintain our emotional health.

Connecting

Connecting socially with others is not always an easy thing to do. We are each caught up in our own problems and worries that others might not understand or care about. Games can act as a "social bridge," giving us reasons to interact with each other, letting us see how others respond to a variety of situations, introducing topics of conversation, showing us what we have in common, and creating shared memories. This combination of factors makes games a great tool to help build and maintain relationships with the important people in our lives.

Exercise

Games, particularly sports, give us reason and motivation to perform healthy physical exercise. Recent studies have shown the health benefits of mental exercise, particularly for the elderly. The problem-solving nature of games makes them flexible tools to provide both physical and mental exercise in many forms.

Education

Some hold the position that education is serious, but games are not; therefore games have no place in education. But an examination of our educational system shows that it is a game! Students (players) are given a series of assignments (goals) that must be handed in (accomplished) by certain due dates (time limits). They receive grades (scores) as feedback repeatedly as assignments (challenges) get harder and harder, until the end of the course when they are faced with a final exam (boss monster), which they can only pass (defeat) if they have mastered all the skills in the course (game). Students (players) who perform particularly well are listed on the honor roll (leader board).

So, why doesn't education feel more like a game? The lenses in this book make it pretty clear. Traditional educational methods often feature a real lack of surprises, a lack of projection, a lack of pleasures, a lack of community, and a bad interest curve. When Marshall McLuhan said "Anyone who thinks education and entertainment are different doesn't know much about either," this is what he was talking about. It's not that learning isn't fun, it is just that many educational experiences are poorly designed.

So why haven't educational videogames found more of a home in the classroom? There seem to be several reasons:

- **Time constraints**. Playing games can take a long time, and a variable amount of time — many meaningful, educational games are just too long of an experience for a classroom setting.

- **Variable pacing**. One thing games are good at is letting players proceed at their own pace. In a school setting, the instructor usually has to keep everyone moving along at a single pace.

- **1965**. People born before 1965 did not grow up playing videogames; therefore games do not come naturally to them and seem kind of foreign. At the time of this printing, the educational system is primarily run by people born before 1965.

- **Good educational games are hard to make**. To create something that delivers a complete, verifiable, assessable lesson, while still engaging students is very hard. And an average semester class contains two or three dozen different lessons that must be covered.

Despite these challenges, games can be excellent tools for education, but they work best as tools and not complete educational systems. A wise educator uses the right tool for the right job — what are the right educational jobs for games? Let's consider some of the areas where games seem to have some advantage.

Facts

One of the first areas that people naturally think of using videogames is to convey facts and to drill those facts. This works mainly because learning facts (state capitals, times tables, names of infectious diseases, etc.) is dull and repetitive. It is an easy thing to integrate them into game systems that give auxiliary rewards as you make progress learning information that is not inherently interesting. Videogames, in particular, can make use of visuals that can help players learn these facts. And while a game may be a minor improvement over the more straightforward ways of memorizing these facts, at the present time they are rarely much more than that.

Problem Solving

Remember our definition of game? *A problem-solving activity approached with a playful attitude*. Naturally, when it comes to practicing problem solving, games have a chance to shine, particularly in cases where students need an opportunity to show that they can use a variety of different skills and techniques in an integrated way. For this reason, it may be the case that game-like simulations may start to serve as final exams in areas where multiple techniques need to be combined in a realistic setting, such as police and rescue work, geology, architecture, management, etc.

Classroom work aside, it is interesting to note that an entire generation is being raised playing very complex videogames that require a great deal of planning, strategy, and patience if the player is to succeed. Some theorize that this will lead to a generation that is far better at problem solving than any generation previous — whether this is true remains to be seen.

Systems of Relationships

The thing that games arguably are best at teaching is illustrated by an ancient Zen koan:

> *Hyakujo wished to send a monk to open a new monastery. He told his pupils that whoever answered a question most ably would be appointed. Placing a water vase on the ground, he asked: "Who can say what this is without calling its name?"*
>
> *The chief monk said: "No one can call it a wooden shoe."*
>
> *Isan, the cooking monk, tipped over the vase with his foot and went out.*
>
> *Hyakujo smiled and said: "The chief monk loses." And Isan became the master of the new monastery.*

The chief monk knew his words could not tell the truth of what a water vase really is like, so he slyly tried to say what it was not. But Isan, whose training was in the most practical of arts, cooking, knew well that some things cannot be understood with words, they must be demonstrated to be understood.

And interactive demonstration is one place that games and simulations excel. Education researchers frequently refer to Miller's pyramid of learning:

FIGURE
30.2

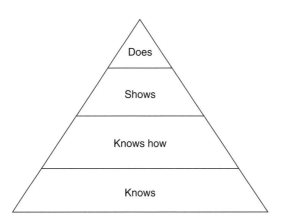

In this model, being able to do something is the pinnacle of knowledge, and game-based learning is almost entirely focused on doing.

Lectures, readings, and videos all have the weakness of being linear, and a linear medium is a very difficult way to convey a complex system of relationships. The only way to understand a complex system of relationships is to *play* with it, and to get a holistic sense of how everything is connected.

Some systems of relationships best understood via simulation are listed below.

- The human circulatory system
- Traffic patterns in a major city
- A nuclear reactor
- The workings of a cell
- The ecology of endangered species
- Heating and cooling in the earth's atmosphere

There is a tremendous difference in understanding between people who have merely read about these things, and people who have played with simulations of them, because the players have not just read about the systems of relationships, they have experienced them. And one of the most powerful ways they experience them is by testing their limits, pushing the simulation until it breaks. How much traffic does it take to make the commute time longer than the workday? How much water can the reactor lose before it melts down? What will irreversibly melt the polar ice caps? Simulations give the player *permission to fail*, which (aside from being fun) is incredibly educational — because the learner not only sees the failures, but sees why they happened, which leads to significant insight about the workings of the whole system.

One of the most striking instances of this I have ever seen is in the game *Peacemaker* from Impact Games. *Peacemaker* is a simulation of the Israeli/Palestinian conflict, where players have the choice of playing the role of either the Israeli prime minister or the Palestinian president, with a goal of trying to make peace between the two nations. When playtesting the game with natives of these countries, the natives would often enter the game with a belief that if the other side would do a few simple things, the conflict would be over. As they would attempt to play the opposing side, however, they would quickly see it wasn't as simple as they thought; complex pressures on both sides make it very difficult to reduce the conflict. Players then quickly succumb to curiosity. First they try to see what it takes to bring these nations to all out war, and when they have that out of their systems, they try to solve the big challenge: Are there any techniques that will successfully work to make peace between these nations?

Objections are often raised about simulating such serious topics. It seems unlikely that these simulations can be perfect. What if someone who plays with a simulation learns a technique that is only valid in the simulation, but would be disastrous in the real world? For this reason, simulations often work much better with a live instructor who is able to point out the discrepancies and use them as

teaching moments. It is worth noting, though, that people do not expect simulations to be completely accurate, and often, the simulation loopholes can be very instructive — they cause players to wonder "why doesn't this happen in the real world?" That question alone can lead to deep insights about how the real world actually works. In other words, in some cases, a flawed simulation can be *more* instructive than a perfect one!

New Insights

In the movie *Groundhog Day*, Bill Murray plays a selfish, arrogant character who gets caught in a time loop that forces him to relive the same day over and over until he gets it right. Over the many repeats of that day, he experiments with how to interact with people around him, gradually understanding them better and better. This understanding gives him insights that cause him to alter his behavior, until finally he has become the kind of person that willfully does the right thing, and when he finally escapes February 2, he is a changed man.

The important part of simulations of systems of relationships is the new insights that are given to the players — they are able to see these systems in ways they couldn't before. And creating the change in perspective that leads to new insights is something games are very good at, since games create whole new realities, with new sets of rules, where you aren't you anymore and you play the role of someone else entirely. This is a power of games that is just beginning to be tapped for the purposes of improving people's lives. It is often said that children who grow up in low-income neighborhoods tend to aim lower in career aspirations because they simply can't imagine they could succeed at a high-paying career. What if games could be used to help them imagine success and make it seem more achievable to them? What if games could help people understand how to escape an abusive relationship, break an addiction, or simply be a better volunteer? Perhaps we have just begun to scratch the surface of how life changing games can be.

Curiosity

It has always been true that students who are curious have an advantage over their classmates who are not, because curious students are more likely to learn things on their own, and they are more likely to retain what they learn, since they learn it because they want to. In a sense, curiosity makes you "own" your learning. But the recent proliferation of Internet access has increased this advantage a thousand times. A curious student can now learn as much as they want about any subject — all the information about every topic known to humankind is only a click away, or will be soon. It seems very likely that a noticeable "curiosity gap" will begin to appear, since curious people will quickly grow to become experts at whatever topics interest them, while the incurious will be left far behind. It is possible that, in the coming decades, a curious mind may be the most valuable asset a person can have.

Surprisingly, though, we know very little about curiosity. Is it something we are born with, or is it something that can be taught? If it can be taught, nurtured, or strengthened, shouldn't that become a top educational priority? Now recall our definition of *play* from Chapter 3: "manipulation that indulges curiosity." Could it be that shifting our educational systems toward more play-based models might be the best possible way to prepare children to thrive in the 21st century?

Can Games Be Bad For You?

Some people are afraid of anything new. This is not unreasonable: many new things are dangerous. Games and gameplay are not new, of course, they have been around since the dawn of man. And traditional games have their dangers: sports can cause physical injury, gambling can lead to financial ruin, and obsession with any pastime can lead to a life out of balance.

But these dangers are not new. They are well-known, and society has methods of handling them. What makes people nervous, especially parents, are the potential dangers of new types of games that have suddenly appeared in popular culture. Parents are always nervous when their children become immersed in something that the parents did not grow up with. As a parent, it is an uncomfortable feeling, because you have no idea how to properly guide your children and no idea how to properly keep them safe. The two areas that cause the most concern are violence and addiction.

Violence

As we've discussed, games and stories frequently feature violent themes, because games and stories are often about conflict, and violent action is a simple, dramatic way to settle a conflict. But no one worries much about the abstract violence that takes place in chess, Go, or *Pac Man*. Worries come about violence that is visually graphic. One focus group I witnessed was trying to determine where the average mom drew the line about what videogames were "too violent" for their kids. *Virtua Fighter* was okay, said the moms, *Mortal Kombat* was not. The difference? Blood. It wasn't the actions that were involved in the games that bothered them (both games are mostly about kicking your opponent in the face), but rather the graphic bloodshed in *Mortal Kombat* that is completely absent in *Virtua Fighter*. They seemed to feel that without bloodshed, it was just a game — just imaginary. But the blood made the game creepily real, and to the moms in the interviews, a game that rewarded bloodshed felt perverse and dangerous.

But there have been many games without any visible blood that have raised concern. The 1974 game *Death Race*, based on the movie *Death Race 2000*, was a racing game that rewarded players for running down little animated pedestrians. When angry parents began to protest this game appearing in local arcades, the

publisher tried to make people believe that they weren't people, but "goblins" that you were supposed to run down with your car. No one believed that because the dangers of reckless driving are too real.

When we did the very first test of *Pirates of the Caribbean: Battle for the Buccaneer Gold* for DisneyQuest, we were terrified. We were bringing families in to play the game, and their reaction was going to determine the future of the game. Everyone on the team was very uncomfortable because the Columbine high school shootings had happened less than a week before, and here we were showing a game where you pulled the trigger on a cannon, over and over, blasting everything in sight.

To our surprise, no one even made the connection, and all the families had great fun. No one expressed any concerns at all about the game being too violent, even though we expressly asked about this in our interviews. Pirate cannons shooting down cartoon enemies was so far removed from the real world that it didn't cause the slightest concern.

What accounts for these differences and inconsistencies? A simple fear: playing games with realistic violent content might make people desensitized to real-world violence, or worse, make them feel that real-world violence is fun and pleasurable.

How valid is this concern? It is hard to say for sure. We know it is possible to become desensitized to blood and gore: doctors and nurses must do this to function and make rational decisions during surgery. Soldiers and police officers must take it a step further and become desensitized to wounding and killing others, so they can think clearly in situations where they must commit violent acts. But this kind of desensitization isn't what parents are worried about — after all, if playing videogames made people grow into better doctors and law enforcement officials, there wouldn't be much cause for concern. No, the worry about game violence is about the apparent similarity between the videogame player and the murderous psychopath — after all, both kill for fun.

But do violent games bring about this kind of psychopathic desensitization, or is something different happening? As we've discussed, the more someone plays a game, the more they see through the aesthetics of the game (for graphic violence is just an aesthetic choice), and put their minds in the pure problem-solving world of game mechanics. Even though the avatar may be going on a killing rampage, the player generally does not have thoughts of rage or murder, but thoughts of perfecting skills, solving puzzles, and accomplishing goals. Despite the millions of people who play games with violent themes, it is rare to hear a story about someone who felt drawn to act out a violent game in real life. It would seem that the average person is very good at distinguishing the difference between the fantasy world and real world. With the exception of those who already have violent psychotic tendencies, most of us seem to be able to compartmentalize: We know that a game is just a game.

But the concern that most have is not about adults — it is about children and teenagers who are still forming their views of the world. Are they able to safely compartmentalize violent play? We know they can with some kinds of play. Gerard Jones, in his book *Killing Monsters,* in fact makes the case that some level of violent

play is not only natural, but necessary for healthy psychological development. But surely, there are limits. There are some images and ideas that children are not yet ready to deal with, and this is why rating systems for videogames are absolutely necessary so that parents can make informed choices about what their children can play with.

So, do violent videogames change us for the worse? Psychology is too imperfect a science to give a definitive answer, especially with something so new. So far, they don't seem to have damaged our collective psyche, but as designers, we must be on guard. New advances in technology will continue to make possible more and more extreme types of violent play, and perhaps we will, without warning, find ourselves crossing some invisible line into gameplay that really does change people for the worse. This seems unlikely to me personally, but to say that it is impossible would be arrogant and irresponsible.

Addiction

The second greatest fear people have about the dangers of gaming is that of addiction; that is, playing so much that it is interfering with or damaging more important things in life, such as school, work, health, and personal relationships. This is not just a concern about too much game playing, because after all, too much of anything (exercise, broccoli, vitamin C, oxygen) can be detrimental. No, this is a fear about compulsive behavior that a person is unable to give up, even though it is clearly having harmful consequences.

It is true that designers do continuously seek to create games that capture and engage the mind — games that make you want to keep playing. When someone is excited about a new game, it isn't unusual for them to compliment it by saying "I love it! It's so addictive!" But by this, they rarely mean that the game is damaging their lives, but rather that they feel some kind of pull to keep returning to it.

But there are people who play games so much that their lives suffer for it. Modern massively multiplayer games, with their huge worlds, social obligations, and multi-year play goals definitely draw certain people into self-destructive patterns of play.

It is worth pointing out that self-destructive game playing is nothing new. Gambling is one form that has been around for ages, but it is a special case, since it is the exogenous, not endogenous rewards that are so addictive. Even without monetary rewards, though, there have long been cases of people playing games more than they should. The most common cases are college students. My grandparents used to talk about classmates who had to drop out of school from spending too much time playing bridge. Stephen King's novel *Hearts in Atlantis* is a story (based on true events) about college students who fail out of school due to their addiction to the card game of Hearts and end up drafted into the Vietnam war as a result. In the 1970s, overplay of *Dungeons and Dragons* led to poor academic performance, and today *World of Warcraft* serves as an uncontrollable temptation for many students.

Nicholas Yee performed a very thoughtful study of the factors involved in "problematic usage" of games, where he shows that the reasons for self-destructive gameplay are different for different types of people, or as he says:

The issue of MMORPG addiction is complex because different players are attracted to different aspects of the game, to different degrees, and may or may not be motivated by external factors that are using the game as an outlet. Sometimes the game is pulling the player in; sometimes a real-life problem is pushing the player in. Oftentimes, it is a combination of both. There is no one way to treat MMORPG addiction because there are many reasons why people become obsessed with or addicted to MMORPGs. If you consider yourself addicted to MMORPGs and your playing habits are causing you real life problems, or if someone close to you has playing habits which are obsessive and unhealthy, consider seeking the help of a professional counselor or therapist who is trained in addiction problems.

There is no denying that for some people, this can be a real problem. The question is, what can game designers do about it? Some have suggested that if the designers wouldn't build in such attractive qualities, the problem would go away. But to suggest that it is irresponsible for designers to create games that are "too engaging" is like saying that overeating is the fault of irresponsible bakers who insist on making cake taste "too delicious." It is incumbent upon game designers, who are responsible for the play experiences they create, to find ways to make game structures fit into a well-balanced life. We cannot forget this or pretend it is someone else's problem. It should be on all our minds, just as it is on the mind of designer Shigeru Miyamoto, who often signs his autograph for children with the following note: *On a sunny day, play outside.*

Experiences

So, do games change people? We have discussed at length the fact that we aren't really designing games, we are designing experiences. And experiences are the only things that can change people — sometimes in unexpected ways. When creating Toontown Online, we created a chat system where players could communicate quickly by picking phrases off a menu. Polite interactions between players seemed to us an important part of the Toontown aesthetic, and we felt it helped encourage cooperative play, so most of the phrases are supportive and encouraging ("Thanks!," "Good job!," etc.). This was in sharp contrast to standard MMO culture, which involves a lot of trash-talking — insulting the people you play with, as rudely as possible. During beta testing, we were surprised to get an e-mail from a player who was upset with us. He explained that normally he played *Dark Ages of Camelot* and started playing Toontown on the side. Gradually, though, he found himself playing Toontown more, and *Dark Ages* less. The reason he was upset with us was that Toontown had changed his habits — he found that he tended not to

trash-talk anymore, and was inclined to thank everyone who helped. He was embarrassed (but also grudgingly grateful) that a simple game for children had manipulated his thought patterns so easily.

You might think that changing someone's communication pattern is not that big a deal — but returning to the question of violence, consider, for a moment, what violence really is. Not the violence of stories or games, but real-world violence. In the real world, violence is seldom a means toward an end; instead, it is a form of communication — one that people resort to when all else fails. It is a desperate way of saying "I'm going to show you how much you are hurting me!"

We are just starting to understand how games can change us. It is imperative that we learn more about how they do, because the more we learn, the more we can use them not just as an amusement, but as a valuable tool for improving the human condition. Take this lens to help you remember this important idea.

Lens #97: The Lens of Transformation

Games create experiences, and experiences change people. To make sure only the best changes happen to your players, ask yourself these questions:

- How can my game change players for the better?
- How can my game change players for the worse?

Is it really your business, though, to worry about how your game changes players? This is the subject of our next chapter.

THIRTY-ONE

Designers
Have Certain
Responsibilities

FIGURE
31.1

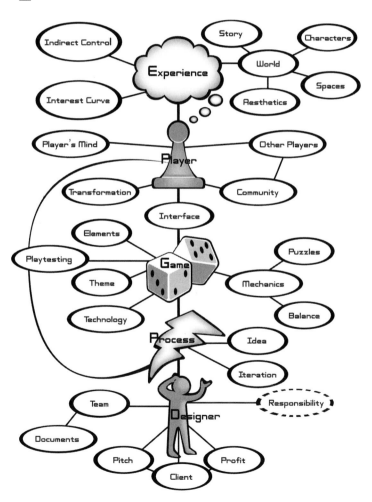

453

The Small Box

The small box gets its first teeth
And its small length
Its small width and small emptiness
And all that it has got

The small box is growing bigger
And now the cupboard is in it
That it was in before

And it grows bigger and bigger and bigger
And now it has in it the room
And the house and the town and the land
And the world it was in before

The small box remembers its childhood
And by overgreat longing
It becomes a small box again

Now in the small box
Is the whole world quite tiny
You can easily put it in a pocket
Easily steal it easily lose it

Take care of the small box

– Vasco Popa

I got into television because I hated it so. And I thought there was some way of using this fabulous instrument to be of nurture to those who would watch and listen.

– Mister Rogers

The Danger of Obscurity

You should be prepared to understand that as a game designer, you are not going to get a lot of respect. If you manage to find a way to design games professionally, you can expect a lot of conversations like this:

FRIEND OF A FRIEND: So, what do you do?
YOU: I design videogames.
FRIEND OF A FRIEND: (clearly uncomfortable) Oh… so, like that *Grand Theft Auto*?

It's the same as if everyone who makes films were asked, "Oh… so, you're a pornographer?"

But you really can't blame people. There is a lot of lurid material in the world of videogames, and lurid stories always get the most press. Slowly, this will surely change, as games become more and more mainstream. But even as it does, and it becomes less embarrassing to be a game designer, it will continue to be a profession where it is difficult to become famous, well-known, or respected. Screenwriters have the same problem: people generally don't care who makes the things they like, and the publishers would rather you didn't become famous anyway, because it makes you expensive. But I'm not complaining about this — I am only mentioning it to point out something quite dangerous: Because you will be able to work in relative obscurity, no one is going to ask you to take responsibility for what you create.

And you might say, "It's not my name on the line, it's the name of the publisher, and they're so worried about getting sued, I'm sure they won't let anything out the door that would hurt anybody."

But are you sure? Corporations make mistakes all the time. And further, corporations have no ethical responsibility. Sure, they have to follow the law, but beyond that, their sole and single purpose is to generate money, and ethics don't enter into it, because corporations have no souls. Bank accounts, yes, legal responsibility, yes, but not souls — and that means no ethical responsibility. Only individuals can take ethical responsibility. Are you going to assume that game company managers are going to take on that kind of personal responsibility? They might, but you and I know they probably won't. No, there is only one person who can take responsibility for what you create, and that is you.

Being Accountable

In Chapter 30 we talked about some ways that games might be dangerous. And as new technologies arrive, there are also new ways for games to accidentally do harm. Of all the dangers that games might or might not contain, the one that is most real and undeniable for players of online games is the potential to meet with dangerous strangers. When most people think about making their online game "safe," they think about making sure that children aren't exposed to foul language. But while foul language may be inappropriate, it has nothing to do with safety. No, the real danger is the fact that online games can be a mask of anonymity which dangerous people can use to take advantage of innocents. If you are designing a game that involves strangers talking each other, you must take responsibility for what that might lead to. This is one of the rare cases where your choices in game design could cause lives to be saved or lost. You might think there is a one in a million chance of something dangerous happening in your game, but if that is true, and your game is so successful that five million people play it, that dangerous thing will happen five times.

Many designers decide that they cannot be held responsible for what happens in their game, and they leave it to the lawyers to decide what is and is not safe. But are you content to leave your ethical responsibility in the hands of corporate lawyers?

If you aren't willing to take personal responsibility for the games you make, you shouldn't be making them. I worked on one project where the team felt so strongly about this we asked our concept artist to create an image of what the cover of *Time* magazine would look like the week a child was abducted due to a lack of communication safeguards in our game. We never showed it outside the team, but every one of us burned this image into our minds to help us remember the responsibility that was on our shoulders.

Your Hidden Agenda

But you might argue that your game really is safe — there is no way it could do harm. And you might be right. Consider this: is it possible you could find a way for your game to do good? To somehow make people's lives better? If you know this is possible, and you choose not to do it, isn't that, in a way, just as bad as making a game that harms people?

Now, don't get me wrong — I'm not the type who is going to tell you that it is the responsibility of game companies to better the human race, even if it means losing some profits. The only responsibility of a game company is to make money. The responsibility for making games do good lies solely with you. Am I saying that you should try to convince management that your title will be better if it can somehow improve mankind? I am not. Management won't care about that — their job is to serve the corporation, and the corporation only cares about making money.

What I am telling you is that, if you want to, you can design your games so that they will improve people's lives, but you will probably need to do this *in secret*. Generally, it will not serve you well to tell management about how it is important to you that you use the powerful medium of games to help people, because if they know that is your goal, they will think your priorities are out of whack. But they aren't. For if you make a game that is really good for people, but no one likes it (the game version of a broccoli smoothie), you haven't helped anyone. The only way your games can serve humanity is if as many people play them as possible. The trick is to figure out what you can put into your best-selling games that will transform players for the better. You might think this impossible — that people only like what is bad for them. But it isn't true. One thing people like better than almost anything else is being cared for. And if you can manage, through your game, to make your players into better people, they will feel, appreciate, and remember that rare feeling that someone else cares what they become.

The Secret Hidden in Plain Sight

Is it overkill to put this much consideration into the effect that games have on people? It is not. Games are not just trivial amusements. Games are a means of creating experiences, and life itself is composed of nothing but experiences. Moreover,

the experiences that game designers create aren't everyday experiences — they are ones where people live out their fantasies and strive to become what they have always secretly wished to be. Fantasy worlds created for children become modern mythology — shared story worlds that stay with them as a guiding compass for the rest of their lives. We create utopias: ideal societies to which all nations are compared.

It is not enough to think of how games affect people today — we must consider how they will affect people tomorrow. You are working in, and inventing, the medium that will subsume all others. The medium that a person is immersed in when they are young defines how they will think for their entire lives. As you continue to invent and improve the medium of games, you are defining the thought process of the next generation. This is no trivial matter.

When you think about it, is there any human activity that cannot be viewed as a game, and therefore benefit from the principles of good game design?

The Ring

Have you ever thought about your pinky? How it is strangely smaller than all the other fingers? It almost seems like an accident — like some kind of withered appendage. But it isn't. It has a purpose that most of us are completely unaware of. Your pinky guides your hand. Every time you pick something up or put something down on a surface, your pinky is there first, feeling things out like a little antenna and safely guiding the hand into position.

In 1922, Rudyard Kipling was asked by the University of Toronto to create a ritual to help remind graduating engineers of their obligation to help society. At the conclusion of this solemn ritual, still practiced today, the engineer is given an iron ring, placed on the pinky finger of their dominant hand, as a lifelong reminder of this obligation.

One day, game designers may concoct their own ritual of obligation, but you don't have time to wait for that. Your obligation begins today — this minute. If you truly believe that games can help people, then, here — take this ring. It is invisible, like mine — that way, you can't lose it. If you are willing to accept the responsibilities that go along with being a game designer, then you should put it on. Wear it as a reminder to let these responsibilities guide your hand. Think about it carefully before you put the ring on, though, because it doesn't come off. Oh — and if you look closely, you'll see it bears this inscription:

Lens #98: The Lens of Responsibility

To live up to your obligations as a game designer, ask yourself this question:

- Does my game help people? How?

CHAPTER THIRTY-TWO

Each Designer has a *Motivation*

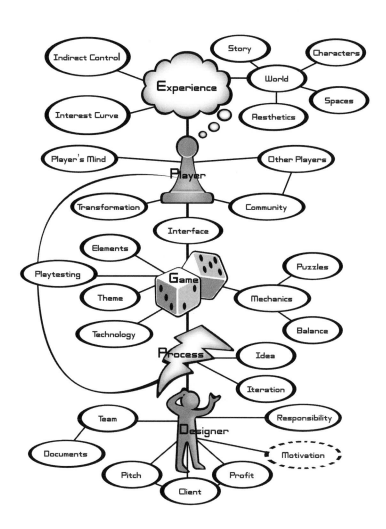

FIGURE
32.1

The Deepest Theming

At the start of this book, we talked about how listening is the most important skill for a game designer. And through the book, we examined facets of listening to your audience, to your game, to your team, and to your client.

But now, it is time to talk about the most important type of listening — listening to your *self*. You might think it is easy to listen to yourself. But our subconscious mind holds many secrets. We often do things, and we don't know why. Why, for instance, is game design so very important to you? Do you know? You might think that the time for this kind of self-reflection can come later. But it can't, because life is very short. In a blink, you will look up, and realize you don't have any time left. For time destroys everything, takes everything away. Like Poe's raven, it mocks you, cackling "nevermore" as it glides into the night. You can't stop it. Your only hope is to do your important work *now*, while you still can. You must run like death is behind you because *death is behind you*. Quick — take this lens so you don't forget.

Lens #99: The Lens of the Raven

To remember to only work on what is important, ask yourself this question:

- Is making this game worth my time?

But what is that important work? How can you know? This is why you must learn to listen to yourself. There is some important purpose that is hidden inside you, and you must find out what it is. Surely there is some reason you are going through all the trouble of trying to design great games. Maybe it is because you can see something in your mind's eye that you feel will change someone's life. Maybe it is because of something wonderful that you experienced once, and you want to share it with the world. Maybe something terrible happened to someone you loved, and you want to be sure it never happens again, to anyone. No one can know this purpose but you, and no one needs to know it but you. We spoke about how much more powerful your game will be if you know its theme, but do you know your own personal theme? You must figure it out as soon as possible, for once you know it, you will undergo an important creative change: your conscious and subconscious motivations will be united, and your work will gain a passion, a focus, and an intensity that cannot possibly be greater.

To help you find your true motivation, take this final lens.

Lens #100: The Lens of Your Secret Purpose

To make sure you are working toward your one true purpose, ask yourself the only question that matters:

- Why am I doing this?

Goodbye

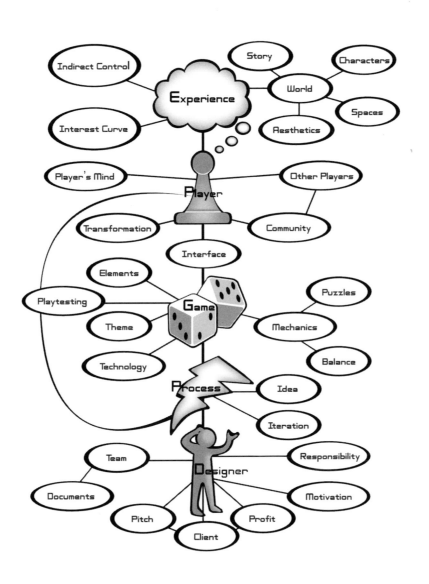

All Good Things…

My goodness! Look at the time! I've talked long enough to fill a whole book. Thank you so much for dropping in — I really do enjoy talking about these things with someone as thoughtful and insightful as you are. Say, what was that clever anagram you mentioned? If I mix up the letters in "Art of Game Design" it spells "Ragged…" something? Oh, yes! Very clever! I'll have to remember that!

You have your map? Your ring? And all your lenses? Good, good. No, really, you can keep them — if you promise to use them. And good luck with that game you mentioned — it sounds really fun! Let me know when we can try it out!

Thanks again for coming, and thanks so much for listening.

Keep in touch, okay?

After all, we game designers have to stick together.

Endnotes

Hello

Page 19 — Maxwell H. Brock: A character in Roger Corman's classic film, A Bucket of *Blood* (1959).

Page 24 — *We might as well omit to study nature because she is old.*

– Henry David Thoreau, *Walden*

Chapter 1: Designer

Page 2 — "When a thing must be attempted, one must never think about possibility or impossibility." I borrowed this phrase from C.S. Lewis in *Mere Christianity*.

Page 2 — "They lack a fear of ridicule." Pointed out to me by Cary Evans.

Page 2 — "'Animation' means 'to give life'." Thanks to Ben Johnson for reminding me of that!

Page 5 — "Brian Moriarty once pointed out…" He said this in his 1997 GDC lecture called "Listen! The Potential for Shared Hallucinations." There is some doubt about this etymology.

Page 5 — "To listen with a silent heart…" Herman Hesse, *Siddhartha*. 1922.

Chapter 2: Experience

Page 12 — "Psychology, Anthropology, and Design." I was surprised to find this triad reinforced by other sources. George Santayana, in *The Sense of Beauty* forms a similar triad of Psychologist, Anthropologist, and Artist. Marc Prensky, in *Digital Game Based Learning*, talks about the three paths to knowledge: "The analytical path, where philosophers reflect, mediate, and make sense of objects and events; the empirical path, where scientists manipulate variables and conduct controlled experiments to validate reliable principles; and the pragmatic path where practitioners struggle with real-world challenges and come up with strategies for effective and efficient performance." Analytical corresponds to Anthropology, Empirical to Psychology, and Pragmatic to Design.

Page 14 — "Xenophilic" You can also say "xenophilous," if you like.

Page 15 — "Socrates, for example, noted..." Plato's *Phaedo*.

Page 17 — "He simply was not able to clearly dissect his experiences." Yes, Jeff, this is you.

Page 18 — "Defeating Heisenberg" Ben Johnson suggests another category of introspection: Looking for the first time that you get swept up in your game.

Chapter 3: Game

Page 26 — "I don't think anyone will disagree with that." Actually, Bernard Mergen will in a couple of pages. See what I mean about no consensus?

Page 27 — "participants received sprays of sugar water..." Berns GS, McClure SM, Pagnoni G, Montague PR. Predictability modulates human brain response to reward. *Journal of Neuroscience* 2001 April 15; 21(8):2793–2798.

Page 27 — "This is a tricky one." I'm not the only one who thinks so. Check this out: "The nature of ... play has long baffled philosophers and psychologists." Colwyn Trevarthen, "infancy, mind in" in *The Oxford Companion to the Mind* (Oxford, Oxford University Press, 2004) p. 460.

Page 27 — "Play refers to those activities..." J. Barnard Gilmore, "Play: A Special Behavior." *In Child's Play*, edited by R.E. Herron and Brian Sutton-Smith (New York: John Wiley & Sons, 1971), p. 311.

Page 28 — "Play is free movement within a more rigid structure." Katie Salen, Eric Zimmerman, *Rules of Play* (Cambridge: MIT Press, 2004) p. 304.

Page 28 — "Play is whatever is done spontaneously and for its own sake." George Santayana, *The Sense of Beauty* (Charles Scribner's Sons, 1896) p. 19.

Page 28 — "Games, competitive games, which have a winner or a loser..." Bernard Mergen, *Play and Playthings* (Westport, CT: Greenwood Publishing Group, 1983).

Page 28 — "In ev'ry job that must be done..." Richard M. Sherman, Robert B. Sherman. "Spoonful of Sugar" from *Mary Poppins* (Walt Disney Pictures, 1964).

Page 29 — "The task he has to perform..." Mihaly Csikszentmihalyi, *Flow* (New York: Harper & Row, 1990) p. 39.

Page 29 — "Work and play ... become equivalent to servitude and freedom." George Santayana, *The Sense of Beauty* (New York: Dover, 1955) p. 19.

Page 29 — "It is an invariable principle of all play..." James P. Carse, *Finite and Infinite Games* (New York: Ballantine Books, 1986) p. 4.

Page 31 — "many people have tried to define 'game.'" In chapter 7 of *Rules of Play*, Salen and Zimmerman have done an excellent analysis of the many definitions

that have been put forth, which I will not repeat here. Not surprisingly, the definitions reach little consensus.

Page 31 — "Games are an exercise of voluntary control systems..." Elliott Avedon and Brian Sutton-Smith, eds, *The Study of Games* (New York: John Wiley & Sons, 1971), p. 405.

Page 31 — "[A game is] an interactive structure of endogenous meaning..." Greg Costikyan, "I Have No Words, and I Must Design." (version 2) p. 24.

Page 31 — "However, the points serve no purpose..." Or, if they had some other purpose, I could never figure it out!

Page 32 — "A game is a closed, formal system..." Tracy Fullerton, Chris Swain, and Steven Hoffman. Game Design Workshop (San Francisco: CMP Books, 2004) p. 37.

Page 34 — "Johan Huizinga called it 'the magic circle'" Johan Huizinga, *Homo Ludens*.

Page 38 — "The whole truth regarding play..." Lehman and Witty, *Psychology of Play*, Chapter 1. 1927.

Chapter 4: Elements

Page 40 — "As she looked around for a new object..." She did eventually stump me: "Daddy, what are feathers made of?"

Page 44 — "...the faster the invading army gets." A note from Wikipedia: "The change in speed was minor at the beginning of a wave, but dramatic near the end. This action was originally an unintentional result of the way the game was written — as the program had to move fewer and fewer aliens it ran faster and faster, but was kept after finding favour with the development team." Thanks to Ben Johnson for pointing it out!

Chapter 5: Theme

Page 49 — *The Plenitude* has finally been published! *The Plenitude*, Rich Gold, MIT Press, 2007. We miss you, Rich!

Page 49 — "The Disney VR Studio" This team used to be part of Walt Disney Imagineering, but is presently part of Disney Online Studios.

Page 50 — "Yo ho, yo ho, a pirate's life for me." Yo Ho (A Pirates Life For Me) X. Atencio and George Bruns, 1967.

Page 52 — "One witty gentleman..." It was Greg Wiatroski. Who else?

"...the cast member..." This is the term Disney uses instead of "employee."

Page 53 — "This film deeply moved audiences..." Moved them to the point of collecting $600 million at the box office.

Page 56 — "Does *Super Monkey Ball* have a deep resonant theme?" But then again, food gathering is a very primal instinct, as is fear of heights...

Chapter 6: Idea

Page 58 — "...my repertory of tricks was limited to two..." Reverse cascade and "the claw." I learned them both from *The Juggling Book* by Carlo.

Page 61 — "...in what parts of the tetrad?" 1: Technology. "Board game" and "magnets" have already been decided. 2: Story. 3: Aesthetic — but be careful — this game needs to feel like a surrealist painting. Does it need to look like one? 4: Mechanics. You might say technology, but perhaps an improvement would be to use a new technology.

Page 64 — "There is a muse..." Stephen King, *On Writing* (Scribner, New York, 2000), p. 144–145.

Page 72 — "...Athena-like..." Read your mythology!

Chapter 7: Iteration

Page 76 — "Best guess. Mr. Sulu." That's a nerdy *Star Trek* reference.

Page 82 — "...Winston Royce, who wrote the paper..." Winston Royce, Managing the Development of Large Software Systems: Concepts and Techniques, Proc. WESCON, IEEE Computer Society Press, Los Alamitos, CA, 1970.

Page 82 — "...Barry Boehm presented a different model..." Barry Boehm, "A Spiral Model of Software Development and Enhancement," ACM SIGSOFT Software Engineering Notes, August 1986.

Page 82 — "...many descendants of the spiral model..." Some of them are Scrum, ROPES, and the fountain model.

Page 89 — "...you can do it all lightning fast!" Chapter 7: Prototyping, in the book *Game Design Workshop* by Fullerton, Swain, and Hoffman has excellent tips for making paper prototypes.

Page 90 — "Game Designer David Jones..." These quotes are from a talk he gave at DICE 2001.

Page 94 — "...never finished — only abandoned." Paul Valery said this about poetry, but it is certainly true of game design as well.

Page 94 — "...Mark Cerny...""The Method" Cerny is speaking from a reference point of action-based platform games. For other types of games, you need to

determine for yourself what the equivalent of "two publishable levels" means. http://www.gamasutra.com/features/slides/cerny/index.htm.

Chapter 8: Player

Page 99 — "If you are creating a game for a target audience…" Some adults have a hard time remembering what childhood was like at a certain age. If you ask someone "What was your favorite book when you were eight years old?" they often draw a blank. If you instead ask "What was your favorite book when you were in the third grade?" they can more easily remember. If this is the case for you, then learn this simple rule: to convert from age to grade, just subtract five. That way, when someone says "What kind of game is good for 10–12 year olds?" you can automatically access your memories by thinking about what you and your friends liked in 5th, 6th, and 7th grades.

Page 102 — Peter Pan and Wendy quote: From the 2003 *Peter Pan* movie.

Page 102 — "Raph Koster, in his book *A Theory of Fun…*" Raph Koster. *A Theory of Fun*. (Paraglyph Press, Scottsdale, 2005), p. 106.

Page 103 — "…males generally have stronger skills of spatial reasoning than females…" Hilmar Nordvik, Benjamin Amponsah. "Gender differences in spatial abilities and spatial ability among university students in an egalitarian educational system," Sex Roles: A Journal of Research, June 1998. http://www.findarticles.com/p/articles/mi_m2294/is_n11-12_v38/ai_21109782.

Page 104 — Heidi Dangelmeier quote: Quoted in Beato, G. 1997. "Computer Games for Girls Is No Longer an Oxymoron." Electrosphere, 5.04, April. http://www.wired.com/wired/archive5.04/es_girlgames-pr.html.

Page 104 — "1/3 of all fiction books sold are romance novels" http://www.en.wikipedia.org/wiki/Romance_novel.

Page 105 — "There is no female equivalent of a pick-up game of touch football." Interesting note from Ben Johnson: Men have also traditionally had a hard time spending time together (without women) when there isn't some sort of work or competition involved. You could say that pick-up games exist so that men can know each other socially. http://www.nytimes.com/2005/04/10/fashion/10date.html?8hpib=&pagewanted=all&position=NYT article on the "man-date" neologism.

Page 105 — "The designers of Hasbro's *Pox…*" John Tierney. "Here Come the Alpha Pups." New York Times, August 5, 2001.

Page 109 — "LeBlanc's Taxonomy of Game Pleasures" The taxonomy is introduced in "MDA: A Formal Approach to Game Design and Game Research" by Robin Hunicke, Marc LeBlanc, and Robert Zubek. It is explained more thoroughly in "I Have No Words and I Must Design" by Greg Costikyan.

Chapter 9: Player's Mind

Page 114 — "Consider this pattern" Borrowed from Julian Jaynes, *The Origin of Consciousness in the Breakdown of the Bicameral Mind* (Dover, 1976), p. 40.

Page 118 — "a feeling of complete and energized focus..." http://en.wikipedia. org/wiki/Flow_%28psychology%29.

Page 118 — A note on flow from Ben Johnson: some EA sports titles create "virtual flow" by letting avatars do things that are superhuman when in a "flow" state.

Page 126 — "Abraham Maslow wrote a paper..." Abraham Maslow, "A Theory of Human Motivation" in *Psychological Review*, 50, 370–396.

Page 126 — A note on Maslow's hierarchy: It is interesting that the hierarchy is at work, even within the game — my first priority is to make my character survive, etc.

Chapter 10: Game Mechanics

Page 138 — "...all about guessing the states of your opponent's private attributes." Imagine how different Monopoly would be if you did not know which properties had houses and hotels on them, for instance. (possible exercise).

Page 138 — "Celia Pearce points out another kind of information..." Pearce, Celia. *The Interactive Book* (MacMillan Technical Publishing, Indianapolis, 1997), p. 423.

Page 144 — "...caused text adventures to fall from favor." This idea was suggested to me by Phillip Saltzman, in an essay he wrote for my Game Design class at Carnegie Mellon.

Page 145 — Parlett's Rule Analysis: David Parlett, Rules OK. http://www.davpar. com/gamestar/rulesok.html.

Page 145 — "foundational rules": Zimmerman and Salen call these "constituative rules" (*Rules of Play*, page 130). David Parlett prefers the term "foundational rules," as do I. "Unwritten Rules": Steven Sniderman. Unwritten Rules. http:// www.gamepuzzles.com/tlog/tlog2.htm

Page 146 — "Consider these tournament rules for playing *Tekken 5*..." These were rules from the 2005 Penny Arcade Expo (PAX).

Page 147 — "Sid Meier proposes an excellent rule of thumb": Sid Meier. Three Glorious Failures. DICE 2001 (video).

Page 162 — "...which squares are landed on most frequently?" The top three most frequently landed on squares, in order, are Illinois Avenue, GO, and the B&O Railroad. Maxine Brady. *The Monopoly Book* (New York: David McKay Company, 1975), p. 92. Don't forget the Chance and Community Chest cards in your simulation!

Page 165 — Tversky quote found in: William F. Altman. "Determining Risks with Statistics — and with Humanity. Baltimore Sun, October 13, 1985. p. 50.

Page 165 — "Tversky asked people to estimate the likelihood of various causes..." Taken from Bernstein, Peter L., *Against the Gods: The Remarkable Story of Risk* (New York: John Wiley & Sons, 1996), p. 279. He took it from a paper by Tversky.

Chapter 11: Balance

Page 177 — *"Alien vs. Predator"* Thanks to James Portnow for this unusual example.

Page 180 — "Michael Mateas points out..." Interactive Drama, Art, and Artificial Intelligence 2002. Mateas, M. Ph.D. Thesis. Technical Report CMU-CS-02-206, School of Computer Science, Carnegie Mellon University, Pittsburgh, PA. December 2002.

Chapter 12: Puzzles

Page 208 — "A young Chris Crawford once made the bold statement..." Chris Crawford, *The Art of Computer Game Design* (Berkeley: Osborne/McGraw Hill, 1984), p. 7.

Page 209 — "A puzzle is fun, and has a right answer." What is a Puzzle? http://www.scottkim.com/thinkinggames/whatisapuzzle/index.html.

Chapter 13: Interface

Page 233 — "juicy:" I first heard this term from the Experimental Gameplay research team at CMU: Kyle Gabler, Kyle Gray, Matt Kucic, and Shalin Shodhan. They made many juicy games.

Chapter 14: Interest Curves

Page 250 — "Mark 2 version of Aladdin's Magic Carpet virtual reality experience" Though the Mark 3 version is playable at DisneyQuest in Orlando at the time of this printing, the Mark 2 version was shut down in 1997.

Page 251 — "*Half Life 2*, one of the most critically acclaimed games of all time." Metacritic score of 96 — not too shabby. www.metacritic.com.

Page 251 — "...graph of the number of player deaths..." From http://www.steam-powered.com/stats/ep1/.

Chapter 15: Story

Page 270 — "How could you make a game out of *Romeo and Juliet…*" I was discussing this idea with Chris Crawford, and he jokingly suggested that perhaps God made time travel impossible in our universe to ensure that our decisions meant something. I still lie awake at night thinking about this.

Page 270 — "…will have to be clever indeed." MMOs do not have save points — and therefore have no time travel. It may well be that the most moving and dramatic gameplay experiences will thus come from that medium.

Page 274 — "As Bob Bates puts it:" From "Into the Woods: a Practical Guide to the Hero's Journey." "…as I paused on my map of 'Treasure Island'…" *The Art of Writing*, by Robert Louis Stevenson, Chapter 5.

Chapter 16: Indirect Control

Page 290 — "But then the art director had an idea." That was Gary Daines.

Page 292 — "Restaurants use this method all the time…" Areni, C.S., & Kim, D. "The influence of background music on shopping behavior: Classical versus top-forty music in a wine store," *Advances in Consumer Research*, 1993, 20, 336–340. ~ Additional research on the influence of music on shopping behavior.

Page 293 — "…$20 just to play this game one time." DisneyQuest originally supported a "pay per ride" model, with the "pay one price" model being optional. The "pay one price" model won out in the long run.

Page 294 — "…we drew up an initial map." Animation Director Bruce Woodside drew the map.

Page 298 — "The Chinese philosopher Lao Tzu wrote…" from the Tao Te Ching.

Chapter 17: Worlds

Page 301 — "the combined sales of all Pokemon products combined is over $15 billion," http://www.usatoday.com/money/media/2006-12-11-foxcards-usat_x.htm.

Chapter 18: Characters

Page 316 — "…a small, distilled list of traits that encapsulate the character." David Freeman is well-known for championing this approach, which he calls the "character diamond."

Page 318 — "This complex diagram..." From *Better Game Characters by Design* by Katherine Isbister, p. 26.

Page 322 — "TRAMP: 'Ere! Where are you going?" *Impro*, by Keith Johnstone, p. 36.

Page 325 — "We are also the only animal that blushes..." Or needs to blush, as Mark Twain points out.

"... the only animal that cries." Some say that elephants cry too. Probably because of all these jokes.

Chapter 19: Spaces

Page 334 — "Imagine yourself on a winter afternoon..." Christopher Alexander. *The Timeless Way of Building*, pp. 32–33.

Page 337 — "In the most profound centers..." Christopher Alexander. *The Phenomenon of Life*, p. 222.

Page 342 — "...pioneered by the designers of *Max Payne*..." *Realistic Level Design for Max Payne* by Aki Maatta. http://www.gamasutra. com/features/20020508/maatta_01.htm.

Page 343 — "...the devil is in the details." Others say that God is in the details. Frankly, I'm beginning to suspect they are the same guy.

Chapter 20: Aesthetics

Page 351 — "distant mountains." Thanks to Ted Elliot for this story. http://www. ugo.com/ugo/html/article/?id=16210§ionId=88.

Chapter 21: Other Players

Page 356 — "You can learn more about a man in an hour of play than a year of conversation." This is frequently attributed to Plato, and said to be part of the text of the *Republic*. Honestly, though, I can't find it in there.

Chapter 22: Communities

Page 358 — "Two psychologists who set out to better understand..." D. W. McMillan and D.M. Chavis, 1986. "Sense of community: A definition and theory," p. 16.

Page 358 — "Amy Jo Kim's succinct definition of community..." Amy Jo Kim, *Community Building on the Web*, p. 28.

Chapter 23: Team

Page 374 — "think of it as… a game for the intended audience." This is how you should have been thinking all along, of course!

Page 380 — "If you give a good idea to a mediocre group…" http://news-service. stanford.edu/news/2007/february7/pixar-020707.html.

Chapter 25: Playtesting

Page 400 — "…if you use a five point scale…" This kind of scale is generally called a Likert Scale, if you want to sound like you know what you are talking about. Most people pronounce it Like-urt, but Dr. Likert pronounced it Lick-urt, so basically it is dealer's choice. Maybe we should ask people to rate the two pronunciations on a scale from one to five.

Chapter 26: Technology

Page 406 — "…another Mickey cartoon that was released six months earlier." What, you don't believe me? http://en.wikipedia.org/wiki/Mickey_Mouse.

Page 409 — "Nobody knows what it's really like, but everyone says it's great." This is a line from the song about the Hype Cycle called *The Spiraling Shape* by They Might Be Giants, in case you want to, you know, sing about the Hype Cycle.

Chapter 27: Client

Page 419 — "Firenze, 1498." My favorite telling of the Michelangelo story can be found in *The 48 Laws of Power* by Robert Greene and Joost Elffers.

Chapter 28: Pitch

Page 423 — "$0.083" That's a dime a dozen, of course.

Page 427 — "Organization will set you free." Alton Brown originated this statement, I believe.

Chapter 29: Profit

Page 435 — "When a consumer buys a $50 retail game title…" Data from "Game Industry Roles and Economics" by Kathy Schoback in *Introduction to Game Development*, edited by Steve Rabin, 2005, Charles River Media, p. 862.

Chapter 30: Transform

Page 443 — "Recent studies have shown the health benefits of mental exercise..." http://www.jhsph.edu/publichealthnews/articles/2006/rebok_mentalexercise. html, for example.

Page 443 — "Some hold the position that education is serious..." These people are often assuaged by semantics: while they may find "entertaining games" unacceptable, they often consider "engaging simulations" a valuable tool — same thing, different name.

Page 445 — "Hyakujo wished to send a monk..." *The Gateless Gate*, by Ekai, called Mu-mon, tr. Nyogen Senzaki and Paul Reps [1934].

Page 445 — "Miller's pyramid of learning..." Miller G.E. The assessment of clinical skills/competence/performance. *Acad Med* 1990:S63–67.

Page 446 — "...a linear medium is a very, very difficult way to convey a complex system of relationships." Writing this book, for example, was no picnic!

Page 446 — "*Peacemaker* from Impact Games" www.peacemakergame.com.

Page 451 — "problematic usage" a more technically correct term than "addiction," which has a specific medical definition.

Page 451 — "Nicholas Yee performed a very thoughtful study..." "Ariadne — Understanding MMORPG Addiction" by Nicholas Yee, October 2002 (http://www.nickyee.com/hub/addiction/home.html).

Chapter 31: Responsibilities

Page 454 — "Mister Rogers" To learn more about this fascinating man, I suggest watching the DVD *Fred Rogers — America's Favorite Neighbor*, 2002.

Page 457 — "In 1922, Rudyard Kipling was asked..." http://en.wikipedia.org/wiki/The_Ritual_of_the_Calling_of_an_Engineer.

Bibliography

Alexander, Christopher. *The Timeless Way of Building*. Oxford University Press, 1987.

Alexander, Christopher. *A Pattern Language*. Oxford University Press, 1987.

Alexander, Christopher. *The Nature of Order: The Phenomenon of Life*. The Center for Environmental Structure, 2002.

Alexander, Christopher. *The Nature of Order: The Process of Creating Life*. The Center for Environmental Structure, 2002.

Arijon, Daniel. *Grammar of the Film Language*. Silman-James Press, 1976.

Aristotle. *The Poetics*. Harvard University Press, 1999.

Arnheim, Rudolf. *Art and Visual Perception*. University of California Press, 1974.

Bang, Molly. *Picture This*. Little, Brown, and Company, 1991.

Bates, Bob. *Game Design, second Edition*. Course Technology PTR, 2004.

Bernstein, Peter L. *The Remarkable Story of Risk*. John Wiley & Sons, 1996.

Brotchie, Alastair. *A Book of Surrealist Games*. Shambhala Redstone Editions, 1995.

Buxton, Bill. *Sketching User Experiences*. Morgan Kaufmann, 2007.

Callois, Roger. *Man, Play, and Games*. University of Illinois Press, 2001.

Carse, James P. *Finite and Infinite Games*. Ballantine, 1986.

Collins, Mark, and Margaret Mary Kimmel (eds). Mister Rogers' Neighborhood: Children, Television, and Fred Rogers. University of Pittsburgh Press, 1996.

Csikszentmihalyi, Mihaly, and Isabella Selega Csikszentmihalyi. *Optimal Experience*. Cambridge University Press, 1997.

Crawford, Chris. *The Art of Computer Game Design: Reflections of a Master Game Designer*. Osborne/McGraw Hill, 1984.

Crawford, Chris. *Balance of Power*. Microsoft Press, 1986.

Cruit, Ronald L., Robert L. Cruit. *Survive the Coming Nuclear War: How to Do It*. Stein and Day, 1984.

Dali, Salvador. *Fifty Secrets of Magic Craftsmanship*. Dover Publications, 1992.

Doblin Group, The. *A Model of Compelling Experiences*. Web site: www.doblin.com.

Dodsworth, Clark Jr. *Digital Illusion*. ACM Press — SIGGRAPH Series, 1998.

Edwards, Betty. *Drawing on the Right Side of the Brain*. Tarcher/Putnam, 1989.

Flaxon, Douglas Norbert. *Flaxon Alternative Interface Technologies*. Web Site: http://www.sonic.net/ ~ dfx/fait/.

Fullerton Tracy. *Game Design Workshop, second Edition*. Morgan Kaufmann, 2008.

Gee, James Paul. *Why Videogames Are Good For Your Soul*. Common Ground Publishing, 2005.

Gladwell, Malcolm. *The Tipping Point: How Little Things Can Make a Big Difference*. Back Bay Books, 2002.

Glassner, Andrew. *Interactive Storytelling: Techniques for 21st Century Fiction*. AK Peters, 2004.

Gold, Rich. *The Plenitude: Creativity, Innovation, and Making Stuff*. MIT Press, 2007.

Gregory, Richard L. (ed.). *The Oxford Companion to the Mind*. Oxford University Press, 2004.

Grossman, Austin (ed.). *Postmortems from Game Developer*. CMP Books, 2003.

Hartson, W. R, and P. C Watson. *The Psychology of Chess*. Facts on File, 1984.

Henderson, Mary. *Star Wars: The Magic of Myth*. Bantam Books, 1997.

Huizinga, Johan. *Homo Ludens: A Study of the Play Element in Culture*. Beacon Press, 1955.

Iuppa, Nick, Terry Borst. *Story and Simulations for Serious Games*. Focal Press, 2007.

Johnstone, Keith. *Impro: Improvisation and the Theatre*. Routledge, 1992.

Kelly, Tom. The Art of Innovation. Doubleday, 2001.

Kim, AmyJo. *Community Building on the Web*. Peachpit Press, 2000.

Koster, Raph. *A Theory of Fun for Game Design*. Paraglyph Press, 2005.

Lynch, David. *Catching the Big Fish*. Tarcher/Penguin, 2007.

Lynch, Kevin. *The Image of the City*. MIT Press, 1960.

Marling, Karal Ann. *Designing Disney's Theme Parks: The Architecture of Reassurance*. Canadian Center for Architecture, 1997.

McCloud, Scott. *Understanding Comics*. Kitchen Sink Press, 1994.

McLuhan, Marshall. *The Medium is the Massage*. Hardwired, 1996.

McLuhan, Marshall. *Understanding Media*. MIT Press, 1998.

Mark Stephen Meadows. *Pause and Effect: The Art of Interactive Narrative*. New Riders, 2003.

Mencher Marc. *Get in the Game! Careers in the Game Industry*. New Riders, 2003.

Miall, David S. "Anticipation and Feeling in Literary Response." *Poetics* 1995, 23, 275–298.

Moore, Sharon. *We Love Harry Potter!* St. Martin's Griffin, 1999.

Murray, Janet H. *Hamlet on the Holodeck.* The Free Press, 1997.

Nelms, Henning. *Magic and Showmanship.* Dover, 1969.

Newman, James, and Iain Simons. *Difficult Questions About Videogames.* PublicBeta, 2004.

Perla, Peter. *The Art of Wargaming.* Naval Institute Press, 1990.

Propp, Vladimir. *Morphology of the Folktale.* University of Texas Press, 1998.

Rabin, Steve. *Introduction to Game Development.* Charles River Media, 2005.

Rouse, Richard III. *Game Design: Theory and Practice.* Wordware Publishing, 2001.

Salen, Katie, and Eric Zimmerman. *Rules of Play: Game Design Fundamentals.* MIT Press, 2003.

Santayana, George. *The Sense of Beauty: Being the outline of Aesthetic Theory.* Dover, 1955.

Schwartz, David G. *Roll the Bones: The History of Gambling.* Gotham Books, 2006.

Sheldon, Lee. *Character Development and Storytelling for Games.* Thomson Course Technology, 2004.

Sutton-Smith, Brian. *The Ambiguity of Play.* Harvard University Press, 2001.

Tinsman, Brian. *The Game Inventor's Guidebook.* Krause Publications, 2002.

Tobin, Joseph (ed.). *Pikachu's Global Adventure: The Rise and Fall of Pokemon.* Duke University Press, 2004.

Utterberg, Cary. *The Dynamics of Chess Psychology.* Chess Digest, Inc., 1994.

Van Pelt, Peggy (ed.). *The Imagineering Workout: Exercises to Shape Your Creative Muscles.* Disney Editions, 2005.

Vogler, Christopher. *The Writer's Journey: 2nd Edition.* Michael Wiese Productions, 1998.

Vorderer, Peter, and Jennings Bryant (eds). *Playing Video Games: Motives Responses, and Consequences.* Lawrence Erlbaum Associates, 2006.

Wakabayashi, Hiro Clark (ed.). *Picasso: In His Words.* Welcome Books, 2002.

INDEX

750.364 LARCENY; FROM LIBRARIES

SEC. 364. LARCENY FROM LIBRARIES - -
ANY PERSON WHO SHALL PROCURE, OR TAKE IN
ANY WAY FROM ANY PUBLIC LIBRARY OR THE
LIBRARY OF ANY LITERARY, SCIENTIFIC,
HISTORICAL OR LIBRARY SOCIETY OR
ASSOCIATION, WHETHER INCORPORATED OR
UNINCORPORATED, ANY BOOK, PAMPHLET, MAP,
CHART, PAINTING, PICTURE, PHOTOGRAPH,
PERIODICAL, NEWSPAPER, MAGAZINE,
MANUSCRIPT OR EXHIBIT OR ANY PART THEREOF,
WITH INTENT TO CONVERT THE SAME TO HIS OWN
USE, OR WITH INTENT TO DEFRAUD THE OWNER
THEREOF, OR WHO HAVING PROCURED OR TAKEN
ANY SUCH BOOK, PAMPHLET, MAP, CHART,
PAINTING, PICTURE, PHOTOGRAPH, PERIODICAL,
NEWSPAPER, MAGAZINE, MANUSCRIPT OR
EXHIBIT OR ANY PART THEREOF, SHALL
THEREAFTER CONVERT THE SAME TO HIS OWN
USE OR FRAUDULENTLY DEPRIVE THE OWNER
THEREOF, SHALL BE GUILTY OF A MISDEMEANOR.

MICHIGAN COMPILED LAWS.